picasso and
the chess player

picasso and the chess player

LARRY WITHAM

Pablo Picasso,
Marcel Duchamp,
and the Battle
for the Soul of
Modern Art

UNIVERSITY PRESS OF NEW ENGLAND

HANOVER AND LONDON

University Press of New England

www.upne.com

© 2013 Larry Witham

All rights reserved

Manufactured in the United States of America

Designed by Eric M. Brooks

Typeset in Whitman and Verlag by Passumpsic Publishing

University Press of New England is a member of the
Green Press Initiative. The paper used in this book meets
their minimum requirement for recycled paper.

Library of Congress Cataloging-in-Publication Data

Witham, Larry, 1952–

Picasso and the chess player: Pablo Picasso, Marcel Duchamp,
and the battle for the soul of modern art / by Larry Witham. —
1st [edition].

pages cm

Includes bibliographical references and index.

ISBN 978-1-61168-253-3 (cloth: alk. paper) —
ISBN 978-1-61168-349-3 (ebook)

1. Picasso, Pablo, 1881–1973. 2. Duchamp, Marcel, 1887–1968.
3. Artists — France — Biography. 4. Picasso, Pablo, 1881–1973 —
Influence. 5. Duchamp, Marcel, 1887–1968 — Influence.
6. Modernism (Art) 7. Art, Modern — 20th century. I. Title.

ND553.P5W547 2013

709.2'2 — dc23 2012034380

[B]

5 4 3 2 1

If only we could pull out our brain
and use only our eyes.

Pablo Picasso (1881–1973)

=======

Painting should not be exclusively retinal
or visual; it should have to do with the gray
matter. . . . That is why I took up chess.

Marcel Duchamp (1887–1968)

contents

1 "Sensation of Sensations" 1

2 The Spanish Gaze 9

3 The Notary's Son 23

4 Bohemian Paris 37

5 Little Cubes 55

6 Modernist Tide 70

7 The Armory Show 81

8 The Return to Order 100

9 A Parisian in America 112

10 Surrealist Bridges 134

11 Europe's Chessboards 159

12 Flight of the Avant-Garde 186

13 Art in Revolt 212

14 The Readymade 237

15 Picasso's Last Stand 254

16 The Duchampians 271

17 Year of Picasso, Age of Duchamp 288

Author's Note 301

Illustration Credits 303

Notes 305

Index 345

picasso and
the **chess player**

1 "sensation of sensations"

On the wintry streets of Manhattan, the foot traffic to see the greatest art exhibition in America had been discouragingly slow. The 1913 "Armory Show" had opened on February 17. It had begun with a gala party, a band, and speeches. The unveiling of provocative Parisian art followed. The newspapers had trumpeted the exhibit opening, but even so, the public was not coming. Then something changed. By the second week crowds began to flock. The public had caught wind of what one newspaper called a "sensation of sensations." It was a single painting among nearly 1,300 canvases and sculptures.

The sensation of sensations was a Cubist painting of a fractured figure moving down a stair, a picture that was given its greatest allure by the title, *Nude Descending a Staircase*. No one really noticed the name of the French artist. He was twenty-five-year-old Marcel Duchamp, who at that time was back in Paris, oblivious to all the Manhattan uproar. The *Nude* hung in the same space, Gallery I, as did a so-so Cubist painting, *Woman with a Mustard Pot*, by a slightly better known Pablo Picasso. The foreign names did not matter as much for the American public as the avant-garde's sheer bravado in this new modern art, filled with its apparent jokes and breach of cultural etiquette. For Americans, this was exactly what was to be expected from the "wild men" of Paris.[1]

By the measure of controversy, Duchamp's *Nude* was a crowd pleaser, apparently worthy of national attention. The image was not obviously a nude, or even a man or woman, but a human-like figure, a splintery wooden skeleton, coming down a stair as if twenty separate snap shots were overlapped. For a young artist like Duchamp, it was a striking and innovative work. It was his first chance to outshine Picasso and, in that sense, the Armory Show was also the first competitive encounter between the life and work of the two artists. By public acclaim, in this round, Duchamp came out the winner. The splintering *Nude* established Duchamp's foothold in America.

The exhibition was held at the Sixty-ninth Regiment Armory building

1

in midtown Manhattan, a vast space used for troop parade drills.[2] On the outside of the fortress-like building hung a banner reading, "International Exhibition: Modern Art." The inside was partitioned by themes and decorated with bright bunting and yellow streamers, dull burlap, potted plants, and hanging green garlands. The so-called "Cubist Room" was at the back of the gauntlet of spaces, a place that the newspapers, tongue in cheek, called the "Chamber of Horrors." At the center of this chamber was *Nude Descending a Staircase*, described by one critic as "an explosion in a shingle factory," and parodied in another newspaper as "The Rude Descending a Staircase," a cartoon about chaos on a subway stair.

The great exhibition also featured European painters from Francisco Goya up to the Impressionists and beyond, making it an object lesson on art, worthy of serious reviews as well. However, the Armory was at heart a mass-media event, geared to drawing crowds, selling tickets, and titillating the public. With its publicity in the hands of a seasoned newspaperman, the exhibit sent press releases nationwide and modern art postcards flooded New York (including a postcard of Duchamp's *Nude*). Newsrooms around the country were mailed an Armory Show press photo, indeed a photograph of, yet again, Marcel Duchamp, who is shown with two brothers, also artists in France.

The International Exhibition of Modern Art, for all of its circus atmosphere, marked a turning point in American awareness of modern art — the Armory Show was the first major importation of the new things happening in Europe, where a movement recently dubbed "Cubism" had emerged. One of the New York exhibition's central goals had been to promote American artists by putting them alongside their European forebears, a plan that somewhat backfired.[3] Although the Armory Show marked the start of serious collecting of modern art in the United States, the American painters and sculptors ended up disappointed. The Europeans received the publicity and sold most of the artwork.

The import of the European avant-garde to New York City had set an important precedent nevertheless, for in future decades, the hub of modern art and the modern art museum would shift to Manhattan. Through the Armory Show, Duchamp had gained an early toehold. Although few people remembered his name, *Nude Descending a Staircase* became an icon of American popular culture, a story of the Parisian in America (and eventually, a Parisian who would become a us citizen). By no intention of

his own, Duchamp had pulled off a classic *succès de scandale*. As a friend joked, his "reputation" as a Frenchman in New York would one day be on par with Napoleon and Sarah Bernhardt.[4]

AFTER THE ARMORY SHOW ran its course from February to March 1913 in New York City, it traveled to Chicago and Boston. In the entire period before, during, and after the show, Picasso and Duchamp were thousands of miles away. In late 1912, a small group of Americans had hurried through Paris, borrowing works by Picasso and Duchamp for the Armory Show, but neither of the artists was around for that moment of contact. During those months, Picasso was busy enough. By turns he was on the coast of southern France innovating "synthetic" Cubism, then moving his studio in Paris, and then traveling to Barcelona for his father's funeral.

Picasso was a young Spaniard in a hurry, the wafting smell of oil paint always around him, a cigarette forever in his fingers — and soon a pipe with fine tobacco, as his income from selling paintings was getting better. His dark hair bobbed over his forehead, and his dark eyes were hypnotic enough to be noticed.

Duchamp could not have been more different, and during the period of the Armory Show, Duchamp was in a far different state of mind than that of Picasso. To get out of stifling Paris, he had just spent several weeks in Munich by himself, and it was a life-changing experience. After Munich he toured Europe to see its art museums; it was only a taste of his future, because he would soon become a traveler, often living out of a suitcase for long periods. On this trip, Duchamp had returned to Paris by the end of 1912, questioning his life as an artist, and mostly holing up in a suburban studio, going out on the town with a raucous, well-heeled friend.

Incessantly, he puffed on a pipe, adding a bit of professorial panache to his otherwise youthful visage (and when he had money in the future, Duchamp preferred chain-smoking Cuban cigars). As a painter, though, Duchamp hated the smell of oil paint. So as an alternative, he began making plans to put his next major art project on a gigantic piece of glass. It would be a hilarious but also "intellectual" piece, one day to be called *The Large Glass*, and it would take its place alongside the *Nude Descending a Staircase* as one of Duchamp's two most famous works.

Despite Picasso and Duchamp's many personal distractions, the Paris

art scene roared ahead. The Armory Show came at the peak of Parisian excitement over Cubism, the chief progenitor of modern art. In fall of 1912, Paris's first major exhibit of Cubist paintings had taken place. Then the first book on the style, *On Cubism*, rolled off French presses. A second one, *The Cubist Painters*, followed in 1913. The Cubist approach to painting had emerged gradually, but then blossomed seemingly overnight, taking on its key early features: a geometrical (or fractal) look, a suggestion of many views on an object, a grid quality, ambiguous space, and very often muted colors. Once it was born—and named "Cubism" in the French press—it moved from outsider status to contending at the center of Parisian art. Cubism even spawned a political debate in the nation's Chamber of Deputies over its threat to French culture.

For some years already, Paris had been a magnet for artists, bohemians, and urban adventurers from across Europe. The city had consolidated this human flotsam in two parts of town, the run-down Montmartre district in the north and the more upscale Montparnasse in the south. In either of these hubs, with their bar and cafe scenes, artists invariably crossed paths. They also met each other at the annual salon exhibits in the great exposition buildings in the heart of Paris. The opportunities for encounters were many. Inevitably that moment would arrive for Picasso and Duchamp.

Although they met, the only account is Duchamp's vague recollection ("I met Picasso only in 1912 or 1913").[5] It was probably at one of the cafes. They were probably introduced by a mutual friend; Duchamp and Picasso had more than a few.[6] "There have been so many cafés in our lives," Duchamp once said of the way Paris bohemians consorted.[7] We can imagine that Picasso would have been puffing on his cigarette, Duchamp perhaps knocking tobacco from his pipe.

The two young artists were a study in contrasts. Picasso was a short, dark-haired, thirty-one-year-old Spaniard with a strong gaze. Duchamp was six years younger, suave in appearance, thin with an aquiline nose, thin mouth, and fair hair combed back. Both of them had the kind of looks that would attract women, and this was especially so for the willowy Duchamp, as it turned out.

For a few years now, Picasso had been doing works that plumbed the depths of human misery. His paintings had very simple titles. Duchamp was on the other side of the artistic coin, the complex, light-hearted side.

When he came to Paris, his first goal was to do illustrations for the satirical newspapers in the city. He surrounded himself with the jokes, puns, and the cheerful sarcasm of the Paris humorists. When he did paintings, Duchamp gave each of his works a long title, what a Paris art critic called an "extremely intellectual title . . . esoteric or unintelligible."[8]

The contrasts did not end there. Picasso and Duchamp orbited in two rival art worlds in Paris. One camp, in which Duchamp held company, was made up of Frenchmen who styled themselves as artist-intellectuals. They wanted to consolidate Cubism as a school with a purist theory, a kind of quasi-science that was the highest evolution of historic French art. Duchamp's two older brothers were leaders in this group, to be called the Puteaux Cubists for the suburb where his brothers lived. The other camp was essentially Picasso himself (joined by Georges Braque). They pioneered the Cubist look, but they shunned speculative theories about art, and they did not join groups of movements.

So when Picasso and Duchamp finally met, it was also an awkward meeting between two philosophical cliques. The leaders of the Puteaux artists "explained Cubism," Duchamp said, "while Picasso never explained anything."[9]

For other reasons, the two artists were probably not impressed with each other. Picasso was bad with French. Meeting fast-talking Frenchmen could be an annoyance. Picasso also had a sour memory about Duchamp's older brother, Jacques. The older artist had laughed at the young Picasso when, like a gypsy, he traipsed into Paris's poorest art enclave eight years earlier, pulling his belongings in a cart.[10] Picasso was an outsider to members of the Parisian middle-class like the Duchamp family. He stayed in his own tight circle — the *bande de Picasso* (the Picasso gang).

By the same token, Duchamp had seen Picasso's early Cubist works, but did not think this outsider was such a great painter. "Absolutely not," Duchamp recalled.[11] Paris swarmed with aspiring artists. Picasso was not the only one, and when it came to the competitive Parisian art scene, Duchamp viewed it differently than the very competitive Spaniard. Faced with the sometimes overwhelming competition, Duchamp preferred to take it easy. He socialized and played chess, a game he had loved since age thirteen. At the time he met Picasso, Duchamp was unemployed. He lived on a parental stipend while Picasso sold paintings. Duchamp soon became so discouraged by the artist's life that he got a job in a Paris library.

IN ALL, THE DAY that Picasso met Duchamp was not worth remembering on either side. It hardly foretold the future, which would be far more dramatic. As the decades passed, and as their lives and works gained prominence in the art world, the rivalry of Picasso and Duchamp became magnified on a global scale. They each came to represent opposite viewpoints about modern art. By the last decades of their lives, they had become, in the hands of future artists and curators, either a banner to wave or a stick with which to wage a partisan battle over the true definition of art.

In the twenty-first century, when art is so pluralistic that nobody tries to define "art" anymore, it may be hard to imagine a time when the definition was being contested across the entire world of art.[12] This contest was at the heart of "modern art," which traditionally is dated from Cubism to the 1970s, when "contemporary art," with its growing variety of forms, expressions, and names, began to blanket the world. Before that happened, however, it was artists such as Picasso — with a rival like Duchamp — who competed to say what modern art was all about. As evidenced by his entire life, Picasso said art was about painting — essentially, a visual experiment. Duchamp had started out in agreement with this view, but over his lifetime changed direction, dismissing what he called mere "retinal" art and presenting an alternative: art was about "ideas" and attitudes, he said, not about paintings or sculptures.

Although Picasso and Duchamp represented this battle of rival notions of art in the twentieth century — over roughly a sixty-year period (1910–70) — it was not a new contest in human history. At other times in Western culture, the arbiters of taste and knowledge debated whether "images" or "texts" were the highest form of human expression and understanding. Writ large in culture, it was also a struggle that seemed to emerge innately from human nature. What two features of the human being are more powerful than the eye and the mind? The visual sense is the most powerful and guiding of the five senses, while the brain, with its up-front executive functions, is the calculating captain of the entire human ship. Can the eye believe what it sees, and can the mind, slippery as it is, trust what it thinks?

From time immemorial, the eye and the mind have worked together for human success, but at some moments in history, they have produced

a cultural battle between image and text. In the twentieth century, with the rise of modern art, Picasso and Duchamp, more than anyone perhaps, represented partisans in a battle that, by the 1960s — and by the end of their lives — produced an entirely new outlook on art, a textual outlook to be called Conceptual art. This battle for the soul of modern art — now essentially over — set the stage for an art world today that is happily pluralistic, but discouragingly confusing, often nihilistic, and oddly commercialized, rife with what one economist has called the "curious economics of contemporary art."[13] The story of how we arrived at this point is also the story of the twentieth century's two most influential artists, Picasso and Duchamp.

When the young Picasso and young Duchamp met briefly in Paris, they were under no obligation to explain themselves, for young artists, fancy-free with a future ahead, brook no such interrogations. As the two men became part of art history, they had to give account of themselves a bit more clearly. This was probably easier for Picasso. Picasso was a lifelong producer of art objects, many of great acclaim. He viewed modern art as an exploration of visual forms. His artworks were his explainers, his ambassadors to the world as he became more famous. Duchamp had a much greater challenge in explaining what he was about. He would claim that the art of the past was passé, dead on arrival, and that a new intellectual dimension in art was required. This was a bold claim that certainly needed a good deal of persuasive justification.

Duchamp found that justification in his own culture. In his own life as an artist, he would gradually echo the sentiments of France's dandy bohemian, the poet Charles Baudelaire, who, before his death in 1867, had famously said "the majority of artists are, let us face it, very skilled brutes, mere manual laborers, village pub-talkers with the minds of country bumpkins."[14] Accordingly, in his youthful zeal, Duchamp began to believe that he could give art an intellectual status, speaking to the human "gray matter," not just the eyeball. "When the vision of the *Nude* flashed upon me," he once said, revealing his ambition, "I knew that it would break forever the enslaving chains of Naturalism."[15] When the chains would not break, Duchamp moved into the alternative course of joke-making on traditional art, perhaps illustrated best by two of his now-famous jocular "masterpieces," *Fountain* (1917), a porcelain urinal turned on its back, and his *Mona Lisa* with a penciled-on mustache (1919).

In their divergent goals—visual versus intellectual—neither Picasso nor Duchamp, both mischievous by nature, lacked sufficient ambition. Picasso was driven by a sense of destiny. Eventually the term "modern art" became synonymous with his name and his boldly painted signature, *Picasso*. Duchamp was a chess player. Strategic and patient, he kept his eyes on the end game. By the 1970s, when modern art was being eclipsed by contemporary art (also called postmodern art), it was common to hear the refrain "art after Duchamp," who died in 1968, and who would soon be associated with postmodern art, even said to be its founder.

Picasso and Duchamp were never close-up-and-personal rivals. Nonetheless, their rivalry for the soul of modern art was real. It began with events such as the Armory Show and their first personal encounter in Paris. From the start, they began to divide up their turf. Duchamp based his end game in New York (thanks to his Armory fame), and Picasso operated from Europe.

Whether in Paris or in New York, how did they do it? How did a dark-eyed young man from southernmost Spain and a quiet, ironic notary's son from a conventional home in rural northwest France end up like two colossi astride the world of modern art? From a pair of Young Turk artists puffing a cigarette and a pipe, lingering around an outdoor Paris cafe, how did they become, as is commonly now said, the two "most influential artists of the twentieth century"? That is the story of this book.

2 the spanish gaze

Pablo Picasso was born on October 25, 1881, in the coastal town of Málaga, Spain, which, at the end of the nineteenth century, lived in the past. Málaga sat at the very bottom of Spain, baking in the Mediterranean heat and cherishing its old Andalusian traditions. For the family of Pablo, however, the future lay to the north in Barcelona. The city was Spain's bridge with Europe, its gateway to the new century. Like a magnet, it would gradually draw Picasso's family north, into the future.

Pablo was the only son of the painter José Ruiz Blasco and his young bride, María Picasso López, and was the only male heir for their entire clan. He lived in Málaga until he was nearly ten, after which José Ruiz Blasco uprooted his family to pursue job opportunities, taking them first to La Coruña on the northwest tip of Spain, and then to Barcelona in 1895.

As a toddler, Pablo was known for his dark eyes, which were not shy at all, and for an ability to draw that seemed to go along with his intense stare. He was naturally curious about his father's art utensils, which lay about the house, and he had four doting women at home—his mother, aunt, and two sisters—who rewarded him for making pictures. Pablo found a way to draw and stuck with it his whole life: he would begin at any point (the front or back of a donkey, for example), and draw with a continuous line, much as he and other children of Málaga did, "with a single stroke," with sticks in the sand.[1] This knack for lyrical line drawing seemed to be in his genes.

As the family moved, Pablo's father focused on his son's artistic training. While living in La Coruña, where his father got a teaching job at an art school, Pablo developed his artistic identity, attending the same institution.[2] Pablo missed the bullfights of Málaga, but that was not his greatest experience of loss. In La Coruña his little sister, Concepción, died of diphtheria. The story goes that Pablo made a pact with God to save her, but to no avail, and this may be the start of his dislike of religion, which increased over time. Another legend has been passed down that once his father realized Pablo's superior talent, he, too, suffered a final

disillusionment — in his own artistic calling. He "gave me his paints and brushes," Picasso claimed. "He never painted again."[3]

At the La Coruña school, Picasso received his first academic training. Later in life, while admiring the free-form drawings of children, he lamented (in humor) that he already "drew like Raphael" in La Coruña.[4] He also began to sign his work, first with "Pablo Ruiz Picasso," then with "P. Ruiz," and still later "Pablo Picasso," dropping his father's name (Ruiz was very common) and adopting his mother's.

From early on, people remarked on the piercing look of Picasso's dark eyes. This seemed poetically natural for someone with an artistic gift. In Málaga, it was also called a *mirada fuerte* (strong gaze), a stare used by men that seemed to possess, even violate, women. Knowing this gaze well enough, the men of Andalusia required women to wear black coverings. According to custom, Andalusian men did not fight, getting enough vicarious violence in bullfights. So they channeled their machismo into womanizing. Later in life, Picasso's friends would justify his remarkable promiscuity by saying, simply, he was "an Andalusian born in the nineteenth century."[5]

Picasso's eyes seemed to seize every kind of imagery. From age ten onward, he was forced to use images to communicate, since his family's mobility put him in the midst of strange new languages. His native tongue was Andalusian, but in La Coruña they spoke Galician tinted by Portuguese, and in Barcelona the Catalonian accent was linked to the region's separatist pride. When words failed, he realized, he could always turn to images to express himself.

Pablo had nearly reached age fourteen in La Coruña when his father got a better job in Barcelona. So en route, the family detoured back to Málaga for a vacation, stopping in Madrid to see the Prado, Spain's national museum. Picasso was stunned by the paintings of the great Velásquez (and the still-belittled El Greco). Both would haunt him for years to come. Arriving in his old hometown, Pablo did a painting of his Aunt Pepa, a work that for the first time showed his "hand," or interpretive style. No academic pretense here, no making Aunt Pepa into an allegorical matron in an oil painting: Pablo portrayed her as a wizened old lady, a person in the world.

At the Barcelona School of Fine Arts (La Lonja), Picasso easily passed the drawing test to enter and became the school's youngest member. He

took up with a group of friends who were five years older than him. For the next decade or so, after which Picasso moved permanently to Paris, he developed the knack of finding Barcelona friends who were from wealthy families. Despite their wealth, these friends inclined to the fashionable modernist lifestyles of the young carefree bohemians, anarchists, and artists. Until his twenties, when Picasso could begin selling his paintings, he relied on many of these wealthy comrades (and on Picasso's own wealthy Uncle Salvador, a doctor in Málaga) to pay his way or get him out of a jam. If Picasso had bouts of impoverishment—spun later into legend— it was because he had decided to take the bohemian oath: never get a job. Otherwise, he had the best art education money could buy. Once he developed his work ethic, and met Parisian dealers, money was never a problem again.

In Barcelona, his father backed him, but clearly to direct him into academic painting, the realistic, methodical style of the European old masters, a style for which there were commissions to be had on traditional subjects. He found Pablo a studio and helped him prepare larger canvases. Along these lines, Pablo's first success was his painting of an ailing woman in bed, *Science and Charity* (1897), which was recognized in a national competition. His later *Last Moments* (1900) was so good that Spain showed it at the Paris International Exhibition of 1900 (the image was later painted over by Picasso, but it is believed to have been a dying figure in bed). On the side, Pablo pursued his own boyish interests: a surviving drawing shows that he wanted to do a large painting of a battle scene. He viewed his father's tastes as terribly bland, and indeed, his father viewed an exotic painter such as El Greco as a corruption of tradition. So when Pablo showed a liking of El Greco, his father scolded: "You are following the bad way."[6]

Young Picasso loved the "bad way" nonetheless. He saw its elements all around him, which included not only a Catalonian revival of strange medieval works, such as El Greco, but also imports from "the North," which meant England and Germany.[7] This was the *fin-de-siècle*, or "end of the century," when art became fascinated with personal disaster. Each northern country offered its version of visual decadence, illness, eroticism, and madness, with Edvard Munch's *The Scream* (1893) and Aubrey Beardsley ("The Fra Angelico of Satanism") and his series of *Salome* drawings (1894) as epitomes of the artistic mood.

In Barcelona, *vitalismo*, the Spanish version of youthful assertiveness, or machismo, mixed handily with the northern versions. These ranged from the "Dionysian art" and ubermensch (superman) of the German philosopher Friedrich Nietzsche, much quoted in Barcelona art journals, to the aggressive sturm und drang of German youth. All of this modernism was intoxicating for Picasso and his friends. Some of them, especially those with money, looked for a movement to identify with, so they took on the trappings of an adult artistic subculture the press was calling "the decadents." Naturally, those who wanted to paint decadence adopted the northern style.

One of its adopted artistic features was "symbolism," the attempt to capture an idea or feeling, not just a replication (as Pablo had done in *Science and Charity*). The symbolist painters, rooted in romanticism and a gothic feeling of mystery, had emerged in several countries and included the Austrian Gustav Klimt, for example. They also included two French painters, Odilon Redon and Pierre Puvis de Chavannes (the first would be a favorite of Marcel Duchamp, the second a favorite of Picasso). At the start of the symbolist movement, the French poet Stéphane Mallarmé explained its sentiments this way: "Paint not the thing, but the effect it produces."[8] There was a far edgier side to symbolism as well (leading eventually to the distinctly separate style of the decadents). The edginess began in poetry when, in 1871, the young French poet Arthur Rimbaud urged his rebellious peers to seek a "deliberate derangement of all the senses," to experience "all forms of love, suffering, and madness." In Picasso's day, the Spanish version was voiced by the painter and writer Santiago Rusiñol. His artistic radicalism was not extreme, simply conforming to the most recent exotic drawing and poetry styles, but in rhetoric Rusiñol eagerly urged artists to "live on the abnormal and unheard of."[9]

Sixteen-year-old Pablo was soon declaring his own autonomy, writing a friend in 1897, "I am against following a determined school as it brings out nothing but the mannerism of those who follow this way."[10] Pablo did not follow, but he borrowed copiously, and the easiest source for that was not the art museum but the new proliferation of illustrated newspapers, journals, magazines, and posters. They were coming down from Paris especially, and being copied by everyone in avant-garde Barcelona. These illustrations used strong outlines, cross-hatching, and dramatic angles of composition, the sum total of which was dubbed the art nouveau (new

art) style, which, having assimilated elements of symbolism, had become international.

Picasso quickly picked up on the new trends. He seems to have been headed for a career in stylish art nouveau illustration if not for his father's alternative choice. He sent Pablo to Madrid to the nation's most prestigious art school, the San Fernando Academy, a guarantee to a painter's career. Despite Pablo's reluctance, his obvious skills greased his way into the academy with ease. It was not a good experience. Either Picasso disliked the training regime, or perhaps, just as likely, he was dispirited by seeing great painters in the Prado Museum, far greater than he, his dead rivals from Spain's golden age. He nevertheless put himself in their league. "Velásquez is first class; and Greco does magnificent heads," he wrote a friend. "Murillo, with all his tableaux, doesn't convince me."[11]

Picasso's formal studies in Madrid lasted only four months. During that time, he developed an early aversion to the Spanish traditionalism of the capital city, and he also nurtured the first semblance of a political attitude. At the time, Spain was entering its disastrous war with the United States. It brought pessimism and dissent upon much of the population, and for a time Picasso was politicized enough to sign an anarchist manifesto.[12] Otherwise, he avoided politics. In a few more years, he would barely escape the draft himself when his wealthy Uncle Salvador paid for his exemption.

Because of the draft, one of Picasso's closest friends from the Barcelona art school, Manuel Pallarès, had fled back to his hometown in the remote mountains of Horta, in southern Catalonia. So when Picasso came down with scarlet fever (a good excuse to end his studies in Madrid), he repaired to Horta to stay with his old friend. Pallarès had been an influence on the younger Picasso. A self-styled modernist, Pallarès was a womanizer, and doubtless took Pablo to his first brothels. From those days, the Barcelona circuses, brothels, and cafes were subjects of Picasso's participation and sketching. In the hills of Horta, Picasso was instead surrounded by raw, hard nature. Away from the influence of museums and publications, he drew and painted by observation, developing a signature style, which included caricature, doing a lot visually with a little, and his trademark—his long flowing lines.

It was the modernist spirit of Barcelona, however, that charted Picasso's future. Picasso and his small, tight circle of friends found their hangout in a Barcelona cafe where the older modernist artists hung their hats.

Els Quatre Gats (the Four Cats) was a tavern and cabaret that catered to families, the artist crowd, and even the anarchist pamphleteers (known for their puffy trousers tucked into their boots and their anti-Madrid *anarquismo*). Opened in 1897, Els Quatre Gats was modeled on the artist cafes in Paris, and Rusiñol aptly called it "a Gothic tavern for those in love with the North."[13]

At the crossroads of Els Quatre Gats, Picasso met the elder artists of note, and among the most talented of them, many of whom had trained in Paris, Picasso developed both friends and rivals. After one of these older artists received rave reviews for an exhibit of 150 works at Els Quatre Gats, Picasso got permission to put on his own one-man show (his first) during the city's festival week in 1900. As best he could, he tacked up a few dozen charcoal portraits and hung three of his best paintings in the crowded space. The drawings were inexpensive so they sold. One of the older painters at Els Quatre Gats joked that Picasso was becoming "le petit Goya," the small Goya.[14] At the time of the two-week exhibit, he was just three months beyond his eighteenth birthday.

For all its allure, Els Quatre Gats cafe was a small-time affair, and it showed Picasso that the real center of the art world was Paris, which had to be every artist's final destination. Thanks to his painting *Last Moments* (1900), he received his own summons to the French capital. On February 24, 1900, the newspapers announced that *Last Moments* was among the works to be shown by Spain at its pavilion during the International Exhibition in Paris. Picasso did not have to go, but here was his chance to gain family approval. "He gave up his studio, left his family, said good-bye to all of us," recalled his friend, Jaime Sabartés.[15]

Dressed as a flamboyant Spanish artist, Picasso and another of his well-to-do artist friends, the volatile Carlos Casagemas, headed for Paris by train in October 1900, the month of Picasso's nineteenth birthday. He was a migrant in a city teaming with hundreds of footloose artists. On arriving in Paris, Picasso and Casagemas rented a room in the south, the Left Bank, in Montparnasse. They also met up with some of the older artists from Els Quatre Gats, already residents in Paris, who offered to show young Picasso some of the ropes. One of the Catalans, in fact, was leaving town, so he promptly offered Picasso his studio—for free—in the north of the city, the cabaret district and artist enclave of Montmartre.

Free rooming was better than paying through the nose. So one day, Pi-

casso and Casagemas bolted from their rented space, crossed the river, and headed to northern Paris. They lugged their baggage in a cart and, on reaching hilly Montmartre, pulled it up the steep, winding streets (since cheap rooms were at the top of the hill). Then Picasso saw a familiar face and heard a derisive laugh. Earlier he had apparently met the well-known Parisian illustrator Jacques (Duchamp) Villon, one of three brother artists in the Duchamp family (including the younger Marcel).[16] Now Villon was laughing at Picasso, probably because he looked like he was skipping out on his rent at the previous location. Picasso took it as a slight. It was also a disappointment, since Jacques Villon was one of Paris's more successful modernist illustrators, seen in publications and on posters (even in Barcelona).

Picasso swallowed his pride and enjoyed the city. This was the heyday of the Parisian cabaret, and as the International Exhibition was the first to give a full national survey of Impressionism, artists such as van Gogh, Gauguin, and Toulouse-Lautrec were also breaking into public view. After a few decades of the sweet visuals of Impressionism — of landscapes, town scenes, and garden parties — a somewhat darker idea was beginning to eclipse the arts, a view of painting advocated by the late poet Charles Baudelaire. When Baudelaire spoke of "The Painter of the Modern Life" (1863), and how beauty can be extracted from evil, his most salient pictorial example was the brothel.[17] Quite apart from Baudelaire's poetry, Paris had indeed become a kind of world capital of the municipally managed bordello (and a fountainhead of photographic and illustrated pornography).

Picasso had seen plenty of Barcelona's red-light district, but it was not nearly as fancy or elaborate as what he saw in Paris. Brothel life was artistically celebrated in the eerie and sad images of Toulouse-Lautrec or the soft pastel "toilette" scenes of Degas. For better or for worse, the brothel would play a monumental role not only in Picasso's personality and anxieties but in his artwork as well.

On this first trip to Paris, Picasso focused on doing works that captured the spirit of French paintings. This meant painting cabarets and street life, especially the lives of women. His visits to the International Exposition, the Louvre, and other museums comprised his first historical initiation to art beyond the Prado. He saw Delacroix, Ingres, Courbet, Manet, Monet, Renoir, Pissarro, Sisley, and Cézanne. What impressed him most was not

the vanguard of so-called scientific Impressionism (pointillism, for example), but the evocative realism of Degas, Toulouse-Lautrec, and van Gogh. Hence, his first painting in Paris was of the cabaret Moulin de la Galette (which had been painted by Renoir, gaily, and Toulouse-Lautrec, ominously). Picasso made the dance hall and human figures darker and more menacing, as if adding some of the northern angst, by way of Spanish dark paint, into the Paris party scene.

At age nineteen, Picasso had stepped into French art, and indeed his first cabaret painting was bought by a French publisher. In the transition to French style, he borrowed the curvy, thick-to-thin lines of Toulouse-Lautrec, and the blurred edges and angled perspectives of Degas—not to mention Toulouse-Lautrec's Montmartre brothels and Degas's "toilette" scenes.

On his two-month first visit to Paris, however, it was not the brothels that plunged Picasso and his friends into deep, troubling waters, but the Montmartre studio itself, which was loaned to him by the Barcelona painter. In Montmartre, the female model was as populous as the artist, circus performer, or con man. The studio Picasso had borrowed came with three models who, while paid for posing, usually slept with the artists as well. Picasso and his two friends paired up, and it was the fate of Casagemas to fall in love with his match of convenience, the model named Germaine, who responded to his fondness—but only for a while.

By Christmas 1900, the Barcelona friends were back at home, but both Picasso and Casagemas were restless about what to do next. Picasso was also finding Casagemas, who showed signs of emotional instability, a burden. So it was with some relief to Picasso that they went their separate ways. Casagemas returned to Paris, besotted by Germaine. Against all hope, he wanted to win back her affections. Picasso headed for Madrid to try his hand at founding (with another moneyed friend) the brief, unlamented radical art journal *Arte Joven* (*Young Art*), which had a heyday of rabble-rousing exuberance for about four months before closing. As Picasso labored on the journal, Casagemas showed up one day at a Paris cafe where Germaine and her friends socialized. He pulled a gun from his coat, and while his shot at Germaine missed, the bullet to his own head put him out of his lovelorn misery.

In Madrid in February 1901, Picasso received word of the suicide by

letter. Besides the death of his young sister, the suicide of Casagemas was the other early event to make its emotional mark on him as a young artist. It would alter the direction in his paintings, a prelude to Picasso's first distinct "period," his melancholy Blue period, aptly named for the mood and the blue oil paint that dominated his works.

Around the same time as the Casagemas tragedy, Picasso received very good news as well. The small-time Spanish art agent in Paris, Pere Mañach, had arranged a show for Picasso at the gallery of Ambroise Vollard, who was emerging as the premier dealer in post-Impressionism. Picasso's show was slated for June 1901. So between that time in Barcelona and up to the last minute in Paris, he rapidly churned out paintings that would appeal to the Parisian market, especially those with a festive Spanish flair. He brought between fifteen to twenty-five paintings and a number of drawings and pastels from Spain, but produced more at his Paris studio—the studio where Casagemas lived on the day he shot himself (and presently, where Picasso, too, slept with Germaine).

The Vollard show went well. He sold half of the works and generated comments of recognition in *Revue Blanche* of a new "Spanish invasion." Picasso's paintings had a thematic pattern: women of all ranks and activities in modern society, but especially, as a *Le Journal* reviewer said, "every kind of courtesan."[18] Another said Picasso was a mere imitator, an emulator of Toulouse-Lautrec. This stung.

From his early days in Barcelona, Picasso had indeed imitated, voraciously trying out every style that came along. At the same time, he had experimented with the act of rearranging reality, hoping to discover a new look, his own look perhaps. In three self-portraits, for example, he presented himself as a precocious prodigy, a wigged aristocrat, and a stiff-collared dandy. On every other subject he mixed and matched, moving through style after style, often producing a new derivation. This would be Picasso's modus operandi across a lifetime of painting: picking an approach and topic, and exhausting it for a time, then moving to another approach and topic. In this, nobody could keep up with Picasso. Nonetheless, the Paris experience in 1901 signaled to him that he needed to take a radical departure, show that he was not a mere imitator of the Paris vanguard.

Thus, over the next five years, Picasso's paint colors evolved from blues to pinks, from his so-called Blue period to his Rose period.

PICASSO'S BLUE PAINTINGS presented a melancholy view of the world. He has only partly explained why he took this turn. "It was thinking about Casagemas's death that started my painting in blue," he once said.[19] Picasso had other anxieties to mix with his blue as well. He saw the tragic street life in Paris and Barcelona. Personally, the Vollard exhibit was a thrill, and yet just as quickly, Picasso was back to square one, his financial future no less secure.

His trips to brothels may have caught up with him as well. Featured in his blue paintings were the sights seen at the hospital-prison of Saint-Lazare, operated by Catholic nuns, not far from Montmartre, where a thousand incarcerated women — many of them prostitutes with infants — suffered all manner of disease, including blindness. Picasso probably first went there to see Dr. Jullien, head of the venereal department, for a treatment. Later in life, Picasso gave only artistic reasons for going: "Free models."[20] Whatever took him there, he made sketches and introduced the theme of women and children in dire circumstances into his paintings, all in shades of blue. He would also apply blue to himself. In spring of 1901, he painted a bold self-portrait, an icon in ultramarine, on which he signed, "Yo, Picasso" (I am Picasso).

After seven months in Paris on his second trip, he returned to Barcelona and pursued his blue painting in earnest. He began to make the blue increasingly luminous. He introduced the ocean and blank sky as backdrops. The first notable result was a picture based on a nun and a prostitute, a stoic cameo of two women, titled *Two Sisters*. The streets of Barcelona had their share of melancholic people to draw upon as well, not to mention the iconic nature of Spain's religious paintings and the revived interest in Spain's medieval and Romanesque statuary, a first glimpse for Picasso of what later became his interest in "primitivism" as an art form.

Being back in Barcelona, Picasso regained a measure of security and stability. He lived at his parents' and worked in the studio on Calle Riera de San Juan (which he had shared with Casagemas). He spent evenings in the red-light district cavorting and sketching. At this time, Barcelona was the most politically riven city in Europe. As with elsewhere in Spain, it experienced worker strikes and police crackdowns. In all of this, Picasso leaned toward anarchism, but mainly the anarchism of morals and art, not political protest. If he had quickly learned the art of managing

the somewhat anarchic relationships around him, in which he played his friends, dealers, and women off of each other (a lifelong trait), he was also becoming disciplined as an artist. At this time in Barcelona, he rose early and put in a solid day of painting. (Later in his life this would flip flop: he would paint well past midnight, and then sleep late.)

Vollard had dropped Picasso because he did not like his unsellable, morose blue paintings. Nevertheless, for the fall and winter of 1902, Picasso headed back to Paris, his blue painting under his arm, determined to show he was no mere imitator of Toulouse-Lautrec. Actually, he had two good reasons to aim for Paris. Just as the military draft was on his heels, a small-time Jewish dealer, Berthe Weill, had offered to show his latest work at her gallery. This was for a month, beginning on November 15. The Parisian art press was looking for a worthy Spaniard, for as the journal *Revue Blanche* asked, "which one — the time is ripe — will become their Greco?"[21] Picasso's blue paintings did not sell, however. A critic for the *Mercure de France* believed he had squandered his talent to "consecrate masterpieces to a negative sense of life."[22]

These three months in Paris were Picasso's worst experience in the city. It was cold and profitless, yet in the long run had the effect of producing one of the legends of him as a poor, suffering artist. The legend was generated by a local vagabond poet who was the first of Picasso's many acolytes during his long Parisian career. He was Max Jacob, the son of a good Jewish family who had chosen the life of the artist and poet. Struggling with drug use and his homosexuality, Jacob was unable to keep a job, so he lived in hovels in the art district of Montmartre. He was not alone. The streets of Paris for a few generations had been home to the honored *artiste maudit*, or "accursed artist," whose choice of that lifestyle went hand in hand with poetic creativity.[23] Though not a great poet, Jacob was a literary sophisticate. After seeing Picasso's exhibit, he left a note to introduce himself, and gave Picasso some companionship during those three cold Parisian months. When Picasso returned to Barcelona, he wrote Jacob, the start of a crucial friendship, one in which Jacob tutored Picasso in French literature and the ways of bohemian Paris.

On his return to Barcelona in January 1903, Picasso began one of his longest unbroken periods of artistic productivity. These fifteen months generated an entire genealogy of blue paintings (and assorted diversions). A final synthesis emerged. It was a clear and original style of bittersweet,

even romantic, figures, the blues at times coming off as embarrassingly bold. These months were the prelude to his largest canvas of all, *La Vie*, or *Life* (1903). After many versions, it ended up, in effect, being a picture of Casagemas and Germaine, with a motherlike figure looking on, and other figures in the background. As if saying good-bye to his past (as a student of academic art), Picasso painted *La Vie* over his old masterpiece *Last Moments*, the prizewinner that had shown in Paris and had brought him to the city as well.

Once Picasso had become famous, he was often asked about the deep symbolism of *La Vie*, presumed to say deeper things about death, life, and love rendered in a modernist, even abstracted, painting. Surprisingly, Picasso rejected such talk of deep symbolism. Of *La Vie*, he said:

> I certainly did not intend to paint symbols; I simply painted images that arose in front of my eyes; it's for others to find a hidden meaning in them. A painting, for me, speaks by itself, what good does it do, after all, to impart explanations? A painter has only one language, as for the rest . . . [then he shrugged].[24]

Both artistically and commercially, *La Vie* was a kind of peak. Finished in May 1903, the work was sold by June for what the local newspaper *El Liberal* called "a tidy sum"; it was one of a "small number of truly significant paintings produced in Spain."[25] After this peak came a high plateau. In the next year (1904) Picasso produced a series of images that have become icons of modern art: the blind man at his meal; the old guitarist; the man, woman, and child of "tragedy"; and the blind beggar. Picasso's father was going blind, and Pablo, too, had worried about it as a byproduct of venereal disease. What Picasso seemed to achieve was finding such examples of human misery and ennobling them in paint. Time proved their popularity as icons that society could feel comfortable with. Once Picasso reached a peroration in extreme monotone blue (see *The Ascetic*, 1903) he backed away, lightening his blues and eventually warming his colors.

By the beginning of 1904, as Picasso was extricating himself from blue, Barcelona's artistic life was dying away. Els Quatre Gats had closed the previous July. Many of the older painters had moved on, many to Paris, making up the "Catalan gang" around Montmartre. All of Picasso's younger friends from the "decadent" days had turned out to be failures (except Sabartés, who went to Latin America to be a businessman and journal-

ist). So Picasso looked toward Paris, working and saving. In April 1904 he fed *El Liberal* a story that he was leaving for an exhibition, a feint that was dramatic but untrue. In Montmartre, a Spanish friend had offered him a cheap studio in an old building nicknamed the Bateau-Lavoir. So Picasso took the offer. His fourth departure for Paris was his last, in effect making him an artist of France, where he lived and died.

Having moved to the entertainment district in northern Paris, the ethos was that of the circus and its performers, from actors to clowns to entire families of acrobats, often gypsy families. The new environment changed the colors and topics in his paintings. During youthful days in Barcelona, Picasso had had a love affair with a girl who rode a horse at the Tivoli Circus, and now in Montmartre, the Medrano Circus was just down the hill from his studio. The circus had its own mysticism, much like a religion. The circus was home also to the clown, the classic Pierrot (Peter), a jester or tragic figure dressed in a costume. This kind of gaudily dressed figure was also celebrated as Harlequin in the theater, popular song, and stories.

In this new environment, one of Picasso's most interesting transition works was *The Actor* (1904–05), done on a large vertical canvas. After this, Picasso freely mixed the identities of actors, clowns, acrobats, and Harlequin. He was discovering a very different pink-and-red type of world. His painting took on a happier cast that made them saleable. Even Vollard began talking to Picasso again. The inspirations and motivations behind Picasso's new direction were complex, but for the time being, he found himself amid the buoyancy of a new Parisian world, a new set of friends, and a new love, a model named Fernande Olivier, who settled in with him at the Bateau-Lavoir. All of these uplifting factors seemed to guide Picasso's next extremely productive period. Apparently the morose, morbid, and angst-ridden mood of the *fin-de-siècle* was lifting from the art world itself, especially in France.

By coming to Paris, Picasso inserted himself into a city of homegrown revolutions in French art. The latest began to erupt soon after his arrival, making Picasso an eyewitness. In 1905, the French painter Henri Matisse stormed the public art scene as the leader of a new group of experimental painters. They used wild colors and rough compositions, earning the name "Fauves," or "wild beasts." The Fauves tried to surpass French painters such as Paul Gauguin, who had introduced "primitive" art, based upon

masks and statues from the Pacific islands and Africa. The stage was set for Picasso to do what he did best: for a split moment he would imitate, and then he would reconfigure. He saw Fauvism and primitivism in 1905, but quickly moved on. The result would be Cubism.

Picasso was not the only eyewitness to the Paris ferment. In one family of French artists, three brothers were also watching keenly. They were the Duchamp brothers — Jacques (originally Gaston), Raymond, and Marcel. They, too, were galvanized by the neo-Impressionists and Fauves, the artistic excitement of the time. Indeed, both Gaston and Raymond took on *noms de guerres*, "Jacques Villon" and "Raymond Duchamp-Villon" respectively, to declare their artistic rebellions. Jacques had become a noted illustrator (and would later become a Cubist painter) and Raymond would excel in sculpture. Marcel, the youngest brother, would eventually join the Cubist revolution as one of its youngest initiates, keeping his "Duchamp" name in the process.

All the name changes among the Duchamp brothers would become confusing for future raconteurs of the Duchamp family legacy. But thereafter, the three distinct monikers set them apart: Jacques Villon, Raymond Duchamp-Villon, and Marcel Duchamp (with Marcel's "Duchamp" surname becoming the most recognizable in art history).

As Picasso was getting settled up the hill in Montmartre, young Marcel was arriving in Paris to try his hand at becoming an artist, just down the hill.

3

the notary's son

On his first visit to Paris, Picasso had had a brief, humiliating encounter with Jacques Villon, Marcel Duchamp's older brother. Picasso absorbed Villon's laughing taunt but did not forget it too easily. Previously, in Barcelona, he had probably seen Villon's illustration work, which had drifted down to Spain in Parisian publications. It was also visible around everyday Paris. At first blush, Picasso probably ranked Villon in the upper tier of poster and journal artists who dominated Paris, the "*fin-de-siècle* admen," as they were later described, led by the Swiss Steinlen and Montmartre's own Toulouse-Lautrec.[1]

Yet Picasso knew nothing of the Duchamp clan, which had three artist brothers, the youngest of them named Marcel.

For a time, Picasso and Marcel Duchamp lived within walking distance of each other in Montmartre, the north Paris art district. In April 1904, Picasso had moved into a rickety studio complex at the top of Montmartre's great hill. Down at the bottom of the hill, long blocks of new six-story townhouse apartments lined broad streets, sharing space with cafes, cabarets, and even brothels. It was to an abode on one these streets, the rue de Caulaincourt, that Duchamp arrived in October 1904. He moved in with his brother, Jacques Villon, who had a large enough apartment. Marcel would stay there for a year, his first attempt at becoming an artist in Paris.

Up on the hilltop of Montmartre, Picasso had put his days of formal training, his days in Spanish art schools, behind him. He wanted to live the artist's life and produce paintings to sell for cold, hard money. At the bottom of the hill, Marcel was in an entirely different situation. He was tired of going to school, but knew that he needed more formal training. Upon his arrival in Paris, he enrolled in the Académie Julian, an esteemed pay-as-you-go art institute with four studios around Paris, one of them strolling distance from Duchamp's residence.

Even in Paris, Marcel continued to be in the shadow of his two older brothers, whom he admired. Arguably, he had pursued art because his brothers had done so first, taking quite a detour from their father's example.

Within the Duchamp clan, two kinds of vocations had tugged on the family. In their hometown of Blainville-Crevon (near Rouen in Normandy), the father was a successful notary, a kind of all-purpose lawyer, accountant, and civic leader. The mother's side was artistic. Her father was famous for his etchings of Normandy landscapes. Young Marcel had a chance to visit his grandfather's studio before he died. At home, he recalled, "We were surrounded by hundreds of his paintings on the walls."[2] In the footsteps of their father, the two older brothers at first had seriously pursued professions, law and medicine, two of the highest. The family was intellectually oriented, though certainly not academic.

Then one day, over Christmas 1895, Jacques came home and declared that he was going to be an artist. He was soon showing the family his illustrations in Paris newspapers, such as *Le Rire* and *Le Courrier Français*. Next came Raymond. In 1900, after an illness halted his studies in the last year of medical school, he announced his intent to be a sculptor. Soon one of his works was accepted in a Paris salon. All of this began happening when Marcel was eight, and the dramatic about-faces of his brothers must have been exciting. Young Marcel was also impressed that, despite the risk of offending their father, his brothers had changed their names—a remarkable flourish of artistic bravado! Once Jacques and Raymond decided to be artists, the scales were tipped for Marcel and later for his sister Suzanne.

The two brothers brought one other gift home for their younger siblings. They brought home a love of playing chess. By this time in Europe, France had a proud chess tradition, and that love of things cerebral and competitive flowed into the Duchamp household. By age thirteen, Marcel was playing the game. The images of chess began to enter his young artistic mind. It was an alternative world, ruled by a king and queen, protected by knights, bishops, castles, and pawns. This world on the chessboard lended itself to youthful flights of imagination, and in time Duchamp would be putting chess characters—the king and queen in particular—in his drawings and paintings.

Duchamp also developed the patience to think strategically. The patience of a chess player was a prelude to every step along the way, from the game's "opening" moves to the tactical steps that usually followed. Then the larger strategy emerged as the board cleared. Finally the end game—the final assault and victory—arose out of the competitive fog into stark clarity. Duchamp would translate the chessboard into life itself,

or so it seemed. And the day would come when people would say that, of all the stages of chess moves on the board, Duchamp's end game was his strongest.

BEFORE MARCEL WAS BORN, his father Eugène and mother Lucie had moved from another Normandy village to the larger town of Blainville. That was in 1884. On July 28, 1887, Marcel was born as the fourth of six children, duly named Henri-Robert-Marcel Duchamp. An infant sister had died before he was born, but now two more sisters followed. Like the proverbial middle child, Marcel stood in a gap of time between his two brothers, who were eleven and twelve years older than him, and his closest sister, Suzanne, who was two years younger. He would be particularly attached to Suzanne, whom he drew in pictures and with whom he played chess.

In another sense as well, Marcel fell between the gaps in his family. When he was still young, Marcel's mother started to become deaf. She had to abandon her love of music and for a diversion turned to watercolors. Marcel did not like these pretty paintings, and there was a likely cause for this negative emotion: in her distress over going deaf, Marcel's mother had pulled away from him emotionally. As an only child at home, Marcel was cared for by a maidservant, not his mother. When his mother gave birth to two more daughters, her attention turned to them. Later in life Duchamp recalled only maternal coldness. If his mother was "indifferent" toward her son, Duchamp's father was "kindly and indulgent."[3]

Marcel's father was the son of cafe owners in the countryside. He joined the French civil service, rose to be a lieutenant in the military, and in 1874 became a tax official, moving up to be the notary in Blainville. In that role, Eugène moved his family into the nicest brick house in town, centrally located across from the church. The townsfolk brought their legal affairs to the Duchamps' front door. Marcel watched as his father settled disputes between people, handled reams of paperwork, witnessed the signing of legal documents, and kept meticulous files and records. Eventually his father would be elected mayor, and thanks to his shrewd and frugal land dealings, he retired in relative wealth.

The prosperity of this large family notwithstanding, Marcel and his siblings were the end of the genealogical line. All of them became dedicated urban dwellers. None produced grandchildren to bring home (though

Marcel, in a fling at age twenty-three, had a daughter whom he abandoned).[4] The love of the city was in the Duchamp blood, as Marcel's mother, Lucie, had cosmopolitan roots in Rouen; she, too, never liked the country life. Neither would any of her children. Marcel turned out to be the classic urbanite. He lived in apartments nearly his entire life. He never learned to drive (or swim) and he constantly traveled, learning how to store things away, how to live out of a suitcase, and how to set up house in temporary lodgings provided by other people.

The father's success as a country notary had nonetheless opened the way for the three brothers to all become artists. He paid for their schooling and gave them a monthly allowance to live on. Indeed, Marcel received his monthly allowance until he was thirty-seven years old, ending in a small inheritance when his father died in 1925. Thanks to his father, Marcel could opt for the bohemian lifestyle of the artist, which meant not holding a job. "One wants so-called freedom," he later said. "One doesn't want to go to the office every day."[5]

As the nearest large city, Rouen was the place where Marcel and his brothers were sent for their education. When Marcel was ten years old —around the time Picasso was showing his *Science and Charity* and attending Madrid's Fine Art Academy—he entered the Lycée Corneille in Rouen. He lived at a boarding house. This was in the footsteps of his brothers. They all received the classic, secularized version of a Jesuit education. This kind of education had allowed Jacques and Raymond to enter schools of law and medicine in Paris (by preparing them to pass the national baccalaureate exams).

At this time, France's national education emphasized science, especially in the form of mathematics and geometry. This was personified in Frenchman Henri Poincaré, who not only popularized such findings as non-Euclidian (or curved-space) geometry and the invisible world of X-rays but had proposed entirely new theories about mathematical systems as well. Marcel must have been an attentive student, judging by his later skills with geometrical drafting and his curiosity in higher mathematics (and his quoting of Poincaré). His lycée awards, however, came in drawing. It was Marcel's fate to be the first of the siblings to excel at art in the lycée's otherwise academic program.

He began at home. What survives of his work shows that in early 1895, when he was eight years old, he drew a picture of a cavalryman in

uniform. His horse is in the distance, as if running away. This was before the lycée, but once enrolled, Marcel's art-making seemed to go into higher gear. In his final two years at Lycée Corneille, when Marcel prepared for his baccalaureate tests (which he passed in fall 1903), he won back-to-back prizes in art. The first was a top award for drawing, though another student surpassed him with the overall art medal presented by Normandy's "friends of art" association. In his final year, Marcel received that top recognition. It confirmed in his young mind as much as anything that art was his future.

Between home and school, Marcel had created his first career portfolio. During 1902, for example—the time when Picasso was in his early Blue period in Barcelona—Marcel was home for Easter doing a watercolor of his sister sitting sideways in a red armchair. Of his surviving works, this picture is probably the first to reveal a serious attempt at artistic achievement. A few months later, when summer arrived, Marcel showed a sudden zeal for art. Imitating Jacques's drawing style, he did several sketches and a watercolor, mostly of Suzanne—tying a roller skate, washing her hair, in portrait. He also did three oil paintings, his first. They were Blainville landscapes: the church across the road, a field and pond, a chapel garden. Marcel did them in the Impressionist style, the type of painting that prevailed in traditional Rouen, a city of art museums.

After this, Marcel surrendered himself to a regimented discipline. He carried a sketchbook at the lycée. He devoted summer vacations to sketching and painting, experimenting with pencil, ink, watercolor, monotype, Conti, and wash. At school in fall or winter of 1902 to 1903, he did a charcoal drawing of a hanging gas lamp, an object he would return to in his career—a four-sided gas lamp with a gas-illuminated filament. Then the following summer, in 1903, as he anticipated his baccalaureate exams, Marcel was home producing more drawings and paintings, six of which are known, two of Suzanne.

At this point in their lives, a comparison between Duchamp and Picasso is surely lopsided. Next to Picasso, whose production of sketches and paintings was abnormally high, Marcel was hardly an overachiever. Though he may have done far more than what survives today to talk about, clearly he was not a fanatic like the young Spaniard.

Marcel's degree of productivity was influenced by his social life at home, which was filled with many happy diversions. This was especially

so when his brothers returned from Paris for family holidays and summer vacations. Their return signaled, almost automatically, a time for chess games. Furthermore, Jacques showed Marcel how he did humorous illustrations for the satirical newspapers in Paris.

What Raymond brought home, presumably, was a window on the medical science he had been studying (before turning to sculpture in 1900). One of the great advances of his day was X-ray photography. The strange world of X-rays had become the rage in popular magazines, a perfect topic for the zany Belle Époque of France, when machines, electricity, and gadgets—and invisible dimensions—fascinated the public. Raymond was also seeing innovations in motion photography. He had worked in the medical laboratory of radiologist Albert Londe, inventor of a camera that could capture, on one sheet of film, nine to twelve consecutive movements in space.[6] Perhaps over a game of chess, or family dinner, Raymond spoke of stop-action motion images, something that probably informed his own later experiments with Cubist sculptures.

Even in rural Blainville, in other words, Marcel was being given a front row seat on the modern world—with its mechanical devices, strange geometries, satirical humor magazines, and, finally, printing machines and photographic contraptions that could make multiple images, as if by magic.

Young Marcel seemed to cope quite well with all of this modernity, but he still had to cope with the normal crises and awkwardness of adolescence, the coolness of his mother, the dominance of two older brothers, and even his complicated feelings toward his sister. His coping mechanism seemed to be humor, a rather normal human discovery. Humor could mask true feelings and, when necessary, give a neglected middle child a way to gain attention. As Jacques would recall, Marcel was truly "the mischievous one" of the siblings. They "always found him very amusing."[7] Later in life, one of Duchamp's most common refrains was that he did things mainly "to amuse" himself.[8] In the far future, friends and critics alike would call him the "class clown" and "public jester" on the world stage of art.

Despite his wry humor, Duchamp also valued dry rationality, the kind seen in the French philosopher René Descartes (who was also trained in Jesuit schools). "I happen to have been born a Cartesian," he once said. On most counts, though, Duchamp would in fact deny the certainty of

knowledge favored by Descartes, who was by contrast humorless, at least compared to the perpetually tongue-in-cheek Duchamp.[9]

IN THE SUMMER OF 1904, Eugène Duchamp gave his son Marcel the blessing at age seventeen to leave home and go to Paris to be an artist. For a worried father, it was reassuring to know that Marcel would begin by moving in with his brother Jacques. Before leaving for Paris, Marcel put himself through some warm-up exercises. At home, he tried to paint an oil portrait using the method of the old masters, which was to paint first in light and dark — called "grisaille" — and then put down layer upon layer of color glazes. Unfortunately, this project did not work out well. For a sobering moment, Marcel faced the fact that it was difficult to achieve the high quality of classical painting. For the next several years, he tried all the old and new techniques. In a moment of candor later in life, he recalled these experiments as "my research toward all sorts of unsuccessful tries marked by indecision."[10]

Nevertheless, at age seventeen, he was brimming with hope. In October 1904 he took the express train from Rouen to Paris, a hundred miles away. He moved in with his brother at 71 rue de Caulaincourt, just down the hill from where Picasso was living in Montmartre, the liveliest and seediest art district of Paris.

What Marcel noticed on arrival in Paris was that, while Jacques loved the fine arts — and would ultimately devote a long life to painting — he hustled in Paris to make a living by selling illustrations. Later in his life, Jacques still had to earn money by doing commercial etchings, a kind of journeyman's trade. Every month, meanwhile, their father came to Paris to pay the bills for his sons' apartment and cafe meals. Marcel enrolled at the Académie Julian and tried to fall into step with what all the young artists were doing, which was carrying sketchbooks. As he recalled somewhat wryly later, "You had to have a sketchbook in your pocket all the time, ready for action in any provocation from the physical world."[11] Marcel followed suit. For instance, he drew everyday workers in uniforms: street sweeper, policeman, knife grinder, vegetable peddler, gas man, undertaker, and funeral coachman.

Going through the motions, though, did not always feel right. After a year in Paris, Marcel felt ambitious to move higher in the artistic ranks. Many art students paid for classes at academies, such as Académie Julian,

but these were like attending the local community college compared to the Harvard of art schools, the French national École des Beaux-Arts in Paris. So Marcel gave it a try. In April 1905, he submitted a charcoal drawing as part of the École des Beaux-Arts entrance test (but did not gain admission). Meanwhile, it was hard to ignore the many diversions of bohemian Montmartre. He began to go to the billiards hall at a nearby cafe rather than the Académie Julian's morning classes. He enjoyed hanging out with the illustrators who wore the proud badge of "humorist," even as they competed to place drawings in newspapers.

The competition in artistic Paris could be bewildering. Over an average year at the two largest public exhibitions—the spring Salon des Indépendants and fall Salon d'Automne—nine thousand artworks were on sale.[12] Although the bohemian oath was to never take a job, these same artists certainly wanted money, hoping to move their drawings or paintings. Hundreds of young artists arrived in Paris every year with the same idea. They poured in from across Europe—Spain, Italy, Germany, Russia, and Poland—and even from America. Many of them showed up in Montmartre and enrolled at the Académie Julian.

Duchamp was also a witness to how an artist on the fringe could suddenly set a trend, become a star. New movements in painting were at that moment making headway against the established tradition of French classicism and Impressionism. In painting, it was an age of "isms." Small groups of artists began to issue manifestos with their paintings. They jockeyed to be at the vanguard, indeed the avant-garde.[13] During Duchamp's maiden voyage in Paris, the latest turmoil in the competition to define the avant-garde was the rise of the Fauves, led by the clearly ambitious Henri Matisse (whose son, Pierre, would travel to America to sell his father's paintings and strangely show up in Duchamp's future).[14]

Looking back on this period, Duchamp spoke of Paris as a roiling pool of ambitions and calculations to shock the public, the scent of artistic fame being thick in the air. On one hand, he would conclude that, true enough, a painting must truly "shock" people to be worth its salt. On the other, he viewed his brothers as having been caught up in the overly ambitious clatter, at least compared to his own outlook. "I had no aim," he said. "I just wanted to be left alone to do what I like."[15]

During these early days in Paris, Marcel may have played billiards more than chess, but he seems to have returned to the board game whenever

he had a chance, and meanwhile, chess was always a guaranteed pastime when the Duchamp family gathered on holidays or summer breaks. Though a chess novice, Marcel could still borrow from the game to see his own life as a series of calculated moves. Life, too, had its end game. He was still wondering what that might be for himself. Having failed to gain entrance to the École des Beaux-Arts, an ambitious attempt just the same, he next tried his hand at commercial illustration. More specifically, he was interested in cartoons. At the time, humorous cartoons came in two formats: the multiple frames of a comic strip and the single frame with a caption or thought balloon.[16] Duchamp chose the second format.

He had imitated Jacques's drawing style early in life, but had now developed his own look, which was quite good as illustrations of the day went. His cartoons were also rather risqué from the start. They made suggestive jokes about little girls and old men, or about attractive or naked women. He looked for a good pun — a play on words — which by then had become a great fashion in French literature. Indeed, some scholars believe that Duchamp's early interest in hilarious puns, and not his interest in so-called Cartesian thinking, is what put him squarely in "the French intellectual tradition."[17]

Humor would not help him escape from a new legislative fact of French life: young men his age were now required to report for three years of military training. That call-up was around the corner for Duchamp. Fortunately for some young men, there were caveats: those in (or studying for) professional careers, crucial to France's economy, could get off with just one year of training. One of the professions exempted was the "art worker." Neither cartooning nor painting counted for this, so Duchamp pursued the alternative: he decided to study for the printer's trade. After a year in Montmartre, Marcel said good-bye to Jacques and returned to live with his parents, who now had retired to a brick townhome in Rouen. In May 1905, Marcel enrolled as an apprentice at a printing company, the Imprimerie de la Vicomte. Over the next five months he gained an invaluable printshop training that he would apply the rest of his life. It was the training of what Duchamp would call an "engineer," not a painter.

The apprenticeship ended with an exam. Its topic turned out to be somewhat prescient for Duchamp's future. At that time, one of the popular topics in the arts was the life and work of Leonardo da Vinci, the Italian Renaissance figure who was still mostly known as a painter only. At

the end of the nineteenth century, da Vinci's "notebooks"—really a random but voluminous cache of note papers—had been discovered by European translators. Once published in English and French, the notebooks revealed him as an inventor, engineer, and student of artistic "science" as well. Anyone working in graphic technology or commercial art now had reason to celebrate da Vinci, and so it was in France. That is why Duchamp's oral exam, given by a master printer at the Imprimerie de la Vicomte, was on the Renaissance figure.

The examining board also asked Duchamp to demonstrate his skill on the printing press. To do this, he used the copper engraving plate from one of his grandfather's popular series, *The Hundred Towers of Rouen*. Effortlessly he produced a quality art print. Not only were the examiners impressed that he evoked his famous grandfather's work but that he, having graduated with a liberal arts degree from the lycée, and having passed the baccalaureate, had nevertheless sought training in the grimy trade of the commercial printmaker.

Despite his excellent exam score, Duchamp did not enter the commercial printing field. Instead, he kept the skill under his belt. He would pull it out later as he made future moves on the chessboard of life.

On October 3, 1905, with his art workers certificate in hand—which gave him the exemption that reduced his military training to a year only—Duchamp reported for duty in Rouen. The following day he began his life with the Thirty-ninth Infantry Regiment. It was the closest he would ever come to a martial spirit, or even to feigned patriotism. Despite himself, he was promoted to corporal in April 1906 and then discharged that October. He returned to Paris, not to re-enroll at the Académie Julian, but to once again try his hand at living the life of the carefree bohemian artist.

This time, for the first time, Duchamp was entirely on his own. His two brothers had left for the western Paris suburb of Puteaux, joining up to acquire a complex of studios. Jacques and Raymond each had a home studio. These shared a back garden. The garden would become the scene of many casual gatherings of artists and many chess games. Retreat to the suburbs well suited Jacques in particular. His easygoing, quiet nature did not match the kind of opportunism that prowled the streets, studios, and cafes of Montmartre. He lived at Puteaux, a married but childless printer and painter, for the rest of his life. Sleepy as Puteaux may have seemed, in the future it would go down in history as a center of artistic ferment.

Back in Paris on his own, Duchamp rented a flat at 65 rue de Caulain-court, a few doors down from the apartment where he had once lived with Jacques. As if strategically placed, the flat was above the Café Manière, where the humorist illustrators in Paris gathered. As Duchamp had learned, the routine for an aspiring illustrator was to visit the news-paper offices of, for example, *Le Courrier Français* and *Le Rire*, in hopes of selling some pieces. During these exploits, Duchamp met a young Span-iard his own age, Juan Gris. He had come to Paris in 1906 to be an illus-trator (and escape the draft in Spain). On the hilltop of Montmartre, Gris had moved into a studio near Picasso in the Bateau-Lavoir.

The Bateau-Lavoir was becoming a small legend. It was a former piano factory now divided into thirty studios, but with a single bathroom for all. Artists lived and worked in their drafty rooms. The nickname Bateau-Lavoir, which meant "Laundry Boat," was probably earned because the building was large, fragile, boxy, and echoing, like laundry boats on the Seine River, or because laundry fluttered in its windows. Either way, Duchamp eventually paid a visit to the Bateau-Lavoir, a world of seri-ous bohemians and promiscuous models, perhaps to see where Gris was working. Mostly, though, he hung out with Gris down below, playing pool and visiting newspaper offices with their drawings.

It was two years before either of them sold anything to the newspa-pers. Duchamp first published in *Le Courrier Français* in November 1908; in the meantime, his work earned its first recognition by acceptance in a spring 1907 exhibition of humorous art organized by the editors of *Le Rire*. This was the first annual Salon des Artistes Humoristes, put up at an ice-skating rink, the Ice Palace. Five of his drawings were accepted that year and four more the next year as well. Hence, Duchamp's artistic debut in Paris was as a humorist. His drawings showed his ken for using verbal puns. In one, for example, a horse-drawn cab is seen empty outside the Grand Hotel, with the caption "*Femme-Cocher*" (female coach-driver). The reader is left to wonder whether this enterprising driver was actually inside having a sexual tryst with her passenger, a kind of horse-drawn, mobile lady of the night.[18]

Young and carefree, Duchamp explored the various options for the bo-hemian lifestyle in Paris, perfecting it in New York later in life when, he recalled, "It was really *la vie de bohème*, in a sense, slightly gilded — luxu-rious if you like, but it was still Bohemian life."[19] Not all bohemians were

the same, of course. The term had French origins, originally referring to transient gypsies. By the 1830s, an era when Romanticism in arts and letters had elevated the artist to the status of a singular, misunderstood hero, the idea of the bohemian attached to painters, poets, and youth who did not want to conform. In the range of bohemians, there were those who risked dire poverty by living the life of the *artiste maudit*, or "accursed artist," living for the day and for every extreme of life, from drugs and sex to sloth, flamboyant dress, and experimental art. As it is told today, the aim of such artists was to completely eradicate the boundary between art and life, with whatever dangers, or confusion with reality, that may require.

In cultural lore, the extreme French bohemian could be a beloved figure, a persona larger than life. This odd public romance began with the fifteenth-century poet François Villon, who committed violent crimes but was excused and honored because, after all, only deranged people can produce art of great intensity. Not coincidentally, Marcel's two brothers had chosen the bohemian moniker "Villon" when they adopted the mantle of artist. On occasion, the nation would bestow honors and laureate status on a proverbial *poète maudit*, as in the case of Paul Verlaine. "Once the boundary is crossed, there is no longer any limit," said the middle-class Verlaine, who then crossed into a life of drink, abrupt violence, and debauchery. Before he died as a Left Bank homeless man (with a nice home), the city put him on an honorary stipend. At his death in 1896, the press hailed him for having lived "a truly Bohemian life."[20] The city mourned him in a mass procession. A monument was built.

Despite these apparent benefits, being an accursed artist on the street was not to Duchamp's tastes, not after his good upbringing, and not with his father's monthly stipend. (During his first year in Paris, Duchamp also had close contact with a lycée friend, whose wealthy parents in Paris fed him nightly dinners at their home). If Duchamp wanted to be a bohemian, an alternative was to be a bohemian "dandy."[21] This person embraced a radical sentiment, both in art and morals, but preferred bourgeois security. The mind was devoted to bohemian permissiveness, but the idea of a hardscrabble living, or even living in hilltop Montmartre, was repellant.

Parisians with bohemian tastes could live out their fantasies at the cabarets, filled with bohemian trappings (and frequented by real poets and artists). Paris had several cabaret districts, and one of them was outside Duchamp's front door on the boulevards of Montmartre.[22] At the cabaret,

clientele shared in the bohemian spirit of drink, song, poetry, hilarity, illicit liaisons, and, finally, a unique attitude of modern Parisian culture: this was an attitude called *blague* (but also *fumiste* and *mystification*). It was an amorphous outlook on the world, but blague was presented concretely in cabaret skits and stand-up reviews.[23] Blague was more than a joke, prank, or naughty pun. It was the oh-so-clever put-down, condescension par excellence. Inclined to humor already, Duchamp put blague in his expanding artist's toolbox. In time, blague became a Duchamp specialty.

The bohemian mystique also reminded the well-educated Duchamp of the fact that artists were often viewed as "dumb painters," as he said himself. This kind of character was made legendary in Parisian writer Henri Murger's 1849 *Bohemian Life*, a stage play about the thrills and tragedies of a Parisian subculture (and which also became a Murger novel and a timeless opera).[24] In his own age group, Duchamp preferred smart painters, and one of them turned out to be Juan Gris, the young Spaniard, who was intellectually inclined.

Gris would become an important name in the rise of Cubism, giving it not only a Spanish flavor but also a distinctive crispness that grew from his training in mechanical drawing, making him someone who liked precision in artworks, as would Duchamp later. After a burst of significant work, Gris would die at a relatively young age (forty). In his short friendship with Duchamp, however, Gris was not necessarily an artistic influence, but played a rather different role: he was Duchamp's fleeting link to the Spanish painters who gathered in Montmartre, but it was a link that went nowhere. From the start, Gris had come to Paris as an admirer of Picasso. Up on Montmartre, he was part of the *bande de Picasso* (the Picasso gang). To Duchamp's skeptical mind, Gris was being far too reverential. Duchamp had been in the shadow of his brothers. He knew what it was like to be around older dominant figures. He preferred his independence. As one Duchamp biographer said, "Although Duchamp saw quite a bit of Gris, he steered clear of Picasso then and later."[25]

Staying away from the annual salons in Paris was harder, at least for anyone interested in art. These were massive art exhibits held in spring and fall at the vast, multi-room Grand Palais on the Right Bank of Paris by the Seine River. The month-long salons were, over time, an excuse in Paris for what amounted to a public holiday. Thousands of painters

exhibited. Many more thousands — citizens, artists, critics, and dealers — swarmed through the large rooms and labyrinthine hallways of the Grand Palais and associated buildings.

The throngs seemed especially lively in the fall of 1905, the season of the Salon d'Automne. In many ways, this salon marked the start of a significant nine-year trajectory in modern art, one that led up to the start of the First World War, and also a trajectory that set both Picasso and Duchamp on their separate roads of destiny in art history.

4 | bohemian paris

The Salon d'Automne, held around October, was the younger of the two annual salons in Paris: 1905 was only its third year. It was associated with the name of Henri Matisse, a founding organizer, and because Matisse preferred juries, the Salon d'Automne asserted some control over what was shown. (The springtime Salon des Indépendants was more of a free-for-all.) The autumn salon also added a new feature to public art shows by including a retrospective of significant bygone artists. In 1905, for example, the Salon d'Automne featured the French neoclassicist Jean-Auguste-Dominique Ingres.

In late 1905, Duchamp was in Rouen, reporting for military duty, but apparently he found time to take the train to catch the Salon d'Automne, held at the Grand Palais. It made a big impression. At the Grand Palais, Matisse and his followers had a room to themselves. They displayed their highly expressive paintings, earning the moniker "wild beasts," or Fauves. The Fauves painted identifiable things — people, still lifes, or landscapes — but with an emphasis on pure color, wanton brush strokes, and avoidance of precision. Fauvism had a short history, quickly polarizing art critics (and going out of fashion). For this brief shining moment, though, Matisse's work "moved" Duchamp. It was this Fauvist loosening up at salons that fueled Duchamp's ambition to be not only an illustrator but also a fine artist. "It was at the Salon d'Automne that I decided I could paint," he said later.[1]

When Picasso came down from Montmartre and walked to the Grand Palais, he viewed Matisse and the Fauves in a different light.[2] He could see how Matisse was gaining attention, and how he used salon controversy to generate publicity. Picasso's real revelation, though, came at the Ingres retrospective, which featured sixty-eight works. Up to now, his Napoleonic-era paintings and drawings had been mostly hidden away in private collections. As an apostle of Raphael, Ingres specialized in the figure, bringing the odalisque, or exotic concubine, into the modern pictorial repertoire. He was also a master of the line drawing, something Picasso could relate to.

At the salon, Picasso saw Ingres's circular painting *The Turkish Bath* (1862), with its harem scene of odalisques relaxing and coiffing each other's hair. Outwardly, Picasso liked to boast of his rebellion against traditional art, but inside, he always felt challenged to match the skill of such great academicians as Ingres (or to do their accomplishments one better). This is one reason why the *Turkish Bath* image, compared to Paris's garden-variety brothel paintings, seared into his memory.

In that autumn of 1905, the pleasantly cool weather brought out other players in the Parisian art world. Among these were the art collectors, a group that included two American siblings from Oakland, California, Leo and Gertrude Stein. They were Jewish expatriates who had just moved to Paris (now, from Baltimore) with a small, inherited fortune. From their large apartment on the Left Bank, they crossed the river and headed for the 1905 Salon d'Automne, eager to see what they might want to buy.

The leader in this venture was older brother Leo. He had studied art history in Italy, tried to be a painter himself, and made his first prescient purchases by discovering Cézanne. At first, Gertrude, an aspiring writer, simply went along. Eventually she, too, caught the collecting bug and, while Leo was big on Matisse, Gertrude was the one who decided (eventually) to advocate for Picasso. "The twentieth century is a period when everything cracks," she would write with hindsight (after the First World War).[3] Early on, she saw Picasso as more suited to such times than Matisse. At this 1905 salon, the Steins took a mild first step. They bought their first Matisse, *The Woman with the Hat* (1905).

The Steins had just begun to open their spacious "pavilion" apartment at 27 rue de Fleurus to visits by painters, writers, or poets. The apartment had a large dining room, where paintings were hung, and an enclosed courtyard. Indeed, it was only on neutral ground such as this — and among moneyed patrons like the Steins — that Picasso and Matisse could navigate their first personal encounter. In certain ways, they lived in two different worlds. Matisse was a man of the salons. By contrast, Picasso worked exclusively with dealers and their galleries, and would not show in a salon for a decade. As a result, to find Picasso, collectors like the Steins had to probe outside the salon system.

Not long after the 1905 salon, Leo Stein did just that when he walked across the Seine one day. He visited the gallery of the small-time dealer

Clovis Sagot, who showed him drawings and paintings by Picasso. Leo was impressed. He bought two paintings. Back at home, Gertrude did not like them. However, 27 rue de Fleurus was something of a fortuitous crossroads, and as it turned out, an enterprising young French writer, Henri-Pierre Roché, at that very moment was talking with Leo about co-writing a book on art. Roché offered to take him to see the mysterious Picasso. (The loquacious, name-dropping Roché, who became a literary figure documenting this period in modern art, ended up as best friend and co-conspirator to Marcel Duchamp.)[4]

With Roché in the lead, Leo went up the winding streets of Montmartre (Gertrude declined the offer). Leo was surprised at the humble and dirty setting of the building where Picasso had a live-in studio, but he was impressed by the art. He extended an invitation for Picasso and his girlfriend to visit the Steins' home. A few days later, Picasso, who did not speak French or English, was standing before the physically formidable Gertrude Stein. She was seven years his senior and the product of Ivy League education in America. They never really overcame a language barrier, using broken phrases — from English, Spanish, and French — and hand signals, but it got better, and that was enough. They both wanted to encourage the "cracks" in the previous century. Their odd chemistry, two outsider expatriates in Paris, began to make art history.

At the end of 1905, when all this took place, the Steins may have been the most solvent American collectors in Paris, but a much larger system towered over them. The best-known names in dealing modern art in Paris were Durand-Ruel, Vollard, and Burnheim, an old line that had been in the business for some time. They had a lock on the newly rising post-Impressionists, with van Gogh (d. 1890) and Cézanne (d. 1906) as their stars. Although Ambroise Vollard's gallery had put up some Picassos at one time, the young Spaniard was forced to work with small dealers, crucial for Picasso to get started, but names that would not resonate in history.[5] After a one-man gallery show in early 1905, Picasso virtually stopped exhibiting in Paris, preferring to require buyers to work with his dealer or come to his studio.

Of the many helpers in Picasso's early career, one of them would finally stand out. He was Daniel-Henry Kahnweiler, a German businessman who hoped to make his mark in Paris as an art dealer for the avant-garde. He was working in London at the time of the 1905 Salon d'Automne. He may

have crossed the English Channel to see it. The scion of a German Jewish banking family, Kahnweiler had worked in Paris and was eager to return as an impresario of the newest art. Once he moved to Paris permanently, it was only a matter of time before he was directed to Picasso's obscure studio, an encounter that came in 1907. Along with Stein, Kahnweiler was another figure who altered Picasso's future.

Writers were the other specialized group of Parisians that visited the 1905 Salon d'Automne with intense interest. Many of them wanted to be poets, but they earned what they could as journalists, clerks, or critics. While the personable Henri-Pierre Roché, whom Gertrude Stein called the "introducer" for his networking savvy, may have been a writer, his day of acclaim had not yet come (he would eventually write the novel *Jules and Jim*, which remained obscure until it was turned into a 1962 film by François Truffaut).

It would soon transpire that the writer of real consequence for Picasso and Duchamp was to be the twenty-five-year-old Guillaume Apollinaire, still unknown, but an ebullient entrepreneur. Born of Polish and Italian extraction, he lived in a southern suburb with his bohemian, quirky mother, and came up to Paris in search of a literary break, haunting Montmartre, the Left Bank, and various editorial offices. With his native wit and literary gifts, Apollinaire landed jobs as a tutor, secretary, editor, and even writer of potboiler pornography. Even Duchamp marveled at Apollinaire's frenetic energy. At cafes where Apollinaire held court, "You couldn't get a word in edgewise," Duchamp recalled. "It was all a series of fireworks, jokes, lies, all unstoppable . . . so, you kept quiet . . . One was torn between a sort of anguish and an insane laughter."[6]

In 1905, Apollinaire aspired to write art criticism—even though he had never studied art. The painter Georges Braque liked Apollinaire, but said, "Let's face it, he couldn't tell the difference between a Raphael and a Rubens."[7] Nevertheless, Apollinaire simply wrote as if he knew everything, and in time it worked very well. Soon, he was the first writer to give serious ink to Duchamp as an emerging painter.

Apollinaire first met Picasso in a bar in the Rue d'Amsterdam toward the end of 1904 or early in 1905 (the dates are disputed). In 1905 he wrote twice about Picasso's gallery exhibits, reporting in *Revue Immoraliste* and *La Plume*. In Apollinarian purple prose, he described the Blue and Rose period paintings as a mix of delectation and horror. He added such flour-

ishes as tying Picasso to "the compositional richness and rough decoration of Spanish art in the seventeenth century."[8]

For a few years already, Picasso had received favorable reviews, most recently in such mainline organs as the *Mercure de France*. After Apollinaire visited Picasso at the Bateau-Lavoir, the enterprising writer decided to become the painter's chief literary advocate, turning the Spanish outsider into a prophet of modern art. With the arrival of a few French writers and poets in Picasso's life, including the saturnine Max Jacob, a resident of Montmartre, the old Spanish-only *bande de Picasso* was dissipating. A new *bande de Picasso* would form, a band of streetwise French poets. Their hub of activity was Montmartre.

MONTMARTRE COULD BE a scary place to visit, especially at night. One Paris chronicler described Montmartre as the oddly shared turf not only of bohemians, workers, whores, and thieves, but a place where a "kind of understanding and comradeship existed between poets and gangsters."[9]

By contrast, some of the artists making headway in Paris lived in the suburbs. Matisse had his home, with wife and daughter, in the south, while the Duchamp brothers, Jacques and Raymond, were out in semi-rural Puteaux. Modern Paris had been redefined by a great building program of the mid-1800s that bisected the city with grand boulevards and, at the turn of the century, erected the Eiffel Tower (and giant Ferris Wheel) and the Grand Palais and Petit Palais as the great venues for the 1900 International Exposition. When all the construction dust had settled, Montmartre was untouched.

As a sweeping hill to the north, it still had farms, fields, chickens, and whatever forms of older housing lined its winding cobblestone streets. It had once been a vineyard, a legacy that explained why drinking establishments tended to dominate the neighborhoods. The precinct had another reputation as a forbidden fruit ever since it had been home to the armed Commune, which, in its attempt to form a new society of communism, art, and free love, fought its own French government on the barricades for few days in 1871. At the top of the mount was a church, whose dome and tower seemed always in a state of construction.

As was the tradition in Paris, every group of painters and poets needed a bar or cafe as a headquarters. Naturally, Picasso and his *bande* found

theirs in the back streets of Montmartre. At first it was called Le Zut. It was the closest thing to the Quatre Gats that Picasso found on his first visits to Paris. By 1903 it had moved down the hill a ways, expanded, and called itself Lapin Agile. To make his mark, Picasso had painted a mural on the walls of Le Zut, and later, at Lapin Agile, he did the same on large canvases. The *bande de Picasso* became regulars.

As small and dowdy as Lapin Agile may have been, it was actually an arm of a large entertainment system that had grown like ivy across Paris.[10] The system took as its model the new phenomenon of the department store, which began to appear in the 1880s, now that the city had its new, wide boulevards. These stores took on the feeling of an all-in-one fantasy world. Their glass showcases beckoned the public inside. The stores spread advertising, posters, and promotional publications across Paris. It was only a matter of time before one brilliant cafe owner adopted the same idea — and the cabaret of Paris was born.[11] Like the department store, the cabaret was a business model, a distinctly commercial side to bohemian life, employing artists to make posters and newspapers, poets to recite entertaining verse, and producing celebrities, from dancers to singers.

One of the best-known cabaret entertainers, the singer and provocateur Aristide Bruant, rose to fame at the Chat Noir (upon which Els Quatre Gats in Barcelona had been modeled). Toulouse-Lautrec's posters made Bruant's image, in hat and cape, famous across Paris. Soon, Bruant branched out with his own cabaret. He tapped illustrators as his propagandists. He also began a political career. In the process, Bruant had funded the opening of Le Zut as a kind of small franchise, which continued when it changed over, in 1903, to the Lapin Agile. If Bruant was a star at Chat Noir, Picasso, at least, was not exactly a nobody at Lapin Agile.

In all of these settings, Parisian blague — the moody, cynical wit also called fumiste and mystification — was in the air. At this moment in Paris, none had refined the art of blaguing modern times better than one celebrated figure in particular, a veritable paradigm of zany, absurd bohemian thought. His name was Alfred Jarry.[12] In 1905, Jarry probably would not have visited the Salon d'Automne because he was so ill from tuberculosis, drug abuse, and alcoholism. He would die at age thirty-four in two more years. Although Apollinaire, as his literary disciple, had known Jarry directly, neither Picasso nor Duchamp had ever met him, though both became a fan of his exploits. In short, Jarry left a fantastical imprint on the

entire world of the Paris avant-garde by his scatological humor in general, and his jokes on modern science in particular.

He began as a kind of prodigy. As a young man, he was an artist, writer, and even printer of quality art books, specializing in the etchings of Albrecht Dürer. Like many, he was fascinated by the new innovations of electricity, high-speed mechanisms, and invisible rays, but he augmented this by reading a great deal of science and science fiction, from H.G. Wells's *Time Machine* to even wilder fare. Early on, he wrote serious speculative articles on how, protected by the universal ether, people could travel in time, across a fourth dimension. For a whole group of Cubist painters after Jarry, the idea of the fourth dimension would evoke visions of a new, higher kind of art.

Jarry was also a natural prankster, and had been since schooldays. It was this, and not the sober academy, that shaped his life, as did his love of intoxicants and eccentricities. On coming to Paris from Brittany, he gained attention from publishers, journals, and circles of the older poets. His appearances and public readings were cheered at the Chat Noir and the Closerie des Lilas (where he would arrive on a racing bicycle). His fame only increased when, at twenty-three, Jarry produced one of Paris's first absurdist theater productions, the play *Ubu Roi* (King Ubu). It premiered in 1896 at the anarchist-inclined playhouse Theatre de l'Oeuvre, where Jarry was secretary, and began with a famous first line, "*Merde!*" (that is, "Shit!").

Jarry's goal was to offend every aspect of French theater etiquette, to go so far over the top that it became interesting. Even before this *succès de scandale*, Jarry had become known as "Père Ubu." Standing less than five feet tall, with long dark hair and mustache, Jarry dressed oddly and spoke oddly, a kind of staccato monotone. He carried a rusty Browning revolver, firing it in the streets or in cafes. And he wrote novels, two of which extended his influence after his death.

The novel *Supermale* (1902) told the story of man who not only bicycled across continents at high speed but who, attached to electrical wires, was able to have nonstop sex with a woman (in a science laboratory): it was a nonpareil joke on mechanics, science, and sex. Just as outrageous was his posthumous *Exploits and Opinions of Doctor Faustroll, 'Pataphysician* (1911). Doctor Faustroll had invented 'pataphysics, a science that viewed all events as momentary hallucinations. What normal science

believed to be a "law" of nature, he surmised, was simply the same hallucination happening twice. As biographers later said, Jarry refused "to take the road of real life." He committed mental "suicide by hallucination."[13]

Jarry's success gave permission to artists and performers to pursue the world of hallucination. The permission was taken by both Duchamp and Picasso; Duchamp read Jarry's works, and Picasso heard Jarry's message from Apollinaire, who carried it to the Bateau-Lavoir studio (Apollinaire also, it is said, acquired Jarry's revolver after his death, bequeathing it to Picasso). If Gertrude Stein endorsed mere "cracks" in civilization, Jarry said: "Demolish even the ruins."[14]

Duchamp was especially drawn to Jarry by way of his science-mocking 'pataphysics (though when Duchamp died, he also had a well-used copy of Jarry's *Ubu Roi* among a handful of books in his studio.) Jarry was the first in a line of writers who produced monstrous but funny parodies of science. Eventually, Jarry was named the father of many children, from Dada to Surrealism and the Theater of the Absurd.

AS A FRENCHMAN, Duchamp simply breathed in the joys of blague. How Picasso digested French blague—since he barely spoke French—is unclear. In all likelihood, it came to him by his poet friends, who were one of the two main forces shaping his life and art at the time.

One day, up at the Bateau-Lavoir, somebody wrote on Picasso's studio door the words "Rendezvous of Poets" in white chalk. Picasso did not object. By now it was indeed people such as Apollinaire, Max Jacob, and other scribes in search of success who began to gather around the Spanish painter. They taught him French and initiated him into the perennial (and absurdly passionate) debate on who were the best French poets; whether it was the bourgeois symbolist Mallarmé, the intellectual cynic Jules Laforgue, the debauched Verlaine, or the moral rebel Rimbaud. During evenings of drink, opium, or hashish, this new *bande de Picasso* would erupt with "Down with Laforgue! Up with Rimbaud!"[15]

We know of this revelry, and the drug use, because of the second great force that was now shaping Picasso's life and art—his first love of any permanence, a girl named Fernande Olivier. She was a model working in Montmartre. Years later, Fernande wrote a memoir that is, in effect, the primary source of information about Picasso's first major period in Paris.[16] Apparently, the Bateau-Lavoir could be as lively as any blaguing cabaret.

"There never was a group of artists more given to mockery in the unkind and intentionally wounding word," said Fernande, speaking with a tinge of vengeance later in life.[17]

Picasso had met Fernande on the street one day outside the Bateau-Lavoir, where she also lived, the model of a sculptor. By the next summer she was living in Picasso's disheveled studio, with its bed, chair, stove, ash pile, and horde of canvases and paint tubes. A mouse lived in a drawer, and Picasso always had a dog. An attractive, flirtatious, and languorous young woman, much abused already in a difficult family and bad marriage, Fernande willingly abided by Picasso's jealous ways (even wearing the dark full covering of the Andalusian women, a protection against other men's "strong gazing"). Nevertheless, all of the young artists and models slept around as they pleased. Gertrude Stein, herself a lesbian and no prude, called this culture of casual hooking up the "fashion of Montmartre."[18]

Fernande was Picasso's first muse. With her arrival, his paintings from the Blue period gave way to the more cheerful Rose period. It was Fernande, and Picasso's frequent trips to the nearby circus, that gave rise to happier images of acrobats, family life, and Harlequin. Indeed, some of the very last Blue period paintings, with images of emaciated, pale women and men, probably arose from Picasso's opium days, when he saw around him not only the poor and women in a hospital-prison but also drug addicts. (After four years of regular opium use, he and Fernande, she said, quit when a painter neighbor on drugs hanged himself.) For the first years of their courtship, Picasso had won over Fernande partly by their common love of opium smoking.

If the joys of Fernande as muse changed Picasso's paintings, how did the poets change them?

One very concrete example was Picasso's use of the Harlequin character, an image well known on postcards, chocolate boxes, and in the theater. However, Apollinaire—who in his youth had written about the Mardi Gras festivals of southern Europe—had brought Harlequin to the fore in his own writings at the time he met Picasso, at the heart of his Rose period. Harlequin stood for many things. Typically he was a lonely, pensive, or wandering figure. He could also be the blaguer and trickster, the absurdist, and in their intellectual life together, Picasso and Apollinaire certainly shared an absurdist predilection.

Beyond Harlequin, Apollinaire introduced Picasso to darker literary

realms. A student of European erotica, Apollinaire made a living writing about the topic, and took cues from Jarry's success. He took more cues from the Marquis de Sade. In Paris, Sade's notorious 1785 work, *120 Days of Sodom*, which combined decadent revelry, sexual experiment, and torture, had been revived in print. It was Apollinaire's treasured possession. Already, Picasso had visited plenty bordellos, but the sexual content of his artwork would be leavened by Apollinaire's tutorials.

A poet such as Apollinaire would seem logical in Montmartre. However, there were some unexpected characters spending time there as well. One of them was a government insurance adjustor and amateur mathematician named Maurice Princet.[19] He was in love with a teenage model on the hilltop named Alice. They would join the Bateau-Lavoir revelry. Princet often hosted opium sessions at his own dwelling. In love with Alice, he eventually married her. By then, of course, Alice had already slept with Picasso, and before long she would leave Princet to marry the soon-to-be-noted painter and ally of Picasso, André Derain. As Stein had surmised, this fluidity of relationships was simply the "fashion of Montmartre."

The important point is that, amid the rise of the new Cubist styles of painting, Princet became a leading advocate of the idea of the "fourth dimension," which had become a popular topic in France from serious science to science fiction (and the normal amount of satirical humor). For decades already, French mathematicians had been talking about non-Euclidean geometry, or the measurement of curved space, which suggested an additional dimension (the fourth) beyond the normal three dimensions of reality (width, height, and depth). After 1900, however, this arcane world of mathematics began to merge with the popular excitement about new "dimensions" revealed in the discovery of X-rays, electromagnetism, and radioactivity. "Herein lies a whole world that no one suspected," the French mathematician Henri Poincaré wrote in 1902 in one of his general-interest books. "How many unexpected inhabitants must be stowed away!"[20]

For Princet, this was an exciting idea, and before long, many of the salon Cubists, including Marcel Duchamp, would be reading Poincaré and talking about a new "painters' geometry" that, presumably, would penetrate higher realms of knowledge and visual experience.[21] Although Princet took seriously his mission to explain the fourth dimension, mixed in with a little opium smoking around Montmartre, his painter friends in

the shabby art district probably preferred Jarry's farcical approach to science and other dimensions (plus the opium).

So Princet sought a more serious audience. He soon became a center of attention among the painters who gathered at the Duchamp brothers' studios in Puteaux. Marcel Duchamp's enticement by the fourth dimension was his first attempt to intellectualize art, and he would stay with the topic for a few years, combining it with his attentiveness to new technologies, such as time-lapse photography. Indeed, Duchamp hoped to be among the first artists to paint the new dimension. He also wanted to be like Jarry and say "*Merde!*" in public.[22]

BETWEEN 1906 AND 1908, after Marcel Duchamp had returned to Paris following his military duty, he revived his hope of being an illustrator. He was accepted into an exhibition and sold a few drawings. His illustrations revealed a taste for humor and the risqué, as seen in a Christmas restaurant menu he designed. It showed a shapely naked woman reeling back on a cafe table, an uplifted bottle of wine to her mouth.

Making it as an illustrator took work, so it was hard for Duchamp to avoid the easier alternative, which was to work instead at enjoying Montmartre's lively social life. After living at his flat above Café Manière, watering hole of the humorists, in the summer of 1907 he moved down a few doors to a larger apartment at 73 rue Caulaincourt, and it was there that he decided to host his own Christmas party. The raucous festivities lasted for two days, and after bitter complaints by neighbors, the landlords lowered the boom on the young Duchamp. He was officially evicted, but under Paris law, he had six months to clear out.

Apparently, city living was not worth the trouble. So with his parental stipend, Duchamp moved to Neuilly, an upscale suburb to the west. A short walk could take him across the Seine to Puteaux, where his older brothers had set up studios. After moving to Neuilly, Duchamp sold his first illustration to a newspaper. However, it was not illustration work that was behind his accelerated rise in Parisian art, but his oil paintings.

At his Neuilly apartment, he began to produce canvases to show at the coming 1908 Salon d'Automne, which required getting past a jury. For the next two years, Duchamp continued with paintings that seemed to move, like stepping stones, across the styles he saw in museums: Impressionist brush strokes; the bright colors of the Fauves; the geometrics of Cézanne;

the pastels of Monet; the ephemeral shapes of symbolist Odilon Redon, and the more realistic quality of Courbet and Degas. Whatever the style, from 1908 onward, Duchamp had entered with both feet into the salon world. He was able to place paintings in every Salon d'Automne and Salon des Indépendants through 1912.

He completed many of these works while vacationing with his family. The long summer retreat was a tradition for many Parisians. The Duchamps gathered every summer on the northwest coast of Normandy, France, in Eugène Duchamp's rented seaside villa, a red brick cottage in the village of Veules-les-Roses. From 1907 on, Marcel Duchamp spent most of his Augusts there. At the seaside, he and his sister Suzanne joined a congeries of young urbanites fleeing the heat of Rouen or Paris. The word on young Marcel was this: handsome and witty, but a bit aloof.

After moving to Neuilly, the other highly regular travel undertaken by Marcel was his Sunday walk to nearby Puteaux, where Jacques's house was a two-story affair with a bay window and balcony on the garden. Raymond lived next door. When the weather was good, the outdoor garden behind the studios, with its open space, tables and chairs, and sagging chestnut tree, was a venue for everything from chess to archery.

The predominant sport was chess. At Puteaux, Duchamp did his first painting on the topic, one of his largest canvases to date, *The Chess Game* (1910). It was an outdoor scene, heavy in greens and done in a Cézannesque style: it shows his two bearded brothers playing as their wives lounge in the foreground. The chess motif would stay with Duchamp for a few more significant rounds in his artwork.

From 1910 onward, Duchamp chose one other topic to emphasize: the painted nude. Even Apollinaire, citing Duchamp's work at a salon, noted this persistence with the theme.[23] Some of these female figures came from Duchamp's imagination, but any Parisian artist worth his salt had a live model. While living in Neuilly, Duchamp found just such a girl in Jeanne Serre. She is identifiable in at least one of his 1910 paintings. Soon enough, Marcel and Jeanne were embroiled in an affair. On February 6, 1911, Jeanne bore Duchamp a daughter. At twenty-three, he was anything but ready to be a father. For all we know, he abandoned Jeanne before the birth. He never looked back.

For the older or married artists who gathered at Puteaux, there was always a bit of flirtation. Marcel kept his amorous relationships to himself.

For the rest of 1911 and 1912 he was hardly abstinent. Marcel frequently took a night out on the town with friends. He apparently had quite a few girlfriends and affairs. The reason was obvious: he was a good-looking, charming Frenchman who, unlike many artists, did not grow a beard or mustache.[24] He let his finely sculpted Norman face, crowned with swept-back hair, do the talking. If other artists wore funny hats, collars, and pants, Duchamp was seen in what might be called business casual.

As a young and handsome bohemian, Duchamp would have many more affairs across his lifetime. Logically, then, he looked back on the very idea of marriage with distaste. Marriage was an incomparable inconvenience, as one of his early satirical drawings hinted: an unhappy man strolling with a carriage and a pregnant wife. "The things life forces men into," he said forty years later, "wives, three children, a country house, three cars! I avoid material commitments."[25]

By professional standards, Duchamp would not produce much art between 1905 and 1910: thirty-six paintings, thirty drawings fit for publication, and 113 casual sketches. Duchamp never viewed art as a strenuous enterprise. As he said years later, he had never "known this strain of producing, painting . . . having a pressing need to express myself. . . . to draw morning, noon, and night."[26]

THE PRODUCTIVITY of Picasso was an entirely different story. Between mid-1904 and mid-1908, which were his first permanent years in Paris, the arrival of Fernande had led to a more cheerful kind of painting and topic, the so-called Rose period.

Something wider in Paris, a mood change, was probably also shaping Picasso's new paintings. The cutting edge of the art world had apparently wearied of the *fin-de-siècle*'s morbid aesthetic. Why not something more upbeat? After all, French culture was always caught in an identity crisis, trying to decide whether the "classical" French spirit originated in the cheerful, sunny south or the grim, cold north. After the *fin-de-siècle* spirit in art seemed exhausted, the Mediterranean seemed to be making a comeback. One clever writer called it a "crusade of southerners against the gods of the north."[27]

During the Rose period, this mood may have guided Picasso's brief detour into a classical look. Despite Apollinaire's love of the dark Marquis de Sade, Apollinaire also loved sunny classicism. He surely egged Picasso

in this direction. It is tempting to say that Picasso was also egged along by what he saw at the Salon d'Automne retrospectives. The retrospective in 1904 featured forty-three works by Puvis de Chavannes, a French symbolist painter who gave a unique feeling to classic motifs: idyllic settings of people in fields, by water and structures, and with their animals. He painted in simplified and pastel shapes and colors, a naïve brushwork done with classical sophistication. As if to officially end his brief but highly productive Rose period, Picasso painted *Death of Harlequin* (late 1905). But before moving on to more radical experiments — such as his almost abrupt turn to "primitive" art after 1908 — Picasso produced some Puvis-like imagery: soft pastoral scenes with people and animals. Picasso's superlative example was *Boy Leading a Horse* (early 1906), which was bought by Gertrude Stein.

Truth be told, Picasso's step into a brief classical period had begun with his portrait of Stein. On the occasion when Leo had invited Picasso and Fernande to the Stein home at the end of 1905, the Spanish painter knew exactly how to play the situation. The Steins were buyers, and Matisse was also making the most of the situation. So Picasso invited Gertrude to his studio to sit for a portrait. Picasso seems to have posed her in a gesture from a classical painting by Ingres, with Stein leaning on her elbow, her other hand on her thigh. On Saturday nights when Gertrude came home from the sittings, Picasso and Fernande joined her for dinner — said to be the start of Stein's Saturday artist soirees. What became even more legendary, even improbable, was Stein's claim that she sat for more than eighty portrait sessions.[28]

What is certain is that, after all the sittings, Picasso finally painted out Stein's face and took a break. They parted as friends, and as Picasso prepared for his summer vacation, Gertrude Stein awaited to see what kind of face he would finally insert. At this point, in spring of 1906, Apollinaire had persuaded Vollard to come up to the Bateau-Lavoir and see Picasso's warmer, rose and classical paintings, which were far more saleable. Vollard made the journey. He was so impressed that he bought twenty canvases on the spot: in cash, he paid Picasso the equivalent of a two-year salary for a Paris workingman. As Fernande said, she and Picasso felt rich. It was time to travel.

At this date, Picasso had been away from Spain for two years. Dressed for the occasion with new suits and dresses, he and Fernande headed for

Barcelona in mid-May to introduce her to his family. Then they trekked north to the town of Gósol in the Spanish Pyrenees, a place recommended by a friend, and reachable in the last stretch only by mule on a mountain trail. Their three months in Gósol, where Picasso lugged his paints, pads, and canvases, was a period of yet another new departure in his art. One obvious influence was the hot, arid, barren mountainscape. His works took on the reddish clay (terracotta) tonality of the soil. As evidenced by his drawings, he was thinking about the formal classicism of Ingres's odalisques but also about the newest thing being shown in Spanish art: a set of Iberian sculptures from the sixth century BCE. By the end of his days in Gósol, Picasso was beginning to render the human form in a tightly composed primitivism, very Iberian in its feeling.

Picasso might have stayed longer, except for an outbreak of typhoid. In mid-August, after three months of their idyll, he and Fernande made the unhappy trip back to Paris, where the musty, unkempt Bateau-Lavoir studio awaited them. Nevertheless, Picasso pushed his ideas from Gósol to a new horizon: he did his most experimental work to date, a large colorful painting with abstractions reminiscent of El Greco, *The Blind Flower Seller*. Then he returned to the Stein portrait, completing it without her present. He painted in a masklike face, Iberian and clay colored. It also showed an early use of a symmetrical almond eye shape that would characterize his portraits for the next few years.

The eyes had shown up in some Blue period figures, and in his Gósol portrait, *Woman with Loaves*. Now, those types of eyes became the primary feature. If there was any doubt, Picasso added them to his first "primitive" self-portrait, *Self-Portrait with Palette*. To the Stein portrait, and much else afterward, Picasso had also carried over something he had seen in the works of the classicist Ingres: the subject's sphinxlike gaze. Picasso would make this frozen gaze iconic. As the story goes, Stein said, "I don't look like that." Picasso said, "You will."

His main worry was Matisse. Just before Picasso had left for Gósol, Matisse had unveiled a gigantic Fauve painting, *The Joy of Life* (*Bonheur de vivre*), at the 1906 springtime Salon des Indépendants. Picasso was stunned. First of all, it was the sheer size. Second, Matisse, breaking all the rules, had painted a kind of sly, disconnected commentary on all the themes in Western painting: themes that mimicked the figures, frolics, and landscapes of Ingres, Cézanne, and Gauguin. More threatening, on

returning to Paris, Picasso learned that the Steins had purchased *The Joy of Life* and displayed it prominently at their home. Perhaps this is why Picasso went so large in his next painting back at the studio, *The Blind Flower Seller* (measuring 7 feet tall and 4.25 feet wide).

The rivalry with Matisse was not over, and the next round seemed to pose the question: Who between them could do the greatest "primitivist" painting? For this, Matisse looked to some ideas in statuary from Oceania and Africa. The next year at the 1907 springtime Salon des Indépendants, Matisse hung his *Blue Nude*, a lumpy and distorted female odalisque. Obviously, Matisse was looking for a spasm of public outrage, which he knew would ratchet up his status as avant-garde leader.

Picasso decided to bide his time on the latest parry by Matisse, a Frenchman who had once studied law, and who still wore tweed coats and gold spectacles. Picasso could hold back for a while, his own upward mobility a source of interim enjoyment. In February 1907, Vollard had made a second round of purchases of his remaining early works (Blue and Rose), finally putting Picasso on a footing of financial security.

For his rejoinder to Matisse, Picasso prepared a large square canvas, but then let it stand empty for a good while. For this project, he did an unusually large number of preliminary sketches. He called it simply "the painting," and eventually *The Brothel of Avignon* (with several possible allusions behind the name, Picasso said later).[29] If the classicist Ingres had formally composed women in *The Turkish Bath*, and after him, Cézanne had produced a formal composition of female bathers, now Picasso would do an equally composed group of women, but as prostitutes (granted that prostitutes were hardly an original topic in Paris, treated in other ways by Degas and Toulouse-Lautrec). After Gósol, this was not the first time Picasso had dramatically simplified human figures, as if clay-colored statues. However, it was the first time that he applied mask-like faces to a group portrait.

He sketched and then painted *The Brothel* in stages. It was something of a secret project, though his regular visitors, and even Fernande, did not seem at all surprised. Picasso originally had sketched a sailor and a student visiting the women in the brothel, but by a process of elimination, his final drawings ended with just five females. He worked on the canvas from late 1906 to July 1907. At the very end, Picasso added two rather frightening mask-faces to the women. In one explanation of this late re-

vision, Picasso had just seen such fearsome, gashed faces on statues from Oceania in the museum-like Trocadéro Palace. Others say the influence is African, while the less frightening female faces, and all of their forms, are Iberian. At the emotional level, Picasso had just fought enough with Fernande for them to break up (temporarily). Perhaps all of this negative feeling about women had now come out in paint. After all, what was more "ugly is beautiful" than a whorehouse? It made Matisse's *Blue Nude* look modest by comparison.

As with many of his significant paintings, Picasso was coy about his ideas, motives, and intentions in *The Brothel*. Over the years he let others draw their own conclusions. Although *The Brothel* was publicly revealed in a 1910 photo, it was not officially exhibited until 1916, when it was given the title *Les Demoiselles d'Avignon*.

When word of "the painting" first spread, it caught the attention of Kahnweiler, the art dealer, who as a result headed up to Montmartre in 1907 in search of Picasso. After that, they made an exclusive contract, and Kahnweiler began to sell Picasso in Germany and Russia. Much later, in 1920, Kahnweiler would declare that *Les Demoiselles d'Avignon* had been the "birth of Cubism."

The other consequential person who went to Picasso's studio to see *The Brothel* was Georges Braque, a Frenchman who was a follower of Matisse. Braque saw the painting in November 1907, and it radicalized his views. He had been trained in the practical decorative arts, holding an art worker certificate. He had a studio in Montmartre, but liked to paint out of doors, especially in the south of France (where Matisse and the Fauves spent summers and winters). Braque's Fauvist landscapes were selling, but this year in the south, at L'Estaque, he had begun to leave behind Fauvism for a geometric style (which he attributed to seeing the very recent Cézanne retrospective: fifty-six paintings plus Cézanne's lost letters, which announced that nature was made of the "cylinder, sphere, and cone").[30]

The evidence that Braque had stumbled onto nascent "Cubism" was a landscape painting he did in October 1907 of the town's waterworks, *The Viaduct at L'Estaque*. The painting was accepted at the next spring's 1908 Salon des Indépendants. So, who gave birth to Cubism? Was it Picasso with *The Brothel*, or Braque with *The Viaduct at L'Estaque*? As Fernande said in her memoir, it was simply in the air. Once Picasso teamed up with Braque, he acknowledged that Cézanne was the "father of us all."[31] When

Braque showed more geometrical works at the next salon, and his friend Derain had joined in, Gertrude Stein took notice, and later turned it into literature. Attending the salon, she said with flourish that the exhibition "first publicly showed that Derain and Braque had become Picassoites and were definitely not Matisseites."[32]

Full-blown Cubism was now on the horizon. The art of bohemian Paris was being drawn down a new path, and many of its painters, including the Duchamp brothers, Braque, and many others, could not resist.

5 little cubes

When Picasso met Georges Braque, they shared some things in common, even though Picasso was classically trained, and Braque trained as an "art worker" in decorative arts and methods. New to them both was the "primitive" look, being seen around Paris in African statuary, or in artifacts from Oceania and ancient Spain. Neither Picasso nor Braque ever met the reclusive Cézanne, who had died in 1906, but his works, now on public display, dazzled them both, as did his now-published idea that nature was made up of the "cylinder, sphere, and cone."

The critics were associating Picasso and Braque as well. This began with Braque's slight at the 1908 Salon d'Automne, when Matisse, on the jury, rejected a set of Braque's muted earth-toned landscapes (and, meanwhile, accepted three mediocre paintings by the young Marcel Duchamp). Of Braque, Matisse said the blockish elements looked like "little cubes." Kahnweiler saw the rejection as an opportunity. He quickly pulled together a gallery show of Braque's works, which again evoked the term "cubes," and by spring, at the 1909 Salon des Indépendants, the term "bizarre cubes" also appeared in print.[1]

After this, Braque mostly turned his back on the salons, and now he had Kahnweiler in common with Picasso. They had become the vanguard of "gallery Cubism," a rival to the gathering network of Parisian painters who, having discovered Cubists ideas, began to display their geometrical works at the salons, a trend that would be called "salon Cubism."[2]

In the first round of inventing Cubism, Picasso and Braque worked separately. They spent their 1908 summers painting landscapes in two different parts of France. Braque went south, back to L'Estaque, where he painted trees, mountains, roads, and buildings as if facets on a diamond. Picasso left for a far less romantic clime, north to the flat little river town of La Rue-des-Bois. Surprisingly, they both came back to Paris with very similar-looking paintings: simple geometrical landscapes, both in muted ochers and greens. Picasso used so much green that this has been called, somewhat whimsically, his "green" period.

After 1908, the influence between Picasso and Braque began to go both ways. When in Paris, they met and talked almost daily. Evenings they would sample the galleries. When they left Paris for summer-to-fall breaks, they exchanged letters or postcards about their exploits. Picasso usually retreated to rented spaces or hotels in the Pyrenees along France's border with Spain, while Braque often headed back to his home territory, Le Havre, on the northwest coast of France.

Traveling with Fernande to Barcelona and then Horta in the Pyrenees, Picasso lunged into Cubism. Holed up in a Barcelona hotel, where Fernande was sick, Picasso did some of his first drastically fractured Cubist drawings: "I understood how far I would be able to go," he said later in life, a development that Kahnweiler would speak of as the Cubist technique to "shatter the enclosed form."[3] As Picasso drew and painted that summer of 1909, he also continued a strategic practice, aided by Fernande, of writing letters to his dealer and collectors to build anticipation for his next round of works.

The sale of Picasso's works in France, Russia, and Germany had been relatively brisk, and they soon would be noticed in America as well.[4] So on return to Paris from Horta, he and Fernande upgraded their living situation. They left Montmartre's rickety Bateau-Lavoir and moved down the hill, finding a large apartment-studio on the Boulevard Clichy, a wide and busy street. Being on the top floor, they had a view of gardens and trees, and inside Fernande watched Picasso work:

> He worked in a large, airy studio, which no one could enter without permission, where nothing could be touched and where, as usual, the chaos . . . had to be treated with respect. . . . Picasso ate his meals in a dining-room furnished with old mahogany furniture, where he was served by a maid in a white apron. . . . He slept in a peaceful room, on a low bed with heavy, square, brass ends.[5]

The apartment soon became a scene of hospitality. As many painters were now holding "soirees" on some evening of the week, Picasso tried it also (though he very soon after quit the practice). On September 15, 1909, he held an open house to show his Horta landscapes. Stein bought one of them, titled *L'Usine* (factory) at Horta, and later claimed, in her self-serving manner, that the painting she had purchased was "really the beginning of cubism."[6] Thereafter Stein insisted that "cubism is a purely

[*sic*] spanish conception and only [*sic*] spaniards can be cubists and that the only real cubism is that of Picasso and Juan Gris."[7] She displayed *L'Usine* prominently at her rue de Fleurus salons.

This marked the start of her alienation from Matisse, a fracture in the entire Stein clan of art collectors that would only widen: Leo and his sister-in-law allied with Matisse, while Gertrude cast her fate with Picasso and Cubism. The relationship between Matisse and Picasso mellowed over time as they realized that, in the Europe of 1913, they had been recognized as the two leading figures of modern art. Regardless, in the small world of Stein's living room, there was a good deal of rivalrous talk, with Matisse performing as "an inspired advocate of his own way of painting, which he defended determinedly against Picasso's muffled onslaughts," by Fernande's account.[8]

Meanwhile, another fracture, between Picasso and Fernande, was widening quickly. During Fernande's illnesses all during the trip to Barcelona and Horta, she and Picasso reached a near-breaking point. She wanted a home to keep, a "husband's" attention, and the degree of stability suited to a Parisian lady, indeed "Madame Picasso" as she preferred. Picasso wanted his freedom. In women, he wanted robust health and companionate service, not to mention sensual attraction. Fernande was the first, but not the last, woman on whom Picasso imposed these hard Andalusian expectations.

Beginning in 1911, for three summers Picasso and Braque met in the town of Céret in the French Pyrenees. Picasso would also drift from Fernande in pursuit of a new girlfriend, a Parisian city girl named Éva Gouel, four years his younger and the former mistress of another painter. Now he and Braque had new kinds of romances going, for Braque, being a mindful Catholic, would soon marry his mistress, Marcelle Lapré, in 1912. After that, the two couples' travels would often take them to the Avignon region, and to the nearby town of Sourges.

As seen in the break with Fernande, Picasso's wandering heart destined him to live a life of unstable relationships. For his art, each new love would mark a new period. Just as Fernande had helped inspired his Rose period, their split probably inspired the harsh *Brothel of Avignon*. In turn, meeting Éva infused his Cubism with a new joy and humor, typified by inserting the words of a popular café song, "ma jolie" (my pretty), into his paintings.

He was also thinking of Éva when, to further escape the old days with Fernande in Montmartre, he made a great social leap across Paris by moving to the Left Bank. This was the neighborhood of Montparnasse, a more upscale art district. In hindsight, Picasso would make ramshackle Montmartre world famous, but in the present, it represented a hard life and typically a world of failure.

Nothing—not marriages, moving, or romantic spats—slowed down Picasso and Braque in their experiments with painting. After a brief foray into landscapes, they both diverted themselves to the classic objects of Cézanne, the still life. The still life allowed Picasso to experiment with geometrical objects—glassware, bowls, fans, melons, apples. Once, Picasso had done a clay sculpture of Fernande's head, reveling in its solid Cubist properties, but the bulk of clay was prohibitive, so those Cubist experiments were forced back onto the canvas.

In their Cubism, Picasso and Braque both used the idea of a "grid," a linear pattern put on the canvas at the start, or emerging in the end. The grid broke traditional perspective and became a trademark of all modern art, which would no longer view the canvas as a window, but rather as a visual object in itself. As Braque said, broken perspective put painted objects nearly into the viewer's grasp, "a means of getting as close to the objects as painting allowed."[9] Braque and Picasso achieved this breakage by using Cézanne's brushwork technique: "passages." Rather than define objects by their clear outlines, edges, and shadows, passages of ambiguously applied paint dissolved part of an object into its surrounding space. Hence the classic look of high Cubism: solid objects that appear, and then dissolve, into space.

In their first period of cooperation, Picasso and Braque pushed this technique to its maximum. It led to what Kahnweiler would later call "analytic" Cubism. The objects that Picasso and Braque painted began to feature increasingly complex, small, and even sparkling facets that, solid here, dissolving there, converged on becoming almost totally abstract. At this point, the two painters showed a different personal touch. Picasso had the much harder geometric line, his muted pallet the harsher of the two. Braque's lines and shapes seemed to have a softer edge. He let his light sparkle a bit more than Picasso.

As they moved closer to pure abstraction, they pulled back. In the little philosophizing Picasso and Braque did about Cubism (and Braque did

more), a central argument of theirs was that Cubism was "realism," not abstraction. It began by looking at real objects and presenting them in a new light. "You must always start with something," Picasso said. "Afterwards you can remove all trace of reality."[10] At the point when the original object is nearly impossible to see in the painting, Picasso and Braque used a trick they called an "attribute." This was a small identifiable element — a painted nail, violin hole, a fragment of rope, or facial feature — that remained visible in what was sometimes an otherwise totally dissolving Cubist painting.

At the height of these Cubist experiments, Picasso said, the painting was "as though it were about to go up in smoke." At that point he stopped; he wanted the painting to keep a link with reality, solid enough for the viewer "to drive a nail into it." To do so, he added a realistic element. "So I added the attributes."[11] These included an earlobe, a lock of hair, or clasped hands. In the painting that verges closest to pure abstraction, his *Portrait of Daniel-Henry Kahnweiler* (1910), Picasso added the attribute of a watch chain.

Now that Cubism was given a name by the art critics, and Picasso and Braque were among the main culprits, Picasso was quite impatient with anyone who wanted to intellectualize what he did. When people asked him what Cubism was about, he'd snap: "There is no such thing as Cubism."[12] Other Cubist painters were talking about painting the fourth dimension, prompting more of Picasso's wry comments. Upon hearing Braque talk theory, he said, "Next thing, he'll invoke the fourth dimension!"[13] Even so, Picasso was certainly within earshot of the discussion about weird new geometries, X-rays, and the fourth dimension. It is likely that Maurice Princet, the amateur mathematician who consorted with the painters, had at least shown him a book, Pascal Jouffret's *Elementary Treatise on Four-Dimensional Geometry* (1903), with its Cubist-like diagrams.[14]

Much of Picasso's aversion to theory arose from his inability to speak French, and especially at Stein's fast-talking soirees. At these, "Picasso would remain morose and dejected for the greater part of the time," Fernande wrote. "People were trying to make him explain his position, which he found difficult to do, especially in French; and anyway he couldn't explain what he felt needed no explanation."[15] Looking back, Braque was amenable to explaining his Cubist period. It was about escaping the "mechanics" of perspective with its "single viewpoint." Cubism offered several

views in one painting.[16] It was an exploration of space, "the materialization, the translation into matter, of that new space which I felt."[17] Picasso stuck to his non-theoretical guns, or was at least very good at giving that impression.

ABOUT NOW, young Marcel Duchamp was getting his first impression of Picasso. He'd once been to Kahnweiler's gallery, where he saw Picasso's small diagrammatic Cubist drawings, framed in blue cardboard. He paid a visit, at some point, to Braque's studio. He was watching the birth of Cubism—and it inspired him. At his Neuilly apartment, where he had his easel and paints at hand, he wondered which direction he himself would go.

Like any young artist, Duchamp had first gone through all the other styles, and he was naturally a little behind in the trends. By the time of the Paris salons of 1910—when he was twenty-three—he was still trying out paintings in the post-Cézanne and Fauvist fashions. Now Cubism was fast emerging, and he was aware of other "isms" as well. One of them was "Futurism," brought to Paris by Italian painters who declared, in newspaper manifestos no less, that modern, industrial motion was the true object of painting.[18] Duchamp, too, was interested in motion. But it came to him not through the Futurists, but simply by way of popular Parisian interest in weird science.

As he cast about, Duchamp had at least settled on a subject matter that he liked, namely, the nude female. Over more than a year, ending in early 1911, he produced a series of twenty-one paintings and drawings of nudes. He tried them in many styles but in the end did not become a Picassoite. The Cubism of Picasso had moved toward monumental, geometric, primitive female figures. Duchamp moved in an opposite direction: toward machines, or toward what he was seeing in the new X-ray photography, which was revealing the bones and sinewy innards of human beings.[19]

If Picasso was more likely to visit Paris's Trocadéro Palace, which had become an ethnographic museum showing African and Oceanic primitive art, Duchamp was more likely to visit a different building: the ancient Priory of Saint-Martin-des-Champs, which now housed the science and technology museum of France's National Conservatory of Arts and Industry.[20] Inside was a cavalcade of devices, machines, and contraptions. They were displayed in glass cases down long hallways. To be sure, it was a very

different aesthetic from what Picasso saw in the crowded, dusty, chambers that held primitive art hacked from wood or stone.

Photography was the other medium that was introducing Duchamp to ideas of motion, and becoming a tool for Picasso as well. During his time in Horta, Picasso had begun to take photos of his paintings, sending the film to Barcelona and then collecting the prints. The photos helped Kahnweiler build a Picasso catalog. For Picasso, their black-and-white simplicity, and the negatives themselves, were probably visual stimuli for more Cubist ideas, and by this time, he might have seen the new trend in X-ray photographs as well.

The new extravagance in photography must have had a stronger pull on Duchamp, though. When younger, Duchamp had heard his brother Raymond talk about the work of Albert Londe, whose motion photos (chronophotography, for chrono, or time), was being diagrammed in walking stick figures. In books and magazines in Paris, these stop-action, time-elapsed images of human bodies or animals abounded. The French physiologist Etienne-Jules Marey, building on Londe, published a time-elapse photo of a human gait: lines and dots marked the limbs and joints. Duchamp may have seen the work of the English-born US photographer Eadweard Muybridge as well. His book, *The Human Figure in Motion* (1885), included twenty-four successive images of a nude woman descending a flight of stairs. Anatomical artists, too, had done line drawings of how torsos and legs go down a stair, and with X-rays all the craze, such illustrated pictures also began to include all manner of internal organs.[21]

With these factors in mind—Cubist facets, machines, photography, and human organs—Duchamp set out on perhaps the most productive period in his life as a painter. It extended over twelve months, from the middle of 1911 to the next year. This was his Cubist period, and these painting would be a central part of what he showed at the public salons in the same period.

His first Cubist painting is a faceted, fractured image of his mother and two sisters playing music, titled *Sonata*. The next, titled *Dulcinea*, was based on a woman he saw on a Neuilly street: he painted her as five cubist-like figures, each changing across the canvas (indeed, from dressed to undressed). It was as if Duchamp was blending Cubism and X-ray transparency. On a train trip to his parents' home in Rouen over Christmas 1911, Duchamp's mind took a new trajectory. He viewed himself as a "sad

young man" barreling over the tracks. So back at his Neuilly studio, he painted a dark picture that looked something like the Marey photo of a body in motion (and titled it *Sad Young Man on a Train*). With this — whatever the "sad" part was about — he formulated the dark, wood-colored, multiple-image style he next put into *Nude Descending a Staircase*.[22]

For a moment after *Sad Young Man*, Duchamp took up the topic of chess players. During December 1911, he worked on two successive paintings of two people playing chess. In the second version, *Portrait of Chess Players*, each is seen in two different positions as they bend over the chessboard. Was Duchamp thinking of an X-ray of a chess player's brain as he was pondering his next move? Duchamp would later suggest that he was trying to paint chess players "thinking," not just posing.

If chess was anything, Duchamp realized, it was thinking. Eventually he would read the expert books on chess. He learned that the more one played chess, the larger a player's memory of game patterns would grow. This allowed quicker recall and, potentially, better moves. It was memory built by sheer repetition, the very thing that Duchamp believed a painter should *not* do — repeat himself. For his entire life, Duchamp fluctuated between being repetitive and denying repetition. Rhetorically, he came down strongly on one side, and that was to say that artists who repeated themselves were failures (and usually repeated themselves to make money). In this period of Duchamp's life, he tried ardently to avoid repeating himself, and his paintings did tend to be different.

Like many painters in Paris, Duchamp, too, had turned to French poets to leaven his ideas. If Picasso and his gang said, "Down with Laforgue," the poet Jules Laforgue was Duchamp's favorite. He liked his intellectual cynicism. So Duchamp set out to try a set of illustrations based on Laforgue's verse. What came out instead was a somewhat mechanical sketch of a nude on a staircase. "It was just a vague, simple pencil sketch of a nude climbing a staircase," Duchamp recalled later, "and probably looking at it gave me the idea, why not make it descending instead? You know, in musical comedies, those enormous staircases."[23] Thus was born his most famous Cubist painting, *Nude Descending a Staircase*. The first version was an oil sketch, now called "no 1." The large finished painting (no. 2) was completed in January 1912.

In doing *Nude Descending*, Duchamp transformed body parts into lines. The lines suggested at least twenty positions as the figure moved down-

stairs. Later in life, he would intellectualize what was probably trial and error: he would call his painting method "elemental parallelism," and, in a burst of bravado, would say one day, "When the vision of the *Nude* flashed upon me, I knew that it would break forever the enslaving chains of Naturalism."[24] Either way, Duchamp believed he had moved beyond the mere look of motion to grasp the very "idea" of motion. His paintings took on a definite look, a muted palette of browns — "wood" colored, he said — and then step by step he augmented this with pinks, ochers, and grays to suggest flesh, skin, and mucous membranes. Duchamp was the first to put such moist, sticky corpulence on mechanical images, creating a truly striking, even eerie, effect. It set him apart from other Cubists.

He was also beginning to stand apart by offering one other unique feature: the obscure or titillating titles he gave his paintings, sometimes painting them right on the front, as he did with the inscription "Nude Descending a Staircase."

In late 1911, Marcel had another chance to experiment with mechanical forms. Around Christmastime, his brother Raymond had asked his artist friends to make pictures to decorate his Puteaux kitchen. Marcel drew, and then painted, a whimsical image of a coffee grinder. The picture showed it from diverse angles, at different moments of operation: it looked almost humanoid, as well as mechanical, and thus the humor. Marcel was beginning to see that a machine's moving parts — levers, pistons, cylinders, cogs, wheels, rubber tubes, and wires — could be taken to be human body parts, tissues, liquids, orifices, and joints.

By its title, *Nude Descending* would make Duchamp famous in America in a few more years. However, *Coffee Grinder* was the most prescient of his future work, when he would begin to make a kind of humorous machine-art. At the time, "I was just making a present for my brother," Duchamp said. Later he realized that his little coffee machine joke had conjured a new "window onto something else" far bigger.[25]

Whether it was coffee grinders or Cubist paintings that, as Picasso said, almost turned into smoke, the upsurge of the new "modern" art was greeted by many art critics as a hoax. By "hoax" they meant the great Parisian tradition of pranks, little plots and escapades to trick the public, after which artists could laugh at the public when the truth was revealed. It had a long history in bohemian Paris especially. Picasso and his band of

poet friends were not beyond the blague and pranks of their culture. Duchamp liked them, too.

The blague tradition was confirmed at the 1910 Salon des Indépendants, where Duchamp had exhibited some of his early nudes. At the same event, a group of jokesters from Montmartre submitted three paintings said to come from the school of "Excessivism." These were abstracted landscapes done by the avant-garde painter Joachim-Raphael Boronali. Actually, the three canvases were produced by a paintbrush attached to a live donkey's tail up at the Lapin Agile cafe. Until the hoax was revealed, the works received serious reviews from the Paris art critics. Picasso, who frequented the Lapin Agile, must have laughed, since he also looked down his nose at the salons. Duchamp, an eyewitness to the whole thing, learned a valuable lesson: how to pull off a successful hoax.

AS A TEAM, Picasso and Braque were hardly done with Cubism. Their period of closest collaboration was about to come. In early February 1911, Picasso received a postcard from Braque, who was in Le Havre, saying Braque would see him in Paris soon. During the next four years, they would work closely together. They would analyze the depth of Cubist form in oil paint and then, in 1913, experiment with mixing materials. They pasted commercial printing on the canvas, made sculptures, and then in an elaboration on simple collage, began mixing their painting and drawing with commercial paste-ons (wallpaper, newspapers, labels, sheet music, advertisements) in a constant play of one off the other.

In the vibrant commercial culture of Paris, with its explosion of commercial advertising — signs, placards, slogans, and newspaper sales pitches — the idea of mixed media on a canvas seemed only natural to Picasso and Braque. It was the real world and, as Picasso said, his Cubism was a kind of realism. This period of Cubism, later called "synthetic" Cubism by Kahnweiler, was begun when Braque put stencil letters on a Cubist painting. This was his 1911 *The Emigrant*. Picasso also began to tap sources in the commercial world. At his Paris studio, using rope, lettering, and oil cloth, he "painted" *Still Life with Chair Caning*. Done on a horizontal oval panel, the work would one day be called the start of "assemblage" art. Picasso (who had already painted words such as "ma jolie" on his canvases) now mixed faux chair caning with the realistic illusion of oil painting.

Henceforth, he and Braque happily competed to find new ways to

insert commercial fragments into the paintings. Art historians believe that Picasso and Braque were now going well beyond traditional *collage* (paste), entering a new dimension of art that would be called (by the art historians) *papier collé* (glued paper).

On a visit to Le Havre to paint with Braque, Picasso decided for the first time to introduce a few bold colors into his muted Cubism palette. He did this with commercial paint, Ripolin, which looks hard and shiny. He put in blue and red, colors of the French flag. "The pictures done with Ripolin, or in the Ripolin mode, are the best," Picasso wrote Kahnweiler.[26] Picasso also added a fake wood-grain effect, or *faux bois*, by dragging a comb through paint, a technique that Braque had taught to him.

The Picasso-Braque collaboration moved into its happiest times as Picasso and Éva left their new home, his Left Bank studio at 242 Boulevard Raspail, for summers in Céret and around Avignon's quaint and hilly inland towns by the French Riviera. Between there and the Avignon area, Braque developed the *papier collé*, and soon after, Picasso followed his lead.

Picasso was the first to try out a kind of cut-and-pasted sculpture, moving away from a bulky clay Cubist sculpture to try something different: sculpture that reveals space. In his Paris studio he made a cardboard-and-string guitar. With sculpture, too, he sought the Cubist effect of dissolving, or confusing, spatial relationships. Examples from African masks were one of his springboards. The mask's eye sockets were protruding cylinders, not the normal recesses. So similarly, on the guitar hole, Picasso put a cylinder that extended out. This was not sculpture that sat heavily on the ground, but that seemed to float in space, designed to confuse its three dimensions. Eventually he moved on to wood and sheet metal. (One day, such sculptures would be built as gigantic concrete-poured monoliths in city squares or on art collectors' estates.)

At the end of 1913, Picasso and Braque had pushed their synthetic experiments about as far as they could go, with slap-dab sculpture at one extreme, and "paintings" made almost entirely of torn and cut newspaper articles pasted down on the other. Back in Paris with Éva, Picasso moved into yet another Montparnasse studio, located at 5 rue Schoelcher. He was feeling restless about what to do next. As they settled in, he began a series of preliminary color drawings, preparing for a large painting that would notably break from his strict Cubism, with its muted hues. This

bright painting, done in eerie colors nonetheless, was to be known as *Woman in a Chemise* (late 1913). It is now described as Picasso's first step toward a fantastical style (later to be called Surrealism).[27]

What Picasso needed at this moment, after a long period of relative isolation from the public, was a bit of controversy, a method of obtaining publicity that he learned from Matisse. This began when Apollinaire printed photos of Picasso's Cubist guitar in a new publication, *Les Soirées de Paris*, for which Apollinaire was editor. Next came the publication of Picasso's plaster sculpture of a Cubist absinthe glass. He cast this into six bronzes, painted each in Cubist frolic, and glued a silver-plated spoon on top. Such experiments drew criticism, even charges of hoax, from a good many art commentators in Paris. For Picasso the main thing was not to be ignored.

WITH THE RISE OF Cubism, and thus the "birth of modern art," the general public and the art specialists were being forced to choose between two very different aesthetics, or definitions of beauty. The first of these alternatives was the older academic tradition, for which France and the other European nations had a rich history. The academic tradition had a substantial establishment of schools, museums, juried exhibitions, and influential art critics. By the time that Cubism was emerging, in fact, Impressionism and post-Impressionism had also been taken under the wing of "tradition," and while certainly not academic, Impressionism had at least been adopted as part of mainstream French culture.

Cubism was the second alternative. Although its approach had a small opening into French culture through the national celebration of Cézanne at the 1907 salon, full-blown Cubism was finally a radical new trajectory. It offered the first "modernist" break from visual arts of the past. Standing for the avant-garde in the face of France's art establishment, Cubism stirred protest and derision, but in the process earned bragging rights for finally breaching the wall of artistic tradition.

Into that opening poured many other streams, with the broad trend of Abstract art being dominant. The common credo was to defy all past visual traditions in drawing, paintings, and sculpture. Eventually, in 1914, this rising tide of modern art was given a somewhat official aesthetic theory. This was the idea of "significant form."[28] Although this idea—that painting is in essence color, lines, shape, and composition on a flat

surface—had been said before, the British art critic Clive Bell gave the phrase staying power. This was born of the conviction that modern art (and even great art of the past) was about "formalism." Pure and simple, formalism was the study of visual effects.

As a modern painter, Picasso could not have agreed more, as would the group of painters who took the modern art cause public in organized groups, such as the salon Cubists, or, in Germany, the expressionist painters. Writers such as Apollinaire would call this new push against tradition "the new spirit" in art. A wide variety of explanatory terms, and movement banners, would be proffered, but as alternatives to traditional art, and even to Impressionism, they were all essentially talking about significant form.

On the surface, this was the tectonic clash between traditional art and modern art, fairly visible to the public through salons, public debates, and newspaper headlines. Deeper down, however, there was one more force that was trying to materialize. This was the concern among modern artists to intellectualize art, to give art and the painters a kind of higher philosophy, elevating them beyond mere craftsmanship and paint.

Here was the tempting notion that somehow "ideas" were superior to the ordinary visual skills, effects, and pleasure of artworks. Neither Picasso nor Duchamp was the person who first opened this Pandora's box of theoretical art. For all practical purposes, Picasso had focused on form, and Duchamp was too young to make a difference.[29] The push for ideas came from among the salon Cubists, incarnated especially in two of their leaders, Albert Gleizes and Jean Metzinger. One of the early calls for ideas in art was their book *On Cubism*, which pitted the brain against the retina. On the fringe of this idea, some artists, still unnoticed, began to believe that the "idea" or "concept" behind a painting was more important than the painting itself.

In another fifty years, this speculative approach would be called Conceptual art. As the new claimant to lead the avant-garde, Conceptual art attacked "modern art" as mired in the past, shackled to formalism. For Conceptual art, the true horizon of art was in the mind—the concepts themselves.

The fact that Picasso and Braque had focused on form did not mean their works lacked mental content, but they were clearly not interested in splitting philosophical hairs. They were concerned with how a painting

looked or felt (and how it rivaled competitors, perhaps), and in the hurly-burly Parisian world of advertising, cabaret jokes, and newspaper head-lines, they simply wanted to join in with visual puns on daily life.[30]

While their puns stopped at the borderland of theory, the art theorists of the future would not. In time, interpreters of their synthetic Cubism would claim to find all manner of hidden "ideas" behind the visual forms. This was especially possible with synthetic Cubism and *papier collé*, since their mixed materials and mediums supposedly opened up deep questions about "what is reality"; that was because a "real" thing like wallpaper, for example, was mixed with an "unreal" thing, such as illusionist painting techniques. In the *papier collé*, art theorists found a quarry with which to build entire theoretical systems, even linguistic systems that deciphered the role of signs and symbols in communication.[31]

Throughout his life, Picasso was never interested in such musings, and often found them ludicrous. Duchamp would be a different story.

Though young among the salon Cubists, he would follow their lead and persuade himself that, ultimately, art is about ideas. In the decades ahead, he would seed modern art with such notions, and live to see the day, in the 1960s, when Conceptual art suddenly began to eclipse modern art as "the new spirit" of art, a zeitgeist for a "postmodern" age, a time when the ideas and attitudes of artists seemed to be more important than the signif-icant forms they could produce in painting or sculptures. As Picasso went from strength to strength in his modern art, Duchamp would become known for something different—for pitting the brain ("gray matter," he called it) against the retina, and in this, Duchamp would become a patron saint for Conceptual art. And as Conceptual art began to dominate in the West, traditional academic art and modern art seemed to have, after all, a great deal in common, and no one personified that hybrid in the twenti-eth century as well as Picasso (a traditionalist and modernist).

However, in the days of Duchamp's *Coffee Grinder* and Picasso's *Absinthe Glass*, all of this was an unseen future. In Paris before the war, it was enough to keep up with the public debates between Fauves, Cubists, and Futurists, all of whom claimed to be the avant-garde, but typically on the grounds of visual effects. Neither Picasso nor Duchamp took part in these open-air disputes. They were part of the avant-garde, but they wanted to participate in private. Picasso kept this privacy through his

self-contained gallery system. Parallel to that, Duchamp created his own world of self-containment, as if a recluse in his Neuilly studio, a very private man indeed.

Nonetheless, they both watched as Cubism went public, which it began to do with a vengeance after 1910.

6 modernist tide

The public spectacle of Cubism, like a gathering parade through Paris, took time to develop. To be an avant-garde movement, it needed a consciousness, which began to emerge in 1910 among the "salon Cubists"—those who showed at the salons. These were the young men (and a few women) who had studied art at various schools around Paris and were trying to make it as painters, a group that included the Duchamp brothers, among many others. At the Grand Palais their paintings were hung like so many postage stamps in many rooms, the walls in dark colors—maroon or forest green. As they saw each other's works, often hung together by coincidence, they began to talk. Then they began to meet.

Their first meeting places were amid Paris's vibrant cafe scene, which had been cultivated for decades already, bringing together poets, artists, and entertainers. Some of the nascent Cubists began branching off on their own. By early 1911, the painter Albert Gleizes, who had already lived in an artists' commune, made his suburban studio a place for Cubist discussions. The idea caught on with the two older Duchamp brothers, Raymond and Jacques. Over in Puteaux, they began to hold Sunday meetings. This was 1911, the year that all three Duchamp brothers had switched to the modern style, with Marcel achieving the most unearthly look. He began to paint fleshy machines, adding bizarre titles.

At Puteaux, Marcel was invariably the youngest. An older set of quick-witted, fast-talking painters and poets surrounded him at every turn. It was hard for him to express his views, if he had any. Luckily, whenever the atmosphere got too smothering, a chess game came to the rescue. It was a welcome diversion for everyone at Puteaux. It was also an added dimension of competition, a matching of wits, suited to a mélange of outgoing creative artists. In chess Marcel could express himself, even win, but finally, withdrawal into chess was not enough, given his temperament. Marcel began to plot his withdrawal from the Cubist collective that he'd fallen into.

Until he made that break, Marcel tried his best to participate. Salon Cubism was the center of action. The salon Cubists were gaining confidence, and Marcel's brothers had given him entrée to that exciting circle. By the end of 1910, the circle took its first bold action in public. Its leaders, Apollinaire, Gleizes, and another painter, Jean Metzinger, led the charge. They asked the 1911 Salon des Indépendants committee to give them an exclusive Cubist room at the Grand Palais. They even ran a campaign to oust some recalcitrant salon committee members to obtain a positive vote on their request.

Naturally, Apollinaire, Gleizes, and Metzinger fast emerged as the chief theorists of Cubism. As an intellectual, Metzinger had trumpeted the Cubist renaissance as early as anyone. His October 1910 article in *Pan*, a literary review, explained that while the new painting built upon Cézanne, it did much more. It also took cues from the new non-Euclidean geometry, even the fourth dimension, as articulated by the local mathematician Maurice Princet. The Cubist room at the Grand Palais, though small, drew sizable crowds when the Salon des Indépendants opened in March 1911. The viewers were greeted with the new Cubist conceit: painting must also be intellectual, a deeper dimension to the visual. As chief propagandist, Apollinaire picked up from there. He praised the work of the different painters in his reviews for the magazine *L'Intransigeant*, and by the end of 1911 he was spending most of his time advocating for the salon Cubists, who were far more theoretical than his old friend Picasso.[1]

All three Duchamp brothers were enthused by the idea that art could be intellectual, an idea found especially in the writings of Gleizes and Metzinger. In previous art, from Courbet to Impressionism, Gleizes and Metzinger said, "the retina predominates over the brain."[2] Art that pleased only the eyeball was merely decorative, an "absurdity." True art should appeal to higher faculties, such as intuition or intellect. This salon Cubist quest for pure, intellectual art became salient enough that even the popular press began to pick up on it, both seriously and in satire. A cartoon showed a painter with a blank canvas, signed, trying to explain that the idea is more important than paint. "It is not painting that matters," one artist told a journalist. Another critic joked that soon they will see "magnificently framed white canvases on which formulas, written with care, will replace colors and forms. . . . The imagination of the visitors will do the rest."[3]

It would take time for the salon Cubists to explain what they meant by "ideas" and "intellect" being crucial to painting. For a start, a lot of them were chess players. They valued the calculating mind. They liked ideas, and this would align them with an interest in Leonardo da Vinci.[4] At this time the Renaissance figure had become very popular, after his notebooks had been translated and published. Discussions about da Vinci, who called painting the "highest science," were robust at Puteaux, led by the older Duchamp brothers. For the first time it had become apparent that da Vinci did more than the *Mona Lisa* and *Last Supper*, for example. He also produced thousands of pages of notes with scribbled text and elaborate diagrams. Many of these texts were about the very problems that painters faced: linear perspective, for instance.

Whereas da Vinci's writings on perspective were quite clear and applicable, it was much harder for the Cubist painters to get a grip on the fourth dimension, which they believed was out there, somehow verified by X-rays, radioactivity, and the non-Euclidian geometry of curved space. A writer such as Apollinaire, like a weathervane, would pick up on this breeze as well, adding poetic fog to it by defining the fourth dimension as "space eternalizing itself in all directions at any given moment."[5] Metzinger had a slightly better grasp since he had studied mathematics. Yet he, too, believed (naively) that a non-physical reality—something like *time*, not space—could be painted on canvas. Equally enthused, Gleizes explained that "between the three dimensions of Euclid we have added another, the *fourth dimension*, which is to say the figuration of space, the measurement of the infinite."[6]

In this attempt to reach the fourth dimension in paint, they were guided not only by Princet, their friend the amateur mathematician, but by looking at popular geometry textbooks—by Poincaré and Jouffret, for example—that showed chart-like diagrams. The topic was a popular one at Puteaux. Picasso never went to Puteaux, but the topic also arose at Gertrude Stein's soirees, where Picasso joked about it at Braque's expense. What Stein noticed about Duchamp on his first visit to her home in 1912 was that "he looks like a young Englishman and talks very urgently about the fourth dimension."[7]

With their theories and their paintings, the salon Cubists had influence in high places. Jacques Villon was on the hanging committee of the 1911 Salon d'Automne, and for that venue he was able to persuade a potentially

hostile Automne jury to allow the Cubists to have a special room; thus, for the second time the insurgent painters had a prominent public space, and it was a larger one as well. At this salon, Jacques and Marcel would hang their paintings as bona fide Cubists. Critics would soon speak openly of "salon Cubism," and the public had another chance to be baffled by, or feel animosity toward, the new, seemingly fractured style of painting.

The salon Cubist ferment, which had the flavor of a happy revolt against tradition, motivated Marcel. Over a twelve-month period he became remarkably productive, turning out several Cubist-like paintings. Across 1911 he exhibited four of these. His latest to be completed was *Nude Descending a Staircase*, so he was thrilled over its chance to debut at the Cubist Room planned again for the 1912 Salon des Indépendants. The idea of the *Nude* came to him like a "flash." He believed the painting, not yet seen by anybody, could be a turning point.

To submit it for the salon, Marcel joined the surge of so many other painters, who traveled down to the Grand Palais to drop off their canvases, leaving them — by the thousands — for the hanging committees, who invariably argued over what went where. Aiming to have his *Nude Descending* hung in the special Cubist room, Marcel did not foresee any problems. After all, in 1844, the Society of Independent Artists founded the Salon des Indépendants to offer all artists the opportunity "to present their works freely to the judgment of the public"; there would be "neither jury nor prizes."[8]

However, being accepted into the official Cubist room was going to require an unexpected layer of screening, Marcel would soon learn. Organizers such as Metzinger and Gleizes were thinking politically. As salon Cubism came under assault from the press as a hoax, they felt their job was to show that it was authentic, an art form that France could be proud of. So on review day, when Metzinger and Gleizes saw *Nude Descending a Staircase*, their minds recoiled. With its title, it seemed to mock sincere Cubism. Worse, it looked like the dreaded Futurism, the aggressive Italian import. Worst of all, the title was written on the front of the painting.

Whatever they truly felt, Metzinger and Gleizes quickly came up with a formal explanation why they had to reject *Nude Descending* from the Cubist room exhibit. It was too "literary" (given the title). It also treated the female nude, sacred in French painting, in an untoward way. The rejection was a delicate matter for an exhibition supposed to have "no jury."

So the panel asked Raymond and Jacques to deliver a proposal to their younger brother: if Marcel removed the title, it could be shown. The only alternative was to ask Marcel to "withdraw" the painting. On the day before the salon opening, Raymond and Jacques put on their best black suits. They arrived at Marcel's apartment in Neuilly.

"The Cubists think it's a little off beam," his brothers said. "Couldn't you at least change the title?"

At the news, Marcel was outwardly stoic. Inside, his cynicism deepened. As he later recalled:

> Even their little revolutionary temple couldn't understand that a nude could be *descending* the stairs. Anyway, the general idea was to have me change something to make it possible to show it, because they didn't want to reject it completely . . . So I said nothing. I said all right, all right, and I took a taxi to the show and got my painting and took it away.[9]

This did not stop *Nude Descending* from being exhibited at other art shows, of course. It showed in a Cubist exhibition in Barcelona and in Paris at other times in 1912. Indeed, it was prominent enough during the real high point of Cubism in Paris, which was a special exhibition outside of the public salons, the Salon de la Section d'Or. Nevertheless, Marcel's experience of rejection at the 1912 Salon des Indépendants' Cubist room turned him against the "temple" leaders, as he said, once and for all.

He carried the grudge despite a kind of let-bygones-be-bygones ethic among Cubist leaders such as Metzinger and Gleizes. The special Salon de la Section d'Or, at which Marcel's *Nude* was welcomed, was organized by Metzinger, Apollinaire, and Jacques Villon. It was held in October 1912 at the prestigious Galerie de la Boétie and featured two hundred Cubist-like paintings and sculpture. At this event, Marcel also showed his newest painting, which combined the theme of nudes and chess: *The King and Queen with Swift Nudes*. He was taking his interest in chess public.

The use of the Section d'Or, or "the Golden Section," was something new. At the Puteaux group, the painters were fascinated by the Italian Renaissance's interest in a "golden ratio," a strangely harmonious way that two quantities visually related to each other. Renaissance mathematicians called it a "divine proportion," and da Vinci spoke of it as a golden section (*sectio aurea*).[10] Although the Cubist painters did not really apply the

mathematical ratio to paintings (Metzinger and Gris tried, but very little), they were vaguely in search of a new "painters' geometry," a kind of nebulous mixture of da Vinci, Poincaré, X-rays, the fourth dimension, and even the occult. Only a broad and catchy title such as "the Golden Section" could cover this nebulous state of affairs. So it became the moniker of their largest-ever exhibition, showing that they were moving on, going beyond Picasso-like Cubism, even spinning apart in new directions.

That same year the critic Maurice Raynal had announced an "explosion of Salon cubism," but he also recognized that "the term 'Cubist' is daily losing whatever defined significance it may have had."[11] Naturally, Apollinaire was the one who volunteered to explain what was happening. Based on his reviews, he gave lectures to open the Section d'Or exhibit, and then packaged these as a 1913 book, *The Cubist Painters*. It was the first attempt to identify the many streams of painting that were fast emerging from the Cubist movement.

The two relevant books at this juncture — *On Cubism* and *The Cubist Painters* — naturally gave some pride of place to Picasso. Duchamp also fared well; two for two, in terms of having Duchamp-related pictures in the two books. *On Cubism* showed his *Sonata* and *The Coffee Grinder*, and Apollinaire — who in recent months had become friends with Marcel — added a portrait photo of him (and a review). For Apollinaire, the fountain of modern art had fallen into four categories, two of which were superior: (1) "Scientific" Cubism and (2) "Orphic" Cubism. Not surprisingly he included many of his friends (and even his mistress) in these two, situating Picasso, Braque, Metzinger, and Gleizes in the first (with a close kinship to a later term, analytic Cubism). According to Apollinaire, Cubism had also taken an equally important departure into Orphic Cubism (after Orpheus, a Greek god of music); it combined abstraction with intellect. Apollinaire put Marcel Duchamp in this favored camp.[12]

As much as anything at the time, Apollinaire's *The Cubist Painters* was responding to the rapid expansion of Cubist influences. That influence — especially the grid and the faceting of viewpoints — had spread across Europe. It went north to Germany, Russia, and Scandinavia. There, native movements began the revolutions that produced Abstract art, an entirely new trend (and an approach, for example, that Picasso and Braque denied entering: they were "realists"). The Abstract trend was vast. It included the stark geometrical grid paintings of the Dutchman Piet Mondrian and

the Russian Kasimir Malevich. Others had adopted the analogy of music for painting, and this included the pure abstractions of line and color by the Russian Vassily Kandinsky, a leader of art movements in Munich.

For all the efforts of Apollinaire, Gleizes, and Metzinger to beautify Cubism, it was not assuaging political concerns over at the French Chamber of Deputies, which sat in Paris. The French state funded the salons in order to cultivate France's artistic heritage, but now Cubism seemed to be taking over the venue, much like a foreign infection. This was a time when France remained bitter toward Germany. The bad memories of the yearlong Franco-Prussian war (1870–71), and its lingering anti-Semitism, still tainted the Parisian air, and this at a time when German Jewish businessmen seemed to run the market for Cubist art.

So after yet another "Cubist room" was held at the fall Salon d'Automne, followed by the highly publicized Section d'Or, the Chamber of Deputies turned its attention to the problem of Cubism. This was December 1912. The protest against Cubism began when Pierre Lampué, a member of the Municipal Council of Paris, wrote in the *Mercure de France* that the Ministry of Fine Arts should not be funding the Cubist displays that are leaving so many Parisians "disgusted." Since the Grand Palais was the nation's great endorser of art, does the national government, he asked, "have the right to lend a public monument to a bunch of hoodlums who comport themselves in the world of art as Apaches do in ordinary life?"[13]

The letter sparked open debate on December 3, 1912, in the Chamber, with two socialists taking sides. Deputy Jules-Louis Breton said that it was "absolutely inadmissible that our national palaces should facilitate manifestations whose character is so anti-artistic and anti-national."[14] Another socialist who liked modern art, Marcel Sembat, defended the Cubists. The matter went no further. Picasso had some grounds to worry about these debates. He relied on German Jewish dealers, and as the drums of war with Germany began to beat, he would be forced to tiptoe through this artistic minefield.

DESPITE THE POLITICAL contretemps, 1912 was a big year for Cubism. It moved ahead with growing force, stopped only by such a massive counterforce as the First World War of 1914–1918. Along the way, advocates such as Metzinger and Gleizes argued that Cubism was not a distortion of French culture. It was a natural step in the evolution of

French painting, even a step to a higher dimension. According to their book, *On Cubism*, this was so because in a Cubist composition the painter must deal with pure forms separated from objects. He must organize forms according to "taste" and "beauty" — a greater and purer challenge than simply painting historical scenes or sentimental landscapes.[15]

Although Metzinger and Gleizes enjoyed theorizing about art, probably their strongest system of thought drew on the immensely popular French philosopher, Henri Bergson, who became so popular that he won a Nobel Prize in literature. In an age of mechanical science, Bergson emphasized "intuition," not the overly rationalistic approach that science was taking. To Bergson's mind, intuition was rooted in a universal force of creativity, the *élan vital*, a force superior to matter itself. For some artists it was a short step to see the *élan vital* in the painter himself, a kind of heroic figure reminiscent of the bygone romanticism of generations earlier.

Since it was these Bergsonian Cubists who seemed offended by his *Nude Descending a Staircase*, Duchamp had ample reasons to view their romanticism as poppycock. "It was a real turning point in my life," he said of the humiliation. "I saw that I would never be much interested in groups after that."[16] With a good dose of cynicism, Duchamp looked on the Bergsonian fad as a kind of mysticism, not a science. He liked the notion of "ideas" behind works of art, but the idea of painters being geniuses with good taste — even the power of the *élan vital* — struck him as puffery.[17]

As the great Cubist year of 1912 came and went, Duchamp had already begun to head off in his own direction. Two events were significant signposts. The first came in the early summer, when he attended the theatrical sensation of the season, *Impressions of Africa*, a stage adaptation of Raymond Roussel's self-published novel (1910). A wealthy eccentric and fan of science fiction writer Jules Verne, Roussel told the story of a shipwrecked group whose members passed their time demonstrating elaborate, absurd contraptions and devices. Duchamp had been delighted by the theater poster, with its cartoon-like vignettes, but was especially awed by the fantastical spoofs on technology on stage. It was life changing for Duchamp's own imagination. As a literary tradition, he embraced Roussel's delightful absurdism as his own.[18]

Roussel's shrewd fantasy world was on Duchamp's mind when, at the end of June, he packed and, having first traveled to Basel, Switzerland, took the train to Munich and rented a small room at 65 Barerstrasse,

where he stayed from June 21, 1912, through August. His activities are unknown, but they included a burst of painterly creativity, perhaps only possible as he tarried monk-like in his Munich cell. Going beyond the stop-action image of his *Nude Descending*, Duchamp drew up a kind of female bio-machinery. As his sketches show, it was a new mechanical look, perhaps a mixture of Roussel's machines and the poet Laforgue's cynicism about marriage and sexual relations, since Duchamp identified his sketch topics as "virgins" and "brides."

He applied this work to a painting titled *The Passage from Virgin to Bride*, and then did one in a similar mode, a work of higher quality titled *The Bride*. As biomechanical, web-like entities, his virgins and brides bore no resemblance at all to real females. But by using fine brushwork, and to eerie effect, Duchamp's most compelling work in oil was *The Bride*. Duchamp must have liked the odd, sinewy, female image, too, for he transferred it verbatim as the "bride" in his next big project, *The Large Glass* (also known as *The Bride Stripped Bare*).

Munich had long been the modern art center of Germany. Duchamp must have wandered its streets and sampled its galleries and museums. He also traveled beyond Munich, gaining a wide exposure to the history of art, sorting out what it meant to infuse "ideas" into painting. Conceivably, Duchamp was considering the fact that past art had always been based on ideas, but ideas about historical events, religious beliefs, or pagan mythologies.[19] This was augmented by the assertions of Gleizes and Metzinger — that from Courbet to Impressionism, "the retina predominates over the brain" — and Duchamp began to feel that even Cubism had gotten merely retinal, with its portraits and still lifes. He wondered whether painting could once again, as he would say later in life, be in "the service of the mind," not just the eyeball.[20]

While in Munich, other than visiting one friend, Duchamp stayed to himself, avoiding the camaraderie of working artists. However, he did obtain a copy of Kandinsky's just-published German-language work, *Concerning the Spiritual in Art*. Duchamp translated parts (into French) in the margins.[21] This did not mean that he was interested in the religion, or in Kandinsky's call for artists to be purists, even messianic. Duchamp was not drawn to Kandinsky's grandiose ideas, much preferring the literary fantasy, humor, cynicism, and absurdity of a Roussel or Jarry. However,

Kandinsky's opening paragraphs in *Concerning the Spiritual* made sense to Duchamp, given his own experience at the Paris salons. "The vulgar herd stroll through the rooms and pronounce the pictures 'nice' or 'splendid,'" wrote Kandinsky, next condemning the frenzied commercial competition between artists, indeed, their "vanity and greed," not to mention the "hatred, partisanship, cliques, jealousy, [and] intrigues" of the art world among painters.[22]

After Munich, which had been "the scene of my complete liberation," Duchamp later recalled, he traveled around in the first three weeks of September, visiting Vienna, Prague, Leipzig, Dresden, and Berlin.[23] In Munich he had completed two new paintings, and his thoughts must have been on the coming exhibitions were he'd show them—the 1912 Salon d'Automne and, in November, the special Salon de la Section d'Or exhibition. In Paris he was still seen as a player. The journal *Gil Blas* reported (wrongly) that he was going to show a new revolutionary painting, titled no less than "La Section d'Or."[24] Either way, the themes of his future in art seemed to be in orbit, not necessarily themes for everyone, but ones that spoke to him: virgins, brides, bachelors, sex, machinery, and the fourth dimension.

What exactly motivated Duchamp in the next few years, as he adopted a growing path of independence, has eluded his biographers, all of whom have noted his deepening grudge toward the painter's vocation. Did he really come to hate the smell of oil paint, as he later joked? Was it that he'd grown averse to the commercial craziness of the art world? Or was it simply sour grapes? Having failed to achieve quick success as a painter, Duchamp might have turned traitor to the profession. In French literature and theater, just such a person had been around for a while. He was called the "*raté*," an amateur who had failed. After that failure, the *raté* built a second career around taunting and satirizing his betters.[25]

As suggested by this literary reference to the *raté*, France was way ahead of most countries in discussing all kinds of art and all kinds of artists. The avant-garde, after all, was a French term, which had just begun to be applied to culture. In 1912, however, at a time when Picasso and Braque were experimenting with *papier collé*, art "isms" were rampant in Paris, and Duchamp was inventing biomechanical nude females, there was not a single modern art publication in the United States.

Then, as 1912 gave way to 1913, a small group of Americans who wanted a modern art revolution in their provincial homeland arrived at the doorsteps of both Duchamp and Picasso. They were looking for paintings to take back to New York City for a large, risky event to be called the Armory Show.

7 the armory show

One day in November 1912, three Americans arrived at Puteaux to see the Duchamps. They were led there by the American painter and art agent Walter Pach, who had been living in Paris.[1] The consummate New Yorker, Pach introduced the Americans, and then gave Raymond Duchamp-Villon some exciting news: in New York City, the Association of American Painters and Sculptors was set to hold a great art show in three months. Named the International Exhibition of Modern Art, it was in need of new European art. It would also go down in history as the "Armory Show," a name derived from its ordinary Manhattan building, yet a name also remembered as an extraordinary turning point in the introduction of modern art to the United States.

At the time of Pach's visit, the Duchamp brothers' works had been returned from the Section d' Or exhibit, none sold. So they let the Americans—Pach, Arthur Davies, and Walt Kuhn—select what they liked. Although Marcel was not around that day, the Americans chose all four of his biomechanical paintings. Of the set, Davies said, "That's the strongest expression I've seen yet!"[2] Jacques and Raymond also offered works, paintings, sculptures, and Raymond's scale model of a "Cubist room" facade.[3]

Puteaux was not the only stop on Pach's tour around Paris for the American visitors. They also went to see Kahnweiler, Picasso's dealer, since Picasso was not around for an unannounced visit. Kahnweiler was about to put on Picasso's largest retrospective ever, slated for Munich at the exact time of the Armory Show, so he offered four Picasso works, but hardly his strongest.[4] Then, on visiting the Steins', the Americans were loaned two more Picassos to send across the Atlantic.

The idea of the Armory Show was hatched earlier that year, soon after the Association of American Painters and Sculptors, Inc., was founded. Some months later the group rented the Armory Building as the venue; it was a block-long edifice used for drills by the Sixty-ninth Infantry Regiment, the "fighting Irish." In its dedication to "contemporary art," the

primary goal of the association was to open an American market for the more serious progressive painters (who were rather traditional by today's standards). "Exhibition is the purpose of our uniting," the group declared at the founding.[5] Yet in the spirit of the French Salon des Indépendants, the Armory Show organizers also wanted to be reasonably open: "the Association feels that it may encourage non-professional, as well as professional artists, to exhibit the result of any self-expression in any medium."[6] To be an "international" art show, the Armory also had to include European art. The organizers expected to gather a sufficient amount of that from American collectors. However, in the fall of 1912, the urge to go art-hunting abroad became irresistible.

Unexpectedly, Davies and Kuhn had seen the catalog for a massive European show that had been underway in Cologne, Germany, the Sonderbund Exhibition.[7] "I wish we could have a show like this," Davies wrote to Kuhn, who was painting in Nova Scotia.[8] The Sonderbund closed September 30. Davies could not travel that quickly, but Kuhn felt a sort of mandate. "In a flash I was decided," he recalled. "I wired him to secure steamer reservations for me; there was just time to catch the boat, which would make it possible to reach Cologne before the close of the show."[9] By November both Kuhn and Davies had reached Paris, and after Kuhn reported what art he had recruited in the wake of the Sonderbund, especially art in Germany and Holland, guided by Walter Pach they scoured Paris (and later London).

To make this work in Paris, Pach was the key. A native of New York City, he came from a prosperous art-related publishing family. He had traveled to Paris to study art and had enrolled at the Académie Julian. While in Paris, the scholarly Pach also became an art consultant, helping wealthy Americans — some of whom visited Europe — understand "modern" art (and then purchase it). He was the first American to write a scholarly work on Cézanne, and many other writings followed, including one on Raymond Duchamp-Villon, Marcel's brother.

Pach recognized that Picasso was in the vanguard in Paris painting, but he was much closer intellectually to the salon Cubists. During his years in Paris, one of the places Pach could spend his Sundays was in Puteaux, and it was there that he may also have first met Marcel Duchamp, who was four years younger than him. At the time that Pach brought the Americans by to request paintings, Marcel was nowhere to be found. In

recent weeks he had returned from his sojourn in Munich, and there is good reason to think he was out on the town, taking the lead of a new friend, who was now Marcel's closest friend in Paris, the painter Francis Picabia.

Over the past year, Duchamp's friendship with Picabia had become one of the most important for his artistic career. Eight years his senior, Picabia was spirited with the Cuban and French blood of his parents, and loaded with family money. He was the first person to really influence the young Duchamp as he drifted from his brothers' shadows. After they had met at the 1911 Salon d'Automne, Picabia showed Marcel the life of a true bohemian, which is the life of hedonism. Not needing a job, Picabia still could afford the fast cars he loved and drove, and could support drinking and opium habits. Picabia gave Marcel "entry into a world I knew nothing of," Duchamp recalled. "Obviously, it opened up new horizons for me."[10]

Together, they enjoyed the sarcasm—the blague, fumiste, and mystification—that went with bohemia, whether in cabarets or publications. As Picabia's wife wrote later, Duchamp and Picabia "emulated one another in their extraordinary adherence to paradoxical, destructive principles, in their blasphemies and inhumanities which were directed not only against the old myths of art, but against all the foundations of life in general." They often joined up with Apollinaire, too, engaging in "forays of witticism and clownery."[11] One day in October 1912, Picabia took Duchamp and Apollinaire on an adventurous drive, up a winding mountain road to Picabia's mother-in-law's home. Holding on for dear life, their hair blown in the wind as Picabia raced his convertible, the three bonded, with Marcel the youngest and most impressionable.

About two months after that excursion, the Americans had arrived in Paris looking for art, and they would choose some Cubist paintings by Picabia to send to New York as well. In addition to knowing the Paris artists, Walter Pach had managed the shipping of the works, and then he, too, prepared to head for New York City. He was returning to Manhattan to be a kind of Armory Show scholar in residence, working with the press and giving public lectures. "Our show must be talked about all over the US before the doors open," Kuhn wrote to Pach from New York, two months before the Armory Show's opening.[12]

Before Pach left Paris, he tried to persuade many of the French artists to come to America for the event. It was a daunting proposal that was not

taken up by anyone—except Picabia, who had the wealth and panache necessary to follow Pach's advice. By the opening of the Armory Show in mid-February 1913, Picabia and his wife, Gabrielle Buffet-Picabia, where in Manhattan, right in the middle of the Armory fanfare. Picabia was a talented painter. For the Armory event, he would also become a celebrity, opening a beachhead among the Manhattan avant-garde that his young friend Marcel would one day storm as well.

COMPARED TO EUROPE, of course, the American art scene was young. For most of its history, American art had mimicked Europe, beginning with its own American tradition of "history painting"—murals of epic events—a tradition gradually augmented by native renderings of the West, the wilderness, and America's own signal events. While keeping the European *beaux arts* tradition alive and well up through the time of the Armory Show, the American arts had a popular side also. After the Civil War, the United States saw a boom in talented newspaper illustrators. They kept up with the growth in mass media. They also became the raw material for a movement of progressive painters.

By the time of the Armory Show, many of them had been producing a new, realistic style of painting ordinary life, especially urban life, now called "social realism." They did not do commissioned paintings for American oligarchs, and in fact they mostly leaned left wing, working for periodicals of that flavor as well. Critics of their highly skilled, yet street-oriented, painting style would give them the pejorative collective name of the "Ashcan School," a label that many of the painters wore proudly. Its members developed the first signs of a progressive art scene, baptizing such neighborhoods as Greenwich Village as places where artists might live and congregate in New York City. Otherwise the American avant-garde was undeveloped, with the chief exception being an avant-garde movement in photography, led by Alfred Stieglitz. His 291 Gallery in Manhattan began to feature new paintings as well, holding a small—and barely noticed—exhibit of Picasso's Cubist drawings in 1911.

Naturally, when the association was formed and the Armory Show announced, the backbone of its participants came from the progressive wing: names such as John Sloan, William Glackens, George Bellows, Stuart Davis, Marsden Hartley, John Marin, Charles Sheeler, Maurice Prendergast, and finally the mentor of many of these painters, Robert Henri,

"dean of the Ashcan School," who naturally was one of eight trustees at the association's founding. Some of them still had one foot in New York's leading *beaux arts* organization, the National Academy of Design, but most had gone their own way. To achieve a balance of opinions among these artistic egos, the main characters were spread across the Armory Show management: Glackens on the panel that chose domestic works, Henri helping to screen foreign art, and Bellows, while on the executive committee, also hanging the burlap on the exhibit partitions.

From the start, the question of who would be selected by various Armory committees and shown in the exhibition raised disputes. The normal amount of grousing followed, and some artists, and even a few officials, withdrew before the show was on. The most contentious topic, however, was how to handle the European art (since the Armory was to be a show that boosted American works). The organizer had decided to take an art-historical approach, tracing the start of modern art to Francisco Goya (d. 1828), and showing its peak with post-Impressionists such as van Gogh, Cézanne, and Matisse.

This was meant to be a fairly modest inclusion of European art, drawn mostly from us collections. But after the trip abroad by Kuhn, Davies, and Pach, the influx of very recent European works began to steal the thunder of the entire Armory enterprise. Even though just a third of the 1,300 works displayed were foreign, they would end up getting the most attention and stirring the most controversy.

Despite this early unhappiness, the show went on, and the publicity went ahead full steam. "The drumbeat was almost worthy of a Barnum, and the circus atmosphere was eventually abetted, when the Show opened, by the spectacular nature of the new art," said one historian.[13] The Armory committee had a veteran newsman, Frederick James Gregg, behind its publicity machine. He sent press releases to media outlets around the country. He also provided the press with a recent photo of the three Duchamp brothers, taken in the garden at Puteaux, a picture that had come into the hands of Pach. Fifty thousand colored postcards also flooded New York—one of the most popular being a replication of *Nude Descending a Staircase*, with its title put plainly in English.

To stir the cultural pot further, Gregg commissioned Mabel Dodge, a wealthy bohemian socialite in Greenwich Village, to write an article, coincident with the show, on how Gertrude Stein invented Cubist poetry.

Writing in *Arts and Decoration*, Dodge said that Stein's writings were "doing with words, what Picasso is doing with paint. She is impelling language to induce new states of consciousness, and in doing so language becomes with her a creative art rather than a mirror of history."[14] In other words it was not clear language, but language with impenetrable syntax.

The Armory opened with great fanfare on the weekend of February 17 with a banquet, media tour, speeches, and regimental band. The public response was slow at first, and organizers became visibly worried. By the second and third week it began to pick up, and not least because of news about Duchamp's *Nude Descending a Staircase*, which was being written about in addition to the postcards that had gotten around.

The number of visitors grew, despite the entrance fee. Once inside, they found the echoing building hospitable enough. It was decorated with spots of greenery, potted pine trees, flags, and bunting. From the ceiling, pale yellow streamers came down to the walls, creating a delicate tent effect over the room. The exhibition space was divided into eighteen sections by partitions. The pathways took visitors on a chronological tour of modern art: from Goya through French modernism; through a very large section of American art; and finally, way in the back, to one of the French art sections that soon was to be called the "Cubist Room," and in some newspaper humor, the "Chamber of Horrors."

Back in that chamber, Duchamp's *Nude Descending a Staircase* became the center of attention. Picasso's Cubist painting *Woman with a Mustard Pot* hung in the same section, but without a noticeable impact on the crowds. Elsewhere, Picasso's *Standing Female Nude* had also been displayed, a small charcoal drawing that was an early hint of analytic Cubism (one critic had previously described it as looking like a broken "fire escape," not like a woman). In the flurry over *Nude Descending a Staircase*, though, Picasso's works seemed to be overlooked, at least by the general public.

Duchamp's *Nude* had the advantage of being larger and having a title that provided newspapers with the potential for jokes, razzle-dazzle, and sensation, a story of French excess for American consumption. For this general readership, most newspaper writers mentioned only *Nude Descending a Staircase*. The name of the artist did not matter, and the Duchamp name did not show up in any headlines. For those who paid attention, the picture of the Duchamp brothers, if anything, showed read-

ers that Parisian artists like Marcel, who did not wear a beard, looked "quite normal," as a *New York Times* caption would say.[15] Many headlines were a straight declaration about modern art. Others played on irony or humor, such as:

"Art" in the Armory
Cubists and Futurists Are Making Insanity Pay[16]

During the Armory Show, all of the new art tended to be called "Cubism," putting the word firmly into the American lexicon. To suit the tastes of the general public, much of the coverage was sarcastic and at times hysterical. Through it all, Picasso's name popped up mostly as a symbol, as when the *Tribune* spoke of "Picasso and the rest of the Cubists."[17] Matisse's paintings of awkward nudes would stir the most anger and sarcasm among American artists and critics, perhaps because, as leader of the Parisian Fauves, he had encroached boldly on the American market. By comparison, Picasso was treated with kid gloves. The more specialized art writers knew that Picasso was a main figure in Europe. But except for the words of a few diehard Europhiles, Picasso's paintings — few in number and hardly his best — did not draw much thoughtful praise.

For many, Cubism was boring. Former president Theodore Roosevelt attended and, writing as "layman," said the new European art did not impress. A writer for the Springfield *Republican*, furthermore, offered a generally positive take on the Armory, but added: "Picasso fails to impress."

As an alternative approach, writers often placed the European modern art in a sociological, and even mental health, context. With a general accuracy, the *New York Times* editorialized that the Cubists "are cousins to the anarchists in politics, [and] the poets who defy syntax." Many of the critics said the European contribution to the exhibition could be taken two different ways. Either it was a hoax by those artists, or it was a sign of artistic decline abroad. "This thing is not amusing," a critic in *Harper's Weekly* said. Taking another view, the *Chicago Tribune* singled out Matisse and argued that his type of paintings was indeed presenting "blague in a loud voice."[18]

Although a surprising number of articles associated Cubism with insanity, a medical field much in the news lately, there were also cheers for art that let human inhibitions show themselves. Putting madness in a good light, one commentator said that benign craziness had always been

behind the genius of art. It was an age-old idea. The avant-garde European paintings showed that "art was recapturing its own essential madness at last," said a letter to the *Evening Post*, "that the modern painter and sculptor had won for himself a title of courage that was lacking in all the other fields of art."[19]

As the center of the art world, Paris virtually ignored the New York event.[20] Nonetheless, amid the New York media fanfare, Picabia gained remarkable publicity as the only real Parisian artist on hand. The short, broad-shouldered Picabia had "dark, artistic eyes," the *New York Times* told its readers, and his personality was as forceful as his Cubist paintings, which were typically in bright reds and suggested mechanical motion.[21] As Picabia became a darling of American newspapers, the *World* did a spoof on one of his printed statements on how the new art was like music (this was Orphism). The *World* offered a prize to anyone who could explain what Picabia meant. The Picabias enjoyed the celebrity. They stayed in New York for several weeks beyond their original plan.

The Armory Show in New York drew eighty-seven thousand visitors. After traveling to Chicago and Boston, where it showed a smaller assemblage of works, the exhibition and its media coverage had exposed several hundreds of thousands of Americans to the European avant-garde.[22] As some of the American artists had suspected, the Europeans received the most attention. They also sold the most art (and after Odilon Redon, Marcel sold the next largest number of works, all four of his paintings, priced low to move easily, it must be noted). The idea of the Association of American Painters and Sculptors had been a noble one. When the Armory tour was over, however, the association collapsed amid disagreement, disputes with the overseas dealers, and financial loss. The association simply dissolved for lack of any more interest.

As an important windfall, the Armory did bring into existence America's first collectors of modern art — even if it was almost entirely European art. They bought from the Armory and kept on buying through the Second World War. While a collector such as the Irish American lawyer John Quinn (for whom Pach worked) helped lead the Armory Show, other future collectors were converted for the first time. Two of them would be significant for American art — and crucial for the future success of Marcel Duchamp in America. In New York, the wealthy matron and art student Katherine Dreier had loaned one of her own van Goghs for the Armory

exhibit, which so exhilarated her that she made modern art her lifelong crusade. In Boston, the scion of wealth Walter Arensberg attended that last lap of the Armory tour; as a poet and modernist, he, too, was converted to art collecting.

Despite the Armory Show's financial failure, not to mention the small dent it actually made in American tastes in art, it nevertheless excited a new crop of young artists to become rebels. One of the young artists who attended the Armory, for example, was a wiry, Brooklyn-accented, Jewish American draftsman, artist, and soon-to-be-photographer. His name was Emmanuel Radnitzky, and as he became a professional artist, he changed it to Man Ray. In the years ahead, Ray would become one of Duchamp's closest companions and co-conspirators.

For the time being, 1913 had been Picabia's brief moment in the American sunshine of celebrity. For all the Americans knew, he was the face of Cubism. Duchamp was also a success, but in a different kind of way. His *Nude Descending a Staircase* had produced a classic *succès de scandale*, and in New York, that accomplishment would not be forgotten.

THE NEWS OF the Armory trickled back to Paris, but barely. It was probably not a topic that Kahnweiler raised with Picasso. For one thing, at that moment, the gigantic retrospective of Picasso in Munich had eclipsed all else. Before and after the Armory, Picasso was frequently on the road, now to the south of France, now to a new Left Bank studio, and then to Barcelona for his father's funeral. Writing from the south of France, Picasso told Kahnweiler that he was trying to evade Fernande, and also asked, "Tell me if Gleizes and Metzinger's book on painting has appeared."[23] Which it had, in Paris, just weeks before the Armory Show opened.

From New York, Pach had written to the older Duchamp brothers, notifying them of the sales and returns. When Picabia arrived back in Paris, he gave Marcel a lively recap of the American experience. The fact was, it seems, the Armory Show was too distant to have any impact on Marcel, for the exigencies of life in Paris were far more immediate. He and Picabia settled back into their Parisian ways.

By the summer after the Armory, Duchamp had been living in Neuilly, very close to Puteaux, for five years. He decided to move back to Paris in October 1913, taking a studio apartment at 23 rue Saint-Hippolyte. During this time, Picabia's uncle got Duchamp a clerk's job at the Biblio-

thèque de Sainte-Geneviève. "I could sit and think about whatever I cared to," he recalled.[24] He was thinking a lot about his own intellectual development. It seemed too late to go into mathematics, which interested him. He took two courses related to library employment, but never advanced beyond "intern" status. At the library, at least, he could leaf through books on the topics that had been so speculative at Puteaux, topics such as non-Euclidian geometry, the fourth dimension, or the newly published copies of Leonard da Vinci's notes, which were presented as photocopies (i.e., facsimiles) of da Vinci's original hand-scribbled pages.

In the end, Duchamp was not suited for higher studies and an intellectual degree. He was still playing a lot of chess. But this seemed to be more of a recreational outlet, not a career. The great chess players began very early in life, spending days and weeks at the board. They filled their memories with all possible moves and combinations. These ran into the tens of thousands. Duchamp was already behind — maybe. Meanwhile, his intellectual model, perhaps, was a poet such as Apollinaire. After the impressionable car ride he had taken with Apollinaire and Picabia, Duchamp fancied that perhaps he, too, could be a poet. He could write down words, playing with them as a poet does. Whatever the realism of that ambition, Duchamp began to write down a growing collection of personal notes.

As Duchamp began to keep notes, as an artist he was thinking about machines. They had been on his mind for a while. Since he had made the *Coffee Grinder* picture during Christmas 1911, he'd also produced one more mechanical image. It was a three-wheeled chocolate grinder, a popular kitchen device that he had seen in shop windows in Rouen.

In seizing on the machine for art, Duchamp was not entirely original. His was a mechanistic age and there was already a widespread tendency to conflate humans with machines as a means of comedy. Eventually, some art historians would call this broad genre the "machine aesthetic" in modern art.[25] A painter like Picabia would apply the machine aesthetic with aplomb. He produced many drawings and paintings that turned people into devices, or that looked in the end like bizarre engineering blueprints. If Picabia's output was frenetic, Duchamp was thinking long-term about one big project. It would be related to his recent paintings — paintings about virgins and brides. He envisioned a work of art that turned a virgin bride into a whimsical, sexual machine, and then tried to relegate her to the fourth dimension.

With such ideas, Duchamp was departing from art and painting and moving toward something like literature. The precedents were all around him in zany Paris's literary life. Alfred Jarry had presented literary Paris with a human sex machine powered by high-voltage electricity. Then came Raymond Roussel's *Impressions of Africa*, a story about fantastically complex devices doing very simple tasks. This idea had also become popular in a new American comic strip craze that had reached Paris. This was the "Invention of the Week" comic by Rube Goldberg, an engineer turned cartoonist. Each week, Goldberg invented a multi-step contraption to, for example, swat a fly, shine a shoe, or pull a tooth. Duchamp had also been trained in cartooning. Like Goldberg, he preferred the single-box format (versus the strip).

Between Jarry and Roussel on one hand, and Goldberg's single-frame comics on the other, Duchamp began to conceive of his singular work as if a gigantic comic box. He at first conceived of putting it on a large canvas, but in time changed his plan to glass (and thus, the project would one day be called *The Large Glass*). He had also retained its "literary" side by keeping notes he jotted down on his musings and ideas, a practice he began as early as his summer in Munich, where he had painted his virgin and bride themes. When he got his library job in late 1913, he wrote more notes. His notes reminded him, for example, to read the "whole section on perspective" at the library in his free time. At the library he also made "calculations" for the size and shapes of *The Large Glass* and put those down in his notes.[26]

As a whole the notes are almost indescribable. They range from puns and abstruse sentences to lists of items and fragments of mathematical speculation. He wrote them on scraps, the back of receipts, bills, ruled school paper, bits of wrapping paper, and cafe stationery. He did not worry about spelling or punctuation. He scratched things out. His pen leaked. He circled in red crayon. He dashed off double underlines. Sometimes a sheet had a drawing with a little text. Other times the scrap had a good deal of text with little or no drawing.

The marvel is that Duchamp would keep all of these sundry pieces of paper, storing them safely away. They stayed intact despite a great many travels, and they even survived two world wars, as if the notes were his most precious possession. He told himself that one day he would put them in a book, a literary guide of sorts for *The Large Glass*, and in the

meantime, they may have seemed to him a jumble of notations, just as Leonard da Vinci confessed that his notes were "a collection without order, made up of many sheets which I have copied here, hoping afterwards to arrange them."[27]

If by keeping the notes Duchamp was pulling a blague on da Vinci's notes, he was also thinking seriously about da Vinci's writings on linear perspective. As would be seen, perspective gave Duchamp a solution on how to "paint" the fourth dimension: it would lack perspective lines, being amorphous in imagery, not a real fourth dimension, to be sure, but a kind of allegory for a dimension that defied physical representation. He would also do this painting of the fourth dimension on glass — indeed *The Large Glass* — which unlike canvas, added further allegorical implications, since the eye can see through glass. Even Leonardo da Vinci spoke of using glass to draw linear perspective.[28]

The notes also show that Duchamp had an amateur interest in higher mathematics, jotting down brief references to the more popular general interest books written by the mathematicians Pascal Jouffret and Henri Poincaré. In Jouffret's book, *Elementary Treatise on Four-Dimensional Geometry* (1903), Duchamp found some helpful analogies for conceiving the fourth dimension, for example. One of them was to think that "the shadow cast by a four dimensional figure on our space is a three-dimensional shadow." Jouffret also offered the very likable image of a blindfolded chess player imagining the board: the chess player's thinking of his spatial moves in time was, supposedly, like imagining four dimensions.[29]

With the idea of using allegory for the fourth dimension, and using standard perspective for the other three, Duchamp began to lay out his design for the future *Large Glass* at his rue Saint-Hippolyte apartment. The apartment had just been remodeled, so Duchamp began to draw his design on a plaster wall, probably having asked the landlord to keep it free of wallpaper for a while. Using pencil, ruler, and compass for the exacting design process, he did a first draft of his "Hilarious picture."[30] It was a series of mechanisms, much like a Rube Goldberg cartoon, with nine men below (called the bachelors) and the virgin above (called the bride). In Duchamp's allegorical mind, the mechanisms were about sexual relations between the bachelors and the bride, an idea that would not be clear to anyone else until after he titled the work, *The Bride Stripped Bare by the Bachelors, Even*, and even then, only after he provide further elaborate explanations.

On projects such as this, Duchamp thought as much as he worked. His thoughts often inclined toward blague. During these months, he was frequently out on the town with Picabia. He consorted with easy girls and kept his eyes on his old group, the salon Cubists. They were still taking themselves too seriously, he felt, and perhaps some blague was in order. Many of the salon Cubists had painted the two icons of Paris, the Eiffel Tower and the Great Ferris Wheel, the latter built for Paris's Universal Exhibitions in 1900.[31]

Duchamp had seen the Tower and the Wheel often enough. They stood for the great technological advances of France, and that made them good topics for blague as well. So one day, on the way home, Duchamp found (or bought) a front bicycle wheel. He mounted it on a kitchen stool and, now in his apartment, he set the wheel spinning—like the great Ferris Wheel in miniature. Parisians revered the Eiffel Tower even more than the Ferris Wheel. So to blague that reverence, Duchamp went out and bought a tower-like bottle drying rack. To make it more than just a rack, he painted a line of whimsical words at its base, a kind of poetry, but also a bit like putting a title on the front of a painting (as he'd done, amid controversy, with *Nude Descending a Staircase*).

The blague did not end there. Another great object of scientific reverence in Paris was an iridium-and-platinum rod that gave the nation its exact measure of a meter. This was the kind of scientific seriousness that creative rebels such as Jarry, Roussel, and Goldberg loved to make fun of. So one day at his apartment, late in 1913, Duchamp took three pieces of sewing thread (called "stoppage" thread), each a meter long, and he held them a meter above a canvas. Then he let them drop and drew their outline on the canvas. In the next months, Duchamp would use the stoppage outlines to produce a painting, *Network of Stoppages* (1914), and to cut pieces of thin wood that mimicked the curves, installing them in a box, titled *Three Standard Stoppages* (1913–14).

Duchamp called his entire approach "Playful Physics," a kind of derivative of Jarry's 'pataphysics. Applied to the traditional meter, the dropped threads, for example, provided a "new shape of the measure of length."[32] Looking back on the stoppage project, Duchamp would explain that it represented a profound insight he had achieved on the role of "chance" in art. It was a personal revelation, of course, since many artisans of the past, and even da Vinci and Picasso, had spoken of chance and accident in art.[33] But

for Duchamp, this naive sense of "discovery" about chance was something special, and in his own mind it became increasingly dramatized in hindsight. As he told one interviewer late in his life, *Three Standard Stoppages*, with its employment of chance, "tapped the mainspring of my future."[34]

BY SPRING OF 1914, though living in very separate worlds, Duchamp and Picasso were laying the groundwork for the future of modern art. As a turning point, this period could only be interpreted in hindsight. In the moment, Duchamp and Picasso were simply following their own instincts as artists. Chronologically, Duchamp had set the first important precedent with his mundane objects, from his bicycle wheel to his threads. Meanwhile, in his 1913 notes, he asked himself the question, "Can one make works which are not works of art?"[35]

Duchamp obviously knew that people make things every day and don't call them "works of art," but his convoluted, rhetorical question was actually making a subversive statement: he was saying that, in the world of blague at least, *anything* could be art, even a bicycle wheel stuck in a chair. Duchamp's ideas about mass-produced objects being art would take a few more years for him to articulate. As with Duchamp's doctrine of "chance," the doctrine of using ordinary "objects" in arts and crafts was not new, either, nor particularly profound. It was Duchamp, however, who would elaborate on the topic. He eventually declared that any banal object could be a work of art if you classified it as "readymade" art—a word that would go down in art history, almost as powerfully as the word Cubism.

Although Duchamp may not have realized it yet, the readymade idea was a vehicle on which he could load a number of his pet theories, from the use of chance in art to the central role of "ideas" in art. He could also find a way to criticize painting, which, at this time in his career, he was feeling a great amount of animosity toward. If he needed a final antidote to painting—or indeed the formula that might destroy it—the readymade seemed well groomed for the task.

As the readymade was positioned to become Duchamp's legacy for the future of modern art, Picasso—who still loved painting—was setting a different kind of precedent that would have a long-term effect. This was Picasso's impact on the world of finance and the visual arts.[36] For this eventuality, the signal event came on March 2, 1914, when a Picasso painting sold at auction for the highest price seen to date in modern art.

The significance was in the auction, for it proved that modern art could be a valuable investment. A decade earlier, a group of French investors formed a small association to buy art, let it appreciate, and then sell it at auction. One of the works they had bought was Picasso's Rose period *The Saltimbanques*. When it came on the auction block that day in March, it sold for 12,650 francs, twelve times more than what they had paid for it six years earlier. The large sum made headlines, and this made Picasso a kind of celebrity. Just as important, modern art gained its reputation as a speculative quantity, as lucrative as stocks, mines, or railroads.

In Paris, Duchamp surely heard the news. He just as surely associated Picasso with a world of art and money beyond his own grasp; it was a topic that seemed to obsess Duchamp for the rest of his life. A year after the famed auction, Duchamp wrote to Walter Pach in America, shunning "the life of an artist in search of fame and fortune," but still wondering how he'd earn his daily bread. "I am very happy to hear you sold [my] canvases," he said in his letter to Pach. "But I am afraid of getting to the stage of needing to sell canvases, in a word, of being a painter for a living."[37]

In 1914, the far future implications of Duchamp's readymades and the Picasso auction were not at all clear. It would have surprised everyone to suggest that, at the end of the twentieth century, modern art would be defined by readymade objects sold at speculative art auctions for millions of dollars.

THE ADVENT OF the brewing conflict between the European alliances was no longer speculative, however. In August 1914, France and Germany declared war on each other. The French believed it would be over in six months, but that prediction was clearly wrong.

Picasso and Éva heard the news in Avignon, where they had gone for the summer. They had met Braque and his wife there for a season of painting. Their lives as artists were good: they had true loves and successful careers. On June 23, 1914, Éva wrote home to Paris, "This morning, Pablo found a rather Spanish house right in town. . . . It's high time we were settled in our own place. This life of hotels and wandering about doesn't do us any good."[38] With the declaration of war, the dream of settling down vanished.

As a foreigner in France, Picasso knew he had to act quickly. The day of the news, he and Éva boarded a night train for Paris. The next morning Picasso took all his money out of the bank (Matisse said it was one hun-

dred thousand gold francs). He also made sure that his non-citizen residency papers were in order. They traveled directly back to Avignon, and the next day Picasso accompanied Braque to the train station. Braque reported to military duty. Picasso and Éva might have stayed in the south for much longer but Éva was beginning to feel very ill, so they headed back to wartime Paris to see doctors. Apollinaire had also been summering in the south with his latest girlfriend. He saw military service as his final chance to become a French citizen. With others he drove back to Paris and, always the poet, he would later note that: "The little car had driven us into a new epic."[39]

THROUGH 1914, the hints of war had not stilled the international art market, and after the Armory Show, one of the few Americans who seemed to stay active in the art trade was Walter Pach. After the Armory, Pach had stayed in New York to concentrate on art dealing. He married and settled down. But he continued to correspond with Raymond Duchamp-Villon, arranging more shipments of art for American collectors, and to talk about Pach's return visit to Paris. As Pach planned that visit, the war intervened. The two older Duchamp brothers were called into duty. Jacques went to the front lines with the infantry, and Raymond was commissioned in the medical corps.

When war was declared, Marcel had been at his parents' summer home on the Norman coast. Under the terms of his earlier military service, Marcel was exempt from mobilization for the moment. Many believed the war would soon be called off. So he stepped in for his brother to continue working with Pach, who had gallery exhibits planned for New York. When Pach arrived in Paris in late 1914, Marcel was a diligent host. They met at cafes on the boulevards St. Michel and Raspail in the Left Bank. Pach told Duchamp more about the Armory Show. He may have shown him press clippings. Marcel agreed to help Pach obtain more paintings. He also offered to provide some of his own works, since, after the *Nude*, a fledgling Marcel Duchamp market seemed to have appeared in America.

When Pach left for New York, he took five of Duchamp's paintings with him. Before he left, Pach and Duchamp sat on a bench one day on the Avenue des Gobelins. Pach urged Duchamp to come to the United States. Picabia had liked it, why wouldn't Marcel?

Seeing Pach off, Marcel was indecisive on the offer. Then the war be-

came more intense. The Germans soon overran Belgium. So in January 1915, the draft board summoned Marcel to duty. His medical exam discovered a heart murmur. He was exempted for the time being, but was hardly in an enviable position. Young men walking around Paris, while husbands and sons were in the trenches, were targets of scorn. Women handed them white chicken feathers or spat at them in the streets.

Duchamp tried to stay indoors and stay busy. At his apartment, he continued to work on the drawing of *The Large Glass*, eventually transferring it from the plaster wall to paper. He also experimented with putting his designs on sheets of glass using lead wire, paint, and foil. He produced two such images, the first being the nine bachelors (which he called *Nine Malic Molds*), the other being a gurney-type "glider" device. In addition to finishing up his master sketch, Duchamp also organized his notes, the many pieces of paper (more like scraps, actually) on which he had been jotting his sundry thoughts for a few years.

For reasons not exactly understood, at one point Duchamp selected a few of the scraps (sixteen notes and a drawing) and, just as da Vinci's note pages had been photocopied in modern books, had his own notes reproduced at a photo-printing shop. Then he mounted each on white art board. Finally, he put these in a plain box, the kind used for photo papers. This would be the famous *Box of 1914*, oddly recognized by artists and art historians as a major accomplishment. At the least, it was Duchamp's first "publication" of his ideas about art and his *Large Glass* project.

In effect, with a project like this, Duchamp was already packing his belongings, prepared for big changes in his life. In his April 1915 correspondence with Pach, he wrote that he was shipping over the promised material: several sculptures by Raymond and three more of his own works, *Nude Descending a Staircase no. 1*; a perspective drawing from *The Large Glass*, and a full painting titled *The Passage from the Virgin to the Bride*. Presently, he wrote again to Pach, this time reminding him that he had had sufficient academic training in France—the lycée, baccalaureate, and library—to obtain a job in the United States. By now it was clear Duchamp wanted to head for America, and one of his final letters (always in French) revealed some ostensible reasons why:

> Long before the war, I already had a distaste for the artistic life I was involved in. It's quite the opposite of what I'm looking for. And so I tried,

through the Library, to escape from artists somewhat. Then, with the war, my incompatibility with this milieu grew. I wanted to go away at all costs. Where to? My only option was New York where I knew you and where I hope to be able to escape leading the artistic life, if needs be through a job which will keep me very busy. I asked you to keep all this secret from my brothers because I know my leaving will be painful for them.[40]

In New York, Pach was trying to line up a welcome party and a job for Duchamp. He wrote the New York lawyer, John Quinn, an important figure in the Armory Show for whom Pach was now an art agent, to pave the way for Duchamp. "He says he would be glad to come to New York," Pach wrote Quinn.[41] Eventually, Pach also would tell Quinn that Duchamp did not want to make his living off selling art, perhaps to assure Quinn that he would not have an artist welfare case on his hands.[42] Savvy in all things art, Pach also remembered to inform the newspapers that, finally, the man behind *Nude Descending a Staircase* was coming to America.

As Duchamp packed for his departure, he left many of his few belongings in his apartment, including the bicycle wheel and bottle rack. He gave the glass "glider" image to Raymond's wife, but crated his other glass experiment (the *Nine Malic Molds*, or bachelors) to take to New York. He planned to travel light: some clothing; his final drawing for *The Large Glass*; other drawings; apparently all, or most of, his notes — and the rest he carried in his head. This mental baggage included the ideas and projects that would occupy him for the rest of his life: the erotic nudes, the taste for blague, the ken for mechanical drawing, and his love-hate relationship to the idea of "art."

Duchamp also looked forward to playing some chess, if the opportunity arose. He had played enough chess by now that he also may have been thinking about an end game for his own life: could he escape the art world into something else, or was it too late, his being a Duchamp?

On June 6, Duchamp took the train to Bordeaux and boarded the steamship SS *Rochambeau*. The ship left at night with its lights out to avoid attracting German submarines. It was the biggest trip Duchamp had ever taken, and yet it would be only the first of countless trips back and forth across the Atlantic. Nine days later the SS *Rochambeau* carried him safely into New York harbor on June 15, 1915. Two years and three months

earlier, Duchamp had missed attending the Armory Show. Nonetheless, the Armory's memory in New York had lingered. It paved the way for Duchamp's new life — the next four years — in the United States, where his blague would revolutionize art.

Back on the fields of Paris, Picasso, exempt from war duty as well, would become a stalking horse for the great debates over art that continued in Europe.

8 the return to order

"My Life is hell," Picasso wrote to Stein in 1915, a year after the war had broken out.[1] It was six months after Marcel Duchamp had left for America. Stein herself had left for Spain. As Éva lay dying of cancer (or tuberculosis) in a crowded clinic on the edge of wartime Paris, Picasso's hell took the shape of a vacuum, steadily emptying.

Everything he had known seemed to have evaporated over the first year of the war: the Paris art scene, his *bande de Picasso*, and his financial security, especially since his dealer, the German businessman Kahnweiler, was in Switzerland when war broke out, prompting the French to confiscate his considerable cache of Picasso paintings as enemy property.[2] When Éva died on December 14, 1915, the vacuum was almost total — but not completely, when it came to women at least. Picasso had given in to his philandering ways in Éva's last year. He also seriously pursued three Montparnasse women — dancers and models — but in a bit of harsh self-realization (at age thirty-four), he had failed to persuade the two he liked best to marry him.[3]

One activity that continued on the Left Bank of Paris was a bohemian salon, or social gathering, held by an exotic Slavic couple, Serge Férat and Helen Férat (Baroness d'Oettingen).[4] In Paris, Serge's generosity represented the last gasp of czarist Russia's decadent class, soon to be swept away by the Bolshevik Revolution. The Férats had more money than Gertrude Stein. Their glittering parties, and lavish spending, soon overshadowed Stein's soirees. Serge, for example, financed Apollinaire's journal, *Soirées de Paris*. As a painter, Serge fell in with the salon Cubists. In the Férat circle Picasso was getting his first taste of the Russian avant-garde, about which he would learn a good deal more very soon.

Operating as a bachelor from his studio at rue Schoelcher, Picasso immersed himself in the scaled-back, wartime Montparnasse scene. He no longer had his first poet and painter friends, or his business manager, to shield him from the rough-and-tumble of Paris, where the opportunists among the avant-garde were always plentiful. They flourished among the

street-life bohemians, naturally. But occasionally they were present also in the Parisian upper class, and it was just such a person, a young poet, who arrived at Picasso's door on a late summer day in 1915 looking for opportunity.

His name was Jean Cocteau, a child of privilege who, to the pride of his parents, was noted in the poetry circles in Montparnasse as a young talent. He produced a repertoire of poetry called "frivolity." His wittiness was undeniable. For Cocteau to rise, though, he needed an avenue into the higher realms of the avant-garde, and that meant finding it among the Cubist painters. He had asked the composer Edgard Varèse to introduce him to Picasso, and the day finally came at the rue Schoelcher studio, "the greatest encounter of his [own] life," Cocteau recalled.[5] As the story goes, Cocteau saw a large Harlequin painting at the studio, and so, on another day, he returned in a raincoat. On entering Picasso's studio, he took it off, revealing himself in a Harlequin costume.

It was this sort of foppish forwardness—combined with homosexual excursions—that won Cocteau both scorn and grudging admiration in Paris. Stein called him a "slim, elegant youth." The bohemian composer Erik Satie preferred "loathsome bird."[6] Either way, Cocteau had talent, ambition, and an inside track in Parisian literary culture. He had a vision of uniting the left wing and right wing of French culture, the wealthy patrons with the left-wing bohemians. It also helped that Cocteau had a way with language. He had the ability to invent a catchy phrase that captured a moment, event, or time. One of those phrases—by no means his alone—had two variations, either *retour à l'ordre* (return to order) or *rappel à l'ordre* (call to order).

The words meant a return to, or revival of, France's "classical" past in literature and the arts. This return seemed especially necessary after the great national debate on the "hoax" of modern art, and especially after the diversity spawned by Cubism. From the start, some French critics had described Cubism as a foreign art form. Now that the war with Germany was on, Cubism was seen as a foreign fifth column in France.[7]

For Picasso at least, it did not take a French literary "call to order" for him to begin recovering some of his own academic training in drawing and painting. This kind of drawing began to show up during his happy days in the south, months before the war had begun. Around Avignon, Picasso had done line drawings of men in bars and women in armchairs:

they were realistic, though the space remained a bit ambiguous, as in Cubism. As one Picasso biographer said, Picasso was "proposing a marriage between the Cubist revolution and Renaissance perspective."[8] By the start of 1915 in Paris, he began doing delicate academic sketches, one of Max Jacob and one of a mistress, for example, and then others of dealer friends (Vollard and a newcomer, Léonce Rosenberg).

Eventually these works by Picasso began to be published: the Jacob portrait was first seen by the art public in 1916. The left-wing artists protested Picasso's classical turn at about the same volume that the right-wing art critics had earlier derided his Cubist sculptures—his guitars and absinthe glasses—when their images were first published. This time the allies of salon Cubism accused Picasso (never one of them, anyway) of betraying the cause. In reality the dispute was hardly noticed beyond the inbred art circles. The war had put modern art on the back burner. The modern painters banded together best they could, as when, in the first part of 1916, most of the prewar Cubists held the "The Modern Art in France" exhibition. It was a patriotic gesture that even Picasso joined, but it was largely ignored. This was Picasso's first Paris salon ever. Also, for the first time in public, he showed *The Brothel of Avignon*, which on this occasion a poet friend officially titled *Les Demoiselles d'Avignon*.

With only two or three exceptions, Picasso did not do any paintings about the war.[9] A few of his 1915–16 canvases—such as *Harlequin* and *Seated Man*—conjured an eerie, disjointed darkness that captured the wartime despair. For those who watched the modern painters, the new directions that Picasso was taking came as a double surprise since, given his isolation, nobody had seen what he was doing for a couple years. For another thing, Picasso was not attracted by the new machine aesthetic, which Cubist painters such as Fernand Léger adopted in highly mechanistic paintings, and artists such as Marcel Duchamp and Picabia played with in other formats.

The more consequential influence on Picasso was his early wartime friendship with the Italian painter Giorgio de Chirico, an expatriate in Paris and a regular at the living room salons of Serge and Helen Férat. At the time, de Chirico was doing what he called "metaphysical" painting. It drew heavily on classical Roman statuary and architecture. In his younger days as a painter, de Chirico had gone to Milan and, seeing the long shadows of classical Italian porticos, began to render outdoor urban scenes.

They were lonely and mysterious, and often had a classical statue and a train, puffing in the distance.

For whatever reason, Picasso was in fact winding down from Cubism, trying to do something different. His departures began with the almost Surrealist moods of *The Seated Man* and *Harlequin*, two large paintings. In the latter one he first used the "pinhead" man (perhaps adapted from Chirico's frequent use of a tailor mannequin's head). The revival of Harlequin, which had been at the heart of his Rose period, signaled Picasso's return to a more classical past. He had last used Harlequin in 1909. Now it came back in a big way. Cocteau in his Harlequin outfit, after all, was a smart move.

COCTEAU KNEW THAT his own success in the avant-garde had to begin in the Cubist circles. He first pursued a friendship with the wife of Albert Gleizes, a leader of the salon Cubists, who soon left France to avoid conscription. Then Cocteau decided to take a more direct approach: right to the top. He studied Picasso and his moves around Montparnasse. With the introduction by Varèse, he put his best foot forward. After that, he was nothing less than worshipful of Picasso, and it worked.

At the time of the costumed visit, Cocteau was on civilian military duty. He worked in the ambulance corps. Later he was assigned to the wartime information office; with his verbal gifts, he wrote feverish propaganda against the Germans. He had enough leave time around Paris, in other words, to try to organize various theater projects. The key, he knew, was to recruit well-known people in the arts. To persuade Picasso, Cocteau had some cards up his sleeve: in drab, blacked-out, wartime Paris, he took Picasso out to see the nooks and crannies of Parisian high society. Picasso favorably compared that life with the artistic detritus that he had known since Montmartre, and still saw around the Left Bank.

Cocteau had been trying to pull together a theater production for a while. His ideas ranged from a burlesque version of Shakespeare's *A Midsummer's Night Dream* to a spin-off of the story of the biblical King David, all of which failed to materialize. When he met Picasso the second time (in Harlequin garb), his recruitment strategy was to remain vague at first, but to eventually make his intentions clear: he wanted Picasso to help produce a play that Cocteau himself had written. Its title was *Parade*.

To move Picasso, Cocteau needed to pull strings among his upper-class friends, generating some powers of persuasion. The person who came to his aid was the wealthy Chilean socialite and art maven, Eugenia Errazuriz, a patron of fashion and the avant-garde. A dark beauty in her fifties, Errazuriz also spoke fluent Spanish. At her social level, she was friends with Serge Diaghilev, the head of the famous Ballets Russes (Russian Ballet). Diaghilev's troupe had been touring Europe, from London to Paris, for some time. Diaghilev had put on *Firebird*, *Petrouchka*, and *Swan Lake* in Paris to rousing acclaim. Meanwhile, one of his Russian soul mates, the composer Igor Stravinsky, had scandalized Paris in May 1913 with *Rite of Spring*, filled with erotic dance and non-harmonic music (and at which Marcel Duchamp had been in the audience).

Cocteau was eager to create his own *succès de scandale*, on the model of *Rite of Spring*, and to take the lead in Paris's modern theater. "May *Parade* distill all the involuntary emotion given off by circuses, music halls, carousels, public balls, factories, seaports, movies, etc. etc," he wrote Stravinsky.[10] Persuaded by such zeal, Errazuriz visited Picasso. Then in May 1916, Errazuriz persuaded Diaghilev to travel to Paris to meet Picasso at his rue Schoelcher studio, whose windows, to Diaghilev's dismay, overlooked the Montparnasse Cemetery. Though contemporary art such as Cubism and abstraction puzzled Diaghilev, he was easily converted. Despite Picasso's worries that he might be leaving the rugged world of the bohemian painter for the effete world of theater, he decided to take the plunge.

The negotiations to join *Parade* changed one other equation in his life. Errazuriz would now eclipse Gertrude Stein as the wealthy female patron. Picasso's friends called her "his Duchess." Before he made a final decision on *Parade*, Picasso needed to move out of rue Schoelcher. The lease was up and the sad memories of Éva lingered. So he moved everything to his already established second residence, a villa in Montrouge, a twenty-minute walk from Montparnasse. The composer Satie also lived in this neighborhood, known as Arcueil. He and Picasso talked over *Parade*; Satie had been invited to write the music. They knew each other from the old days in Montmartre, when Satie was a cabaret pianist. Satie loathed Cocteau. However, he liked the idea of working with Picasso and Diaghilev. By late August all parties had agreed. Dogged by doubts, bad feelings, and lack of money, the show did go on.[11]

As master of the production, Diaghilev arrived in Paris the first week

of September 1916 to give his French team their schedule. They had five months — until January — for preparatory work. Then they would all meet in Rome, headquarters of the Ballet Russes, which had left Russia, as the revolution was soon to topple the old regime. In Rome they would begin to produce the props and costumes and practice the choreography. Presented with his first theatrical production, Picasso's job was to design a stage set, a large curtain mural, the costumes, and then, assisted by crafts-men and painters, construct and paint all of these, all of it to be com-pleted well ahead of the May 1917 opening night. Wise in the ways of art dealers, Picasso asked for a contract. His fee was 5,000 francs, "and if I have to go to Rome, a thousand francs extra. The drawings and models re-main my property."[12]

Presently, Picasso and Satie began to dismantle Cocteau's original script. "I really do count for something in *Parade*," a frantic Cocteau wrote to a female patron of the arts.[13] Satie wrote to the same patron, showing little mercy. "Picasso's ideas I find even better than those of our Jean: what a malheur!" Satie wrote. "I am for Picasso, and Jean doesn't know it! What to do? Picasso tells me to keep working with Jean's text; while he, Picasso, is using another: his own."[14]

As these exchanges took place in the fall of 1916, Picasso was still try-ing to persuade one particularly fickle mistress, a certain Irene, to marry him. They shared a domestic life at the Montrouge villa, where Picasso sketched *Parade* sets and costumes. In tune with Picasso's return to ear-lier, more classical themes, he revived his use of Harlequin, acrobats, and horses in his ideas for the main curtain. His sets and costumes, however, were distinctly Cubist. He designed three-dimensional Cubist bodies to be worn by some of the actors. When the day of departure for Rome had arrived, Irene had flown the coop for good, and Picasso's heady plan for a marriage in Rome was in ruins. His only traveling companion would be Cocteau.

They took the Rome Express on February 17, 1917. At last Cocteau had forged a strong personal link with a leader of the avant-garde. He would orbit around Picasso — mostly to Picasso's benign tolerance — for the rest of his life: another sly poet to the painter. Picasso's trip to Italy, his first, would produce far more than just Cocteau's fawning admiration. Quite apart from *Parade*, the trip thoroughly exposed him to the classical past, a massive dose of what he had seen only dimly in de Chirico's paintings.

When Picasso had done his realistic drawings of, for example, Max Jacob, he was thinking of the French academician Jean-Auguste-Dominique Ingres. Now, for the next three months ending in mid-May 1917, Italy immersed him in the classical and the pagan.

On arriving in Rome, Picasso stayed at the dance company's preferred Hôtel de Russie on the via del Babuino. For the short period, Picasso also found a studio on the via Margutta. He had a view of Villa Medici, named for the Renaissance dynasty of bankers, princes, and popes. In his free time, Picasso went to the art museums with Stravinsky and, apparently on his own, sampled Rome's brothels. He also continued his line drawing, doing caricatures of Stravinsky and Diaghilev. Once the work on the theatrical was underway, the group took some springtime jaunts. Naples was the main destination, the start of Picasso's encounter with Roman antiquity under the hot Mediterranean sun. For the rest of his life, Picasso would evoke pagan themes he saw everywhere—bacchanals, centaurs, the Minotaur, and rapes by the gods. He had seen these topics in French academic paintings. On closer inspection, Italy now opened his eyes wide to the alluring pagan ethos, the world of Greek and Roman mythology.

In Rome he saw monuments, frescos, and mosaics. He viewed the art of Florence, once the seat of Europe's art academies (a seat that had, in effect, moved to Paris after 1648). Perhaps most compellingly, Picasso took several trips to the ancient sites of Pompeii and Herculaneum, two ancient cities at the foot of Mount Vesuvius. By one account, he "was thrilled by the majestic ruins, and climbed endlessly over broken columns to stand staring at fragments of Roman statuary."[15] He tried to imitate the ancient murals of naked women engaged in household sport. "I've done several Pompeian fantasies," he wrote Gertrude Stein.[16] The monumentality of Italy affected him with the same impact that the African sculpture had in his pre-Cubist period. He also recognized that the French painters with whom he increasingly identified—Jean Corot and Ingres, for example—had studied in Italy. By leaving Paris for Rome, moreover, Picasso soon developed a new *band de Picasso* in the midst of Diaghilev's ballet company.

Inevitably, the band required a new lover for Picasso. She would be the Russian ballerina Olga Khokhlova. "I have sixty dancers," Picasso boasted to Stein. Olga, however, caught his fancy, and for the first time Picasso had to deal seriously with a woman who played very hard to get. Diaghi-

lev told Picasso that he had to marry a Russian woman before getting any further, and that would be the story of Picasso and Olga. He was ready to try settling down. She was the daughter of a Russian colonel, not exactly nobility, but she was obviously at ease in the kind of social world that Picasso had also grown accustomed to back in Paris.

Picasso courted Olga through the months of run-up to *Parade*, and then after the Paris run, followed her and the troop to Barcelona, where they did a more classic production (plus one showing of *Parade* in Madrid — to the perplexity of the tradition-bound Spaniards). In Barcelona, Picasso introduced Olga to his mother. She did not necessarily like Russians. So on the scene, Picasso painted the dark-haired Olga in traditional Spanish dress, an image he gave to his mother. Easing the way for the courtship was the amicable Eugenia Errazuriz. After tutoring Picasso in his dress and etiquette, Errazuriz introduced him one night to the King of Spain, who was present at a great banquet for the Ballets Russes.

The Russian troupe headed next for Argentina. Olga, instead of joining them, waved good-bye from the dock. She returned to Paris with Picasso, and on July 12, 1918, they married in a Russian Orthodox church. Apollinaire, Cocteau, and Max Jacob were witnesses, a stark illustration of the two worlds that Picasso would now straddle — the bohemian and the aristocratic. For the honeymoon, Errazuriz gave Picasso free reign of her costal villa in Biarritz on the southwest tip of France.

On Picasso's return to Paris, the dust had settled from the production of *Parade*. It had opened at the Théâtre du Châtelet, the largest playhouse in Paris, and it caused sufficient scandal to be a success. The strong Cubist costumes reminded some of the theatergoers, once again, of German villainy, and shouts arose at the start. "Go back to Berlin!" came one of many hostile harangues. "Shirkers! Draft dodgers!"[17] Famously, the oversized Apollinaire, having returned from the war front with a head wound, rose in his sky-blue uniform and bandaged head, and spoke eloquently to calm the French audience. "Without Apollinaire," Cocteau recalled, "women armed with hairpins would have gouged out our eyes." The music by Satie — an atonal cacophony, not a melody — also jarred nerves. The next day the worst reviews called Cocteau, Satie, and Picasso the three scoundrels.

Nevertheless, *Parade* went down in history as a shift in modern theater. As a wordsmith, Apollinaire would add another new term to the art

world. He wrote the program notes for *Parade*, and for lack of a better way to describe it—he first thought of calling it a "supernaturalist" play—he hit upon the neologism "*sur-realism*" (beyond realism). He thought the word worked just fine. (He soon after wrote his own comic play, subtitled "a surrealist drama.")[18]

As the playwright of *Parade*, Cocteau had its internal meaning all figured out: it was simply the story of three circus workers—an acrobat, a Chinese magician, and a young American girl—who performed on a Paris boulevard in order to lure the public into the circus. They in turn had three "managers," the villains of the piece. The managers pushed them to work hard. According to Cocteau, it was the poetic story of superficial art (the street barking) versus art's internal integrity (the show inside).[19] The symbolism eluded theatergoers. The sensory effect was what mattered.

Picasso had contributed to that by mixing his classical and Cubist themes, managers with skyscrapers on their heads and Rose period-type *saltimbanques* (acrobats). This was the mix that would follow him the rest of his career, and it would eventually produce a kind of hybrid that one day would be called full-blown Surrealism (a moniker officially adopted by a group of Paris-based poets and painters who emerged in the 1920s). For now, Picasso's experience with *Parade* acclimated him to the idea of large and complex three-dimensional projects. He would design sets for four more Diaghilev productions.[20]

By the time Picasso and Olga returned to Paris, the war was ending. The armistice was signed November 11, 1918. Two days before that, Apollinaire, weak from his injuries, died in the great 1918 influenza epidemic, a global pandemic that killed more people than the war that preceded it. France had "won," but at great cost. At the time of Apollinaire's funeral, Picasso and Olga were staying in the elegant Lutétia Hotel in Paris. By the end of the month, assisted by Picasso's new art dealer, the Frenchman Paul Rosenberg (who handled Picasso during German-born Kahnweiler's wartime absence from Paris), they had moved into a large apartment on 23 rue la Boétie. It was an elegant Right Bank neighborhood populated by dealers and galleries. Picasso also bought the apartment one floor above. That became his studio—a space in which Olga was not allowed.

After the war, the "call to order" was stated more publicly than ever before. Naturally, a number of cultural groups claimed to speak for France's "classical" tradition, some finding its roots in the south, others in the

north.[21] Even the Cubists argued that they were classical: they put rational compositions on canvas, much like the French academicians. In any case, all across Europe, Abstract art went to the wayside as more artists started doing realistic paintings.

After the bloodbaths on the Marne, the unbridled experiments of high Cubism, Orphism, and Abstract painting seemed too close to the frenzied passions of war. Braque, having recovered from his war wounds, began to paint more realistic works. Even then, a Braque exhibit of his new Cubist-realism struck friendly critics as burdened by the past: "The atmosphere is morose and heavy, like that of a Hypogeum [underground vault]."[22] A diehard Cubist like Derain now declared that, after all, Raphael of the Renaissance was "the greatest misunderstood painter."[23] Simply put, Cubism "no longer offers enough novelty or surprise to nourish a new generation," a formerly pro-Cubist poet offered.[24]

French literature had also returned to order, mostly in the mold of the Latin classical voice. None other than Apollinaire had declared the new direction. Hailing from the Mediterranean, and reveling in classical themes (even in de Sade's pornography), Apollinaire had always been a southern classicist, a lover of Italian farce, romance, and festival. He never liked Picasso's turn to primitivism. Before he died, Apollinaire had offered these apologetic lines in a 1916 poem, keen to show how the appetites of the young avant-garde must have looked:

Be indulgent when you compare us
To those who were ordered perfection
We who seek adventure in all places
We are not your enemies . . .[25]

A few months before he died, he also wrote to Picasso, "I would like to see you do some big pictures like the Poussin, something lyric."[26] A foremost advocate of the return was Cocteau, who, because of his social upbringing, retained a conservative streak. He wrote and he spoke. In Brussels, Belgium, he addressed a group on postwar arts and culture and claimed that yes, indeed, it was none other than he who had persuaded Picasso to return to classical painting. The call to order was also driven by the industrial efficiency that Europe had discovered on a war footing. Factories, bureaucracies, farms, and even urban domiciles were nothing if not vast and orderly now. Discovery of efficiency was one fruit of the

war. The vitalism of the past—whether in Bergsonian philosophy or wild atonal music—seemed naive.

In some sectors of art, the ideal of order was being emulated in new and sometimes extreme ways. The chief example was the work of Piet Mondrian, who argued for a "purity" of orderly construction. He believed that pure orderliness and a simplicity of color (black, white, red, blue, and yellow) were the highest fulfillment of composition in painting, an idea somewhat based in Theosophy, a mystical outlook on the universe that Mondrian, Kandinsky, and others drew upon to talk about aesthetics.

Kahnweiler, who had been Picasso's dealer, was also presenting some new theories. When the war had broken out, he had been on vacation in Switzerland. After seeking a brief haven in Italy, he returned to the neutral Swiss state to sit out the war—as a German he could not return to France, and as a pacifist he did not want to serve in the German army. He instead studied philosophy at the University of Bern. As a result, when he wrote his interpretive history, *The Rise of Cubism* (1920), he introduced the philosophical distinction between Cubist approaches that were "analytic" (breaking reality apart) and "synthetic" (joining disparate pieces of reality together).[27]

For Picasso, nearly all of these modern theories were irrelevant to his daily work, which had now turned toward classicism. He may have caught the classical mood and subject matter during his trip to Italy, but he also looked to the two towering French painters—Poussin and Ingres—as rivals to be surpassed. Besides his marriage, which included a new regime of social life organized by Olga, one other matter was put in order after the war. Almost by acclamation, the art establishment declared Picasso and Matisse as the masters of modern art. For the next several years, they would be put together in exhibitions, which, in the words of one catalog, placed side-by-side "the most famous representatives of the two grand opposing tendencies in great contemporary art."[28] This was good marketing, though somewhat too much for the old-fashioned Matisse, who was chagrined by the sales pitches of the modern-day galleries.

At the end of the war, Picasso was thirty-six and Matisse was forty-eight. They had seen each other more often during the war than any other time. Their rivalry remained, but their friendship also deepened. In one significant contrast, Matisse had left his long-suffering wife for a "harem" of young models, whom he lived with at his studio in the city of Nice in

southern France. By contrast, Picasso had stepped into marriage. Both of them, nonetheless, had turned their postwar attention to the sunny climes of France's southern coast.

Very soon, with Olga in tow, Picasso's primary retreat became the beach resorts on the yet-undeveloped French Riviera. He could have painted back at his large Paris studio, one flight above his opulent apartment. However, Picasso had fallen for villas on hillsides and coastlines. "I knew right away that [the] countryside was for me," he recalled.[29] The Mediterranean's bathers—baigneuses—became a topic for his attempts to combine classical drawing and painting with the exaggerations of Cubist space. A typical example was his tiny oil painting Bathers (1918). Its three women, sailboat, and lighthouse create an imaginary world of disproportioned figures, delighting in line and color, much as if Poussin or Ingres had been on hallucinogens.

Over time such bathers took on many incarnations: voluminous monuments, biomorphic creatures, insect-like stick figures. These experiments put Picasso on a gradual road to his own kind of "surrealism," a literary and art movement that would not be formed until 1924 (though Apollinaire had already coined the term on a lark in 1917). As a painter, Picasso stood in a legacy of fracturing reality, as already seen in van Gogh, Cézanne, and Matisse. Those three painters had been systematic: van Gogh used the thick curvy line; Cézanne, the short, choppy brushstroke; and Matisse a network of decorative patterns. By comparison, Picasso rearranged reality in an endlessly arbitrary fashion.[30] And for the time being, he seemed to do so while also moving within the rhetorical guidelines of postwar France, the call to order, a revival of classicism as a framework for art.

Not everyone wanted order, though. In 1916 in Zurich, a group of poets and artists who were war dissenters were trying to create an alternative world of anti-art (soon to be called Dadaism). The spirit of Dada never reached the United States with much force, since after all, American did not enter the war until the end of 1917, and it was largely isolated from Europe's travails. As seemed usual for his life, Marcel Duchamp would be caught between the experiences of Europe and those of America. He arrived in New York City in early 1915, and for him the art world was not going to be about new styles or war protests. It was simply about doing what he wanted, enjoying life, making his Large Glass, and spreading around a little blague.

9 a parisian in america

Like so many immigrants before him, Duchamp arrived in America by the narrows in the Port of New York. It was a spring-like day, June 15, 1915, and he was met at the dockside by Walter Pach, the young American artist and art dealer who had befriended him in Paris. Amid newspaper reports of the arrival, Pach gave Duchamp quick entrée in the city, which would soon enough see him headlined as the "Nude-Descending-a-Staircase Man."[1] Pach worked for the lawyer-collector John Quinn, who would help Duchamp during his first year in Manhattan. For the first few days, Pach put Duchamp up at his apartment, and then took him uptown, in effect, to Duchamp's destiny.

That destiny was the wealthy bohemian collector Walter Arensberg and his wife Louise. A Bostonian transplanted to Manhattan, Arensberg had been baptized into modern art by the Armory Show. During those Armory days in Boston, Pach had met Arensberg and spoke highly of Duchamp. Now, as New Yorkers, the Arensbergs offered their West Sixty-seventh Street address as a place for Duchamp to stay, easy enough as they spent the summer in Connecticut. Both Walter, a poet, and Louise, a musician, had ample inherited wealth, so a life of bohemian leisure and art appreciation suited them well. As fate would have it, Walter was also a chess aficionado. Duchamp's first few months in New York at their well-appointed duplex were like a dream.

After housesitting at one more apartment, Duchamp settled at the nearby Lincoln Arcade Building at 1947 Broadway, where many artists had studios, and now frequented the Arensberg home for their evening parties. At this early stage, Walter did not yet comprehend everything that Duchamp had actually imported to America—his notes, his ideas, his blague, and his *Large Glass* project. Very soon, though, Arensberg would inaugurate his lifelong support of Duchamp. It began with a deal: he would pay Duchamp's rent in New York in exchange for his *The Large Glass* when it was completed.

Arensberg had just entered his prime as an art collector. Both his

and Louise's investments—he was from a Pittsburgh steel-and-banking family and she a Boston textile fortune—were doing well. Arensberg's conversion to modern art had been total, as was his decision to join the avant-garde. In no time, he became pivotal in the story of the art salons in bohemian Manhattan. During the Armory Show era, the salon that had been dominant was photographer Alfred Stieglitz's circle, situated at his 291 Gallery (nicknamed for its Fifth Avenue address). It was a tiny center of cutting-edge artists, a group that Picabia had met in 1913, opening the way for him to illustrate covers for Stieglitz's 291 magazine.

The Stieglitz circle was not almighty, however. During the Armory, it began to be overshadowed by the more socially vibrant salon of New York heiress Mabel Dodge, a bohemian divorcee. She had arrived in New York after seven years in Florence, Italy, where she had held open house. She had also seen Gertrude Stein's social salons in Paris. "I wanted to know everybody," Dodge said of New York, "everybody wanted to know me. I wanted, in particular, to know the Heads of things, Heads of movements, Heads of Newspapers, Heads of all kinds of groups of people."[2] The Dodge salon produced America's first literary art colonies. After the seasons of parties in Manhattan, her playwright friends would head for Province-town, Massachusetts, and later to far-off New Mexico.

When the Arensbergs first arrived in Manhattan, they were drawn to a poetry salon instead, a gathering held at the Greenwich Village home of Allen and Louise Norton, small-time publishers of the poetry journal *Rogue*. There, Arensberg met writers and chess players. Through them, he began to meet practicing artists. By the time Duchamp arrived in Man-hattan, the Dodge salon—too elite for Duchamp's tastes anyway—was unraveling, but Arensberg had launched his own, just a year old and on the rise.[3]

Arensberg was an unlikely founder, and certainly no revolutionary. He was known for maintaining a rumpled appearance. He had something like an open marriage with Louise, but for his modest behaviors, he never became famous in Manhattan in the manner of the flamboyant Mabel Dodge, an active bisexual who had a celebrated fling with the crusading journalist John Reed. For altering the direction of American art, though, the group that Arensberg attracted up through 1917, the year America en-tered the First World War, was the most important of the period. With his Parisian credentials, Duchamp would be at the center of this, "the hero

of artists and intellectuals, and of the young ladies," one eyewitness said.[4] Even before Duchamp arrived, others from Paris had hit the Manhattan shores, including Picabia and his wife, Gabrielle. Picabia had been assigned to a French economic mission in New York related to Cuban trade (since Picabia's father was Cuban, his mother French), a duty that he skipped out on (and then was dismissed from, on mental health grounds).

If Picabia had been the center of attention during the Armory Show, he was now eclipsed by Duchamp. Any expatriate from Europe, meanwhile, was welcomed at the Arensberg salon, a place where artists and hangers-on were experiencing something like the Roaring Twenties before its actual time. "No sooner had we arrived in New York than we became part of a motley international band which turned night into day . . . living in an inconceivable orgy of sexuality, jazz, and alcohol," wrote Gabrielle Buffet-Picabia, who chronicled the period.[5]

To reach the Arensberg festivities, visitors entered the West Sixty-seventh Street building's Gothic edifice, traversed a marble lobby, past a porter in uniform, and took the elevator to the third floor. The apartment had a high-ceilinged study and dining room, and above that, two large bedrooms. The walk from the Lincoln Arcade Building was short, so Duchamp arrived nearly every day. Duchamp felt right at home. When he had first arrived, the Arensberg apartment already featured sculptures by Brancusi and paintings by Matisse, Gleizes, and Jacques Villon. The parties started in late evening. At midnight they were given a burst of new energy when chocolate pastry and more whiskey were served.

Besides art, sex, and alcohol, the other international language at the Arensberg parties was chess. Arensberg himself had been captain of the Harvard chess team in his student days. No matter how raucous things became, there was always a chess game going on in the corner of the Arensbergs' apartment, often with Duchamp at the board. Frequently, after everyone left, Duchamp and Arensberg would play chess until daybreak. Their minds thought alike, and that included a poetic sense as well.

Later in life, Duchamp would struggle to explain how chess, which is orderly, can be like the chaotic, indifferent elements of art and poetry. Try as he might, he was unable to make a plausible and clear connection. So Duchamp finally described chess not as a visual thing, but something like poetry, word-objects that are moved around in various relations. Chess had its firm structure, to be sure, and like any chess player, Duchamp

thought in terms of opening moves, the next strategies that marked the middle of the game, and then the end game, a period of intense thinking when the last pieces on the board amounted to the final field armies of each player. Duchamp would often say chess was more an art than a science, but then he would say the opposite as well.

In the future, whenever people asked Duchamp for public comments on chess, he was asked as an artist (not as a chess instructor, for example). His responses were pithy but nebulous. They pointed to the inherent difficulty in trying to make chess into something more than what it is: a logical game that relies on memory and a focused temperament. Even Duchamp-the-artist immensely enjoyed the logic, the precision, and the competition; his passion for chess showed that gamesmanship was an elemental aspect of his character.

Whereas Duchamp's French personality became a favorite topic in Manhattan bohemia, Arensberg did not have to explain much about himself. Though a failed poet, he had mastered it academically. At his Cambridge home, he had translated French poetry by Laforgue, Verlaine, and Mallarmé into English. Then he moved on to theories of language, including the idea of secret codes existing in classical works, which surely tantalized Duchamp.[6]

As with the Dodge salon, the Arensberg salon also branched out beyond Manhattan. Arensberg came in contact with a three-man "colony" of artists, some of whom were working in New York, who had settled in Ridgefield, New Jersey, a ferry ride across the Hudson River. One day in September 1915, Arensberg took Duchamp there, and it was then that Duchamp met Emmanuel Radnitzky, a man three years his junior, by now having taken the name Man Ray. Duchamp did not speak a word of English, but he and the American-born Ray developed a special bond. As they batted a tennis ball back and forth on a lawn, Duchamp generally said yes to whatever Ray would say. Like Arensberg and Duchamp, Ray also liked to play chess. Ray's first wife, from 1914, was Belgian, a French-speaking free spirit who introduced him to the Paris avant-garde, a love of ribaldry, and the absurdity that grew from French poetry (Apollinaire's, if not quite Alfred Jarry's).[7]

Before Duchamp arrived in Manhattan, Pach had taken seriously his note that he'd like to work in a library. Quinn, the lawyer, got Duchamp a job interview at the Morgan Library. Nothing came of it, but by October,

Quinn had angled Duchamp a position, working from two in the afternoon to six in the evening, at the Institut Français. "My hope is surpassed," Duchamp wrote Quinn in gratitude. "I will have the entire freedom I need."[8] The freedom would be devoted mostly to his social life, but second of all — in terms of time and energy — was his production of *The Large Glass*. One day, finally, Duchamp went out and ordered two panes of glass. When joined, they would produce an object 9 feet high by 5½ feet wide. They were delivered to his Lincoln Arcade Building studio. He set them flat, about waist-high, on sawhorses.

When Man Ray finally visited Duchamp's studio, he remarked at its barren, dusty, ambiance. He said the room looked "abandoned." A sink and plumbing were against one wall with a pipe running to a bathtub in the middle of the room. Duchamp had hung a few of Jacques's paintings, and one of his own drawings, but otherwise, Ray recounts, "The floor was littered with crumpled newspapers and rubbish." A single light bulb lit the room. That is probably why, last of all, Ray noticed in a corner a large piece of thick glass "covered with intricate patterns laid out in fine lead wire." On the wall next to it hung Duchamp's diagrammatic sketch for *The Large Glass*, filled with "precise drawings . . . symbols and references."[9]

Ray's visit had come in fall of 1916, which suggests that Duchamp was taking a while to get settled in New York as an artist. Four months after arriving, Duchamp told a New York reporter, "I am very happy here. . . . I have not painted a single picture since coming over."[10] Six months after arriving, he wrote Quinn to reassure him that, in effect, he was "working hard" on art. He added the fib that "I have almost finished the big glass you have seen when I began it."[11] For now, though, Duchamp was mostly working on his social life. *The Large Glass* would be "completed," but that would be in seven more years.

In New York, Duchamp found the same kind of patron-artist hierarchy that had eluded him in Paris, but which now materialized in Quinn, Arensberg, and others. "Helping artists was a virtue for rich people," Duchamp said later in life.[12] With such help he could continue in the only life that he knew, the bohemian life. Still, Duchamp would prove to be an adept entrepreneur when opportunities arose. Soon after arriving in Manhattan, many of the ladies he met in the Arensberg circle asked him to teach them French, especially young women of wealth and leisure.

In addition to his gift for wit and blague, and his Norman good looks, Duchamp had a gift for language. His English improved very quickly. A day would come when he was perhaps the most fluent English-speaking French artist between the two continents.

The lessons (which cut short his job at the Institut Français) linked him to one entire household in particular. A year into his American sojourn, Duchamp was teaching French to the three sisters of the Stettheimer household, a wealthy German Jewish family, in New York. The sisters—Carrie, Florine, and Ettie, from oldest to youngest—were bright and precocious; Florine became an artist, and Ettie, with a doctorate in philosophy from Heidelberg University, a novelist. None of the three married, and while Florine painted an homage to Duchamp, it was Ettie (thirteen years older than Duchamp) who openly flirted with him, but went only as far as putting a character like him in her novel, *Love Days*. The cultured sisters (who already spoke French) paid Duchamp two dollars an hour for the French lessons, a very good fee; his monthly rent was thirty-five dollars, and Arensberg was already handling that.

WHEN DUCHAMP TOLD the reporter in fall 1916 that he had "not painted a single picture since coming over," he remained true to his word for a long time coming—except for one brief relapse.

In New York, Duchamp would meet another significant patron in his life, the modern art collector and advocate Katherine Dreier. From her estate in Redding, Connecticut, Dreier had traveled to study in Europe. She became a painter herself, and early on bought works by van Gogh and others. As a single, educated woman of means, Dreier devoted her life to beneficent social reform, and at the head of that parade was modern art, "an uplifting and moral force in society."[13]

Dreier, too, had been inspired by the Armory Show, and now she was in the presence of the famous Duchamp, artist of *Nude Descending a Staircase*. Dreier was a good-hearted, natural-born organizer, but ultimately a somewhat homely spinster. She had the private funds necessary to do what she liked. In Duchamp, she found not only a sophisticated French protégé, but, in effect, a son (and perhaps an imaginary beau). She asked him to do a painting for her to fit a long horizontal space in her library (to be titled *Tu m'*, and now a prize of the Yale University Art Gallery). Duchamp complied, and the painting, done in 1918, was indeed his very last.

Like Arensberg, Dreier would also become fascinated by his *Large Glass* (the two of them would, alternately, own the work).

With *The Large Glass* project, Duchamp was becoming more of a crafts-man and engineer than a painter. The machine aesthetic was on the rise in New York. Duchamp was working on his *Large Glass*'s machinery, a Rube Goldberg–style sex machine. Then when Picabia had returned to New York, he also began to draw machines, sometime as allegories of friends (Stieglitz was drawn as a camera; a female collector as a spark plug). "The machine has become something more than a mere appendix to life," Pica-bia told the *New York Tribune* when, soon after Duchamp's arrival they were featured as "French artists" spurring on American art. "[The ma-chine] has come to form an authentic part of human existence," Picabia said.[14]

The machine was just one piece in a larger concatenation that would shape Duchamp's next moves as an artist. All around him the new aes-thetic was about photographs of objects and the new poetry, which *à la* Gertrude Stein and others, was about word-objects. A mere object—and any would do—could be photographed and called fine art, as Stieglitz had shown. A poem, by the same token, could be simply a string of words about objects. This was the modernist poetry advanced by Stein in Paris, Ezra Pound in London, and William Carlos Williams in the Arensberg cir-cle: the focus was on objects, particulars, not the big ideas, symbols, sen-timents, or themes of past verse. As Pound said, "Direct treatment of the 'thing.'" Besides chess, this modernist view of language was the intellec-tual content of the otherwise hedonist Arensberg salon: the group was in-terested in linguistic games, puns, and "little magazines."[15]

Although "art" was the target of this new "modernist" attitude, the out-look's rejection of all aesthetics of the past, and its elevation of banal ob-jects, made it a kind of anti-art as well. Staying on message, Duchamp aimed his anti-art statements at painting. A 1915 headline in *Arts and Dec-oration* picked up the irony of a French painter talking this way: "A Com-plete Reversal of Art Opinion by Marcel Duchamp, Iconoclast."[16] The ever-perceptive Gabrielle Buffet-Picabia, looking back on the period, said that Picabia and Duchamp "pursued the disintegration of the concept of art, substituting a personal dynamism . . . for the codified values of formal Beauty."[17] This personal dynamism produced the twentieth-century artist as a person who is famous for being famous. This artist was more like a

Tarot card reader or swami, welcomed at the bohemian salons of upper-class women, whether in London, Paris, or Manhattan.

In this role, Picabia would soon recede from the New York scene. He was medically discharged from wartime duty — probably because of a nervous breakdown. Still independently wealthy, he left for Barcelona, the other city where artists in France had gathered to wait out the war. In that city, Picabia published his own anti-art magazine, titled 391: He was picking up where Stieglitz's moribund 291 magazine had left off. For the next decade, Picabia made some art, but he used it mostly in tandem with his attacks on whomever and whatever he disliked, liberally expressed in his many self-funded publications.

In Picabia's absence, three others became Duchamp's best friends in New York. They were Man Ray and two Frenchmen, the Swiss-born artist Jean Crotti and the writer Henri-Pierre Roché. Roché, who was emerging as a novelist, was a ladies man foremost. He had several affairs in New 'York, and, thanks to his memoirs, we know that Duchamp did also. One of their shared lovers was the young San Francisco girl Beatrice Wood, who fell in love with both of them, but connected first with Roché. When he left, she slept with Duchamp. Young and precocious, Wood — like Roché — became a memoirist. She left behind the best account the high times of the Arensberg circle.[18] That left Crotti and Ray as Duchamp's chief co-conspirators in art.

For a time, Crotti lived with Duchamp at the Lincoln Arcade Building, after which Arensberg would rent an apartment for Duchamp just above his own. One day in later 1915, as Duchamp and Crotti walked down Broadway, they entered a hardware store. For the first time in their lives, they saw a snow shovel. Duchamp bought it, and Crotti carried it home on his shoulder. At some point, Duchamp painted the words "In Advance of the Broken Arm" on the shovel, and added his name, much as he painted small-print, enigmatic titles on the front of his paintings. Such titles, he knew well, changed the context of an object; at the least, they had fun with the viewer; and the more enigmatic the title, the better the blague. Then Duchamp hung the shovel by a wire from the ceiling.

Years later, Duchamp would interpret the shovel incident as part of his revolutionary idea of the readymade. Actually, in 1915, he did not seem quite so sure about his goals. His earliest approach to the philosophical aspect of the readymade was his cryptic note of 1913: "Can one make works

which are not works of art?" After arriving in New York, he did not necessarily need the idea of the "readymade" to do what everyone else was doing: incorporating banal objects into "art," and turning fine art on its head by new uses of poetry, jokes, photos, and cartoons. As 1915 passed, he began to think again about his bicycle wheel and bottle rack in Paris, and how, as ordinary mass-produced objects, they might also be counted as fine art, or a new anti-art. Then in January 1916, it dawned on him: these two objects could be a way to redefine, or undermine, art itself.

Quickly he wrote his sister Suzanne in Paris. He asked her to go get (and save) the two items. He explained, somewhat ingenuously, that he had in fact purchased the bottle rack "as a sculpture already made":

And I have a plan concerning this so-called bottle rack. Listen to this: here in N.Y., I bought various objects in the same taste and I treat them as "readymades." You know enough English to understand the meaning of "ready-made" that I give these objects. I sign them and think of an inscription for them in English. I'll give you a few examples: I have, for example, a large snow shovel on which I have inscribed at the bottom: *In advance of the broken arm*, French translation: *En avance du bras cassé*. Don't tear your hair out trying to understand this in the Romantic or Impressionist or Cubist sense — it has nothing to do with all that. . . . This long preamble just to say: take this bottle rack for yourself. I'm making it a "Ready-made" remotely. You are to inscribe it at the bottom and on the inside of the bottom circle, in small letters painted with a brush in oil, silver white color, with an inscription which I will give you herewith, and then sign it, in the same handwriting, as follows: [after] Marcel Duchamp.[19]

With this, six months after arriving in New York, Duchamp had formally invented the readymade — a term he always used in English. He had launched a truly great bifurcation in modern art. This was a chasm not just between two styles, but in the question of art and anti-art. He later said that readymades were no less than "a form of denying the possibility of defining art."[20] The chasm was a mind game, to be sure. On one side of the chasm stood Duchamp. On the other side, Picasso and Matisse held their ground, looking a bit old-fashioned with their canvases and oil paint.

As a mind game, as well, the idea of the readymade was going to take time to move beyond the musings of Duchamp and become a topic of in-

terest to the wider art world. For the time being, something like the ready-made was akin to Alfred Jarry's 'pataphysics, a clever and absurd idea, but hardly an art theory being considered in art academies (although Jarry's ideas would soon give rise to an official Theater of the Absurd in Paris). For the visual arts, a serious theory of modern art had just been hatched a year before Duchamp bought the shovel. In 1914, the British critic Clive Bell proposed the concept of "significant form," a universal measure of what made a painting, whether traditional or modern, successful in the deepest possible way.

The idea that Duchamp's readymade would one day rival "significant form"—and the entire modern art approach of "formal analysis"—for preeminence could hardly have been imagined in 1915, when Duchamp was putting his artist's signature on such everyday objects. But strangely enough, that day would come. In many ways, the chasm between significant form and the readymade would define modern art at the end of the twentieth century, creating a Grand Canyon of sorts, a chasm dividing modern art from "postmodern" art, with Picasso standing on one side and Duchamp on the other.

For the time being, the idea of the readymade was born in very inconspicuous circumstances. Duchamp had first shared his idea with his sister, perhaps discussed it with Crotti, his roommate, and began to share it with Arensberg and his circle. For their party life in Manhattan, the readymade exploits were cheerful blagues, jokes on serious painting, artists, and art. In time, Duchamp would intellectualize the readymade: he would make it an equally serious philosophy, according to some. For now, fun was good enough.

In Manhattan he began to sign other things. One night at dinner with his Arensberg circle friends, he scribbled his name on a large painting in an upscale restaurant. He told the poetess Louise Norton, soon to be his blaguing co-conspirator, that he would like to turn the gargantuan Woolworth Building into a readymade; he had only to sign it.

For the next three years, Duchamp bought, found, or made similarly mundane objects and added them to his repertoire. This bland repertoire could not possibly merit media attention, but as the famed Frenchman behind *Nude Descending a Staircase*, the newspapers and galleries were always looking him up anyway. Two Manhattan galleries, Bourgeois and the Montross, asked Duchamp for artworks to display and sell. For these

spring 1916 shows, he also offered some new readymades, requiring Bourgoise to accept them if they wanted other Duchamps.

Readymades could be ephemeral things: a shovel, a comb, a coat rack, a plastic typewriter cover. They were hard to remember. No one is quite sure which ones showed at the Montross and Bourgeois, for instance.[21] At the time, the shows themselves prompted news coverage. The *Evening World* sent a writer to interview Duchamp and Crotti at their flat, where the conversation at one point turned to the shovel hanging from the ceiling. An *Evening World* sub-headline, "Big, Shiny Shovel is the Most Beautiful Thing He Has Ever Seen," would quote Crotti, who had charmed and blagued the reporter.[22] Nowhere did the April 4, 1916, article explain the "readymade" concept, so probably Duchamp had not revealed its subversive power. That would come next.

AS THE EUROPEAN CONFLICT still seemed far removed from America, the progressive artists of New York, with memories of the Armory Show, decided to form another artists' association. In late 1916 they formed the Society of Independent Artists, Inc. They planned a great art exhibition for the next year, in April 1917, at the Grand Palace Building in Manhattan.[23] They modeled it on Paris's springtime Salon des Indépendants, which, by rejecting the jury system, the American organizers said, had "done more for the advance of French art than any other institution of its period."[24]

There were twenty founding members of the society, mostly American painters of the so-called "Ashcan" school, but also including Marcel Duchamp. The names of Picabia, Albert Gleizes, and Jacques Villon (in absentia) were also added to give a European flair to the launch. By turning to Duchamp, the society also linked up with Arensberg, a man of wealth and enthusiasm, a gatherer of artists, and a collector. Another enthusiast, Katherine Dreier, was recruited to head public education for the exhibition.

The society bylaws said that "any artist" could be a member and exhibit by paying a one-dollar initiation fee and five dollars for annual membership. In effect, that was six dollars to exhibit two paintings. With generous fanfare, the public was invited to submit its art. Not a few newspapers joked about how now, for six dollars, anyone could be an "artist." While the Society of Independent Artists could not control the quality of the

submissions, it could at least try to make the exhibit space look very good. So its officers made Duchamp, an observer of Paris salons, president of the hanging committee. Not all the founding artists agreed with the "no jury" tradition, but at this juncture there was no going back. Additionally, Duchamp had added another rule to further democratize the show: "Hung in Alphabetical Order."

In Paris, the democracy of the Salon des Indépendants had often produced humorous outcomes — variations on blague. The painting by a donkey tail was the most famous, but often enough pranksters would submit things like a chamber pot as a sculpture, not as a philosophical statement, but simply as a joke. Once, when Cézanne was asked what he would submit to the next salon, in a tone of sarcasm, following in his usual curmudgeonly kind of response, he said, "A pot of shit!"[25] For the 1917 show in New York, none of the society organizers had raised the specter of joke submissions. During organizational meetings, Duchamp apparently did not inform anyone of the long history in Paris of such shenanigans, brought on by jury-free shows. If something happened in New York, the society would have to play it by ear.

As the day of the New York event approached, the response was overwhelming. The society exhibition would be the largest gathering of art in the nation's history, admittedly of very mixed quality. Indeed, someone did submit a chamber pot, empty and clean (and one member of the executive committee, the painter William Glackens, "accidentally" dropped it, whereupon it broke to pieces).[26]

Duchamp was busy, right at the center of things, overseeing the hanging of the entire show. The paintings hung on endless partitions that ran between the great white columns of the massive hall. Duchamp paced off the aisles and estimated that the exhibit of 2,125 works by twelve hundred artists amounted to more than two miles of art. After hours, Duchamp relaxed, imbibed, consorted, and played chess with his closest circle of friends — Arensberg, Ray, Roché, Wood, and Louise Norton. At one point Duchamp had an idea, and most of his circle was in on it. Duchamp would never explain his motives, whether he was mounting a chessboard-like attack on the art world, or just instigating an old-fashioned Paris blague. He spoke only with his actions.

A day or two before the exhibition opened, a delivery truck pulled up at the Grand Palace Building, and its driver carried in a heavy object for

submission, along with the application form and six dollars, all signed by "R. Mutt" of Philadelphia. It was a white porcelain urinal, and the form showed that it was titled *Fountain*. The "R. Mutt" signature on the urinal was placed in such a way that it had to be displayed on its back (not as it would hang on a bathroom wall). In the flurry of final arrangements, the painters on the head committee saw it as a hoax. Then, Arensberg conveniently arrived. He furiously argued with the painter Rockwell Kent over admission of the urinal. Suddenly, too, the young Beatrice Wood came upon the scene, and this is what she claimed to hear:

> "This is indecent!" said Kent.
>
> "That depends on the point of view," Arensberg replied.
>
> "There is such a thing as decency, an end to how far a person can go."
>
> Arensberg said, "But the purpose of this project is to accept anything an artist chooses. It is in our bylaws."
>
> "Do you mean that if a man chose to exhibit horse manure we would have to accept it!"
>
> "I'm afraid we would."
>
> "Someone has sent it as a joke," Kent said of the urinal.
>
> "Or a test," said Arensberg.[27]

In her memoirs, Wood gave two different accounts, both well crafted since she had been in on the secret: the secret was that Duchamp had submitted the urinal, and Arensberg was chief co-conspirator. Remarkably, the secret of the subterfuge was kept until years after, shrouding the event in much mystery (and reams of scholarly speculation).

The society elders could not outright reject it (or break it), so the bathroom appliance was simply placed behind a curtain. Appalled at the anti-democratic move, Duchamp and Arensberg resigned (and probably told the newspapers). As Duchamp wrote his sister Suzanne, "I handed in my resignation and it'll be a juicy bit of gossip in New York. I felt like organizing a special exhibition for things refused at the Independents, but that would be a pleonasm! [i.e. tautology] And the urinal would have been lonely."[28] The writer Louise Norton, a Duchamp confidant, hinted at his motives when she wrote, "There is among us today a spirit of 'blague' arising out of the [urinal] artist's bitter vision of an over-institutionalized world of stagnant statistics and ancient axioms."[29]

The gossip did spread, but only a little. Newspapers reported Duchamp's resignation. Newspaper etiquette required that the urinal be called "a bathroom fixture" or "a familiar article bathroom furniture"; some of the public may have thought it was a toilet. The society's executive committee, too, was thrown into tizzy. Dreier, who admired young Duchamp, was particularly upset at his resignation. She had cast her vote against accepting the urinal because it lacked the basic criterion of "originality." She believed it was Mr. Mutt's hoax. Poor Duchamp was the victim. As head of public education, she had recommended that the society invite Mr. Mutt to New York to answer for his "bravado"; Duchamp could present his case as well! After talking with Arensberg, Dreier wrote Duchamp, trying to persuade him not to resign. In all sincerity, she wrote:

> It was simply a question of whether a person has a right to buy a ready-made object and show it with their name attached at an exhibition? Arensberg tells me that that was in accord with you [sic] "Readymades," and I told him that was a new thought to me, as the only "readymades" I saw [at Duchamp's apartment] were groups that were extremely original in their handling. I did not know that you had conceived of single objects [as readymades].[30]

Dreier, innocent of all the blague, remained loyal to Duchamp. She stayed unflappable as one absurdity led to the next. As head of public education, she supported Duchamp and Arensberg when they organized a public lecture on "The Independent Artists in France and America." For this, they brought in the rabble-rousing poet and boxer Arthur Cravan, a crony who had lived in Paris, where he made his outrageous reputation. The event convened. On arrival, Cravan mounted the stage dead drunk. As he took off his clothes, he hurled verbal insults at the audience. The police arrived. Duchamp did not see a problem. This was the spirit of blague: "What a wonderful lecture," he said.[31] Arensberg paid Cravan's bail.

From the day the Mutt urinal arrived, the Society of Independent Artists was in a bind: how could it reject anything? Its president ruled that it was disqualified by insufficient information on Mutt's submission form. The urinal was not "sent back," but put aside. Soon, Arensberg or Wood retrieved it. Now, the idea was to document it as art. Man Ray could have taken a photo of the urinal. Instead they took it to Stieglitz, the grand old man of art. They told him that the work had been censored. No more

informed than Dreier, Stieglitz sympathized with poor Mr. Mutt. He took a quality fine-art photograph of the urinal. He also signed the photo. This became the image that put the porcelain object—which Louise Norton called "the Buddha of the Bathroom"—in art history.

In the meantime, the dispute failed to generate the newspaper publicity Duchamp et al. had hoped for. So Duchamp, Wood, and Roché put out their own publicity sheet, *The Blind Man*. The first issue was dated for the exhibition opening. It did not mention the urinal. A few weeks later, as the exhibition continued, they put out the second (and last) issue of *The Blind Man*. The publication was mostly a review of "The Richard Mutt Case," as an editorial headlined. The editorial, probably written by Duchamp, rejected the "grounds" on which Mr. Mutt's urinal had been rejected: that it was supposedly immoral, or that Mr. Mutt did not make it with his own hands. "He CHOSE it," the editorial (i.e., Duchamp) said. "He took an ordinary article of life, placed it so that its useful significance disappeared under the new title and point of view—created a new thought for that object."[32]

Here, in a few short words, was the manifesto of Duchamp's readymade revolution.

Hardly anyone noticed. It was well worth some fun around the Arensberg salon, but that was all. The power of the idea had to grow over time. The idea of the readymade also became more complex and, as Duchamp conceded in old age, very nebulous indeed.

———

THE SECOND ISSUE of *The Blind Man* was illustrated on the cover by a Duchamp work of art, the *Chocolate Grinder* image, which pointed back to Duchamp's *Large Glass*, which had mostly been gathering dust in his Lincoln Arcade apartment. Back in October 1916, after Duchamp had lived in the Arcade Building for a year, Arensberg rented him the suite above his own apartment, and Duchamp, with the help of movers, transferred the giant plates of glass to their new home. This became the studio of much more renown, since Henri-Pierre Roché took photos of it sometime between 1916 and 1918. The change in residence also made it as convenient as possible for Duchamp to attend the Arensberg parties, just downstairs, and expand his social contacts in New York City.

By spring of 1917, the *Fountain* would have its moment of fame, but *The Large Glass* continued to enjoy virtual anonymity for many more years.

Duchamp's title for the project, chosen before he left Paris, was *The Bride Stripped Bare by Her Bachelors, Even* — a fairly helpful title compared to his readymades. At its most simple, the top half of the tall rectangle showed the mechanism and processes of "the Bride." The bottom half showed the mechanism and processes of "the Bachelors." As one of his notations said:

2 principle elements: 1. Bride
 2. Bachelors

Graphic arrangement.
a long canvas, upright. [he later chose glass]
Bride above — bachelors below.[33]

By this arrangement, Duchamp finally tried to "paint" the fourth dimension. He realized this was impossible, actually, but he could do it symbolically. To establish the three dimensions of traditional perspective, Duchamp designed all of the "bachelor mechanisms" in the lower half of the glass in precise linear perspective, with the vanishing point at the dead center of the entire glass. "For me," he said, "perspective became absolutely scientific."[34]

These lower drawings showed the mind of an engineer. In the upper half, the bride mechanism lacked perspective; her shapes were flat, organic, distinguished only by being larger or smaller. By this arrangement, Duchamp suggested that the bride was in the fourth dimension, suitable for what he called "the halo of the bride, the sum total of her splendid vibrations . . . the elements of this blossoming, elements of the sexual life imagined by her the bride-desiring."[35]

While the problem of painting the fourth dimension would forever elude art, Duchamp had intellectualized it in the upper half of the glass. He otherwise balanced the work in a traditional format: heavy below, light above. The "bachelor machine" was an architectural base, the bride above a "sort of apotheosis of virginity."[36] Duchamp presented both the bride and the bachelors as complex mechanisms. As an entire composition, the glass was no doubt allegorical as well — perhaps an allegorical story of the Virgin Mary, or of a country fair's bride-and-bachelor game or, more simply, a good old-fashioned story of bachelor lust.[37]

Whatever the case (and Duchamp remained vague), Duchamp made the "bachelor apparatus" far more complex than the bride, who was likened

to an automobile engine that runs on "love gasoline." By comparison, the bachelors play their part through two dozen mechanisms. All of them had one goal: for the bachelors to express their biological desire for the bride.

Put together, the allegory and the mechanism produced a kind of plot, much as a Rube Goldberg machine, step by step, opened a can of beans or lit a cigar. The plot of *The Bride Stripped Bare by the Bachelors*, however, exceeded all comic strips in its sexually evocative storyline. Once upon a time, the bachelors had stripped the bride naked, and she, too, had become naked in her imagination, awaiting orgasm. Aroused, the bachelors masturbated. Their liquid attempted to cross the sex barrier. Despite that effort, the bride and bachelors remained isolated. The consummation of love was frustrated. Each bachelor continued his futile activity, which Duchamp coyly described as "grind[ing] his own chocolate."[38]

Duchamp himself never wrote this down with narrative clarity. Duchamp would say that the notes and *The Large Glass* had to go together to be a complete package, though he never organized them in a such a helpful way. By comparison, such idols of his as Jarry or Roussel had used lucid prose to explain the functions and consequences of their devices. Even more so, Rube Goldberg laid out the flow of countless hilarious actions with crystal clarity. By contrast, Duchamp's "playful physics" remained inexplicably abstruse. The *Large Glass* story has no clear order of events, no beginning or end. Later in life, Duchamp seemed to say thank you to academics (who probed the glass to earn art history degrees) for making sense of it for him.

Duchamp's goal was playful physics, and play he did. With abandon, he randomly inserted in his notes for *The Large Glass* myriad scientific terms and devices he'd seen in museums and in popular science magazines. Expressing Duchamp's profligate thoughts, his notes ranged over pistons, cylinders, machines, clocks, magnetos, sieves, rods, tubes, compressors, runners, hooks, cogwheels, parabolas, funnels, and pumps. He added in laws, units of length, electricity, gravity, lubricants, molecules, oscillating density, illuminating gas, infinite surfaces, rectilinear angles, and the "elemental parallelism" of a body (also known as a "demultiplied body"). As an aside, he thought about cannibalizing a dictionary, collecting random words "for the written part of the glass," and then moved on to meteorology, agriculture, mathematical duration, and the third, fourth, and fifth

dimensions.[39] He cited Pascal Jouffret and Henri Poincaré as his mathematical authorities.

For an innocent viewer, who might have stumbled upon the entire *Large Glass* project one day, the Duchamp biographer Calvin Tomkins has provided a most helpful analogy. Tomkins likens *The Large Glass* to James Joyce's nearly-impossible-to-read *Finnegan's Wake*. Both works are unique, in a class of their own. As "literary" works—works that require outside expert explanations—each is also inexplicable (or perhaps undecipherable). Only a general impression can be taken away. Once a cognoscenti states the story line of the *Large Glass*, the innocent viewer might also conclude that, whatever it all meant, Duchamp, in his early twenties, was thinking a lot about sex.

For all the formulas, big words and musings in his notes for *The Large Glass*, Duchamp still had to produce the physical thing itself. For this task, his skill as a draftsman quickly outstripped his intellectual coherence. He used rulers, measurements, and compasses to sketch out the blueprint for putting his mediums—wire, varnish, mirroring, oil paint, and drilled holes—on the glass. By using mechanical drawing, Duchamp wanted to show that he was "indifferent" to the normal artistic ego of oil painting, in which the "paw," or style, was overly important. As one of Duchamp's cryptic notes explained: "Painting of precision, and beauty of indifference."[40]

Duchamp might have completed *The Large Glass* in a year, more or less. The incentives were few, however (even though Arensberg had paid for it). He arrived in New York with the blueprint drawings. Finding the right materials posed some challenges. He first tried etching the glass with acid, but that was dangerous and toxic. He finally settled on gluing down lead wire as the best way to create the line drawing on the glass. This was precise and tedious work. For one element in the lower half, Duchamp had an outside expert apply a perfect oval of mirror-silver, and then Duchamp scratched it to produce a highly precise series of oval lines. Visiting one day, Man Ray cringed at the tedium.

"There might be a photographic process that would expedite matters," he said to Duchamp.

"Yes, perhaps in the future photography would replace all art," Duchamp replied.[41]

During the first year on the project, Duchamp did the more irregular bride shapes: the upper half of the glass. One of the bride shapes was taken from his painting *The Bride* (1912), a kind of sinewy, bent tendril shape. In the bachelors' bottom half of the glass, the mechanisms were highly precise: the bachelor molds, a sliding gurney, the chocolate grinder, a series of conical sieves, an eye chart. Duchamp worked on the bottom part from 1916 to 1917, he recalled: "It took so long because I could never work more than two hours a day." Nor did he work every day; the project could be left fallow for weeks at a time. When *The Large Glass* was "completed," it did not match everything in the original blueprint. The project dragged on.

> You see, it interested me, but not enough to be *eager* to finish it. I'm lazy, don't forget. Besides, I didn't have any intention to show or to sell it at that time. I was just doing it, that was my life. And when I wanted to work on it I did, and other times I would go out and enjoy America. It was my first visit, remember, and I had to see America as much as I had to work on my *Glass*.[42]

Duchamp was going on three years in America. Some of the excitement had died down. He'd seen the parties, met ladies teaching French, and not only encountered American artists but "threw . . . the urinal into their faces as a challenge," as he said.[43] *The Large Glass* was there as a backup whenever there was nothing else to do.

Then there was chess.

A year after he had arrived in New York, Duchamp joined the newly formed Marshall Chess Club, founded in 1915 by the US chess champion Frank Marshall. The club met at midtown Manhattan cafes, imitating what Marshall had seen in Europe. It was a place where young players could improve their game and, in Marshall's ambition, when it finally got a building in Greenwich Village, could rival the fusty Manhattan Chess Club. Duchamp also played chess with Man Ray, who had become his most regular companion. Duchamp's real happiness in life began to orbit around the chessboard, not *The Large Glass* or the *Fountain*.

LIFE FOR EVERYONE changed dramatically in 1917 when the United States joined the war. The American government forged an agreement with France that made Duchamp eligible again for conscription.

The United States entered the war on April 6, 1917, and in May the US

Congress passed a compulsory draft law for anyone ages twenty-one to thirty-one, which would include Duchamp: age thirty and a bachelor. In October 1917, Duchamp was summoned to work as secretary to a captain at the French Mission in New York. But his heart was not in it; he had fled France "basically for lack of militarism," he later recalled, and now in America he faced the rise of "American patriotism, which certainly was worse."[44] So he made plans to leave. He set his sights on someplace European enough to get by. Such a place was Buenos Aires, Argentina.

Naturally enough, if Duchamp did not like war, he had no qualms with vying women, several of whom competed for his attention. One Stettheimer sister did paintings about him. Another used him as a character in her novel. He would be a central figure in the memoirs of Wood and Gabrielle Buffet-Picabia. Meanwhile, in Katherine Dreier's eyes, Duchamp could do no wrong. She was probably the first to suggest that he was like Leonard da Vinci, and she professed his "absolute sincerity" during the Mutt affair; his artistic tolerance was "the guarantee of his real bigness."[45] She never quite got his French blague, however. When Duchamp made her the 1918 painting, he titled it *Tu m'*, which in French elided into a pun (*Tu m'emmerdes*; "You're a pain in the ass"). The French jokes continued to escape Dreier, a woman of serious Germanic genealogy.

The next woman in line would be Yvonne Crotti, former wife of Duchamp's artist friend Jean Crotti. At the outset of the war in Europe, Jean and Yvonne Crotti had gone to America. As a Swiss, he was exempt from military duty. When the Crottis returned to France in 1916, he carried letters from Duchamp to his sister, Suzanne. By and by, Jean Crotti and Suzanne fell in love, so Yvonne ended up a divorcee back in New York, where she became Marcel Duchamp's mistress. When he booked his steamship ticket to Argentina, she did likewise. They caught the USS *Crofton Hall* in mid-August. The ocean trip was dark and stuffy—submarines prowled the Atlantic—but nevertheless it was a "delightful voyage," Duchamp wrote the Stettheimers. To Arensberg (who had put *The Large Glass* in storage), Duchamp wrote that while ocean bound he was "working on my papers [notes of *The Large Glass*], sorting them out. . . . Not seasick yet."[46] The ship reached Buenos Aires by the broad Rio de la Plata in mid-September.

On the French front the war was pushing itself to exhaustion. Then, on October 7, Duchamp's brother Raymond died of illness contracted

during his medical duties. Tragically, this was only a month before the November 8, 1918, armistice was signed. There was little Duchamp could do but write condolence letters to his family. He and Yvonne rented a small apartment in Buenos Aires. Despite the poverty and distasteful machismo that dominated Argentine life, Duchamp wrote Arensberg, "You can smell peace here and it's a joy to breathe it in."[47] Life was soon full of surprises for Duchamp. A week after he landed, Katherine Dreier showed up in Buenos Aires. She had come, she explained, to write an article on the liberation of women in backward Argentine society.

Duchamp quickly occupied himself away from the ladies. He set up a studio, did an experiment on glass for one part of *The Large Glass*, and with thoughts of being a long-time resident, seriously considered the "market" for Parisian art in Argentina. He remained a loyal pen pal with everyone, writing the Stettheimers that Buenos Aires was "just a large provincial town full of very rich people with absolutely no taste, and everything bought in Europe."[48]

Buenos Aires was not without its happy discoveries. One of them was a theater that showed imported Charlie Chaplain movies. Duchamp went often, and may have seen Chaplin's silent comedy *A Woman* (1915). In the film, Chaplin cross-dressed like a woman — in fur collar, eye makeup, and hat — to escape being caught in apparent *flagrante delicto*. Watching the film, Duchamp may have wondered what he himself would look like cross-dressed (something he would try in the near future).

The other discovery was a vibrant local chess scene. Unfortunately for Yvonne, on or around the first days of 1919, chess became Duchamp's favorite mistress; forlorn, Yvonne returned to Paris. For a start Duchamp found old chess magazines and replayed forty games won by the Cuban prodigy, José Raúl Casablanca. He also took lessons at the local chess club, carved his own chess pieces, made rubber stamps for playing chess on paper, and sent Arensberg a code system to play chess by correspondence. "I play night and day and nothing in the whole world interests me more than finding the right move," Duchamp wrote the Stettheimers.[49] On this dispiriting note, in April, Dreier returned to New York. Then, before leaving for France himself, Duchamp wrote to Arensberg, "I find all around me transformed into knight or queen and the outside world holds no other interest for me than its transposition into winning or losing scenarios."[50]

DUCHAMP LIVED IN Argentina for nine months. In June 1919 he took a ship back to France, necessary to renew his US visa, and on arrival he visited his family in Rouen and Puteaux. In the fall he and his brother, Jacques Villon, put on a memorial exhibit of Raymond's sculptures at the 1919 Salon d'Automne. Once Dreier had gotten back to New York, she, too, traveled to Europe, visiting relatives in Germany; she also received an art-buying tour around Paris from Duchamp and Henri-Pierre Roché, who had meanwhile begun to talk about some postwar art-dealing together.[51] Duchamp also met up with Picabia, who had just separated from his wife, Gabrielle (with whom Duchamp therefore lodged in Paris). Like Picabia and Roché, Duchamp carefully steered clear of the bitterness among Paris artists over who had served in the war and who had fled.[52]

There was little time for chess, but Duchamp did notice the start of a new avant-garde activity in Paris called Dada, a kind of revival of Alfred Jarry's anti-art. This time the idea had been reinvented by a handful of poets and artists who protested the war in Zurich, Switzerland. They were proudly anti-art, much as Picabia had lately been in Barcelona, where he had published his iconoclastic sheet, *391*. In the meantime, the Romanian poet Tristan Tzara, still in Zurich, had issued a worldwide 1918 Dada manifesto. "The new artist protests: he no longer paints," Tzara declared. "There is a great negative work of destruction to be accomplished."[53] During the summer of Duchamp's arrival in Paris, the literary journals had begun to notice Dada, dismissing it as foreign "drivel."[54]

Duchamp stayed in France for only six months. When he left, the word "Dada" was not necessarily on his lips. Duchamp was still thinking in terms of blague and readymades, as evidenced by some of his activity just before he returned to America. He produced three comical readymades: a fake check for his dentist; a postcard reproduction of the *Mona Lisa*, which he altered by penciling on a mustache and goatee (with the initials "L.H.O.O.Q.," which punned, "she has a hot ass"); and a glass ampule obtained at a pharmacy and now filled with "Paris air." He gave the *Mona Lisa* to Picabia, and the Paris air was a gift for Arensberg.

Then, after spending Christmas with his parents, Duchamp caught the ship at Le Havre on the evening of December 27, 1919. Dada was about to explode in Paris, but Duchamp would have to hear about it back in Manhattan.

10 surrealist bridges

At the end of the war, European critics were giving modern art two prognoses. In one, Picasso and Matisse heralded "two grand opposing tendencies" in modern art, an idea echoed in England by British critic Clive Bell, who said in 1920 that, even for ordinary people, Picasso and Matisse "have stood, these ten years, as symbols of modernity."[1]

Another view, growing strong on the continent, divided up European art between two different styles of painting, the Fauvist-Cubist-Abstractionist camp on one side, and the revival of classicism, the postwar "return to order," on the other.

Another possibility was on the horizon, however, and its fountainhead would be Dada, the absurdist movement that began inconspicuously in Zurich, but which, on arrival in Paris, began to galvanize something new. Dada was far more of an attitude than a style, and accordingly, its force arose from three energetic dissenters in the arts, all of whom had plenty of caustic attitude to spare. They were Francis Picabia, Tristan Tzara (from Zurich), and a young Parisian poet named André Breton. They would launch "Paris Dada." After a short fitful history, it gave rise to a revised version of itself, soon to be called Surrealism.

No one in 1920 had figured that this Dada attitude would ultimately bifurcate modern art even more than Picasso and the traditionalists were doing already. Similarly, no one could have predicted that Marcel Duchamp would become the patron saint of Dada, though he was not a member of its organizing bands. The subversive attitude of Dada would eventually rival "significant form" as the essence of modern art, and by the end of the twentieth century, every kind of art would look rather traditional, even Picasso's, in contrast to the Dada legacy.

Although the nonsense term "Dada" had been coined in Zurich in 1916, its game plan was quietly reborn in 1918, the last year of the war, when Picabia and Tzara learned of each other. In Barcelona, Picabia had been publishing his incendiary pamphlet 391, sending it around by mail. In Zu-

rich, Tzara had issued his Dada manifesto, also by mail, and soon he would hear of Picabia. In Tzara's third issue of his own incendiary publication, *Dada*, he declared: "Long live Picabia, the antipainter from New York!"[2]

Upon returning to Paris, Picabia was still in possession of sufficient wealth to do what he liked. So in January 1919, he and has wife Gabrielle traveled to Zurich to meet Tristan Tzara. Over the three weeks that followed, Tzara helped his new friend produce the next issue of *391*. In turn, Picabia designed the cover for the combined fourth and fifth issues of *Dada*, entitled *Anthologie Dada*.

Then Picabia returned to Paris (soon to leave Gabrielle and take up with a new mistress). Before returning home, however, Picabia had persuaded Tzara to eventually come to Paris. That same year, Picabia had responded to an anti-art survey by a new literary magazine, *Littérature*, which had just been founded by André Breton, an enterprising medical student-turned-radical poet. Breton wanted to revive the spirit of Alfred Jarry in French letters. As Breton mixed his poetry writing with his medical duties during the war, he envisioned himself as a "joyful terrorist," his targets being traditional literature, logic, and morality.[3]

So when Picabia and Breton finally met, the former told the latter about Tzara, and the circle was complete. Picabia, Tzara, and Breton would become the early triumvirate of a new phenomenon, Paris Dada, to be born as a separate and distinct movement from Zurich Dada and Dada in Germany, both of which had blossomed, ever so briefly, during the actual war years.

And as fate would have it, the two artists whom Breton most wanted to draw into his own Paris Dada circle of influence would be Picasso and Duchamp.

The practical foundation for Paris Dada was established by Breton, a natural organizer. He was a unique product of the postwar experience of young poets. One result of the "call to order" in France was to produce a new wing of rebels, an avant-garde that believed their elders had gone soft. Such was the rebel-story of Breton, who had been an acolyte of Apollinaire. Before the war, Apollinaire had championed radical ideas from Rimbaud to Jarry. His *Soirées of Paris* had become the leading arts periodical in Montparnasse. Young poets like Breton, seeking a career advance, idolized Apollinaire. Breton served as his secretary for a time and, as a medical student, had served in the psychiatric corps of the French war effort.

After the war, though, Apollinaire joined the call to order. Breton felt betrayed. For inspiration, he turned to what he had learned in psychiatric clinics, or mental hospitals for soldiers, adding to that the haunting, demented verse of the Comte de Lautréamont's *Songs of Maldoror*. Breton also took the new ideas of Sigmund Freud seriously: he believed that poetry could reveal the unconscious. Such new poetry could undermine mere "literature," which had reinforced social conventions and normal aesthetics. Or, as he said, "A monstrous aberration makes people believe that language was born to facilitate their mutual communication."[4] To advance this cause, right after the war Breton took over a foundering journal, renamed it *Littérature* — as a kind of mocking twist on what he opposed — and gradually dedicated its pages to the sort of verbal and poetic revolution that Tzara was talking about. The war had left serious literary journals in ruins, and by Breton's chance opportunity in early 1919, *Littérature* would soon make him and his co-editor "hot young men on the literary scene," as one biographer said.[5] In hindsight, the journal would be the first "Surrealist" publication, of which Breton would found many more.

Now that *Littérature* had some momentum, Breton set out to organize a literary circle. Already, he had a few close compatriots, among them the writers Louis Aragon and Paul Éluard (whose fates would end up tangled in the life of Pablo Picasso). To expand his following, Breton held "First Friday of Literature" events. They were somewhat staid poetry readings, but when held at a Paris arcade, they could draw a curious crowd.

The Café Certa became the nascent Dada movement's headquarters (though for important decisions its leaders usually met at Picabia's well-appointed home). All that was needed was the arrival of Tzara. That came in January 1920, and it was hardly an auspicious event. He showed up unannounced, awkward, and penniless at the apartment of Picabia's pregnant mistress when Picabia was out. Nobody (except Picabia) had seen Tzara, so when he was presented to the others at Café Certa, it was to some surprise: he was short, swarthy, and myopic with his thick glasses. His French was bad. His laugh was very odd.

Nevertheless, as a high-energy publicist, Tzara was handed the leadership at Café Certa, and soon he delivered everything the Paris following had expected: publicity, scandal, and controversy. What might be called a "Dada spring" in Paris began immediately. It started in late January and featured five major events, one in late January, three in February, and an-

other in May, that one being a "Dada Festival" in a large concert hall. In the course of early 1920, Dada would also pit itself against the most conventional art group still active in Paris—the salon Cubists. The Cubists were trying to regain their prewar footing. In spring of 1920, their first chance to regroup was at the Salon des Indépendants.[6]

The salon Cubists secured a room at the Grand Palais, but a revival of Cubism was not going to be easy. For a start, Picasso had turned down the offer to show at the exhibition. This only increased murmurs about his betrayal of modernism; he had seemingly married into an effete Parisian class, and he had turned to classical kinds of painting. Picasso had not specifically offended the salon Cubists or the Dadaists, other than by moving up in French society, or seeming to have put on airs. But his sheer fame made him a handy foil against which the Dadaists and salon Cubists could both compare themselves—as they also battled each other for public attention. Amid this artistic triangulation, the Paris Dadaists saw the 1920 Salon des Indépendants as a major proving ground for who would claim the avant-garde mantel in Parisian arts and letters.

The Dada eruption at the Salon des Indépendants was their most outrageous to date. Breton and Tzara had rented a large auditorium at the Grand Palais. Under Tzara's guidance, the group put out flyers and posters saying Charlie Chaplin would appear "in the flesh" at the February 5 event. He did not appear, of course, and when the crowd jeered, Tzara was ready: they hurled insults back at the public. The initial allure of the Dadaists was suggested by the fact that even leading literary figures, such as André Gide, would attend, as he did on this day. As he described it, "Some young people, solemn, stilted, tied up in knots, got up on the platform and as a chorus declaimed insincere inanities."[7]

The seven Dadaists had lined up on stage to read:

Before going down among you to pull out your decaying teeth, your running ears, your tongues full of sores,
Before breaking your putrid bones,
Before opening your cholera-infested belly . . .
Before all that,
We shall take a big antiseptic bath,
And we warn you;
We are murderers.[8]

After seeing this offensive outburst, the more respectable salon Cubists declared Dada anathema. The feelings were mutual. Picabia intensified his anti-art decrees. Even Picasso, as a kind of collateral damage, was being hit by Dada shrapnel. He apparently took it in stride, remembering his own artistic youth in Montmartre when Alfred Jarry, a pre-Dada figure, had been much admired. Indeed, it was exactly Alfred Jarry, a creator of scandal, who Breton and Tzara had in mind as they continued the Dada spring of 1920. They held a few more prominent events. For entertainment hungry Paris, Dada indeed stirred a few fads. Cabaret reviews did "Dada skits." New songs became satires of Dada. And newspapers grappled with how to boycott or criticize Dada without lending it more free publicity. The Dada springtime passed, however, for lack of further interest.

BACK IN NEW YORK, Duchamp may have heard some news of these Dada eruptions, but he had other more immediate priorities, mainly financial. Over the fifteen months of his absence, much had changed in New York. He arrived in the cold of January 1920. The old galleries had closed. Arensberg was immersed in writing his books on secret codes in Shakespeare and Dante. Just as Duchamp landed, the US Prohibition laws had gone into effect.

Duchamp rented a ground-floor apartment in a dreary brownstone at 246 West Seventy-third Street. He took *The Large Glass* out of Arensberg's storage closet and put it back on saw horses. He spent his time with Man Ray, rejoined the Marshall Chess Club, and gathered new pupils for French lessons. Near the end of February 1920, Gabrielle Buffet-Picabia arrived in New York. Awaiting her divorce from Picabia, she moved in with Duchamp; she became his mistress for three months (an affair they continued back in Paris over the next three years).

As always, Dreier was the woman most happy to see Duchamp. She had returned from Europe with many new paintings for her growing collection. In March 1920 — as the Dadaists carried on in Paris — she summoned Duchamp to her Connecticut home. She wanted to found a modern art museum with Duchamp as director. For this meeting, Duchamp had brought along Man Ray. He suggested the organization use a French term, such as "Société Anonyme." Duchamp was named president and Ray secretary.

Now a capable photographer, Ray began to document Dreier's collection. They rented a suite in a brownstone at 19 East Forty-seventh Street. It was white walled, and Ray painted the five-foot banner. The Société logo was a chess knight that Duchamp had designed in Buenos Aires. It was a three-person organization with a grandiose subtitle: "Museum of Modern Art." But in fact, it would soon become the first modern art museum in the United States, and Duchamp, "indifferent" or not, was at the helm. He once again became a spokesman to the New York press on modern art, which he presented as benign and humorous. In all seriousness, Dreier wanted to revive the lost Manhattan excitement of the 1913 Armory and the Independent Artists extravaganza of 1917. On April 30, 1920, the Société held its first exhibit, a show of sixteen works that ranged from van Gogh and Brancusi to Gris and Picabia—and Duchamp and Ray as well (whom Dreier labeled as Dada artists).[9]

Duchamp had meanwhile moved back to the Lincoln Arcade Building, his home for his next three-year residency in America (with frequent trips back to France to renew his visa). After a year at the Arcade, enough dust had blown in from the windows on Broadway to cover his neglected *Large Glass*. So Ray photographed this "dust collecting" (and later, Duchamp varnished some of the dust onto the final *Large Glass*). Then Duchamp, assisted by Ray, set out to create a contraption—it was like a spinning propeller on a stand—that produced visual effects. The "propeller" was actually five long glass plates, spaced apart over two feet or so, each with white lines. When it spun (by electric motor), a head-on view of the plates produced a circle of white lines oscillating in depth. The thing was eventually titled *Rotary Glass Plates (Precision Optics)*. But for the moment, as if crying eureka, Duchamp and Ray believed they had invented Dada "optics," part science, part fantasy, a theme that Duchamp would carry into the future.

At one point, Duchamp told Arensberg about Paris Dada. So Arensberg wrote his own Dada "manifesto" (to be published in Breton's *Littérature* along with many other French members' manifestos). In turn, Arensberg told an editor friend at the *New York Evening Journal* about Duchamp. So the newspaper deployed a reporter down to the East Forty-seventh Street headquarters of the "Société Anonyme" to find out about Dada, said to be the newest thing in art.

The result was a January 19, 1921, headline: "'Dada' Will Get You if You Don't Watch Out; It Is on the Way Here."[10] It was true that Dada was

merely "on the way" because New York Dada did not really exist, except in the private antics of Duchamp and Ray. Zurich and Paris had Dada gatherings, a hierarchy, members, demonstrations, street hawking of pamphlets, and public disruptions. Also accurately, the *Evening Journal* assessed that Dada was simply another blip in the blague-oriented modernist literary movement. "It has attacked Paris with lunacies, jibes, and insulting ironies, . . . New York has sypathetic [*sic*] souls awaiting Dada."[11] At the Société Anonyme headquarters, everyone present tried to give the *Evening Journal* a definition of Dada.

"Dada is a state of mind," said Ray. "It consists largely of negations."

Duchamp said, "The Dadaists say that everything is nothing; nothing is good, nothing is interesting, nothing is important."

"Dada is irony," said Dreier.

Finally, the painter Joseph Stella, who had been in on the urinal blague, gave a more practical denotation. "Dada means having a good time — the theater, the dance, the dinner," he said, adding further: "To poke fun at, to break down, to laugh at, this is Dadaism."[12]

Now that the *Evening Journal* had been asking about Dada, Duchamp and Ray felt they had better create it in New York. Thereupon, they produced a pamphlet titled *New York Dada*. It came out in April 1921. And to give the pamphlet an angle, Duchamp dressed as a woman and took the name Rrose Sélavy, a word that was a sex pun when sounded out (in French). Ray took photographs of the cross-dressed Duchamp, who looked almost exactly like Charlie Chaplin when he dressed as a woman — fur collar, dark makeup, batting eyes, and a fashionable hat — in his 1915 movie *A Woman*. Ray printed a small Rrose image, which Duchamp pasted on a perfume bottle. Then Ray photographed that as the front-page image of the maiden issue of *New York Dada* (which also had a Rube Goldberg cartoon inside).

As Rrose Sélavy was born, though, the publication *New York Dada* died (after that one issue). Nevertheless, thereafter Duchamp used Rrose Sélavy as his alter-ego, and indeed Rrose may have been the only lasting upshot of European Dada in the United States. Man Ray would convey the bad news to Tzara, explaining why Dada "cannot live" in New York. The craziness seen in Greenwich Village alone, built over two decades, was already far more Dada-ish than Duchamp and Ray could hope to produce. "All New York is dada, and will not tolerate a rival, — will not notice dada," Ray wrote to Tzara.[13]

ALTHOUGH IT WAS DOUBTFUL that a New York Dada ever existed, the image of Duchamp as a Dada patron saint was growing in Paris. This was compliments of Picabia, who told tales of their adventures. Unbeknownst to Duchamp, Picabia had made his *Mona Lisa* blague famous. Picabia lost the original postcard that Duchamp had given him. So Picabia got another, put on the mustache (forgetting the goatee), and printed it in his *391* pamphlet. The Dadaists thought it was brilliant.

As Duchamp's image floated above the Dada circle in Paris, Breton, Tzara, and Picabia came to loggerheads over who was in charge. For a year or two they shifted alliances: all three at odds, or one joining the other against the remaining figure. When the uppercrust literary journal *Nouvelle Revue Française* asked Breton to be a contributing editor, Picabia viewed it as Breton's careerism and "out and out" hypocrisy, since Dada was anti-culture. In turn, Breton began to see Picabia as a buffoon. Picabia's wealth prompted some Dadaists to view him, with his taste for coat and tails, as too snobbish for Dada.

The real heart of the leadership battle was between Breton and Tzara. In *Littérature*, Breton began to assert that the Dada movement was "primarily French." He traced its lineage to Jarry, among others. He also said the "new spirit" of the movement was built on the foundation of the Freudian unconscious and interest in automatic writing, a practice in which the unconscious revealed itself. The internal conflict would not be resolved until 1924, when Breton declared Dada a kind of treason, and founded Surrealism, in the image of Breton, as its successor.

In the wake of this drama, with its new fight among the Paris avant-garde, both Duchamp and Picasso came out on the winning end. Breton realized that, in building his movement of literary Surrealism, he needed the reflected glow of Picasso and Duchamp, like a moon orbiting two different suns. With a periodical in his control (and more to come), Breton's strategy was simply to write articles in praise of Picasso and Duchamp, an old trick known by ambitious art critics for years. He would also use his influence to persuade wealthy art collectors to buy works done by Picasso and Duchamp.

The Paris Dadaists came to the idea of holding Dada art shows only gradually. The first opened on May 2, 1921, at the Galerie Montaigne. At this time, painters such as Jean Crotti and his wife Suzanne (Duchamp's

sister) had formed their own Dada satellite. They participated in the show and sent an invitation to Duchamp to contribute some pieces. In New York, Duchamp was just about to return to France to renew his US visa, but he was there when Suzanne's letter came. As an anti-artist, however, Duchamp said that he refused to exhibit; exhibiting art was like marriage, so conventional. He cabled back a reply that would become celebrated in Dada annals, the pun "PODE BAL — DUCHAMP," or "balls to you." (Hence, the show's catalog had three blank spots for Duchamp, and three blank cards hung on the exhibit wall.)

This was Breton's first try at being an art gallery host, which would never suit his nature. He was intimidating: big and solid with a giant head, thick hair, and a permanently serious look on his face that verged on imperious. On opening night at Galerie Montaigne, Breton stood by solemnly. Visitors were greeted by barks, gibberish, Tzara's stage laugh, and other calculated absurdities. Up to now, Picabia had been the only real painter in the movement, but as he was being pushed out, the German Dadaist, Max Ernst, was being featured. Ernst would eventually migrate to Paris and eclipse Picabia as the premier painter of Dada, and then of Surrealism. (In another decade, the young Spanish painter Salvador Dalí would arrive in Paris, rival Ernst for the crown, become the icon of Surrealist painting in the United States, and finally be expelled from the movement by Breton; as usual, the amicable Duchamp avoided such conflict, and would be lifelong friends with both Ernst and Dalí.)

One significant visitor to the Galerie Montaigne exhibit on opening night was the wealthy fashion leader, Jacques Doucet, now approaching seventy, and spending his money on a massive library collection and on art. The previous year, Breton had become Doucet's secretary for the library project. Gradually, Breton was persuading Doucet to buy modern art, not just classic French works.

As a member of the Paris fashion world, Doucet had already visited Picasso at his Montrouge studio, a time before Picasso had even departed for Italy to start working on *Parade*. But thanks to Breton's tenacious recommendations, Doucet eventually agreed to buy Picasso's 1907 painting *Les Demoiselles d'Avignon*, a done deal at the end of 1923, after which it hung in Doucet's large stairwell (and, more importantly, was preserved for history). As such early works by Picasso were beginning to find their place in art history, a chapter on Picasso and Dada was never really writ-

ten. The Dadaists resented that Picasso was rich. He also had begun to paint more traditionally. A gap of social class and age divided Picasso from the young Dada rebels, and for some of them, this was enough to harbor resentments galore.

By all accounts, Picasso had no comment on Dada, and probably viewed its exhibitionism with bemusement, even nostalgia. In his own pre-Dada youth, he had traveled to Madrid to start the rebellious youth journal *Arte Joven* (1901). For that pamphlet, Picasso had produced some of his "most sinister, cruel and satirical works," according to art historians, and the editorials certainly had the ring of a pre-Tzara challenge: "Come, youth, and join the struggle. . . . We know that the gilded youth of Madrid and the illustrious ladies of the aristocracy do not like Arte Joven! That pleases us immensely."[14] Over the next few decades, Paris Dada, too, would become a kind of packaged novelty, sold in stores and written about by art historians, but for now it was pure ferment.

As Breton tried to manage the Dada effervescence, he continued his art dealing, which was an important way for him to build bridges with Picasso and Duchamp. During his employment with Doucet, he steered the elderly collector to buy two works by Duchamp. So when Duchamp returned more permanently to Paris, he and Doucet were not exactly strangers; with Breton as mediator, they became friends of an art-dealing kind.

Shortly after the Galerie Montaigne exhibition (1921), Duchamp reappeared in Paris (for his visa). He stayed several months. He moved back in with Yvonne, his former mistress (and former wife of Crotti, his brother-in-law). It was a fabled time in Paris, the 1920s, when Hemingway and the American literati settled in the city (and the south of France) on a strong dollar against the weak franc. As Duchamp wrote home to New York, "All of Greenwich Village is out strolling in Montparnasse."[15] Duchamp did not head for Gertrude Stein's salon, of course, but lingered loosely around the Dada ferment. It was at this time that he visited some of the Café Certa meetings, where his legend had grown.

At the time, Duchamp was thirty-four, a decade older than the Parisian Dadaists. According to accounts, the young Dadaists held him in virtual awe, even though none of them, not even Breton, had seen much of his art, and certainly not *The Large Glass*. Duchamp was glib on the matter, writing to the Stettheimer sisters, "From afar, these things, these [Dada] Movements take on a kind of appeal they don't have close up, I can assure you."[16]

Nevertheless, it was at this time, in summer of 1921, that Duchamp urged Man Ray, now in marital trouble, to cut loose and come to Paris. He, too, had a kind of legend going at the Café Certa. When Ray arrived, the Dadaists loved his Brooklyn accent. By Ray's own account, they were "strangers who seem[ed] to accept me as one of themselves."[17]

They immediately planned a one-man show for Ray. It opened in December 1921 at the Library Six Gallery and bookshop. Outside were red balloons and inside thirty-five paintings, collages, and objects by Ray. The day before, Ray decided to include a readymade. So he went to a hardware store, bought a flatiron, and glued tacks to its flat surface, titling it *Gift*. (The absurdity of it made it Ray's most famous Dada artwork.) The show failed to sell anything. In hindsight it marked the end of excitement for Paris Dada, but it did launch Ray into a successful career as the official photographer of the Paris avant-garde, and eventually even high fashion and glamour (especially after he migrated to Hollywood in the 1940s).[18]

Not long after Duchamp returned to New York (his visa in hand), Breton decided to begin elevating him, making him the stuff of legend, in his magazine *Littérature*. This began in the October 1922 issue, with Breton, like many others, talking about Duchamp's good looks ("admirable beauty of the face"). In purple prose, he began: "It is by rallying around this name, a veritable oasis for those who are still seeking, that we might most acutely carry on the struggle to liberate modern consciousness." Breton celebrated Duchamp's independence. He was not a joiner. His kind of person would "toss a coin up in the air and say: 'Tails I leave for America tonight, heads I stay in Paris.'" He applauded Duchamp's philosophy of "indifference," which Duchamp had put into action under his doctrine of the readymade, "signing a manufactured object" to make it art.[19]

In the October and December (1922) issues of *Littérature*, Breton also published several of Duchamp's puns, spoonerisms, and phrases. It was the first declaration that Duchamp was part of French literature. Breton cited some examples of Duchampian puns: "Advice for intimate hygiene: Put the marrow of the sword into the hairy place of the beloved." Another: "Rrose Sélavy finds that an insecticide must sleep with his mother before killing her; bedbugs are *de rigueur* [required]."

Breton waxed glowingly on Duchamp's literary merit. In the December *Littérature* he claimed that some of the "strange puns" had been received by telepathy by a member of his Dada group, who was in a sleep-like

trance. He noted that Duchamp's puns had a unique mixture of mathematical calculation in the wordplay, plus guaranteed humor. "To my mind," Breton said, "nothing more remarkable has happened in poetry for many years."[20]

AS THIS WAS PUBLISHED in Paris, Duchamp was barely scraping out a living in New York City. Overall, his three-year postwar residency in New York was rather unfocused, and this last year was particularly desultory. One last time he tried dealing art, with Henri-Pierre Roché as his partner in Paris. He would have liked a job in filmmaking as a cameraman, but instead he borrowed money from his father to try a cloth-dying business, which started up but soon failed. He corresponded with Tzara about a mail-order business selling gold Dada bracelets (D A D A on a chain).

With time to spare, Duchamp also brought *The Large Glass* to an ironic conclusion, which he called "definitively unfinished."[21] To Duchamp's surprise, Arensberg announced that he was moving to Los Angeles. The collector Quinn was interested in buying the unfinished *Large Glass*, but for only a moment. So Arensberg sold ownership of it to Dreier. As Duchamp wrote Jean Crotti before he left for Argentina in late 1918, *The Large Glass* had become "this big piece of trash" he planned to finish quickly (though he dawdled for five more years—an eight-year project total).[22] Once *The Large Glass* was "finished," Dreier bought it as part of her personal collection, safely storing it away.

With Arensberg moving to Los Angeles and Ray in Paris, Duchamp still had the Stettheimer sisters to visit. He also presided over the Société Anonyme, which otherwise had shut down for eighteen months as Dreier traveled in Europe to buy more art. Duchamp also edited the Société's first (and last) book project, a collection of articles by the *New York Sun* art critic Henry McBride, who began his writing career covering the Armory Show in 1913.

Duchamp had one other person to turn to, and that was his alter-ego and new pen name Rrose Sélavy. He began to employ her more and more, perhaps as a shield, or maybe as a marketing device for whatever he might do next. He began to write more and more puns, mostly sexual, and released them under the Rrose Sélavy brand name. Rrose was not quite enough, however, and as he confided to Picabia in a letter, he was in and

out of a deep funk: "I'm on the bottle again. Doing nothing." So chess came to the rescue, as it often would. "Have played little chess in four months," he told Picabia. "Going to start my training again."[23]

He lived up to that New Year's resolution, and its turning point came for him in fall of 1922 at the Marshall Chess Club. Its founder, Frank Marshall, had invited the Cuban prodigy José Raúl Casablanca, the new world champion, to be player in residence. For the fun of it, Casablanca offered to play twenty-five games at once with the many neophytes around the club. Duchamp was one of them. Although Duchamp and reportedly everyone else lost their games to Casablanca, Duchamp felt energized. He was determined to return to France and play competitive chess.

But before leaving New York, Duchamp had to get one more goofy artistic act out of his system. Duchamp liked his face a lot, as Man Ray liked his own face, too: they both compiled lots of pictures of themselves. So Duchamp made yet another readymade-type item: a wanted poster with his mug shot inserted, but not his real name. "Wanted: $2,000 Reward," it said. "Known also under the name RROSE SELAVY." With this gesture, he began his attempt at a professional career in chess.

In February 1923, he boarded a ship from Manhattan to Rotterdam. He moved to Brussels, got a room, and began practicing at the famous chess hangout, the Café du Cygne, where he was welcomed on the French-speaking chess club team. He eventually returned to Paris, where he had a few irons in the fire. One of them was his new friendship with the wealthy art patron Jacques Doucet, who owned two Duchamp works. Breton set up a formal lunch for them in late fall of 1923, and during that time, Duchamp presented Doucet with the idea of making the collector another version of the spinning optical machine he had produced in New York with Man Ray (now titled *Rotary Glass Plates*, 1920). Doucet agreed. Then Duchamp headed back to Brussels for his first big chess tournament, writing to Doucet thereafter on almost intimate terms. "I am doing very well in this tournament, which is my first important one," he wrote Doucet. Duchamp had apparently told Doucet of his female alter-ego, so he could also say, "Rrose Sélavy has something of the *femmes savantes* — which is not disagreeable."[24]

This was an important year for Breton as well; he was forming his final plan to launch the Surrealist movement. Picasso was moving a lot between Paris and the south of France, and as a married man of means, he

nevertheless had developed another vacuum around him, unfilled by his wife Olga's social life. Thereupon, it was filled by a new trio of poets, the pre-Surrealist Breton and his two friends from school days and the army, Paul Éluard and Louis Aragon. Breton also admired Duchamp. But during the heady days of trying to build the Surrealist movement, he wished that Duchamp would help more: he would soon be chiding Duchamp for giving up art for an "interminable game of *chess*."[25]

IN 1924, BRETON officially declared the founding of the Surrealist movement by publishing the first Surrealist Manifesto. By definition, Surrealism was the tapping of the unconscious, which in his group's poetry writing meant "automatic writing"; letting words come out with no effort to assert conscious control of their choice or composition. It was a recipe for incoherence, and even Sigmund Freud (whom Breton visited) did not see what his psychiatric "science" had to do with the Surrealists, "who have apparently chosen me for their patron saint," but who seemed to be "cranks."[26]

Breton had far better luck communicating with Picasso. In the cultural maelstrom that was Paris, Picasso was being pilloried from two sides. He never was one of the salon Cubists. And now that he had turned to realistic painting, those Cubists had even less good to say about him. On the other hand, many of the scrappy Dadaists resented anyone in a high social position, and among the arts, Picasso was their easiest target of invective. Breton leaped into the gap, defending Picasso. In a 1922 lecture in Barcelona, he credited Picasso as the very pioneer of modern art: "This is the first time, perhaps, that a certain outlaw attitude asserts itself in art."[27] Then he published the text in his mouthpiece, *Littérature*. Still, among some Dadaists, the anti-Picasso mantra increased, building up new pressures inside the small tribal world of Dada followers.

This internal drama was well known enough to Picasso, in fact, that when the Dadaists were finally expected to come to blows at the "Evening of the Bearded Heart," a public soirée held by the Tzara camp in July 1923, Picasso dressed up and took a booth in the large theater to see what would happen. At one point, a Tzara partisan took the stage and began a harangue, which included the provocative phrase, "Picasso dead on the field of battle." Breton and his camp had also come to the theater, ready to heckle, and at this slight to Picasso, Breton jumped to the stage, shouting

in Picasso's defense, and finally, with his heavy cane, breaking the arm of the Tzara partisan. Later, Picasso said he enjoyed the spectacle, though he took no sides. The event marked the self-destruction of Dada, opening the way for Surrealism under Breton's command. As biographer John Richardson said, Picasso "liked Tzara well enough for his anarchic Jarry-like spirit," but "thought it wiser to keep in with the increasingly magisterial Breton."[28]

Soon enough, Breton was invited for a formal visit with Picasso, who in summer of 1923 was staying at the Hôtel du Cap in Antibes, a sleepy little town on the Riviera. (He was a guest of the wealthy American bohemians Gerald and Sarah Murphy, who moved to the south of France to take advantage of the strong dollar.) Presumably, Breton introduced Picasso to the ideas of Surrealism—the work of the unconscious. Perhaps they discussed it as Picasso did a fine-line etching of Breton. The etching gave Breton the look of a leader. It was just the endorsement he craved. He used the etching as the frontispiece for his next book of poems. (After the visit, Breton finally persuaded Doucet to buy *Les Demoiselles d'Avignon*.)

When Breton had his meeting with Picasso, the Spanish painter—age forty-two and fifteen years Breton's senior—was a different man from their passing encounters years earlier. Life for Picasso had changed dramatically in February of 1921 when Olga gave birth to their first and only child, a son whom they named Paulo. The arrival of a newborn, and the early years of Paulo's infancy, dictated where Picasso would live and paint over the next few years.

Throughout the 1920s, Picasso based himself at his upscale apartment at 23 rue la Boétie. It was at his La Boétie studio that Man Ray took the photograph of Picasso that appeared in the July 1922 issue of *Vanity Fair*, an image that became a classic impression of the Spanish artist to Americans. In reality, Picasso spent much of each year moving his family between Paris and their favorite spots on the Riviera, to a beach town on the Normandy coast, and for one summer to a villa in the cooler and hilly climes of Fontainebleau, a little south of Paris. During this period, Picasso explored two different personal themes: the death of his old friends (and an old era), and the ethos of a mother and child (the future).

For the summer after Paulo's birth, they went to Fontainebleau, where the cool air, rather than the heat of the coast, was better for the baby. Picasso painted in the garage of the villa. He produced two works that

seemed to bring closure to his past. They were two large geometric portraits, both of them titled *Three Musicians*. The two canvases were very similar. In each, the three "musicians" probably represent Apollinaire (a Pierrot in white); Jacob (a monk in dark cowl); and himself (a checkered Harlequin). In ways, the *Three Musicians* was a farewell to Cubism and his two bohemian street friends, one taken by death, the other in a monastery to fight his addictions.

Before Fontainebleau, Picasso had been sketching and painting compositions with solid, monumental female nudes. These figures conveyed a distinct classical aesthetic, with the drapery looking like fluting in Greek columns. At Fontainebleau, he brought those studies to a peroration in *Three Women at the Spring* (following a Poussin biblical theme). He had also revived his use of clay colors: pinks, browns, and white. Working in Paris he also produced *Reading the Letter*, an equally statuesque picture of two young men — now in city clothes, not Greek togas — seated at the roadside, contemplating what they had just received in the mail.

As Picasso moved from one location to another with Olga, he also began to focus on themes he saw in his infant son. With the birth of Paulo, Picasso had done some of his first tentative "Mother and Child" drawings. These would become a full-blown series, evocative of the classic Virgin and child. He painted Olga as an idealized Greek woman in *Mother and Child*. He also produced tender drawings of his infant son, reviving in a new way the oval-shaped eyes — called "hemstitched" eyes — of his earlier period. In all, Picasso was painting happy works, flooding his *Still Life with Fish* with brightness and color, revealing humor and bizarre new renderings of human forms, typified by the two monumental figures in *Women Running on the Beach*.

The happiness could not last. Picasso chafed at his spousal duties. He was always restless with his women, a feeling that was now compounded by demands that he settle down as a husband. He tired of Olga's preference for resort towns, not the wild beaches he preferred, and her tight organizing of their social life in Paris. At one point, Picasso hung a sign on his studio door at the rue la Boétie apartment: "I am not a gentleman." As the marital relations began to break down, Picasso had new emotions to put into his paintings. Such emotions were always autobiographical to a certain extent; they frequently reflected the woman in his life, for good or ill.

Picasso's restlessness must have reached a peak in 1927 when, walking on the streets of Montparnasse one day, he approached a seventeen-year-old girl—tall, nubile, and blonde—and worked his wiles. Her name was Marie-Thérèse Walter, who lived with her mother in Paris, and within the year Picasso had her meeting him at a secret flat as his mistress and muse on the side.

Technically, Marie-Thérèse was underage, so the date of their meeting was kept secret for many years; this protected Picasso from any possible legal charges. In any case, she fell in love with him and pliantly did his bidding; he made her read the Marquis de Sade to understand his sexual tastes, and during summers he put her up at nearby "youth camps" when he spent the season on the Riviera with Olga. Picasso's ability to keep this kind of secret was remarkable; for all Olga knew in Paris, he had a second studio that he constantly wandered off to, and even Picasso's friends suspected nothing. Eventually, Marie-Thérèse became pregnant. In 1935 she gave birth to a girl, who they named Concepción (after Picasso's youngest sister, who had died), but whom they called Maya.

The stories of his separate lives with Olga and Marie-Thérèse were told in his paintings of the later 1920s, but it was not the only story. By the time Breton had launched Surrealism as a literary movement—his manifesto was released in 1924—painters such as Max Ernst had been experimenting with "biomorphic" forms and collages that put together strange combinations of objects. Isolated from these developments, Picasso created his own kind of "surrealism," to which he only later would allow such labels to be attached.

With his women and his own kind of surrealism in hand, three kinds of paintings flowed from Picasso's brushes in that decade, and also from his etching stylus.

The first kind was simply pleasant. These paintings arose before he met Marie-Thérèse, and they continued through his portrayal of her, typically as a bright, curvaceous, and happy composition of a woman. His pleasant paintings often had a touch of Surrealism. Such a happy mood was caught in Picasso's still lifes with windows behind. Such was the case with *Studio with Plaster Head*, done at Juan-les-Pins in the summer of 1925. Picasso painted this by looking at his son's toy theater, rendering it with the distinctly surrealist feel of disparate objects juxtaposed in eerie, funny, and colorful ways.

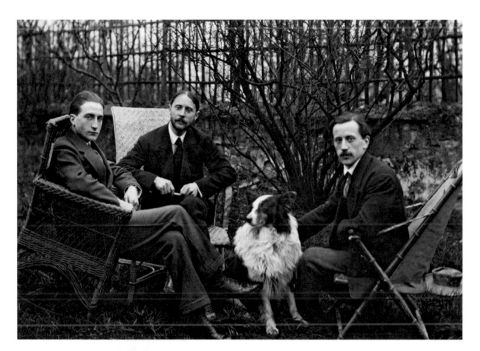

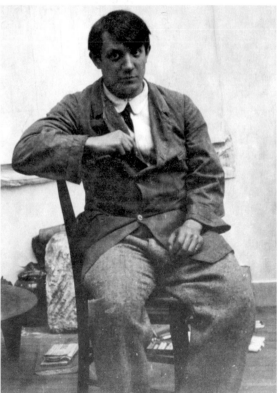

1 ‖ This photo of the Duchamp brothers—(from left to right) Marcel Duchamp, Jacques Villon, and Raymond Duchamp-Villon—at the Puteaux studio garden in Paris was printed in American newspapers during the 1913 Armory Show.

2 ‖ Picasso in 1914, about age thirty-three, in his rue Schoelcher studio, his second studio in Montparnasse, the Left Bank of Paris.

INTERNATIONAL EXHIBITION
OF MODERN ART
ASSOCIATION OF AMERICAN
PAINTERS AND SCULPTORS

69th INF'T'Y REG'T ARMORY, NEW YORK CITY
FEBRUARY 15th TO MARCH 15th 1913
AMERICAN & FOREIGN ART.

AMONG THE GUESTS WILL BE — INGRES, DELACROIX, DEGAS,
CÉZANNE, REDON, RENOIR, MONET, SEURAT, VAN GOGH,
HODLER, SLEVOGT, JOHN, PRYDE, SICKERT, MAILLOL,
BRANCUSI, LEHMBRUCK, BERNARD, MATISSE, MANET, SIGNAC,'
LAUTREC, CONDER, DENIS, RUSSELL, DUFY, BRAQUE, HERBIN,
GLEIZES, SOUZA-CARDOZO, ZAK, DU CHAMP-VILLON,
GAUGUIN, ARCHIPENKO, BOURDELLE, C. DE SEGONZAC.

LEXINGTON AVE.–25th ST.

4 ‖ The February 1913 International Exhibition of Modern Art, set up inside the Sixty-ninth Infantry Regiment Armory building on Lexington Avenue, was divided into eighteen sections.

opposite:
3 ‖ The poster for the 1913 Armory Show listed only European artists.

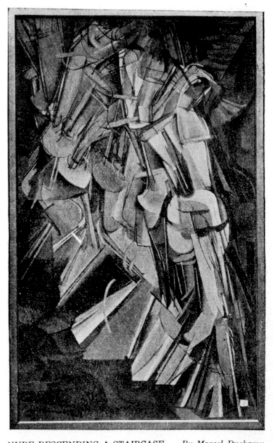

NUDE DESCENDING A STAIRCASE *By Marcel Duchamp*

5 || An Armory Show publicity postcard of Duchamp's *Nude Descending a Staircase* (1912) was distributed around New York City.

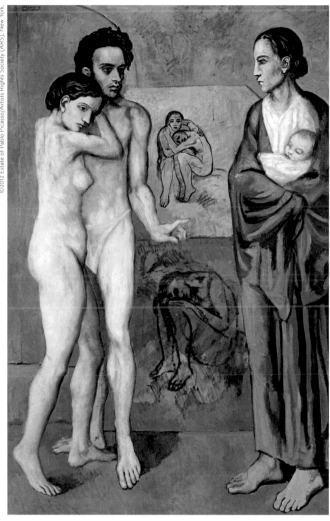

6 ‖ Picasso's Blue period oil on canvas, *Life* (1903), is believed to be about his suicidal friend, Carlos Casagemas.

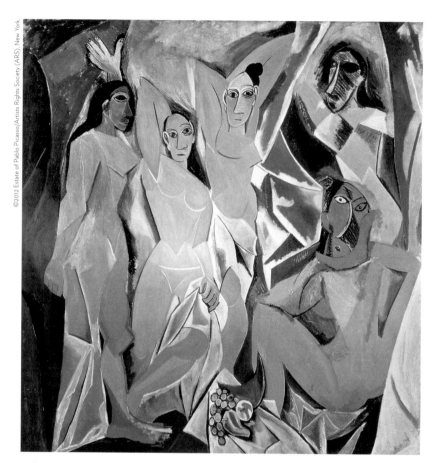

7 || Picasso's *Les Demoiselles d'Avignon* (1907) was an early experiment with primitive and geometric elements, leading to his later analytic and synthetic Cubism.

8 || Picasso's return to classical themes was typified by a "maternity" series, which included this pen-and-ink, *Mother and Child* (c. 1922).

9 || Picasso's Surrealism reached a crescendo in *The Crucifixion* (1930), an oil on panel that echoed early crucifixion images in European art.

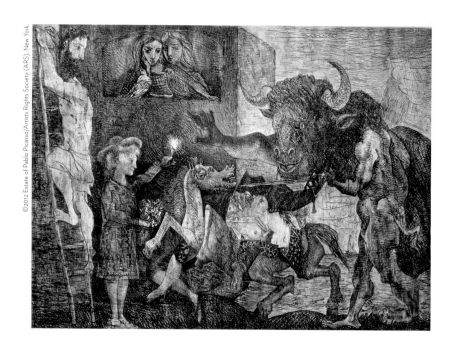

11 || Gertrude Stein in her 27 rue de Fleurus apartment with Picasso's portrait of her (1906) hanging in her gallery-like living room.

opposite:
10 || The mythical creature of the Minotaur, half man and half bull, began appearing in Picasso's works in the 1930s, including his famous etching, *Minotaurmachy* (1935), which was printed in several versions.

12 || Guillaume Apollinaire in Picasso's first Paris studio at the Bateau-Lavoir, where Picasso and Fernande Olivier lived from 1905 to 1909. To Apollinaire's right is an African statuette.

13 || Olga Khokhlova, the first wife of Picasso, with Serge Diaghilev, head of the Ballets Russes, in Monte Carlo in 1928.

14 ‖ (*From left to right*) André Breton, Paul Éluard, and Tristan Tzara in Paris, 1932.

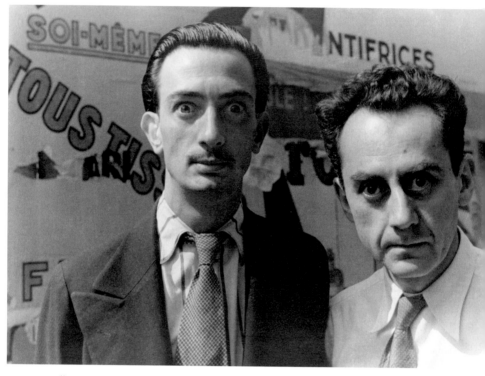

15 ‖ Salvador Dalí (*left*) and Man Ray in Paris, 1934.

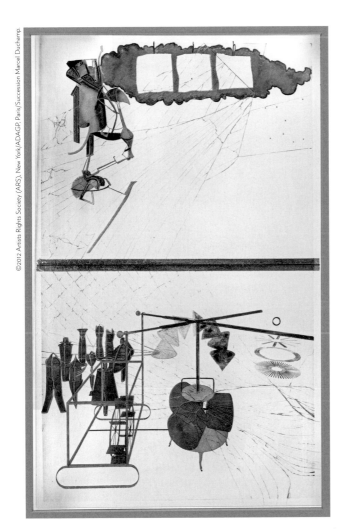

16 ‖ This 1935 miniature replica of Marcel Duchamp's *Large Glass*, mass produced by Duchamp to include in his series of "box" museums, shows the basic mechanisms in the original *The Bride Stripped Bare by the Bachelors, Even* (1915–23).

Above, the bride is a "female hanged body" with wasp and weathervane shapes. This is further attached to the horizontal cloud-like and flesh-colored Milky Way with three square draft pistons. Below, the mechanical activity of the bachelors includes (from left to right) the *Nine Malic Molds* (bachelor uniforms), chariot with runners, water mill, scissors, sieves, *Chocolate Grinder*, and occultist chart. The bar at the middle of *The Large Glass* stands for the bride's clothing and the bar's midpoint is the vanishing point for the linear perspective rendered in the bachelors' lower half of the glass.

17 ‖ Duchamp with Katherine Dreier (c. 1936) in the library of her Redding, Connecticut, estate. Duchamp's last painting, *Tu m'* (1918), sits atop the back bookcases, and the reconstructed *Large Glass* is beside him.

18 ‖ Marcel Duchamp with his *Rotary Glass Plates (Precision Optics)*, which he made in 1920 and often showed in exhibits during his lifetime. Behind him hangs his early oil painting, *The Chess Game* (1910).

19 || Marcel Duchamp's *Box-in-a-Valise* (1935–41), which contained sixty-nine miniature replications of art works and curious items produced by the artist. These include his paintings on chess themes (foreground), his *Mona Lisa* with a mustache, and, hanging in the box, a miniature urinal based on his original *Fountain* (1917). His 1912 painting *The Bride* (miniature, upper left) was the basis for shapes in his *Large Glass* bride.

20 || In 1937, Picasso painted *Guernica*, shown here in his Paris studio at rue des Grands-Augustins. His mistress, Dora Maar, took photos of the painting process.

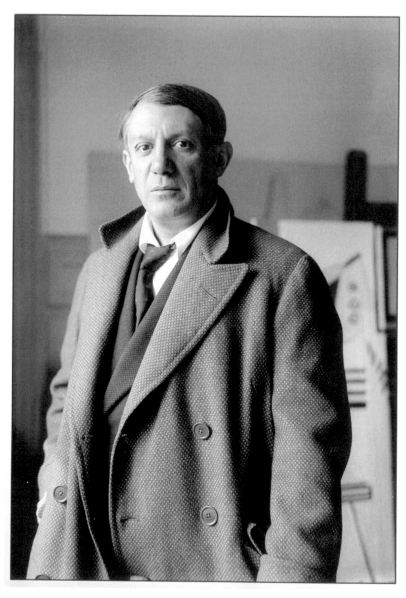

21 || Picasso in 1928, around age forty-seven, at the height of his powers.

If Picasso's new love for Marie-Thérèse had its Surrealist expression, it was in simplified, circular, female forms. The epitome of such works inspired by Marie-Thérèse's was his *Girl Before a Mirror*, painted in spring of 1932 at an inland villa in Boisgeloup, Normandy, where Picasso kept his young mistress in a secret idyll.

The second kind of painting was tense. If not for Marie-Thérèse, Picasso might have used his Surrealism to portray only a sinister world, reflecting his fights with Olga. Tension between them began to appear in the mid-1920s, even before Marie-Thérèse. As Picasso further strayed from the hearth, Olga responded with increasingly neurotic behavior, which in time devolved into screaming matches in public. While in Monte Carlo in 1925, Picasso painted *The Dance*, considered his first truly Surrealist work, but it was marked not by pleasantries. It showed nightmarish angst.

By now Breton had launched a new publication, *Révolution surréaliste*, and to complement his fall 1925 article, "Surrealism and Painting," he published two of Picasso's most wrenching images: *The Dance* and *Les Demoiselles d'Avignon*. At the end of 1925, Picasso detoured from his custom of avoiding group shows. He allowed Breton to hang one of his works, *Man with a Guitar* (1912), in Breton's first official Surrealist exhibition, held in November at the Galerie Pierre Loeb in Paris. Picasso was now officially welcomed under the Surrealist umbrella. In fact, by 1929, when Breton issued his Second Surrealist Manifesto, which reflected an embittered period (when his followers were deserting him), Picasso became even closer with him, at least in lending his artwork to Breton's projects.

Toward the end of the 1920s, Picasso was pushing the edges of Surrealist experimentation, taking on its humor, enchantment, violence, and also misogyny. If at one time Picasso's beach bathers were glamorously distorted humans, they now became monsters. This was his third kind of painting, more defined by subject matter — bathers on the beach — than being pleasant or harsh. The bathers ranged from the strangely comic *Bather with a Beach Ball* (1929) to the spooky *Seated Bather* (1930) and *Figures by the Sea* (1931), both of which represented women with hard, bone-like, fleshy structures with sharp edges, knife-like tongues, and sawblade teeth. Some looked like tall piles of organs or bones. Although in 1930 Picasso also began producing series of classical etchings to illustrate Ovid's *Métamorphoses* — which means "transformations" — his parallel

beach monsters would become his own world of incredibly transformed humans, sometimes called his own *metamorphoses*.

In the saw-tooth females, interpreters of Picasso see his bitterness toward Olga, if not women in general. The peak of his Surrealism came in 1930. In homage to Matthias Grünewald's tortuous Christ on the cross, Picasso offered his own: *The Crucifixion*. A large painting, it was perhaps his first step in a future course he would take: reaching back to an "old master" work to reinterpret it in a Surrealist or synthetic-Cubist style.

AS PICASSO BASKED in the south, Duchamp was getting by up in Paris. Although chess was his new avocation, the undercurrents of art dealing, art exhibits, and his fickle relations with women continued to tug on his life. These preoccupations, which involved a good deal of travel, never derailed Duchamp from the chess circuit, however. In this decade, he became the master of a four-ring circus. Between 1926 and 1936, he crossed the Atlantic three times for art events in America, he made and sold art, he negotiated his life with at least three demanding women, and he rose on the French chess ladder.

He was able to keep his focus by staying aloof of the more aggressive, collective Dada activities, for, as Man Ray explained, Duchamp "never talked in public."[29] There was no ban on art dealing among the Dadaists and Surrealists. Breton bought and sold art much of his life. In Paris, under the name Rrose Sélavy, Duchamp ran an auction to sell eighty of Picabia's paintings. And in the United States, Duchamp would also become the leading dealer in sculptures by his Paris friend and drinking partner Constantin Brancusi.

When it came to making new works for sale, Duchamp was primarily in the service of the elderly collector Jacques Doucet. Duchamp had persuaded Doucet that his previous project, *Rotary Glass Plates* (1920), had been a serious use of optics in modern art, and so, beginning in 1924, Duchamp began to produce a new optical device for Doucet. Between chess tournaments, he drafted the design. It was a spinning dome shape with spirals painted on it. This was mounted on a shaft and base, standing about chest high from the floor, turned remotely by a small motor. Duchamp titled the work *Rotary Demisphere* (1924)

With Doucet's money, Duchamp paid craftsmen and electricians to produce the device. For a fairly simple machine, this took nearly a year

to complete. "I almost (!) finished mounting the striped globe on the first plate," Duchamp wrote Doucet in late 1924, seven months into the project. "We can expect a rotation experiment next week."[30] After delivering the device to Doucet, Duchamp also sent a rather demanding follow-up letter. He insisted that the object not be displayed as art per se. "All painting and sculpture exhibitions make me sick," he told Doucet. "And I would like to avoid being associated with them. I would also be sorry if people saw in this globe anything other than 'the optical.'"[31]

Then he asked Doucet's support for another project. At the time, Duchamp liked to go play chess in Nice during the winter. The Monte Carlo casinos were nearby. So Duchamp took an interest in the roulette tables. He commenced on a Dada joke about gambling and art investments. As a skilled draftsman and printer, Duchamp made an investment bond with the heading "Roulette de Monte Carlo," and put his own picture on it (a picture of him with shaving lather creating horns and beard). The bonds paid out twenty percent and were signed by Duchamp and Rrose Sélavy. He printed a limited number and asked friends — including Doucet — to buy one as an investment (not bona fide, but potentially profitable if that piece of Dada art, to be titled *Monte Carlo Bond*, was sold later on the art market).

As part of this blague, Duchamp said he hoped to pay investors dividends based on his winnings at the roulette tables. Indeed, in Monte Carlo, Duchamp was studying the roulette system. As a gamesman he thought he could figure out the probabilities of roulette — much as the French mathematician Pascal had done with dice games — and win money. By some accounts Duchamp was able to break even at the tables, suggesting that he had developed an adequate gaming method, whether mathematical or instinctual.

After this rather normal pursuit of playing the odds, Duchamp entered a dreamier realm: he wondered whether roulette — a game of chance — could be constrained enough numerically to mimic the logic of chess moves. This kind of merger would probably elude even an Albert Einstein, but for Duchamp, it was more an employment of his "playful physics" than real science. He was caught up in a whimsy that he could really merge the roulette wheel with the chessboard.

Whatever Duchamp's true intent, he passed on the whimsy to Doucet, enthusiastically announcing his accomplishments in Monte Carlo. Not only could he come out even in his roulette bets, Duchamp said, he had

taken control of the casino wheel as if it were a chess piece. "This time I believe I have eliminated the word chance," he said. "I would like to think I have forced roulette to become a game of chess."[32] Duchamp may have been blaguing the old man, but Doucet followed the pursuit with interest. The *Monte Carlo Bond* even got ink in the avant-garde circulars of Greenwich Village.

ON HIS RETURN from America to Paris in 1923, Duchamp had found his own surrogate Greenwich Village on the Left Bank near Montparnasse. He had moved into the Hôtel Istrai at 29 rue Campagne Premiere. The hotel was a kind of bohemian commune used by artists, models, and other residents amicable to the 1920s Parisian version of free love. The Dadaists—many of whom would be turning into Surrealists over the next few years—met across town, in the cafes of Montmartre, since that is where Breton lived: indeed, Breton lived in his 42 rue Fontaine apartment—a kind of Surrealist library and museum—from 1922 nearly until the day he died.

One day, amid this rotating cafe scene, Duchamp saw a face he was familiar with from Greenwich Village, the young American widow Mary Reynolds. She had lived in Manhattan with her husband, who had gone to war in Europe, where he died in the flu epidemic. Then like other Americans, she moved to affordable France, where she bought a small house in Paris. Eventually she became a bookbinder, producing collector-quality covers for avant-garde classics, from the Marquis de Sade to Rimbaud, Jarry, and others. Everyone in bohemian Paris had believed Mary was engaged to a rakish young American artist and writer, Laurence Vail, who had adopted the nickname "King of Montparnasse." However, to everyone's surprise, in 1922, Vail suddenly married a Paris newcomer, the American heiress Peggy Guggenheim.

Duchamp arrived a year later. After meeting Mary, they embarked on an affair. Over their many years together, Mary recalled, Duchamp often hid their relationship in public, going to awkward extremes. In the long run, bohemian Paris knew well that she was Duchamp's "American mistress," especially as Mary began to hold daily soirees at her garden house at 14 rue Hallé, just south of Montparnasse, where Marcel was a regular fixture, and where he helped Mary decorate and showed his own pipe collection.[33] They also enjoyed the cafe scene, going often to the Boeuf sur le

Toit, a chic Right Bank venue frequented by Jean Cocteau's circle. All the while, Duchamp kept his own austere flat—with its chessboards—and operated like someone in an open marriage, except that they never married. Not that Duchamp was utterly opposed to marriage. It awaited him (and *not* with Mary) sooner than he imagined, but first there was a series of major art events in the United States to attend to—and a turning point in the Duchamp family line.

During 1925, Duchamp's mother and father, married for fifty years, died within a week of each other. His monthly stipend now ended, but he received a final inheritance of about ten thousand dollars. This was going to come in handy, for the next year—1926—was one of travel, keeping up with chess matches, and a little art dealing as well. The biggest art event on the horizon was being organized by Dreier, who had landed a coup for the Société Anonyme: it was going to hold a modern art exhibition at the Brooklyn Museum of Art, the second-largest art venue in the New York area, and a stronghold of traditional kinds of artworks as well.

Once Brooklyn had signed on, Dreier headed for Europe to buy a wide sampling of current painting and sculpture. "I need you especially now," she had written to Duchamp. "You know that Modern Art does something to people which they need very much."[34] When she arrived in Paris around the end of March 1926, Duchamp took her to local exhibits, galleries, and studios. He pointed her to what to look for in Germany, and went with her to Italy for the Venice Biennale.

After three months, having visited five countries, Dreier had lined up the most representative exhibit of European art to be shown in America. In Paris, Duchamp handled much of the shipping, but Dreier had also made links with a host of other artists, from Léger and Mondrian to Kandinsky and Schwitters. In these kinds of circles, Dreier heard the salon Cubist line that Picasso (and Braque, too) had betrayed the cause of modern art. Duchamp also urged her to avoid Picasso, writing that she did not need to include "such successfully marketed stuff" in her "exhibition efforts."[35] At Picasso's dealer, Dreier chose just two older works, in the decade-old analytic Cubist style.

To explain the absence of so towering a modernist as Picasso in the Brooklyn exhibition, Dreier wrote in the catalog that he was a "middle-aged gentleman who started life full of enthusiasm," but who had "settled down to retirement as far as the world of art goes today."[36]

The early part of 1926 had occupied Duchamp with chess tournaments, but by fall he had cleared his calendar for a major trip to the United States, to help with the Brooklyn project, but also set up a Brancusi show in Chicago. On October 18, Duchamp docked in New York, having arrived on the SS *La France*. He had a month to design the layout of the two hundred works to be shown at the Brooklyn Museum. For the first time, his *Large Glass* was going on public display, and naturally it was given a special room, positioned by the works of Mondrian and Léger, two of Dreier's favorites (since Mondrian, like Dreier, was a Theosophist, as was Kandinsky). The Brooklyn show opened on time, around Thanksgiving, and to great acclaim. Unlike his *Nude Descending a Staircase* at the Armory Show, Duchamp's *Large Glass* did not raise a single eyebrow, apparently, even with its title about bachelors "stripping bare" a bride.[37]

Then Duchamp headed for Chicago, helped wrap up the Brancusi show (shipping back the unsold art), and before his return to Paris spent a little more time in New York. He wanted to attend the auctioning off of John Quinn's art collection. Having died in 1924, Quinn left behind the largest private pool of modern art of anyone in America.[38] With the ten thousand dollars Duchamp had inherited, he bought a few Picassos and some pieces of his own that Quinn had acquired from Walter Pach. By February 1927, Duchamp was on an ocean voyage back to France, with spring chess tournaments lined up.

This was no ordinary voyage, at least according to Julien Levy, who would become an important art dealer in New York City. The young Levy had just met Duchamp in New York, and the Frenchman urged Levy to head for Paris. Levy, the son of a Manhattan real-estate mogul, had dropped out of museum studies at Harvard and, interested in art dealing, was beguiled by the idea of promiscuous Paris, a place for a young man to indulge his fantasies. Indeed, on the ocean voyage, Duchamp explained to Levy one of his own fantasies, a work of art he hoped to make some day.

One day as they sat on the ship's deck, Duchamp was playing with a few wires. When Levy asked what it was, Duchamp said he was thinking of making a soft, life-sized, mechanical sex doll with a vagina that self-lubricated, used by a man, Levy recalled, as "a sort of '*machine-onaniste*' without hands."[39] It was not a new idea in Europe's underground trade in perverse male entertainments. In Duchamp's hands, the idea had a more elevated resonance. If he made such a contraption, it would do in three

dimensions what his "bride motor" stood for on the flat surface of *The Large Glass*.

After the ship reached France and Duchamp settled back into his routine of following chess matches, he felt a rare existential chill: after so many months on the road — ships, trains, hotels, and living out of a suitcase — Duchamp was longing for stability, and that meant having a source of income. This is when the marriage option arose (and it was not with the long-suffering Mary Reynolds).

Out of nowhere, the Picabias had decided to act as matchmakers for Duchamp. They introduced Duchamp to a marriageable woman, Lydie Sarrazin-Levassor. Duchamp was forty and Lydie twenty-five, the child of a wealthy French industrialist. Her parents worried about the future prospects of their unassuming daughter. So Lydie and Duchamp agreed to marry. Dreier was crestfallen at the news, but Duchamp wrote to explain: "I am a bit tired of this vagabonding life and want to try a partly resting one."[40] In truth, he'd run out of money.

Just before their wedding day, Duchamp learned that Lydie's allowance from her family's wealth was actually very paltry. In turn Lydie first heard from Duchamp that he was unemployed. The ceremony went forward anyway, and Man Ray took the formal wedding photos. In the first days of their marriage, Duchamp apparently ignored her to study his chess problems. Out of frustration one night, Man Ray recounted, "Lydie had arisen and glued down all the pieces."[41] Duchamp would meanwhile disappear, taking the bus to Nice to play chess. They had sex, but only after Duchamp made her shave off, from the neck down, every hair on her body. By the start of 1928, Lydie petitioned for a divorce. The grounds were neglect.

Duchamp knew that Dreier would be happy at the news. He was back to enjoying "every minute of my old self again," he wrote to her. "Chess is my drug." Punning his first initial, he signed the letter, "Affectionately: Dee (vorced)." As part of his old self, Duchamp also returned to his fickle relationship with Mary Reynolds. They went on together across two decades, from the ebullient 1920s, through the Great Depression, and up to the occupation of France by Nazi Germany. Duchamp was never unsatisfied with the relationship: he always came home to Mary. Mary, who struggled with drinking, was never quite happy about her Marcel. He was "incapable of loving," she told one friend. Or, as she told Duchamp's literary pal Roché, "Marcel is debauched."[42] Roché reflected on the fact

that, with women, Duchamp mostly fantasized, as proved by his flings, his art, and his puns. Roché was a seasoned playboy himself. So he also commented that Marcel could have gotten as many women as he wanted, even rich *and* beautiful ones.

Instead, Roché said, "He preferred to play chess."[43]

11 | europe's chessboards

For some time now, Duchamp had been writing his friends to say, "My ambition is to be a professional chess player."[1] However, it was probably Breton's 1923 article on Duchamp that electrified the avant-garde grapevine with news that Duchamp had traded in art for the game board. "Duchamp does hardly anything now but play chess," Breton had written in *Littérature*. "He consents, if you will, to pass for an artist, in the sense of a man who has produced little because *he could not do otherwise*." The news drifted back to New York. In fall 1924 the avant-garde newsletter *Little Review* reported, "Marcel has given up painting entirely and has devoted most of his time to chess."[2]

The news was quite old, but the mystique lingered. Quitting art was oddly heroic. Arthur Rimbaud had famously given up poetry after a short burst of adolescent creativity. Dada preached that everyone should give up art. In reality, Duchamp was going through another of his many cycles. He started chess in his mid-thirties. At that age it was time to develop an end game for his life, whether that would be in the chess world or the art world. A life of chess was his hope. Art was his great fallback, the default world in which he had been formed. So he needed to have two end games, one for each option.

When Duchamp entered the chess world, all the great moves, problems, and end games had been covered. These could be learned in books, which were a chief source for Duchamp's self-education. "Duchamp applied absolute classic principles," said one of his opponents. "He was very conformist."[3] The chess world also had many examples of rebels. Although a chess wizard like José Raúl Casablanca was known for his end game, he was also a source of constant surprises in his innovative moves and tactics. Duchamp, too, would try to adopt some of his own unique approaches. He never explained what those were, though he was known for — and spoke about — being an "artist" who played chess. Observers seemed to agree on one area at least: "Duchamp had a predilection for the endgame."[4]

Duchamp was thirty-six at his first big Brussels tournament. After that,

he joined the local team in Rouen, his hometown, and then moved up to the French national team. In 1925, he did well enough in tournament points to be earn the designation as a "Master" in the French Chess Federation. With a good national showing, he was invited to join the French Olympic team. He appeared on that international stage in 1928, and then played Olympiads in Hamburg (1930), Prague (1931), and his last in Folkestone, England (1933). In Hamburg he came full circle. He played the US champion Frank Marshall, leading to a draw, which was better than a loss. At the International Paris Tournament he beat the Belgian champion and drew his match with the top winner of the competition.

For all France's love of chess, it could not produce a winning team. Even so, Duchamp was probably one of the country's twenty-five best players, and at various tournaments often finished near the top. He became a familiar visage in world chess circles. He had met Casablanca. Being on France's five-player Olympic team, he also knew its captain, the Russian-born Alexander Alekhine, who took Casablanca's world title in 1927. After 1931, Duchamp served as an officer of the French Chess Federation and as a delegate to the International Chess Federation. He was "a good deal more serious about chess than he ever was about art," said the German-American chess master Edward Lasker (distantly related to world champion Emanuel Lasker).[5]

After a decade of effort, however, the top of the mountain never came into view. "Of course you want to become champion of the world, or champion of something," Duchamp once said.[6]

In the world of chess, players often spoke of the beauty of a game, much as mathematicians spoke of the "beauty" of their equations. Duchamp had rejected the idea of beauty in painting, though he had endorsed what he called the "beauty of precision" and "beauty of indifference" in works such as his *Large Glass*. Either one of these — precision or indifference — could have made chess beautiful to him.

There was no question about precision, for it was the fulcrum of victory or defeat. As to indifference, though, Duchamp was contradictory when it came to chess. On one hand, he said that chess was a contest with all the elements of "vanity" that come with winning. "Chess is a sport. A violent sport," he once said — also once saying it's about killing the opponent — all of which seemed to dispel anything like indifference. "If it [chess] is anything, it is a struggle."[7]

At other times, Duchamp would speak of chess as if it were a ready-made, an object that stirred no emotion, conviction, or ambition whatsoever. Chess is "purer, socially, than painting, for you can't make money out of chess." When someone does a painting, he frames it and sells it, while "at the end of the game you can cancel the painting you are making." In other words, "Chess has no social destination. That is what is especially important to me." Except that, of course, he would have immensely enjoyed being champion of the world. His overall contribution was not minimal, however, and it finally included a legacy of his public thoughts about chess and art — stated in a few interviews and public talks to chess players — and the fact that he became coauthor of a rather academic book on an obscure end game in chess.[8]

Through the mid-1930s, as Duchamp approached age fifty, he played his best cards, naturally enough.[9] From early in life, Duchamp knew that he had the kind of poker face good looks that could win friends and influence people. To this he added a natural touch of flattery. He could say just the right thing, especially in his adopted home, the United States. When he first arrived in New York City in 1915, he offered to newspaper interviews such *bon mots* as "the American woman is the most intelligent in the world today — the only one that always knows what she wants, and therefore always gets it." At the end of his career, he spoke similarly to his peers in chess. "All chess players are artists," he said, addressing a New York State Chess Association banquet.[10]

By the 1930s, the more cynical and risqué side of Duchamp's message for the world was expressed by his female alter ego, Rrose Sélavy. He let Rrose do most of his controversial talking. A favorite phrase she liked to put on Duchamp's Dada works was "Rrose Sélavy and I value the bruises of the well spoken Eskimos." Rrose's language was usually more blue than that. Picabia's *391* published her witticisms: "Oh! Do shit again! Oh! douche it again!"[11] Another time, Duchamp and Man Ray went out to the Puteaux grounds to film the seven-minute *Anemic Cinema*. It was a film that showed ten spiral designs they had been painted on cardboard circles and spun on a bicycle wheel. Each of the circles had a sexual joke, what Ray called Duchamp's "spiral monocycles embellished with delicious pornographic anagrams."[12] The jokes disappeared when the circles spun.

Another strong feature of Duchamp's character emerged in his perpetually equivocal relationship to art and business. In principle, he said he

shunned art as commerce (or a way of making a living), yet there seemed no escape.

When Duchamp needed money, he looked for something to sell, finding his own ways to reconcile the objects he created with the marketplace. This was apparently the case when he returned, a third time, to his spiral optics theme. Using cardboard, he created a set of six round plates, designed to sit and spin upon a record player. Each plate had a different spiral design on both sides. The twelve images, drawn with commercial precision, were printed by an offset lithograph company. Duchamp called them *Rotoreliefs*. He even claimed they were a scientific breakthrough in optics, "a new form, unknown before, [which] are producing the illusion of volume or relief," he wrote Dreier, who tried to help him market them as toys in the United States.[13]

First, however, Duchamp tried to hawk them in a booth at the 1935 Paris Concours Lépine, an annual trade fair for inventions and household devices. The disks were very similar to the whirligig toys already owned by children. So in a month at the booth, Duchamp sold only one set. As he wrote Dreier, "This is a complete failure commercially."[14] In art, however, rejection can be presented as a principled success. The Surrealists applauded Duchamp for being anti-commerce at the Concours Lépine. In his correspondence with Dreier, Duchamp seemed to make the same point. He asked her to underprice them when Macy's ordered a set for review. "They were only typographical prints on cardboard and have no value as originals," he told her.[15] Nevertheless, Duchamp's commercial ambition was just below the surface. He had planned to copyright the *Rotoreliefs* in the United States.

BY CONTRAST TO Duchamp's lukewarm return to Dada art, having been driven back into its arms by the faltering of his chess ambitions, Picasso was having banner years in the early 1930s. The Depression had created a new kind of culture in Europe, increasing the public taste for sensation as a welcome diversion from penury. This influenced cabaret life, which went to new extremes, for example, and it amplified the fantastical pursuits of the Surrealists, with whom both Duchamp and Picasso had steady contact.

Despite the din of sensation, Picasso still managed to stand out in the Paris crowd, and Duchamp could not help but notice. Whereas the De-

pression sank the art market, Picasso's works remained collectable for future valuation. As many artists were going under, "Picasso can wait," said Kahnweiler, his former dealer.[16]

Picasso was also seriously entering the annals of history at this time. In 1931, one of his acolytes, the Greek-born art aficionado Christian Zervos, published the first of a series of volumes collecting all of Picasso's works, what art experts call the "catalogue raisonné" of an artist (every single work with each documented). The first of the Picasso volumes covered 1895 to 1906 (and there would be thirty-two volumes in the end). Meanwhile, the first monograph books on the life of Picasso also were rolling off the presses. Three dealers wrote books on Picasso, including Kahnweiler's Picasso-centric history of Cubism, Wilhelm Uhde's *Picasso and French Tradition*, and yet another by the French dealer André Level. The Surrealist poet and Breton protégé Louis Aragon also came out with *Painting as Defiance*, all in praise of Picasso.

Picasso decided this was a good time to organize his first retrospective in Paris. The paintings dated from his youthful bullfight pictures and Blue period and ran up to his *Three Musicians*, his neo-classicism, Surrealist *Crucifixion*, and his work inspired by Marie-Thérèse. After the exhibit finished in Paris, it traveled to several European cities. In Zurich, the psychologist Carl Jung famously commented that Picasso's fragmentation in his work suggested a classic schizophrenia.[17]

The press coverage in Paris was extensive. Though it featured the normal comments that Picasso's work had created a "crisis of the arts" with its "iconoclastic rage," others in the old guard took off their hats for his remarkable range and bravado. "There are so many different kinds [of painting] here," wrote critic-painter Jacques-Émile Blanche. "Each mode, each stage of Picasso's journey requires the critics to alter their posture." He said that Picasso had used both manual dexterity and good taste to create objects that are "stimulating, ingenious, and poetic. He can do everything, knows everything, and succeeds in everything he tries."[18]

As the historic Picasso entered the mainstream canon of European art, his contemporary work had become distinctly Surrealist. This was his own doing, but it was definitely highlighted, and egged on, by the way Breton was linking his Surrealist movement—which now had a second, more radical, manifesto—to Picasso's fame. Breton claimed leadership of Surrealism, but the current avant-garde movement was as splintered as its

personalities were assertive. One of them, the librarian and ethnographer Georges Bataille, specialized in Surrealist literary pornography. In his slick, colored publication *Documents*, he dedicated the entire 1930 issue to Picasso. Another avant-garde publication, *l'Intransigeant*, took readers on a "Visit to Picasso," with photographs of his studio and work.

The funding for such publications was coming from major Swiss or French publishers. Despite how Bataille and Breton loathed each other, with a funding agreement they became co-editors of the high-quality color publication that the Swiss owner titled *Minotaure*, the half-bull, half-man mythical beast. It was slated to come out in 1933. Only days earlier, the Surrealist photographer Brassaï (Jules Halasz) knocked on Picasso's door asking for a cover design. Picasso produced a collage and painting—a Minotaur with a drawn knife—and Brassaï took the photo. After this, Picasso and his Minotaur (typically pursuing maidens) became famous. The first issue of *Minotaure* brought Picasso's high Surrealism to the public. It featured his sequence of thirty beach monster, or *métamorphoses*, drawings in which women are morphed into assemblages of odd shapes.

Not all publicity was welcomed by Picasso. As he would argue for his entire life, his affairs with women needed no justification, and in turn, they were nobody's business. However, in 1933, Fernande Olivier disagreed. She published her memoirs, *Picasso and His Friends*, covering their nine years in Montmartre. Apparently, Max Jacob had helped her write the book, which has given historians the best knowledge of Picasso's early days. With lawyers, Picasso tried to stop publication but failed. Its release also quickened the unraveling of Olga's tolerance for her husband's behavior. At the time, Gertrude Stein was still completing her book, the *Autobiography of Alice B. Toklas*, which, by including several accounts of Picasso, she believed would secure her own fame as the Cubist writer. Now, worried that Fernande had scooped her, Stein began readings from her manuscript at her salons. At these events, Olga bolted for the door, jealous and embarrassed. Picasso shrugged. "All that is so long ago," he said.[19]

AS DUCHAMP WATCHED Picasso, he was painfully aware of his own lack of dealers, biographers, or acolytes to tell his story. There is no evidence that he was personally jealous of Picasso, though he clearly wasn't enamored. He wasn't trying, for instance, to persuade Dreier, a representative of the American art scene, to admire Picasso, a Paris celebrity

with "such successfully marketed stuff."[20] But by looking at Picasso, Duchamp realized what he himself had to do. If Duchamp wanted to make a dent in the art world, he would have to market himself. About this time, Duchamp conceived the end game for his life as an artist: he would create his own kind of retrospective and museum. It would be Dada-style, but it would be executed with his typically meticulous precision.

At this moment, *The Large Glass* was on his mind for several reasons. During yet another of Dreier's visits to Europe, this in spring 1931, as they were having lunch at Lille, France, while touring, Dreier broke the bad news. At some point after *The Large Glass* had been triumphantly shown at the Brooklyn exhibit, it was trucked to a storage facility and the glass ended up shattered (either on the bumpy ride or while in storage). Duchamp took it with stoic cheerfulness, not wanting to depress an already distraught Dreier.

Later, in 1936, he traveled to the United States, spending two months in Connecticut to piece together *The Large Glass* (and squeeze it between two more plates with a new heavy bracket). It was duly installed in Dreier's home library. "I like the cracks, the way they fall," Duchamp said much later, and later still: "It's a lot better with the breaks, a hundred times better."[21] On this same US sojourn, Duchamp visited Arensberg in Los Angeles to talk about ways to consolidate all of Duchamp's early works, some of which were in various collector's hands.

The easiest way to begin a consolidation of his life's work was to dig out the 1912–15 notes he had taken in the early days of designing *The Large Glass*. He had been keeping them for some reason. Now they became the basis to build his own catalogue raisonné. Later in life, Duchamp said that, all along, he had planned to recopy the notes and organize them "somewhat like a Sears, Roebuck catalog."[22] In other words, as with the captions under Rube Goldberg cartoons, his notes might provide a step-by-step account of the actions of the bride and bachelors machines in their elaborate sexual encounter — or, by another stretch, be likened admirably to the scattered notes of Leonard da Vinci.

At this time in his life, standing in the shadows of Picasso and a thwarted chess career, Duchamp had to play his strengths. These strengths all hinged on *Nude Descending a Staircase*, *The Large Glass*, and his concept of the readymade. He also enjoyed publishing. He'd just done a fancy chess book, bound in the highest quality, and he had, after all, been trained as

a printer. In the future he would increasingly design and print gallery catalogs.

The steps necessary to organize all these strengths, however, began with his humble, yellowing accumulation of bizarre personal notes, now the starting point of his lifetime end game. He spread them out on a table and then chose the ones directly related to the themes, allegories, and functions in *The Large Glass*. He put these in a main stack. The remainder, those sundry notes that were left, he put to the side; these were his notes on science, mathematics, and the fourth dimension, which he shunted to a secret holding place.

At this moment of final selection, Duchamp had before him ninety-four pieces of paper (actually, eighty-three notes and eleven photographs), all in great variety, from lined writing sheets to scraps and backs of receipts he'd jotted upon.[23] He would now do with these items what he'd done with those he put in the so-called *Box of 1914*. He was meticulous. He scoured Paris for the exact kind of paper he had used before in each case. Since some of the papers—either scraps or with edges torn from pads— had irregular shapes, he cut their shapes in zinc plates and tore around the edge to create exact replicas of the original scraps.

At some point, he had a commercial printer replicate by photography his handwriting on the scraps. Duchamp mounted each of the paper shards on art board. Then he obtained a number of photo-paper boxes, each of which he covered in green suede to give the feeling of quality packaging. To put a title on each of the boxes, he punched tiny holes in the suede so dotted white letters would appear. Then in each box he put a full set of the ninety-four printed items (notes and photos). Voilà! He called the work *The Green Box*. He put three hundred on the market (cut back from an original plan of five hundred).

The entire line was called a limited edition, a standard technique for boosting the value, but he also listed twenty "deluxe editions," a high-end version that allowed him to charge a higher price, all in hopes of recouping his expenses. He sold boxes to his regular suspects, such as Arensberg, Stieglitz, Dreier and others. He also sold them to prominent Surrealists, such as Breton, who would write about *The Green Box*, and the British Surrealist Roland Penrose, who would thus import, as it were, Duchamp to England. Duchamp also mailed a review copy of *The Green Box* to the *New York Times*, where a reviewer called it—quite accurately—"the

strangest book of the season," a kind of "profound detritus, dumped . . . into a box."[24] Duchamp was able to move ten deluxe editions and thirty-five standard ones, but sales were not exactly brisk.

Undeterred, he wrote Dreier that he wanted to go still further: he wanted to collect his lifetime works in, say, a real book. *The Green Box* was not quite a lifetime retrospective, such as the Zervos volumes and Paris exhibit were for Picasso. Then an idea struck. Duchamp decided to make a miniature, portable museum that contained replications of all his "greatest hits," so to speak, from his early paintings, through his *Large Glass*, sex puns, and spirals. Thus was born the *Box-in-a-Valise*. Duchamp had so few works that he could include nearly all of them, shrunk down in a small container.

Even more than *The Large Glass*, the *Box-in-a-Valise* would be the most complex, drawn-out project that Duchamp would launch. It took him only eight years to "complete" *The Large Glass*. It would take thirty years (finally, by the rescue of Xenia Cage, wife of John Cage, other friends, and a future daughter-in-law) to produce his newest commercial vision: the *Box-in-a-Valise* was to come out in a limited edition of three hundred mini-museums in a fold-out box (measuring 16 x 15 x 4 inches) each with sixty-nine replications of the Duchamp works. When Duchamp first told Dreier about his plan, he asked her to remain hush-hush, since "simple ideas are easily stolen."[25] The technical challenge to make the tiny museums was significant, but to this, Duchamp applied his technical training, and his knowledge of craft industries and supply shops around Paris.[26]

As this box came together, producing a Marcel Duchamp catalogue raisonné in three dimensions, the analogy of chess could not have been too far from his mind. In terms of consolidating his legacy, Duchamp had moved beyond the opening game. By the measure of chess, he was now at mid-game. This was a time to apply his shrewdest tactics. Always in mind, though, was the end game. It was enough to wrap up Duchamp in his own little world, as if seated at a cosmic chess match, and that may be one reason why, among so many avant-garde figures in Paris, it was he alone who did not show up at one of the big social events of the season.

This was the greatest-yet Surrealist art exhibit in Paris. It came in the spring of 1936 at Galerie Pierre, where Picasso had held his own retrospective. The opening was a who's who of new and old talents. The painters Max Ernst and Joan Miró where there. To the shock of everyone, even

Picasso dropped by (prompting Surrealist poet Paul Éluard to celebrate the appearance in poetry). Duchamp continued to be a reliable no-show. For most of his life he refused to attend openings, even for events that he organized.

He might have attended out of deference to Breton, who had organized the exhibit, but this did not transpire. Breton was younger than Duchamp, and despite Breton's domineering personality, he would melt in deference to Duchamp. In Paris, Duchamp received his only media coverage in Breton's publications. Breton published his sex puns as poetry. When Duchamp's chess book came out, Breton excerpted a bit of it in his newest publication, *Le Surréalisme au Service de la Révolution* (which joined Surrealism to Marxism). In 1933 Breton also printed a one-page sampling from notes Duchamp was compiling for *The Green Box*. When *The Green Box* came out, providing the "intellectual" basis for *The Large Glass*, Breton wrote glowingly of Duchamp's accomplishment.

This was Breton's 1934 essay "The Lighthouse of the Bride," which said that *The Large Glass* was an ultimate solution to the "relationship between the rational and the irrational." Breton knew well that *The Large Glass* was a masturbation machine, but anyway, this was the kind of topic currently at the heart of Surrealist literature. For inspiration, Surrealism looked at everything from the Marquis de Sade to the Paris strip joints, and that was only the beginning. As early as 1920, the painter Gleizes observed of the Dadaists, "Their minds are forever tormented by sexual delirium and a scatological frenzy. Their morbid fantasy runs riot around the genital apparatus of either sex."[27] This foreshadowed the time when American expatriate writers such as Henry Miller lived in Paris, combining the Surrealist spirit with literary pornography; Miller wrote *Tropic of Cancer* (1934), which both revealed the debauchery of bohemian life in Paris and bootlegged the Paris genre to underground America.

Either way, Breton spoke of Duchamp's notes on his masturbation machine in exultation: "No profounder originality had ever been seen to flow more evidently from any being more obviously committed to a policy of absolute negation." Breton outdid his normal purple prose. Of *The Large Glass*, he insisted "that it should be kept luminously erect, its light there to guide ships of the future through the reefs of a dying civilization."[28]

Duchamp probably chuckled when he read this. For the time being, he was picking his fights selectively in the art world. On one hand, he

would sometimes urge his collector friends to not lend his pieces for exhibits — since in his higher principles of anti-art, he opposed such conventional art practices. At other times, he was eager to have his works on display, even ambitious for the opportunity, as evidenced in his marketing of *The Green Box* and *Box-in-a-Valise*. When he made his trip to the United States in 1936, his priority was to repair *The Large Glass* so that it might be exhibited at the Museum of Modern Art (though ultimately it was too fragile to move). On this same trip, which involved a good deal of train travel, including a visit to Arensberg in Los Angeles, Duchamp made his way to Cleveland, happy about a special exhibition there of his *Nude Descending a Staircase*. He also supported the Art Club of Chicago when, in February 1937, it held his first one-man show, using nine works owned by Arensberg.[29]

In America, Duchamp was guaranteed the kind of publicity that had not yet extended beyond Breton's small publications in Paris. During his February show in Chicago (which he did not attend), the art critic for the *Chicago Daily News*, who had met the Frenchman earlier, praised Duchamp with just the right calibration: "Duchamp had the lightest touch of all the Cubists," unlike the serious Braque, Gleizes, or Picasso. "Duchamp is at home in Chicago's loop, on New York's Broadway. Picasso, you can imagine exploring the tombs of Egypt or the catacombs of Rome."[30]

In New York, both Picasso and Duchamp were being recognized, with Picasso in the obvious lead. The Museum of Modern Art (MOMA) had purchased *Les Demoiselles d'Avignon* for a record price, relishing the thought that one day New York might supplant Paris for modern art. By the time 1936 was over, MOMA had also put on two major exhibits that would include both Picasso and Duchamp — together for the first time. The first of these was "Cubism and Abstract Art," which included Duchamp's oil painting, *The Bride*, and the second exhibit was the much larger "Fantastic Art, Dada, Surrealism," held in December. With this exhibition, Dada and Surrealism gained official status in the American art world.

As far as MOMA was concerned, Picasso was already the king of modern art, and the museum collection was shaped in his Cubist image. Nevertheless, the "Fantastic Art" exhibit also canonized the offbeat Duchamp. His oddities and readymades — the *Three Standard Stoppages*, *Rotoreliefs*, *Pharmacy*, *Bottle Rack* (a photo), and *Monte Carlo Bond*, among others — were among the eleven items, and the head of MOMA, Alfred Barr, would

have shown *The Large Glass*, but it was too fragile to leave Dreier's study. Duchamp—a freewheeling naysayer of museums as mausoleums—had nevertheless gained official museum status, as if he'd been shown in an American Louvre.

This particular case also showed that Duchamp viewed any publicity— even bad publicity—as beneficial to the Dada-style artist. MOMA had, at the last minute, included art by children and the insane in the "Fantastic Art, Dada, Surrealism" exhibit, right along with Duchamp's. Dreier was outraged. She held a press conference denouncing such a "derision" of Dada and Surrealism in public. However, Duchamp advised her that "the amount of publicity is proportional to the number of lines written for as well as against," and there was nothing wrong with publicity.[31]

For Duchamp's reputation in America, Arensberg and Dreier had been essential. However, Barr would add something different to Duchamp's fortunes. At first, Barr and Duchamp did not like each other, Barr seeing Duchamp as a fraud, and Duchamp seeing the American as an ambitious interloper, trying to steal modern art with his Rockefeller money (since the founding of MOMA in 1929 essentially eclipsed Dreier's Société Anonyme). First impressions didn't last, however, especially after Barr reached out with flattering letters about *The Large Glass* ("I have always been so much impressed by it").[32] More important, Barr would put Duchamp into the flow of art history. As an intellectual who used diagrams, Barr tracked the evolutionary progression of modern art, as if a biological tree of life. He fit various painters into the branches and, indeed, turning points, to dramatize something like the Hegelian march of the artistic spirit. Thanks to the 1936 MOMA exhibits, organized by Barr, Duchamp found himself squarely in the march of art history, right alongside Picasso.

On his 1936 trip to the United States, lasting three months, Duchamp managed to elude attendance at both the Chicago and New York exhibits. Before heading back to Paris, however, he received some additional ink. Holding to his official position, Duchamp told an interviewer from the *Literary Digest*, one of America's mostly widely circulated periodicals, that painting was as despicable as ever. "For me, painting is out of date . . . a waste of energy, not good engineering, not practical." The article's clever headline, "Restoring 1,000 Glass Bits in Parcels; Marcel Duchamp, Altho an Iconoclast, Recreates Work," captured some of Duchamp's perennial

dilemma (he was anti-art while still doing art). Either way, Duchamp gave a fitting 1930s farewell to America and to painting: "We have photography, the cinema, so many other ways of expressing life now."[33]

IN PARIS, whatever contentment Picasso had felt from his success was being muddied by his relationship problems. His quandary was not about defining art, but about his life with women. With the birth of his daughter Maya by Marie-Thérèse Walter in late 1935, the seven-year secret about having a young mistress was out: Olga sued for divorce, which Picasso resisted, since it meant losing half his property to her. During this peak of marriage conflict, a time when Picasso was also juggling Marie-Thérèse and a new infant, he turned for strength to his Spanish roots.

There to hold his hand, for example, was Eugenia Errazuriz, now seventy-five, who in Spanish apparently commiserated with Picasso's side of the story. At this time also, Picasso asked his old Barcelona friend, Jaime Sabartés, to drop everything and come be his secretary. In the short run, Sabartés began to manage Picasso's complicated and often secret life; in the long run, the talented Sabartés, who had worked in journalism, also became Picasso's editor, wordsmith, and hagiographer. He arrived at Picasso's side in November 1935. Given the timing, Sabartés naturally allied with Marie-Thérèse and Maya, an alliance that was sorely tested when Picasso suddenly brought a new mistress into the picture. This new mistress also spoke Spanish.

During these years in the south of France, Picasso had become a magnet to a new group of poets. Breton was too self-regarding to become a follower, but his two early protégés—Louis Aragon and Paul Éluard—were amenable to being Picasso followers in proportion to their alienation from Breton, which one day became complete. Among the Surrealists— Bataille, Ernst, Éluard, and Penrose in particular—sexual experimentation was a way of life. As friends of Picasso, Éluard and Penrose were eager to provide him with similar delights, even with their own spouses. One day they introduced Picasso to someone new: a young Surrealist photographer named Dora Markovitch, shortened to Dora Maar. Dark haired and sophisticated, Dora was young and, having been reared in Argentina, spoke Spanish. The story goes that Picasso first saw her at a Surrealist cafe, where she was playing a Surrealist betting game, rapidly stabbing the knife into the table top between her fingers, with occasional misses.

On a balmy night in the coastal resort of Cannes, Éluard and Penrose arranged their rendezvous; a walk on the beach, and then Picasso and Dora were off to a bungalow. She was soon Picasso's new mistress. Dora lived with her parents in Paris and after scouting a new studio for Picasso at 7 rue des Grands-Augustins — which ran along the Seine on the Left Bank — that address became her sometime domicile. Dora was no naive youngster. She had been mistress to Bataille, himself not quite the Marquis de Sade, but in a literary way, very close. After initiating Dora into his world of radical sex and radical politics, Bataille affectionately described her as "inclined to storms — with thunder and lightning."[34]

Gradually, over the next ten years, Dora Maar became Picasso's companion in public, while in private — and remarkably unknown to most of Picasso's circle — Marie-Thérèse remained his mistress in hiding, the mother of his child. The unfortunate Sabartés, overseer of Marie-Thérèse, would always feel that Dora Maar was an intruder. Yet Picasso had no greater apologist than his longtime friend. Sabartés simply rationalized the sexual escapades as unfortunate, but unavoidable: "He plunges ahead impetuously and blindly."[35]

Naturally, Dora's image would join that of Marie-Thérèse in the paintings Picasso did up to the outbreak of the Second World War. The two women could not have been more different; Marie-Thérèse blonde, soft, and naive about world affairs; Dora dark, alluring, and eager to talk art and politics. Since two of Picasso's properties — his apartment at rue la Boétie and the villa in Boisgeloup — were caught up in his separation from Olga, Picasso now had to set up two new venues, one each for Marie-Thérèse and Dora. In each, he painted them. Marie-Thérèse's residence was a villa just west of Paris, Tremblay-sur-Mauldre, and it was here that Picasso produced a range of colorful still lifes, combined with the round, soft curves of Marie-Thérèse.

In contrast to this tenderness, Dora Maar (often painted at Grands-Augustins) comes off sharp from the very beginning. He first painted her in September 1936. Thereafter, she is identified by her long red nails and dark brown hair. In the future the hair would become bold lines mixed with color. Picasso gave Dora a distinct gaze (and sometimes with two eyes on the side of her head). The summer of 1937 was his Dora period, a time when her many visages seemed to dominate his work.

The constant shuttling around between the women had its price. For a

start, Dora did not like Picasso's main home at rue la Boétie, where Sabartés was in charge (and the spirit of Olga still lingered). Dora came only to Grands-Augustins, where she and Picasso would only partly escape the tensions of life. On breaking with Olga, Picasso had developed a painted image of a "shrieking woman." Soon, Dora's face in paintings would stand for the "crying woman." Such a woman's face—shrieking and crying—would eventually come in handy, making art history.

For Spaniards of Picasso's ilk, the crying had only just begun. In 1933, after years of autocracy, Spain experienced a bloodless overthrow of its monarchy. Now, as a republic, it slated a general election for 1936. Even before then, Picasso had returned to liberated Spain in joy and triumph. He jumped into his chauffeured Hispano-Suiza, a large automobile, and made a pilgrimage to Barcelona with his family, staying at no less than the Ritz Hotel. With equal enthusiasm, Barcelona's municipal museum would try to stock his paintings to show Spain's contribution to modernization.

Soon, Spain's left-leaning Popular Front entered into a political contest with the deposed military and the oligarchs. As the election approached, the progressive forces seized on everything possible to publicize the liberal cause in Spain. An element of that showcasing came in January 1936, when the Friends of Modern Art organized a Picasso exhibition that opened in Barcelona and traveled to Madrid.

Picasso did not attend, but the Barcelona opening was not without its Picassoesque pomp. Sabartés read Picasso's poetry. Salvador Dalí, by now the most famous Surrealist painter (especially in America), read a text of praise. And from the Parisian avant-garde, Paul Éluard arrived to lecture on the accomplishments of Picasso. The Popular Front indeed won the election in the following months, but no sooner had it taken office in Madrid, attempting to get organized, than the military generals, led by Francisco Franco, staged a nationwide coup—the start of the Spanish Civil War.

The clash between the ideological Left and the Right, the communists and the fascists, had been brewing in Europe for over a decade, but Spain was the first spark of war. The Spanish Republicans became the cause célèbre of many European intellectuals. Not a few writers, poets, and artists joined the International Brigade, which armed itself to fight Franco's forces. As fascist Germany and Italy funded Franco, the Soviet Union funded the Popular Front. The Spanish Republicans also turned to the

world-famous Picasso, declaring him head (in absentia) of the Prado Museum, a symbolic move that they hoped would rally further world support.

When Éluard began to write poetry about the struggle in Spain, however, Breton reacted strongly, since Surrealist poetry did not hinge on historical events, but the unconscious. As young men, Breton and Éluard had shared the Dada and Surrealist cause of "joyful terrorism." Now they broke sharply over politics. Breton was plain on this: his friendships were based on proper ideology, not mere human affections. More than Surrealist anti-aesthetics was at stake. In Moscow, Joseph Stalin had just put on the "show trials" that prompted Leon Trotsky to flee for his life to Mexico (where he was assassinated), and that ended in famous revolutionaries — Zinoviev, Kamenev, Bukharin, and Kirov — being shot or imprisoned for "betraying" the Marxist-Leninist revolution.

Everyone on the Left was forced to take sides, including the Surrealists. Breton had sided with Trotsky, and in 1938 would visit him in Mexico (where they drafted a manifesto on art and revolution). However, Éluard, Penrose, and Aragon believed the Soviet Union was the savior of the progressive forces. That meant siding with Stalin. "The proletariat of the whole world is under attack in Spain," Penrose said. "And it's the future of mankind that the Spaniards — and a good many foreign revolutionaries too — are defending."[36] Through thick and thin, Éluard and Aragon, at one time reluctant, now became stalwart members of the French Communist Party. Aragon loyally declared that "socialist realism" was the only valid visual art.

Fortunately, Picasso had learned to stay above the political fray. In any case, Éluard was now his closest poet friend. Éluard now stood in the shoes once occupied by Jacob, Apollinaire, and Cocteau. As a poet, though, Éluard was also a political advisor, the first for Picasso. He was also the person who brought Dora Maar into Picasso's life, and it was in that closest of circles that Picasso watched events in Spain. Dora, being fluent in Spanish, stayed up on the news crossing the border.

Having received word of the atrocities of the civil war in Spain, Picasso's first rapid response was to create a comic strip series of etchings ridiculing Franco, *The Dream and Lie of Franco*, using all his Surrealist and "monster" vulgarity to present the general as a pervert and buffoon. It was caricature at its most extreme, and soon even this would come to Picasso's aid for his bigger project, a mural-sized painting about the Span-

ish conflict. As the Republican government continued to hold on in Madrid and other major cities, some business as usual had to continue. The 1937 World's Fair opened in Paris. It needed pro-Republican artwork to decorate the Spanish Pavilion. The government turned to Picasso, who, despite his allergy to commissions, accepted the job.

For a few months, Picasso was unable to arrive at a clear vision for a big mural. By contrast, he was used to turning out large-scale theater settings in a week or two. From all sides, meanwhile, he was getting advice: for example, he could play off Francisco Goya's icon of protest against Napoleonic dictatorship, the execution scene in the painting *The Third of May*. Picasso was undecided. Then came the headlines that shocked the democratic world. In aid of Franco, the Nazi Luftwaffe, using for the first time their new Stuka dive bombers, had bombed the town of Guernica on April 26, 1937, killing a large fraction of the civilian population.

Picasso, with Dora at his side, seized on the atrocity as his mural theme. They first saw the pictures of the rubble, fires, and carnage a few days later in the French Communist Party newspaper *Ce Soir* (edited by Aragon and, interestingly, for which Duchamp wrote a chess column). In his painter's mind, Picasso began to combine the news photos with many of his old standards: bulls, horses, shrieking women, girls with lanterns, and collages of newsprint, just to mention a few. He put down forty-five preliminary studies, borrowing images from his recent etching series, *Minotauromachy*, which depicted a young girl with a lantern leading a blind Minotaur past a dying horse. Then through May and June he produced the giant canvas, to be titled *Guernica*. Of all the final elements in *Guernica*, the lantern had been in the sketches from the start.

Sensing the historic moment, Dora took photos of Picasso's studies and his putting paint to canvas at different stages.[37] It was a real production; sometimes Picasso is shown painting in coat and tie. An adept painter herself, Dora helped put in large parts of the final brushwork, especially the black strokes that stood for newsprint. These told the viewer that *Guernica* was in the news: it was happening now.

The World's Fair opened on July 12, and the Spanish Pavilion included not only *Guernica*, but also his two bronze sculptures *Head of a Woman* (1932) and *Woman with a Vase* (1933), both inspired by Marie-Thérèse. *Guernica* received mixed reviews. The most surprising criticism came from the political Left. In league with Soviet aesthetics, the Left favored

heroic "socialist realism." It criticized *Guernica* as reeking of tragedy and defeat, not a victorious proletariat. Even in Spain, the Left said the Surrealist painting was "antisocial and entirely foreign to a healthy proletarian outlook."[38] (The Trotskyite art critic Clement Greenberg in New York felt equally negative about *Guernica*, but for his own reasons.) As usual, Picasso took this in stride. Long after the World's Fair and the Spanish Civil War, Picasso could take pleasure in a growing public admiration for the gigantic, enigmatic canvas. For now he offered a few private, bitter rebuttals to his critics. Then he headed to the Riviera for his summer at Mougins, a little town a few miles north of Cannes.

Quite apart from *Guernica*, the clouds of war could not distract Paris from its perpetual hometown debates over modern art, putting both the avant-garde and the traditionalists in a bind suited to each. During the 1937 World's Fair, the avant-garde jockeyed in two rival exhibits over who was truly the cutting edge. The traditionalist bind was probably far worse: as they argued that Cubism and Abstraction had corrupted French culture, in fascist Germany, Adolf Hitler was saying the same thing, that modern art was undermining German culture. His regime held the famous exhibition of "Degenerate Art" (or "Entartete Kunst") which opened in Munich with more than a hundred works. Then it traveled across Germany and was seen by two million citizens. The exhibition, paired with paintings by people in insane asylums, included such names as Beckmann, Ernst, Kirchner, Klee, Kokoschka, and Mondrian. The three Picassos shown came from his Blue and Rose period, and were surely not the prettiest.

These Nazi, and later Soviet, assaults on modern art caught American attention in a big way. As a global ideological war heated up, some American policy-makers began to equate modern art with democracy. It would have far-reaching implications down the road. For now, the American art establishment and the US mass media opened their arms wide to *Guernica* when it arrived in 1939 as part of a world exhibition tour. The exhibit included the photos Dora had taken of the painting in progress. The show opened in New York, Los Angeles, Chicago, and San Francisco. Picasso's Surrealist photographer friend Brassaï took photos for a big spread in *Life* magazine.

Then in November 1939, Barr's MOMA pulled out the stops. It held the largest-ever Picasso retrospective, "Picasso: Forty Years of His Art," which included 344 works. This, too, traveled across the US. The events of 1939

firmly put the image of Picasso in American minds, much as *Nude Descending a Staircase* had done for Duchamp in a different, now-forgotten era.

During the World's Fair in Paris, Breton had been disgusted at the art shown by the French state. As the leader of Surrealism, he had also given up on systems, whether communist or democratic. Eight years earlier, his second manifesto of 1929 had called for political action, but by now he had decided to hew only to personal revolution, sidelining social reform for the heart of Surrealism in the first manifesto, which said, "only the marvelous is beautiful." As Breton had said further, "We really live by our fantasies when we *give free rein to them*."[39] So Breton gave free rein to fantasy, sex, and the unconscious by way of Surrealist art shows.

That was possible because Breton, like Duchamp, was never completely averse to a little business on the side. In early 1937, a Paris businessman hired Breton to manage a new gallery in the fashionable Saint-Germaine-des-Paris neighborhood. Breton named it Gradiva Gallery (after a 1903 German novel of delusional love, *Gradiva*, which Freud had analyzed for its dream sequence). Breton asked Duchamp to design the entrance. Duchamp installed a large plate glass with the silhouette of a man and woman, arm in arm, cut through it. Breton also persuaded Picasso to design the gallery letterhead.

The gallery failed, but by year's end Breton and Éluard (who were still on speaking terms) were approached by a more powerful figure in the Paris art world. He was the upscale gallery dealer George Wildenstein, who ran the prestigious Galerie Beaux-Arts, whose clientele reached high into Parisian society. At the advice of his art critic friends, Wildenstein sought entrée into the newest market. So he asked Breton and Éluard to organize an "International Surrealist Exhibition."

The agreement was struck. Next, Breton and Éluard turned to Duchamp, Dalí, Ernst, and Ray to help design the gallery environment. Breton had control and veto power on the design, but he vested the most authority in Duchamp. Though busy with his *Box-in-a-Valise* production line, Duchamp liked the idea of creating a radically new kind of gallery environment, much as Picasso had designed theatrical sets. In New York, Duchamp had leaned toward stark white rooms in Société Anonyme exhibits. In 1930s Paris, however, the cabaret aesthetic was leading everything to the more risqué and bizarre. In general, the Great Depression had produced a taste for extreme spectacle. For Surrealists, dummies and

mannequins had become favored objects, especially doll-like naked female dummies or, as seen in the paintings of the Belgian Surrealist Paul Delvaux, voluptuous, zombie-like nudes. Breton and Duchamp decided they'd like to go further than all of these.

With the January 17, 1938, opening approaching rapidly, a general theme was arrived at. They would put an outdoor environment indoors. The gallery floor plan had a long entrance hall that fed into a large central space. That space was to offer the effect of an outdoor grotto, cool and dark. To achieve this, Duchamp hung twelve hundred newspaper-stuffed coal bags from the ceiling, spread dried leaves on the floor, added puddles of water and reedy plants, and put a flickering electric brazier (like an outdoor fire) at the center. Outside the entrance, Dalí set up his *Rainy Taxi*, in which an elegantly dressed female mannequin sat in the back seat, ensconced in plants, as rain water (through pipes in the taxi ceiling) fell on her. Later, snails would crawl on her as well.

Back inside, the entrance hallway was lined with fifteen wax female mannequins, the kind that were made to be sexually attractive for fashion stores. Each was decorated differently, often bizarrely, by a Surrealist artist. The hallway also featured street signs: "Street of Lips," "Blood Transfusion Street," and "All-Devils Street." Duchamp left his mannequin conspicuously naked except for a coat and hat, and then a "red light" in the coat pocket. He signed "Rrose Sélavy" by the crotch. To add more of this risqué flavor, four gaudy, disheveled brothel beds stood around the grotto. For added effect, a recording of laughter at an insane asylum was played, coffee was brewed for the smell, and on opening night a least, a partially naked vaudeville dancer dashed in, gyrated on one of the beds with a rooster, and on her stomping retreat splashed the floor's dirty water on guests.

Despite the dim lighting and bewildering cacophony, visitors who stayed (for some rushed out) were treated to Europe's most comprehensive exhibit of Surrealist art: some 230 works by sixty artists from fourteen countries. Duchamp showed his *Rotary Glass Plates* (1920) optical device.

The newspapers made merciless fun of the exhibit: "When Dada Goes Gaga," "The School for Pranksters," "Surrealism's Death Agony," "Surrealism Dead, Exhibit to Follow."[40] Attendance at the month-long exhibit was outstanding, but it seemed to be mostly teenagers and gawkers. In many

ways the exhibit was the high-water mark of the Surrealist movement, made all the more so by Breton and Éluard producing an exhibition catalog that was, in reality, an "abridged dictionary of Surrealism" with 368 definitions, most of them absurd or humorous. On opening night, January 17, Breton was in a bad mood, so the eloquent Éluard, wearing tails, read Breton's welcoming remarks. As usual, Duchamp was nowhere to be seen.

That day, Duchamp and Mary Reynolds had taken a train and boat to London. At the moment, Duchamp was also working for an American dealer, Peggy Guggenheim, who had a lot more money to spend than Breton, who was always broke. Guggenheim, an American heiress, was opening her first art gallery, the Guggenheim Jeune at 33 Cork Street, London, and she had recruited Duchamp to curate and install the first show. Duchamp had met Guggenheim at Mary's home around the start of 1937. Many years earlier, Mary had been the lover of the American artist in Paris, Laurence Vail, a man who, making his choice in 1922, had instead married Guggenheim for her money. All was forgiven, though, so Mary and Peggy Guggenheim remained close friends, and now, in fact, the somewhat promiscuous Peggy had a crush in Duchamp. As she wrote in her memoirs, *Out of This Century*, "Every woman in Paris wanted to sleep with him," and indeed claimed that she, too, had the honor.[41]

Whatever the truth, she had hired Duchamp to select and organize the material for her first London show. Oddly, Duchamp had chosen drawings by Jean Cocteau, a poet, but in Paris, everyone with a name did "drawings," and since 1930, Cocteau had become a rising name in French avant-garde filmmaking. Duchamp and Mary headed for London to hang the exhibit. Guggenheim's gallery, her first, was set to open on January 24, 1938 (as her elderly uncle, the mining magnate Solomon R. Guggenheim, was about to open, the next year, his own Museum of Non-Objective Painting in New York City).[42] She had no more luck than Breton had had with Gradiva. However, the attempt launched a fruitful business partnership between her and Duchamp for the next several years. "He taught me the difference between Surrealism, Cubism, and abstract art," she said.[43] "I could not distinguish one modern work from another."

The market for avant-garde galleries was picking up on both sides of the Atlantic, and a well-known kind of chemistry was coming into play. Investors needed art experts to tell them what to buy, what to show, and what to sell. Duchamp was such an expert, and as he realized the

potential here, he also began to see more clearly the end game for his life in art. Dreier, too, was trying to get Duchamp's attention. So were two American dealers. Julien Levy, who'd met Duchamp on the ocean voyage, was back in Manhattan eager to corner the Surrealist market. And Sydney Janis, the wealthy clothing dealer, also wanted to break into the new art scene. Janis had tried (unsuccessfully) to persuade Dreier and Arensberg to merge their collections, rich in Duchamp materials, into a museum of modern art in Los Angeles.

As these failed ideas whirled around in America, Guggenheim had Duchamp's ear in Europe. After a year, she closed her London gallery and hired the British art historian Herbert Read to help her establish a modern art museum. This began with Read preparing a list of artworks the museum would need. To his chagrin, no doubt, Guggenheim took the list, but dropped London: she would open a museum in New York instead. She promptly took the list to Duchamp in Paris. She had forty thousand dollars to spend. She asked Duchamp's help in buying everything they could find, mostly in Paris. The clouds of war were making Guggenheim's famous shopping spree a matter of urgency.

AS SPAIN WAS falling to Franco, and Hitler was on the march, Picasso continued his routine of living in Paris, where he had two residences, and spending summers in the Riviera. One summer, he stayed in Man Ray's apartment. That was 1939, a time when he produced his most fascinating painting of this tense period, *Night Fishing at Antibes*, Antibes being one of the resort towns on the Riviera. Picasso was fascinated by how at night the fishermen used bright lights to draw fish, both hooking and spearing them. He used this nocturnal drama to suggest something about how the war-torn world was looking to him — kaleidoscopic with dark and light, life and death. As another symbol of the time, he'd collected a bleached cow skull from the beach. It would come in handy: he did a variety of skull paintings during the war.

Around him, Picasso's poet friends were at war with each other. After Breton's three-month trip to Mexico as part of a French "cultural mission," he returned in late 1938 as a fiery Trotsky partisan, attacking the Soviet obeisance of Éluard and Aragon. "Picasso is right in the middle," said Éluard, who otherwise was speaking well of the Soviets to Picasso.[44] Then came a crushing blow to the Left: in 1939, Stalin revealed his non-

aggression treaty with Hitler, as the two dictators divided up Poland as war spoils. It was a nightmare for the Marxist Surrealists. For a good while, a cold silence fell across their once vibrant opinions.

Imagining the worst, Picasso tried to consolidate the location of his mistresses and tried to keep his mind on his work. For many of the artists in Paris, the city of Royan, a beach town on the Atlantic coast halfway down the French coastline, was eyed as a haven from the growing hostilities. So Picasso took Marie-Thérèse and Maya there, put them in a hotel, and made Sabartés overseer. Over the next few months, he moved Marie-Thérèse and Maya to a villa in Royan. He and Dora took the hotel, and he also rented a full studio on the third floor of an oceanfront house. The spectacular view showed up in some of his paintings. Still, Picasso had to spend most of his time in Paris. "I am working; I am painting; and I'm fed up," he wrote Sabartés. "I would like to be at Royan; but everything takes too long."[45]

Eventually, Picasso made his way to Royan. He was there in September 1939 when France declared war on Germany. Suddenly, the nightmare of requisition came back to him from the First World War. He and Dora took the next train to Paris. He checked on his artworks in Paris bank vaults. He also made sure his papers were in order. Much of Picasso's highly valued art was safely on tour or in galleries in allied nations. Some of it, though, was in territories besieged by the axis powers, its fate uncertain.

After this first Paris sortie, Picasso and Dora returned to Royan, though he would go back on more errands. During his days in Royan, Picasso continued to fill his sketchbooks and paintings with local scenes, such as the fish market and, in one canvas, *Cafe at Royan*. By the next year, in May 1940, the Germans began the invasion of France. In the weeks, and even days before, many in the Surrealist circles had fled to the west coast. Picasso and Duchamp both left Paris on May 16, a day after the German breach of French territory, Picasso ending up in Royan, where Breton had also gone, and Duchamp joining his sister Suzanne on the coast just west of Bordeaux, and Mary Reynolds joining them soon after. They all sat by the radio when news came that France had fallen. Picasso was in Royan on June 23, 1940, when the Germans marched into town. Just two doors down from him, they took over an oceanside hotel as Nazi headquarters. Their red Swastika flag snapped in the costal winds. Two days later, France's new Vichy government signed an armistice with Germany. On

the day of the armistice, Picasso was just as helpless as anyone: he painted a full-face portrait of his five-year-old daughter Maya.

For now, the Germans had control of the north and Paris, but the south was considered a free zone, or so it seemed. Eventually Picasso returned to Paris. He and Dora went first, filling his big car, the Hispano, with his artwork. They moved into the Grands-Augustins studio. Picasso found another apartment on the Boulevard Henri IV and asked Sabartés, still in Royan with Marie-Thérèse and Maya, to bring them there. Picasso left the opulent apartment at rue la Boétie empty, available as needed. During the first year of the occupation, German officials took stock of Picasso's belongings. They looked in the Paris bank vaults. One day, they also visited Grands-Augustins. As Picasso tells it, a German officer picked up a postcard image of *Guernica* and asked, "Did you do that?" Picasso replied, "No, you did."

Fortunately for Picasso, the Germans knew of his international renown. They saw no advantage in harassing him. They only forbade the Vichy regime to exhibit his works. Both Picasso and Matisse had been invited to the United States, and Mexico had offered Picasso asylum as well. Neither wanted to leave France, however, and as Matisse wrote his son in New York in September 1940—with the kind of egotistical artist's verve that Duchamp bridled at—"If everyone did his job as Picasso and I are doing ours, all of this wouldn't be happening."[46]

While the day would come when the French resistance considered Picasso one of its own, in practice he laid low. It was heroic enough to stay in occupied Paris. Short on food, art supplies, and even coal, Picasso nevertheless found ways to express his artistic energies. There was nothing else for a left-wing artist to do. For now, the United States was neutral and the Soviet Union had allied with Hitler.

"WELL, IT HAD TO COME," Duchamp had written Dreier in September 1939, when war had been declared.[47] His first reaction, like that of many in Paris, had been to leave the city, and in this first instance, he had gone south to join Mary, who was on the Riviera for the summer. When the coast seemed clear in December—for a real war had not yet ignited—Duchamp and Mary returned to Paris. He had two big projects to stay abreast of. Although Guggenheim had left Paris for Switzerland in spring 1939, she still relied on Duchamp to finish with some of her

painting purchases. Guggenheim had already transported the bulk of her acquisitions to the Grenoble Museum, where the artworks were hidden away. Eventually they were crated and labeled "household goods." This allowed the cache to circumvent export restrictions when, in spring 1941, it was shipped from Marseille to New York.

Duchamp's second flight from Paris had come on May 16, 1940. Paris had fallen in mid-June, and after that, he and Mary had stayed put on the western coast. Then in September they returned to the capital city. Neither of them seemed in a hurry to exit the occupied country. For one thing, Mary did not want to leave her house and cat, as Duchamp recalled. Duchamp also had his *Box-in-a-Valise* project spread all over. He needed to consolidate what he had done so far. His friends in America worried about him. Dreier was beside herself trying to find ways to rescue him. Arensberg worked his own end. "DO YOU NEED HELP?" he had cabled Duchamp on June 20, 1940.[48] The cable included $125. Eventually Duchamp would need help, but for now, the *Box-in-a-Valise*—the very summary of his life—came first.

By the time war had been declared in 1939, Duchamp had already completed a first round of about fifty small photo reproductions for the *Box*. Then in September 1940, as the sky battle raged over Britain, he worked with his Paris craftsmen, who completed making the small solid objects, such as tiny urinals. Now he had enough of all the sixty-nine pieces to make fifty boxes (which he would do in America). He also knew where his fortunes lay; so in January 1941 he completed one box, the first, as a special gift for his financial patron Peggy Guggenheim. It was a deluxe edition, which he gave to Henri-Pierre Roché, who brought it to her later.

By spring of 1941, travel restrictions had tightened under the Germans and the Vichy regime. It was time for Duchamp and Mary to part. She was staying in Paris. He put his sights on America, taking a route through the southern coast, where his sister, Suzanne, had a home in the town of Sanary near Marseille. By posing as a cheese deliveryman, bearing the requisite papers, Duchamp carried his *Box-in-a-Valise* materials to Sanary. It took three trips, and then he never returned to Paris. At this point, Marseille had become the only free port operating in occupied France, and it was there that Guggenheim finagled to have Duchamp's cache put inside her "household goods" shipment. The tiny pieces were on their way to New York.

Duchamp would live in Sanary for the next eleven months, awaiting his passport, exit visa, and American emigration papers. These were all working their way through a Byzantine process, which almost faltered. At age fifty-two, Duchamp was weary at yet another wartime flight. Yet it seemed the best alternative. In recent years, Arensberg had been trying to persuade him to move to Los Angeles and become head of his Francis Bacon Foundation, dedicated to the proposition that the English states-man was the true author of Shakespeare. Duchamp had been indifferent. Now, as Arensberg, Dreier, and even Alfred Barr scrambled to try to get him out of occupied France, he was almost lackadaisical.

To start the process, Arensberg had officially invited Duchamp to America on August 22, 1940. He assured Duchamp that he had sent a law-yer to Washington "to personally take up the case with the Federal Au-thorities."[49] In correspondence, Arensberg said the money problem might be worked out based on his purchase of more Duchamp items. Duchamp asked them to send all the paperwork to the American consulate in Mar-seille, which was close to Sanary.

Many of the Surrealists, also hankering to leave France, were holding out at a hotel near Marseille; Breton was their titular leader. Duchamp preferred his independence. He met up with Roché, went to Monte Carlo, and traveled to Geneva (to collect money owed to him). He found the oc-casional cafe for a chess game, for he "needed a good chess game like a baby needs his bottle," Roché said.[50] During this impasse, another bene-factor came into Duchamp's life. He was Frank Hubachek, a wealthy law-yer in Chicago and an art patron; he was also Mary Reynolds's devoted brother. As Hubachek reluctantly accepted Mary's decision to stay in oc-cupied Paris, he worked with Arensberg to muster the money for Du-champ's overseas travel.

Finally, Duchamp was able to match up his French passport and exit visa with the American entrance visa, which came at the last minute. A few days later, on March 14, 1942, Duchamp left Marseilles on a small steamer bound for Casablanca, Morocco, where he stayed eighteen days. After a plane flight to Lisbon, he boarded a neutral Portuguese ship, *Serpa Pinta*, which had a week-long stopover in Bermuda before reaching New York City. Duchamp's good luck was holding up. His only luggage on the trip was his precious prototype for the sixty-nine items in the *Box-in-a-Valise*. This was his thirteenth Atlantic crossing. It was an escape, but by

its exotic portages, it was "the best trip of all. It was perfectly delicious. All the lights were on and we had dancing on the deck every night." In a few more weeks, as *Time* magazine noted, Duchamp was "comfortably installed in Patroness Peggy Guggenheim's swank apartment" at 440 East Forty-first Street.[51]

12 flight of the avant-garde

The first cold winter in Paris was a sign of deprivations to come. From his encampment at the Grands-Augustins studio, where he lived the entire war, Picasso could walk fifteen minutes to visit Marie-Thérèse and Maya at their apartment near the Bastille. He did that every weekend. Once a week he visited Olga and Paulo where they lived on the Avenue des Champs-Élysées. At Grands-Augustins, Dora Maar kept up on politics. Some of Picasso's friends allied with the French resistance, such as Éluard, who had rejoined the Communist Party and gone underground. Eventually, Picasso's Jewish friend Max Jacob would wear the yellow star, and he would die of illness before he could be sent to the camps.

"I didn't paint the war because I'm not the kind of painter who goes out to look for subjects, like a photographer," Picasso said later.[1] If artists such as Picasso were censured or worse, others—such as the poet Cocteau and painter Maurice Vlaminck—collaborated with the Vichy government, which mixed its calls for traditional and nationalist art with an occasional pragmatism that gave some leeway to the avant-garde.[2] Artistic activity was surprisingly robust under Vichy, in fact, but the longer-term debate in Europe pitted classicism and "socialist realism" against all forms of abstraction. The fascists and Marxists were enemies, but they both opposed abstraction and held a common preference for "reality" in art. By contrast, an exiled Surrealist such as André Breton advocated "the marvelous," which meant fantasy.

With no particular stake in that public political debate, Picasso continued easel painting (and later became interested in sculpture). What appeared on Picasso's canvases were mostly female faces, women in armchairs, still lifes, and the occasional view of the Paris skyline. Before the war, Dora's face had become his new template. It was often portrayed in harsh, striated lines, giving Dora—as with Fernande, Éva, Olga, and Marie-Thérèse—an identifiable ideograph. His wartime paintings were not cheerful, but a hint of dark humor often glimmered through as he mixed up the shapes of things—people and fish, for example—in comi-

cal ways. To speak of war, or the death of a friend, Picasso often turned to the cattle skull. One of those wartime icons was *Still Life with Steer's Skull* (1942), a large and eerie painting (about 3 x 4 feet) done in black, purple, blue, magenta, and the incandescent white of bone.

When sculpture drew his interest, Picasso's friends in Paris helped him with a risky intrigue: obtaining bronze to cast his work. The primary result was a piece that became, after the war, a symbol of art and the resistance: the over-life-size *Man with a Lamb* (1944). Picasso did the sculpting with clay and plaster in the bathroom at Grands-Augustins. Then his friends took the cast to a foundry that trafficked in "illegal bronze." The finished work was spirited back to Picasso's studio in the dark of night. The statue, for which Picasso had begun doing sketches in July 1942, revived an old genre. It was classical humanism, a man holding a sheep, as if the good shepherd.

An occasional philosopher, Picasso often said art should disrupt civilization. Now, at a time of chaos, the *Man with a Lamb* did the opposite: "The creative artist is to stabilize mankind on the verge of chaos," he was reported as saying.[3] On the other hand, the war and other exigencies caused him to swing between extremes. So while he produced *Man with a Lamb*, he also came up with the comic-Surrealist *Bull's Head* (1942), made by joining a bicycle seat and handlebars he saw in a trash heap.

By the time the Allied forces landed in Normandy in June 1944, a prelude to the German expulsion from Paris, Picasso was hosting fellow Spaniards at his studio. They prepared for what no one expected so quickly: liberation. During the weeks of street fighting, Picasso lived with Marie-Thérèse and Maya. Picasso became an overnight celebrity as a symbol of the Paris resistance. American GIs crowded into his Grands-Augustins studio for photographs. In August, he painted his first work to have a hint of springtime; he also produced violent drawings, but ones with the heroic spirit of classical painting.

At age sixty-two, Picasso still had the wandering eye. He began flirting at a cafe one day with a twenty-one-year-old art student, Françoise Gilot, and after that did not discourage her visits. He was three times her age, but a mutual seduction was soon underway. For more than a year, Françoise held back. She then decided it was her destiny to be with the great man. By spring of 1946, Picasso asked her to move in permanently at Grands-Augustins.

All the while, of course, Dora Maar was incensed. She called Françoise a mere "schoolgirl," not even a college student. As usual, Marie-Thérèse was in the dark and felt more abandoned than ever before. She wrote Picasso distraught letters almost daily. Dora got the worst of it. Her old Surrealist friends, Éluard especially, barely forgave Picasso for how he treated Dora. On top of that, the Surrealists were deep into Freudian psychiatry. Dora's distress was taken as a mental breakdown. So Picasso's personal doctor, the Surrealist psychiatrist Jacques Lacan, who applied Freudian theory to art, took Dora under his care. He gave her electrical shock treatments.

As Dora, the "crying woman," left Picasso's paintings, the new ideograph of Françoise entered, though she was the least painted of Picasso's many muses. He first painted her as a simple, delicate, abstract flower (*Woman-Flower*, 1946). She could later be identified in figures with a long body, large breasts, and a round head. He made her hair into a sunburst. Early on, Picasso had courted Françoise in the beach towns of the Mediterranean. He took her to meet the aging Matisse at his Hôtel Régina in Nice. They learned lithography together at print shops and visited the pottery kilns of the region. One day in Paris, he took Françoise to his old haunts in Montmartre. There, he introduced her to an old, toothless woman—the formerly beautiful Germaine, the girl that Casagemas had committed suicide over. Beauty does not last, he told his young mistress.

Once an ardent feminist, Françoise soon gave Picasso two children. The first, Claude, arrived in May 1947 and their second, a daughter named Paloma, came two years later. After this birth, Françoise was considerably weaker. Her healing was slow. True to Picasso's pattern, when his women became ill or pregnant, he looked elsewhere. During the war, he had been interviewed by a young female journalist for the student communist newspaper. She was Geneviève Laporte. Now Picasso looked her up, and Geneviève was willing. By the time Françoise left Picasso in 1953, he was seventy and still carrying on with Geneviève.

The one redeeming aspect to all these female heartaches was that many of Picasso's lovers wrote memoirs—Fernande, Françoise, and even Geneviève Laporte—that passed on otherwise hidden details of his life and his methods as an artist. (Duchamp had the same "problem" with his friends' and lovers' memoirs.) Picasso attempted to stop publication

of the memoirs by Fernande and Françoise, but to no avail. The turmoil of Picasso's love life paid off most in his art. When love first bloomed, his painting showed a new verve, and even in the ruins of a relationship, something interesting could emerge on canvas.

TWO MONTHS AFTER the August 1944 liberation of Paris, its art leaders organized a triumphal salon, a revival of the great tradition of the Salon d'Automne, but this time called "Salon of the Liberation." As the organizers explained in the announcement, the salon was "prepared during enemy occupation, organized during the fighting."[4] The organizers gave Picasso his own room in the vast Grand Palais, where he mounted a retrospective of his work, completed mostly during the occupation, which amounted to seventy-four paintings and five sculptures.

Besides a few friends, no one had really seen Picasso's work since *Guernica*. Among his largest paintings were *Woman with Artichoke* and *Chair with Gladiolus*, and he also showed the eerie *Still Life with Steer's Skull*. There were also many portraits based on Dora, Marie-Thérèse, and Maya. As it turned out, the dark mood of the works did not please the art critics on the political Left or on the political Right. As with *Guernica*, the Left viewed Picasso as missing the story of triumph over fascism. The Right continued to see his Cubism as an acid corroding French tradition. The general public found the paintings simply depressing after four years of occupation.

In the streets of France, a violent purge still awaited the Vichy collaborators. At the same time, a great political vacuum opened that was filled by the Communist Party members who had been in the resistance. The French Communist Party suddenly became one of the most influential blocks in the new liberation government. The communists were welcomed by many, but still disliked by many more. In this tug of war, Éluard and Aragon had Picasso's ear, and that actually explained more clearly the negative reaction to Picasso's exhibit at the autumn "Salon of the Liberation." Two days before the opening, the Communist Party newspaper, *Humanité*, announced that Picasso had joined the Party. "While I wait for the day when Spain once again can receive me, the Communist party of France has opened its arms," Picasso said, further praising "all the fine faces of insurgent Paris which I know from the days of August on the barricades."[5]

WHEN DUCHAMP ARRIVED in New York in spring of 1942, there was hardly a barricade to be seen. What he saw was the rapid appearance of new Manhattan art galleries, filling up with European fare. He was also surrounded by French émigrés, many of them spirited out of Marseilles at the last hour by the short-lived American Committee for Aid to Intellectuals. Many had their travel fare paid by Peggy Guggenheim, including Breton and his wife, and the forlorn German painter Max Ernst (twice escaped from detention camps), who was now Guggenheim's husband, which helped facilitate his emigration.

After a short stay at Guggenheim's home, where he began to meet émigrés and the young avant-garde of New York, including the musician John Cage, Duchamp returned to his old stomping ground in Greenwich Village, where the Marshall Chess Club was meeting at the Pepper Pot restaurant. He rented an austere flat on the fourth floor of a brownstone at 210 West Fourteenth Street, a Duchamp address that would become mythical and legendary.

In uptown Manhattan, two great events for modern art were in the making. In both cases, Breton — still wearing his mantle as leader of Surrealism — seemed to play the central role. On return from Europe, Guggenheim established her Art of This Century gallery at 30 West Fifty-seventh Street, a few blocks north of the new Museum of Modern Art (MOMA) edifice. Her opening exhibition was slated for October 20, 1942.[6] The Guggenheim project, though relying on European advice and artwork, was meant to be a distinctly American affair. The other uptown event was organized by the émigrés and the Coordinating Council of French Relief Societies. Help was provided by collectors such as Guggenheim, Dreier, and Arensberg, and also by MOMA curator James Sweeney and the Surrealist gallery dealers Julien Levy, Pierre Matisse, and Sydney Janis. Designed by Breton, the French Relief Societies event was titled "The First Papers of Surrealism," which made sly reference to the paperwork required of the immigrants.

There seemed to be enough quality work to go around in the two exhibits of fall 1942. In effect, these events brought all the future power brokers of avant-garde art in New York out of the woodwork. Around this time, Guggenheim managed to gather thirteen of the émigrés for a group photo, probably taken in her living room, and later known as "Artists in

Exile." At the center of the group sat the large-headed Breton (and Guggenheim inserted herself as well). Duchamp stood in profile in the back row. Down in front, seated and wearing a bow tie, was the Jewish architect Frederick Kiesler, trained in Vienna as a professional exhibition and theater designer, and now an Austrian-American. For the art events of fall 1942, Duchamp and Kiesler were the two men to watch.

Before their shared days in Manhattan, Duchamp and Kiesler had met in Europe. In Paris in 1925, at the International Exposition of Modern Industry, Kiesler had exhibited a geometrical sculpture (similar to a Mondrian painting), his utopian "City in Space" design. At this event he met Duchamp. The next year, Kiesler emigrated to New York and Katherine Dreier recruited him (along with Duchamp) to design futuristic rooms for the Société Anonyme's 1926 exhibition at the Brooklyn Museum of Art. A short man with tall ambitions — one of them being advocacy for Duchamp, eventually — Kiesler landed a teaching post at Columbia University. In 1937 he mainstreamed Duchamp's *Large Glass* by extolling it in an essay in *Architectural Record*, praising it as a superb example of spatial painting: "it will not fit any descriptions such as abstract, constructivist, real, super — and — surrealist without being affected. It lives on its own eugenics. It is architecture, sculpture and painting in ONE."[7]

Duchamp and Kiesler had now, in the 1940s, met up again, and Duchamp was happy enough to accept Kiesler and his wife's offer for him to be a houseguest, renting a room in Kiesler's lower Seventh Avenue penthouse apartment (which gave Duchamp a separate bathroom and door). Beginning in October 1942, Duchamp lived there for a year. October was the month, in fact, when both Kiesler and Duchamp unloosed their powers of art gallery design on New York. Months earlier, Breton had recommended to Guggenheim that Kiesler design her two-room Art of This Century gallery, a design that put the paintings and sculptures at evocative angles on the walls and floor. Meanwhile, after the bizarre theatrical effects Duchamp had given the 1938 Surrealist exhibit in Paris, Breton brought him forward to design the "The First Papers of Surrealism" show, which Duchamp would make famous by winding "a mile" of string around the gallery, as if a giant spider web.

The two exhibitions ran back to back, opening just six days apart, but as the dust settled, Duchamp seemed to get the most publicity. It was much like his arrival in 1915, but now the Manhattan context was Duchamp at

the center of imported European Surrealism. Three months after his arrival, for example, *Time* magazine sent over a photographer to get pictures of Duchamp with his portable museum, the *Box-in-a-Valise*. Later that year, he got headline coverage for his mile of string as well. Though the chaotic threading confused visitors, and at times seemed to block access to the actual paintings on display, the web also provided "the most paradoxically clarifying barrier imaginable," said the *New York Times*. It was no less than "spell-binding."[8]

Gradually, it seemed, Duchamp was becoming something of a set designer, a maker of installed environments, like a backstage theater worker, and no longer a maker of banal objects called readymades. He had not attended the opening of either of the uptown events. But the idea of designing room environments had clearly caught his fancy, probably in the same way that Picasso had been attracted to making three-dimensional theatrical productions.

On a small scale, his *Box-in-a-Valise* — now on a production line in Duchamp's threadbare studio — was also about a three-dimensional presentation. Moreover, Kiesler was giving him some ideas. For some time already, Kiesler-the-architect had been experimenting with gallery presentations. One of his creations was a peephole exhibit mechanism; as the viewer looked through a hole, the viewer also turned something like a ship's large steering wheel on the wall, and before the viewer's eye this moved art items, like a circling display case. In late 1942, for a "kinetic" exhibit at Guggenheim's gallery, Kiesler installed the wheel to display Duchamp's sixty-nine miniature *Box-in-a-Valise* items, presented almost like items in the food-selection machine of an automat.

The two-eyed "peephole" was long employed by commercial arcade owners, offering the allure of a private movie and, in the case of nudity, the thrill of being a voyeur. Duchamp was taken by the idea. For the "First Papers of Surrealism" he put together a single peephole collage. With voyeurism in mind, he cut a hole in cardboard covered with tinfoil, and behind it revealed a photo of female breasts taken from a Surrealist painting, *The Break of Day* (1937) by Paul Delvaux, the Belgian who specialized in voluptuous, zombie-like nudes (inspired, Delvaux said, by life-like medical and anatomical exhibits). Duchamp's quick collage was titled *In the Manner of Delvaux*. Previously, in 1927, Duchamp had suggested to the art dealer Julien Levy that he wanted to make a life-size female machine;

now his plan drifted toward the use of peepholes and a nude mannequin. Rather than a giant mechanized doll, Duchamp's fertile imagination envisioned a stage set or museum diorama, with the doll lying still.

During Breton's days in Manhattan, he seemed to imagine only the worst in a city he disliked. He refused to learn English. As the lonely streets became even lonelier—because there was no cafe culture—Breton turned to the elder Duchamp for advice and solace. He also got a job with the French unit of Voice of America. He and Duchamp met often at the only French cafe they could find, and in front of what few Surrealists he could gather, Breton paraded his awe of Duchamp. However, Breton's political idealism, namely his Marxism, had faded. His faith in any political system became passé. So he grew in the conviction that sex was the only "marvelous" thing left. Having lost one great social myth, the communist paradise, Breton needed another, so he turned to the utopian writings of François Fourier (d. 1837), who presented the case for a free-love society. Though an atheist, Breton waxed esoteric as well. He talked about higher beings that surround the human universe.

At the least, Breton had a new book coming out, which was reason to celebrate. At Breton's request, Duchamp designed a shop window display to announce the arrival of Breton's latest book, *Arcane 17*, a prose reflection on nature, Tarot cards, and his new romance. This was at Bretano's bookstore. For the display, Duchamp put up a naked female mannequin accompanied by a Surrealist painting (by Chilean émigré Roberto Matta) of a man and woman copulating. The vice squad made Bretano's take it down. So Duchamp and Breton moved the exhibit to the Gotham Book Mart, known for importing, under the American censorship radar, Parisian blue literature, such as Miller's *Tropic of Cancer*. To assuage complaints, the Gotham manager put a tiny "Censored" card in the appropriate place.

Window design was nice, but fortunately, Duchamp had a few much larger projects to attend to. These projects made up his end game in life, a plan to secure his place in the art world by throwing a permanent spotlight on his own collected works.

He was now in his mid-fifties, and time was passing. His patron Katherine Dreier was not getting any younger either. She had had a remarkable twenty-year run with her Société Anonyme, which held eighty-three exhibits. The Société collection (separate from her private collection

that included Duchamp's last painting, *Tu m'* [1918], and *The Large Glass*) amounted to 616 works by 169 artists from twenty-three countries. Several museums had eyes on obtaining her collection, but it was the Yale University art gallery, just down the road from her West Redding, Connecticut, homestead, that was most persuasive.

In 1941 she agreed to bequeath the Société holdings to Yale, where they became the nucleus of its modern art cache. The Yale curator called it "the first archive for the study of the modern art movement in an American educational institution."[9]

Naturally, Dreier insisted that Duchamp, as Société president (and executor of her estate), play a major part in the bequest. So in 1943, Duchamp began to compile an annotated catalog for all the works and artists, he himself writing the Picasso entry. Picasso "was able to reject the heritage of the Impressionist and Fauve schools and to free himself from any immediate influence. This will be Picasso's main contribution to art," Duchamp wrote.

> He has never shown any sign of weakness or repetition in his uninterrupted flow of masterpieces. The only constant trend running through his work is an acute lyricism, which with time has changed into a cruel one. Every now and then the world looks for an individual on whom to rely blindly — such worship is comparable to a religious appeal and goes beyond reasoning. Thousands today in quest of supernatural esthetic emotion turn to Picasso, who never lets them down.[10]

In short, Picasso's main sin was that he played to the crowd (and in comments elsewhere, Duchamp did accuse Picasso of repetition).[11] Duchamp was also able to include entries in the catalog about his family, which now attached its legacy to Yale University, soon to be an Ivy League hub of modern art. Yale revealed its indebtedness to the Dreier-Duchamp alliance in 1945 by holding the first ever exhibition on "the Duchamp brothers." For this, the curator, George Heard Hamilton, took a train to Manhattan and bought a snow shovel to stand in for Marcel Duchamp's 1915 readymade. "On that occasion the snow shovel reappeared in the world of art, not the 'original' but a new one, another actual shovel, carefully lettered like the first," said Hamilton, inaugurating Duchamp into American academia.[12]

In the period between living at Kiesler's apartment and moving into his own storied Fourteenth Street flat, Duchamp was fairly active in sampling

the New York art scene, which meant going to various galleries and art parties. In general, he preferred to stay among the Europeans. That was for good reason. The American painters in New York resented the continued European dominance, illustrated even before the war when Salvador Dalí, in 1936, appeared on the cover of *Time* magazine, leading Americans ever after to see him as the pope of Surrealism, a new, weird style of painting (since Americans never learned it was actually a literary movement in Paris; and that actually, Breton claimed the title of Surrealism's pope).

Already in 1940, the New York painters had picketed Alfred Barr's MOMA for featuring only European modern art (including, on occasion, works by Duchamp). By the end of the decade, when Abstract Expressionism had given the Americans a more unified identity in New York, they also protested against the Metropolitan Museum of Art for excluding their contribution to art. In January 1951, *Life* magazine published a famous full-spread photo of the American insurgents, now known as "The Irascibles."[13]

To her credit, in the early 1940s, Guggenheim had included some American Abstract painters in her Art of This Century gallery. One of them was Robert Motherwell, who, as an Ivy League educated painter, became the official spokesman and editor for the rising force of Abstract painting in New York. Eventually she would fund some of the painters directly. The most famous was Jackson Pollock, a very good investment indeed.[14] Other than Motherwell, none of the Americans really noticed Duchamp, just another European émigré.

As an anti-painter, Duchamp did not waste any love on the Americans, either. They showed an excitement about large canvases, deep angst-driven gestures, and thick paint. One critic labeled them "action painters," and it was said that their painting was "heroic" and sought "deeper truth." All of this struck Duchamp as the same dumb fluff that he'd seen among the salon Cubists thirty years earlier. With their expressionism, he viewed the New York painters as doing "acrobatics," and before his eye believed he was witnessing a new "debacle in painting."[15] Later in life, Duchamp was forced to recognize that the 1940s and 1950s in New York were artistically significant, but even at that point, he credited the émigré influence as the leaven in the bread.

He also waxed nostalgic about the good old days. Thinking back to 1915, when he first came to New York, Duchamp said that art in Manhattan was more "genial" and innovative. In those days "art was laboratory

work; now it is diluted for public consumption." As with any older person, Duchamp naturally enjoyed contrasting the halcyon past with the misguided present. "Today the abstractionists who are working are merely retinal," he said in a 1953 interview. "They merely repeat and that is not good. To keep on doing the same thing is like being an old maid."[16]

The New York art scene still had a strong contingent of Europhiles. One of them was James Sweeney, who had already been director of painting and sculpture at the Museum of Modern Art (1935–1946) for seven years when Duchamp arrived in town. A native of Brooklyn, the large and athletic Sweeney had studied literature at Cambridge, edited a Paris review, and, like Irishmen before him (namely, John Quinn), was a supporter of James Joyce; he'd helped edit his works. With a taste for Joyce, Sweeney clearly had a taste for Dada as well, which explained his growing interest in Duchamp.

One of Sweeney's projects was a series of interview articles on "Eleven Europeans in America," which included Duchamp. With Duchamp in particular, Sweeney pursued extensive taped interviews in hopes of writing the first book on him (which never transpired). In any case, in the postwar years, Sweeney was a kingmaker for artists, especially after 1952, when he became the decade-long director of the Guggenheim Museum (founded by Peggy's uncle, Solomon). Sweeney elevated Duchamp in significant ways. He injected him into major New York exhibitions and even got him on national television in 1956, when Sweeney interviewed Duchamp amid his artwork for the NBC series "Wisdom: Conversations with Elder Wisemen of Our Day."[17]

Besides Guggenheim, Duchamp had a few other gallery owners who valued his friendship, especially as an advisor on what European art to invest in. Chief among them was Sydney Janis, a wealthy shirt manufacturer who, before the war, had wanted to sink his money into a major modern art museum. Now, he became known in New York for exhibits that also had a scholarly flavor to them. For a mind such as Janis's, the English-speaking Duchamp was the most interesting European artist. For one thing, he could guide Janis in what was hot. "Marcel had the inner confidence that I've observed in only one other painter, Mondrian," Janis said later. "Both Marcel and Mondrian liked things that were very different from what they were doing. They didn't have to protect their own point of view, all the time."[18]

Having talked to both Arensberg and Dreier, Janis was also aware of Duchamp's exploits before his later biographers had got hold of them. As early as 1945, Janis and his wife Harriet wrote an analysis of Duchamp's intellectual contribution as an "anti-artist." This was published in the Surrealist journal *View*, which dedicated an entire issue to Duchamp in 1945 (the issue was overseen by Breton, who used it to present Duchamp as the historic bridge between Cubism and Surrealism).[19] For the next decade, Duchamp would aid Janis in developing his gallery, helping with topics, such as the 1953 exhibit "Dada 1916–23," and with catalogs.

Manhattan's uptown gallery scene would play an important part in what Duchamp decided to do with his life after his emigration. At one of these galleries, not surprisingly, a fateful turn came fairly early on, perhaps as early as 1943, when Duchamp met a vivacious Brazilian artist who was showing her Surrealist sculptures in New York in a joint exhibit with Mondrian. Her name was Maria Martins, wife of Brazil's ambassador to the United States, but already known as a femme fatal, mistress to one émigré sculptor, Jacques Lipchitz, and rumored to have slept with Nelson Rockefeller as well (since, somehow, three of her sculptures were acquired for the permanent collection of MOMA, of which Rockefeller was president).

Apparently, Martins — who went by the artist name of simply "Maria" — relished her reputation. She merged her own personality with her interest in Brazilian river goddesses, who devoured their prey. She expressed this mystique of danger in a poem about the demise of poor Lipchitz who, fighting against his passions, fled from her boudoir to return to his marriage. Maria said in her poem:

Even long after my death
Long after your death
I want to torture you.
I want the thought of me
to coil around your body like a serpent of fire
without burning you.
I want to see you lost, asphyxiated, wander
in the murky haze
woven by my desires.
For you, I want long sleepless nights

filled by the roaring tom-tom of storms
Far away, invisible, unknown.
Then, I want the nostalgia of my presence
to paralyze you.[20]

With poetry like that, André Breton favored Maria also. He liked her spooky sculpture as well. He agreed to write the catalog essay for the March 22, 1943, show of her eight bronze Surrealist sculptures at the Valentine Gallery in Manhattan. It was at that show's opening that Duchamp may have met Maria. Whatever the case, the coincidences he saw between his life and hers became an obsession. In her discreet way, Maria had continued her role as a well-known hostess in diplomatic circles in Washington, where her husband and three teenage daughters lived, but she was very often in New York on the pretext of operating her sculpture studio, making and marketing her jewelry, and fulfilling social roles in Manhattan's art and diplomatic world.

Having arrived in winter of 1941 to 1942, she rented a three-bedroom duplex at 471 Park Ave at Fifty-eighth Street, with a high-ceilinged studio on the ground floor. When she and Duchamp began their affair, perhaps as early as 1943, he would rendezvous with her at the uptown apartment, staying days on end. "I have started to dream about number 471, as that is where we had our best times, and to relive them will be joy redoubled," he wrote to her when she was away.[21] Maria had also visited Duchamp's simple studio flat at Fourteenth Street. He would eventually urge her to leave her family and live with him in the cramped studio space, a way to realize her "higher destiny" with him in the true life of two artists shut off from the world.

The Marcel and Maria story might have been a "princess and the pauper" fairy tale with a happy ending. It was complicated from the start, however. Neither of them was suited for a committed relationship, apparently, and Duchamp had his past with other women to deal with. That past, in the person of Mary Reynolds, suddenly arrived in New York in early 1943, just as Duchamp was falling for Maria. In wartime France, Mary had helped the resistance. Her code name had been "Gentle Mary." On her discovery by the Gestapo, she escaped to Spain on foot, an eight-month ordeal across the Pyrenees Mountains. How Duchamp handled these love affairs—with Guggenheim and Dreier also pouring affections

upon him — is a mystery. At times like this, his famous indifference came in handy. Mary convalesced in New York for the next two years. She sought a linguist job with the Office of Strategic Services. Then, six weeks after the war was over, she returned to her beloved home in Paris, just south of Montparnasse. Duchamp, who could not dissuade her, saw Mary off at the docks.

Over the same period, in Manhattan, Duchamp and Maria Martins had begun to arrange their life together between her apartment and his flat. In the process, Maria learned about Duchamp's plan to make a great work of art, something as big as *The Large Glass*, perhaps even bigger. Still in the idea stage, Duchamp's new project had the feel of Romeo and Juliet, at least on Duchamp's part, and was clearly motivated by his discovery of Maria. Duchamp's idea was to build a theatrical set, like a diorama at a museum, which would somehow include a naked female mannequin with her legs spread open.[22]

He had toyed with the idea for a while. Since the 1938 "International Surrealist Exhibition," theatrical settings with naked female mannequins had become a kind of Duchamp specialty, including his bookstore exhibit for Breton. He also liked the idea of peepholes. To move ahead on his new project, he persuaded Maria to help him by providing her body as the model. She was excited by the idea of Duchamp casting her naked body to create a form for his mannequin.

So they went to a casting expert Maria knew from her own work, and he trained them in body casting. Duchamp eventually made a cast of Maria's crotch and legs, with her left leg extending out, creating the kind of posture — what Duchamp called "my woman with open pussy" — that would characterize his mannequin.[23] Maria and Duchamp were having some naughty fun. As a woman who lived in the heart of wealth, society, and modern art, she was drawn to Duchamp's mystique as a Parisian living the bohemian life, the life of a true artist.

AT THE TIME, a bit of bohemian myth begun to swirl around Duchamp. He was said to be a kind of artistic hermit, even a "monk," living in self-depravation at his unadorned Fourteenth Street garret, dedicated to the "gray matter" of art and chess. The reality was not quite so austere, of course. Duchamp had lived at the Kiesler's comfortable apartment for a year. After meeting Maria, he spent a good many days in her sumptuous

abode. When the press came, however, he met them at his garret. A *Life* magazine writer portrayed him as an aging "high-brow" oracle living with a mere chessboard, "outwitting" the rat race society. "Ambition, as he well knows, is a trap, and might threaten his individuality by entangling him in competitive activity," *Life* reported.[24]

Duchamp did prefer a life that was simple and portable. He spoke highly of *la vie de bohème*. He expected to be a pariah; the artist must "be completely blind to other human beings — egocentric in the grand manner."[25] Though usually dapper, a Paris dandy, he had the skinny bohemian look. By one testimony, at meals he ate only a few peas and a tiny bowl of noodles; his flat had only a few crackers and pieces of chocolate. When asked by the press, Duchamp disclosed that he was living on something like a monk's wages. "My capital is time, not money," he said, and in letters to patrons, he spoke of the boredom of "my usual life" and drudgery of making all those *Box-in-a-Valises*.[26]

There was another side to the bohemian, too. He seemed to think a lot about money, and actually did not do too badly. In letters to his patrons, he talked often about income. Duchamp was dumbfounded, he told Dreier in a 1944 letter, that he could be a "star" in the New York art world, but still "not to be able to at least make an ordinary living out of it."[27] Nonetheless, Duchamp could afford to chain-smoke Cuban cigars and go out for double martinis most nights. If anything, Duchamp wryly corrected, artists like himself are destined to be a "lewd monk" in the tradition of François Rabelais's writings (which followed the mischievous adventures of monks enjoying wine, women, and song).[28]

In hindsight he spoke of his bohemian life in New York and elsewhere as "slightly gilded — luxurious, if you like."[29]

Before Duchamp met Maria, she, too, had enjoyed a luxurious life. She also had fairly high recognition as an artist, praised as an important new Latin American sculptor. One of her large figurative sculptures (plaster painted like bronze) of an exotic river goddess — eight feet tall and based on Amazon River myths — had been debuted at the Philadelphia Museum of Art in 1940. When it was bronzed soon after, the museum purchased it for permanent display on the East Terrace. In this manner, Maria had gained permanence at the Philadelphia museum, which sat on a hill, like the Acropolis, and looked like a massive Greek temple (and which, one day in the future, would also contain the works of Duchamp).

As a fellow artist, Duchamp began to show his affection toward Maria by making art for her (as she apparently did for him, or, at least, she was inspired by their affair to make art).[30] In the first such gift, in 1946, Duchamp, now about sixty, ejected his seminal fluid on a piece of plastic, put over it another sheet (like his two-ply repair of *The Large Glass*), mounted it on black velvet, and then framed it. He titled the swirling dried shape *Defective Landscape*, and sent it to Maria, who had temporarily returned to Brazil with her family, and who received it happily, perhaps not knowing Duchamp's innovative medium.

Compared to such small "artworks," however, Duchamp had a vision of making a gigantic homage to Maria, now that she had agreed to let him cast her body for a diorama with a naked female mannequin. He once called the mannequin "Our Lady of desires," since he joked with Maria about them putting behind the outside world and cohabiting at a secular monastery, his studio. Whatever his original idea might have been, the diorama was turning out to be his love letter to Maria, who, for all he knew—and wished—would leave her family and join him in bohemia. It was a hope denied. In 1948, after perhaps five years of their Manhattan affair, Maria followed her husband to Paris for his final tour of diplomatic duty. By 1950 she would be back in Brazil with a retired husband.

As the return to Brazil approached, Duchamp felt helpless. He tried to evoke Maria's sympathy. "I believe more and more in an absolute retreat from the world," he wrote. A state of despair descended after the middle of 1950. Duchamp wrote her that he was "totally lost now that we are completely cut off from each other," and the next year he was "seized by blind rage" over their separation, but mainly because she had missed her "higher destiny" of being a real bohemian artist with him.

"Where are our happy days and happy nights?" he asked.

Maria visited New York in late 1951, rekindling Duchamp's hopes, but he was deluded by love. After the visit, he wrote, "I am more and more convinced that our situation is hopeless." He hoped for a miracle, a way to realize a "semblance of happiness."[31] Finally, Maria was out of the picture—but the diorama, taking on a life of its own, would continue to live on in a strange new way.

DUCHAMP'S INFATUATION with Maria had begun as a wartime love affair, and when the Second World War ended in 1945, both he and

Picasso were nevertheless required to put aside some of these matters to deal with the postwar art world. The same would be true for Breton, who divorced his second wife during the war and found a third. The new Bretons returned to Paris in April 1946. The bitter feelings among French artists over their political alliances, some with the Vichy, others with the communists, were hard to avoid in Paris. When Duchamp returned, he managed to skirt them entirely, it seems. This was not the case for Breton, who wanted to re-establish his leadership at the head of Surrealism, which he believed was a distinctly French movement of arts and letters.

On the streets of a coastal town in the Riviera one morning, Breton crossed paths with Picasso, who extended his hand.[32] Breton, believing that Picasso had sided with Stalinism, refused to reciprocate. He even demanded an explanation for Picasso's Communist Party membership. "My opinions," Picasso told him, "derive from my experience. Myself, I consider friendship more important than politics."[33] Committed to Surrealist ideology more than friendship, Breton turned away, unforgiving. In Breton's view Moscow was simply victimizing the avant-garde as useful idiots.

During the war years in Manhattan, Breton and Duchamp had spent many an afternoon at the city's only French cafe, talking and killing time. By the time they both traveled back to Paris separately after the war, they were easy enough allies. They had jointly planned a new Paris event, a "Surrealism in 1947" exhibit. Arriving in Paris in May 1946, Duchamp had brought Maria Martins along for a short visit to the city. Duchamp himself stayed only six months, having gone mainly to renew his US visa. After Maria had left Paris, Duchamp met up with Mary Reynolds, and they took a five-week vacation in Switzerland. Some of these days were spent at a hillside inn overlooking Lake Geneva. From there Duchamp espied an enchanting visage, the Forestay Waterfall. For his diorama, Duchamp had not yet decided on the environment in which he would put his naked female mannequin. As he watched the waterfall, and doubtless thought of Maria, he wondered: maybe he should do a landscape with a waterfall.

When Duchamp left Paris in January 1947, he agreed to be the in absentia New York organizer of "Surrealism in 1947," and meanwhile sent the ambitious Kiesler to Paris to help Breton design the gallery exhibit. At the heart of the exhibit was a grotto, draped in white fabric, called a "hall of superstitions." Another hall would have a billiard table. Rounding up

the usual suspects, the exhibit opened at the Galerie Maeght, featuring eighty-seven artists from twenty-four countries. Back in New York, Duchamp designed and produced about a thousand catalogs. On the cover of each he and a helper glued a foam "falsie" with painted nipple, and added the title "Please Touch." Then he shipped them to Breton in Paris.

For such an event as the "Surrealism in 1947" exhibit—a kind of absurd ode to anarchism and Freudianism—the mood in Paris was not nearly as receptive as the one Breton had found among the black-tie art mavens in New York. Paris was in financial ruin and riven by the political divisions of the Vichy period. Even after the fall of Vichy, the celebratory "Salon of the Liberation" had hit a wrong note, since Picasso's dark paintings were hardly what Paris wanted to see. Now came the freakish Surrealist exhibit. Janet Flanner, an American correspondent in Paris, called it the "first psychopathic aesthetic exhibition since the war." In her *Paris Journal*, Flanner continued: "In the midst of the crisis in civilization, the intelligentsia Surrealists are still raking in cash through the inspiration of their private, patented muse—a composite of the Marquis de Sade, Machiavelli, Maldoror, Narcissus, Mammon, and Moscow."[34] The writer had accurately summarized the proud sources of Surrealism. Rather than a revival, the exhibition was the last gasp of Surrealism. In any case, Paris was the past for Duchamp. He applied for US citizenship as "Surrealism in 1947" fizzled.

DUCHAMP WAS HAPPY to leave behind postwar Paris, where art had become a political minefield. That was for Picasso to negotiate. Not only were Picasso's associates divided sharply over Trotsky versus Stalin (that is, Breton versus Éluard and Aragon), but now Moscow was pontificating about "correct" forms of art.

By turns, Moscow looked upon Picasso's art as corrupt and bourgeois, and yet conversely, Picasso the man was a friend to the workers and a "Comrade of genius." His fame aided Soviet propaganda. Meanwhile, from time to time, Moscow's official voice on artistic orthodoxy, the painter Alexander Gerasimov, pointed out Picasso's impurities. "It is inconceivable that Soviet socialist art should be in any sympathy with decadent bourgeois art represented by those two exponents of formalist thinking, the French painters Matisse and Picasso," he wrote in *Pravda* in 1947.[35] Even so, Éluard praised his old friend in the French party newspaper, *Humanité*,

and in 1950 Moscow gave Picasso the Stalin Peace Prize. (He was given the prize again in 1962, when it was re-named the Lenin Peace Prize.)

Now that the French Communist Party was in the postwar mainstream, having filled the National Assembly with many of its elected delegates, it looked for roots in France's artistic past. It also promoted official party artists at the two annual salons. The party organs, for example, pointed to Gustave Courbet, the French pioneer of realism (unlike the "decadent" Manet) and a member of the Paris Commune, beloved of Karl Marx, as foreshadowing the communist aesthetic. Courbet would not get off easy in all quarters, however—Duchamp accused him as the one who had started the infamy of "retinal" art in France. (The Communist Party, naturally, had never heard of Duchamp.) For its present purposes, the party promoted the academic painter André Fougeron, who specialized in socialist realism of historic events related to workers. He also illustrated *Humanité*. As Fougeron's rivalry with Picasso got personal, Picasso joked in private that he should teach Fougeron how to properly paint hands and feet, the hardest parts in life drawing.

Nonetheless, Picasso played a minor institutional role for the party. When the party held its first postwar congress in May 1945, Picasso provided a realistic portrait of France's party head, Maurice Thorez. This was a wise enough move, since at this congress, party officials declared their hopes that art would adopt a "realism which celebrates the role of the working class."[36] Otherwise, Picasso did not adjust his work to any kind of ideological aesthetic. His most compelling single painting of these years followed in the footsteps of *Guernica*, a similarly Surrealist tableau, *The Charnel House* (1945). It represented the tragic death of a family, but probably was Picasso's response to what he learned about the Holocaust.

When Picasso's *The Charnel House* showed the next year at an exhibition celebrating the French resistance, "Art and Resistance," held at Paris's new National Museum of Modern Art, many in the Communist Party were distressed by his continued non-realism. In time, the Communist Party in France was forced to tolerate an aesthetic compromise, with the French party official Roger Garaudy arguing that, while Picasso's art was not suitable for communist cultural goals, "a Communist has a right to enjoy and admire the work of Picasso—or of anti-Picasso."[37] Among Picasso's old friends, the dogmatically socialist-realist Aragon disagreed. Éluard simply wandered off in his own tastes; he took a fancy for the "de-

generate" and naive art of the Frenchman Jean Dubuffet, who mimicked graffiti and children's scribbles.

As the Cold War became chillier still, Picasso spent more of his time in the warm climes of the Riviera, taking Françoise and their two children there in summer and winter, and favoring a new location, the village of Vallauris. In Vallauris, he became fascinated with animal images, among them the owl and the dove, both of which he was putting into lithographs. Early in 1949, Aragon saw one of Picasso's dove lithographs in Paris, and asked to use it for the poster for the world communist Peace Congress coming to the city. Picasso let him use it as he liked, noting later that the dove, in fact, is a bellicose bird, one that kills its rivals in the cage.

Nevertheless, the first Picasso dove became an instant celebrity not only in the communist "peace" movement but in the popular media of the world. In the next few decades, doves began to appear everywhere, from angry 1960s antiwar banners to cheerful Christmas cards. At the outset, however, Picasso's first dove image began his artistic negotiations with groups allied to the Soviet Union, all of them eager to control Picasso as much as possible. They were disabused of the idea that Picasso was a pliant artist, however, when Stalin died on March 5, 1953, and the question of his artistic portrayal arose.

As editor for the pro-Party *Les Lettres françaises*, Aragon had quickly recruited Picasso to supply an illustration of Stalin to honor his passing. Picasso looked over young and old photos of the beloved strongman and, still not getting the sensitivity of the matter, chose a more youthful one from 1903. On a deadline, Aragon accepted the drawn image, which was quite stylized. The next day the Communist Party was not pleased. Picasso, the most famous artist in the world, had sketched something like a cartoon mask of the young Stalin. The Party wanted a heroic head of the senior statesman. By necessity, the French Communist Party denounced the portrait, adding that it did so "without in any way casting doubt on the sentiments of that great artist, Picasso, whose attachment to the working class is well known."[38]

Beyond the working class, meanwhile, Picasso felt how the modern art world's attention was shifting to the Abstract Expressionists in New York, where the financial wherewithal of the United States — and the many émigré painters — had moved the hub of modern art away from Paris. What bothered him most, though, was that while people nodded approvingly at

his work, even his mediocre work—it was "a Picasso" after all—they no longer viewed him as an innovator. The cutting edge was passing him by. He was becoming an old temple, now overgrown with vines. "What have I done to deserve this treatment?" he said to a friend. "Why do they treat me like an historic monument?"[39]

One feasible answer was that Picasso was hovering around seventy. Even he was looking for a more settled existence. He looked for it in the south of France, with its Mediterranean heat, ceramic kilns, and villas. Soon after the war ended, the curator of the Antibes museum (in 1946) gave Picasso use of the castle-like Grimaldi Palace as a studio, destining the villa to become a regional Picasso Museum. Not far away in Vallauris, Picasso bought a former warehouse that he turned into a double studio, one for ceramics, a second for painting. Sabartés, his secretary—who in 1946 published *Picasso: Portraits and Souvenirs*, the first of his memoirs about life with his boss—was always there for the logistics, moving all Picasso's things into the Grands-Augustins studio, for example, and keeping track of all the rest. Picasso needed one more emotional thing: a protective new "bande" around him, and in the next decades it would turn out to be, as usual, some very old friends, and some very new ones.

Eventually, in 1950, the town of Vallauris, whose mayor was a communist, had adopted Picasso as its honorary citizen. In their city square, the town fathers installed his original bronze *Man with a Lamb*, a 1944 work that would be recast in two additional versions. The town also gave him a deconsecrated Catholic chapel to decorate as a "Peace Temple." (He enjoyed the project, since Matisse, in the town of Vence, had just decorated an in-use Catholic chapel.) Picasso began two immense mural paintings, *War* and *Peace* at the end of 1952, and they were installed at the Peace Temple in 1954.

Despite the comforts of the warm south, and some major artistic distractions, other aspects of Picasso's life unraveled. His friend Éluard died in 1952. He was the last poet to be a Picasso advisor, and another would not fill those shoes. The government in Paris, meanwhile, was forcing Picasso to give up his longest-standing residence, the apartment at rue la Boétie, because of the housing shortage. His friends in the art world tried to intervene, but to no avail. Picasso's worst problem, however, would be brought on by his own behavior. In a few more years, Françoise became fed up with his infidelities, and she, too, left him.

IN NEW YORK, Duchamp was also sorting out his past and present in regard to the women in his life. In 1950, Duchamp had received news that Mary Reynolds had terminal cancer. She was living alone in Paris. Awkwardly, the news came to Duchamp at the peak of his despairing infatuation with Maria (she was headed back to Brazil, never to return). Mary's brother, Frank Hubachek, asked Duchamp to go see Mary in Paris. Duchamp replied that he had "insufficient funds—a somewhat common condition for artists," so Hubachek sent him money for the trip.[40] Duchamp arrived to be with Mary, now at Neuilly clinic, four days before she slipped into a coma. The only friend he visited was Henri-Pierre Roché. By this time in his life, Duchamp spoke of the old group in France as "the Parisian crocodiles."[41]

After Mary's funeral in Paris, Duchamp settled her estate, which included two properties. She had left behind her art projects, such as her book bindings, and a good deal of memorabilia from the days of Dada and Surrealism in Paris. Duchamp sorted through everything. He shipped the belongings to the family in Chicago, where Mary's historical records were donated to the Art Institute of Chicago. In the process, he destroyed all the letters that he and Mary had exchanged over the years, and any other personal data that Mary might have kept on him. Hubachek was deeply grateful to Duchamp for the years he had befriended his sister, Mary, and so provided Duchamp with a financial gift, indeed a kind of artist's lifelong stipend.[42]

On return to America, Duchamp's mind shifted from the Chicago art scene connected to Mary's family to another famous venue, the Philadelphia Museum of Art. If Picasso was complaining that he was being turned into a monument, Duchamp was happily welcoming the fact that the same was about to happen to him in Philadelphia.

That story had begun in the 1940s, when the great art museums of America, seeing the country's ascendance, began to battle each other to obtain the modern art collections that had been spirited out of Europe, where the Nazis were stealing everything they could find. (Famously, the Louvre staff hid everything in the south of France, and its collection survived). At a time like this, the art collection of the elderly Walter Arensberg—who would die in 1954—was being eyed by institutions that hoped to acquire his legacy. Whoever got the Arensberg Collection, though,

would also have the bulk of original works by Duchamp chained to the very heart of Arensberg's lifetime cache.

At his Hollywood home, just five blocks from the famous Grauman's Chinese Theater, Arensberg had assembled his vast collection of modern art and pre-Columbian art, mostly stoneware, and allowed the public to visit by appointment. There were few visitors, though. Since the Depression, and through the war, the Arensbergs had lost some of the wealth of their dual inheritances, but Arensberg's wife had been much more prudent. As Arensberg corresponded with Duchamp to help him escape France, and later to gain US citizenship, they also talked about buying and selling art. Duchamp helped Arensberg acquire some Picassos, and some of his own works, such as the Cubist-style *The Chess Players*, which Walter Pach was selling.

The Arensberg collection did not lay dormant or obscure for long, however. Soon after the war ended, a veritable list of blue-chip museums began courting the aging Arensberg, who had no children. More than thirty institutions wanted his art collection, among them the National Gallery of Art in Washington DC, MOMA in New York, Boston's Museum of Fine Arts, Harvard's Fogg Museum, the Los Angeles County Museum, San Francisco's Legion of Honor museum, and the universities of California, Minnesota, and Stanford. They soon learned of a non-negotiable condition: whichever museum got his bequest had to create a permanent monument to Duchamp's works. As early as 1944, Arensberg had promised the collection to the University of California. But when the trustees saw the package with Duchamp's work at the center, they wiggled out of the agreement, for, as Arensberg wrote, "the conservative trustees hate the stuff."[43] The other museums were not so circumspect. Arensberg's alma mater, Harvard, was pressing in, and the national and California museums were making glowing offers, such as new buildings to house the collection. As they courted Arensberg, their obsequiousness could become annoying. The head of modern painting at the Art Institute of Chicago complained privately that Arensberg was "leading [his] victims on unmercifully" in the negotiations, yet in 1949 it held a "Twentieth Century Art from the Louise and Walter Arensberg Collection" exhibit to grease the wheels. The most aggressive of all was Fisk Campbell, director of the Philadelphia Museum of Art.

It was time for Arensberg and Duchamp to hold a meeting. After three

days in San Francisco to participate in an expert panel at the "Western Roundtable on Modern Art" (where he enunciated the idea of the "esthetic echo," or a rare individual's intuitive power to appreciate art), Duchamp swung by Hollywood for a summit with Arensberg and some bonhomie with Man Ray, who also had settled in California (before finally retiring to France).[44] Philadelphia was looking very good. It had presented Arensberg with a floor plan for a permanent exhibition. A short while later, Duchamp wrote that "all in all, there is a good air of permanency in the [Philadelphia] building," but Arensberg postponed his decision for another full year.[45]

When Duchamp gave this pro-Philadelphia advice, he was fully aware that Maria Martins's bronze statue decorated the East Terrace of the museum. A new kind of end game had come into view. Could he possibly have his life's work installed in the same museum, even looking out on Maria's work—two secret lovers joined in a monument of art history? Duchamp was a man in love, or at least an artist infatuated, so the prospect was too enticing to overlook. And since no one influenced Arensberg more than Duchamp, the choice of Philadelphia seemed a fait accompli. At the end of 1950, Campbell arrived at the Arensbergs' for a Christmas dinner. The air was still filled with uncertainty. Arensberg was in a gruff mood. Finally, he signed the legal documents on December 27, 1950, and said to Campbell, "I feel as if I were kissing my children goodbye."[46]

Arensberg had purchased pre-Columbian art as a very personal hobby, but the rest of his collection had been shaped by Duchamp, his chief advisor for the past thirty-five years. Arensberg had been clear with Duchamp about his intentions in the bequest. "In a way, therefore, the museum will be a monument to you, and . . . will serve as a means of defining how completely individual is your contribution to the art of the 20th century," he had written Duchamp at the very outset of the process.[47]

Just as Arensberg and Duchamp had conspired in submitting the urinal to the 1917 art exhibition, now they had conspired in Duchamp's end game—to establish a monument to his anti-art philosophy. As biographer Calvin Tomkins said, Duchamp, who "played such a key role in the decision [for Philadelphia], was now poised to preside over his own posterity."[48]

The Arensberg Collection amounted to around one thousand items, more than two hundred of them paintings, including important works by

Picasso, Léger, Braque, Cézanne, Matisse, Renoir, and Modigliani. It also included the largest single collection of Brancusi sculptures, since Duchamp and Roché were the exclusive US dealers for Brancusi. At the center of it all, however, was one dominant artist: fifty-three works by Marcel Duchamp, ranging from his paintings and readymades to notes that he had scribbled or printed on paper. The condition of the agreement with the Philadelphia Museum of Art was that the Arensberg Collection — with Duchamp as its centerpiece — had to be presented as a permanent ensemble for twenty-five years after its full installation. (The collection was valued at two million dollars in 1954.)

From much experience, Duchamp had become an expert in exhibit installations. The process would take time in Philadelphia. The museum set aside ten high-ceilinged rooms for the Arensberg exhibit, with the largest to be used for Duchamp's work. The one great caveat in the entire operation was Duchamp's *Large Glass*, which was owned not by the Arensberg Collection but by Katherine Dreier. When she died in 1952, Duchamp settled her estate, much as a loyal son might do; they also had an amicable understanding. Dreier would give the *Tu m'* painting to Yale, but they wanted *The Large Glass* installed in Philadelphia. Duchamp wrote to Arensberg about it, since Arensberg would probably have to apply some pressure to make Philadelphia not only accept *The Large Glass*, but give it prominent display. "A broken glass is difficult to swallow for a 'museum,'" Duchamp wrote Arensberg.[49] He told Duchamp not to worry.

Sooner than he thought, Duchamp was in Philadelphia supervising the installation of the greatest Conceptual artwork — or greatest blague on art — to be bolted down in an American museum. "We must be careful not to drop it, it might break someone's foot," he said at the time. The glass stood nine feet tall, and if it had eyes, it could be said to have been looking out a great glass door onto Maria Martins's bronze statue on the East Terrace, since the Duchamp gallery was in the east wing. The large exhibit area also had a small anteroom, which contained works by Vassily Kandinsky, considered the father of Abstract painting. With the future in mind, Duchamp took the measurements of the Kandinsky room. This would be the exact dimensions of his diorama with the naked mannequin. One day, he thought, Kandinsky might just have to move.

For a few years Duchamp was busy traveling to Philadelphia, where he oversaw the construction, lighting, and installation of the entire Arens-

berg Collection. Sadly, the Arensbergs would never see its final home. Louise died on November 25, 1953 and soon after, on January 29, 1954, Walter also passed away. Duchamp had assured him that their great project together had ended splendidly. The gala opening for the Arensberg Collection came on October 15, 1954. It was the first opening Duchamp ever attended, it is said. The night before, Hurricane Edna blew through. At the reception, the talk was as much about the weather as the art.

13 art in revolt

On the eve of Duchamp's apotheosis at the Philadel-
phia Museum of Art, a new generation of Dada-like art began to percolate
from unseen corners of America. Not knowing this, Duchamp was in-
clined to protest the absence of artistic rebels in postwar America, which
he viewed as awash in the retinal art of Abstract Expressionism. "There is
no spirit of revolt—no new ideas appearing among the younger artists,"
he said.[1]

Although Duchamp did not see it, an indigenous American revolt,
to be called "neo-Dada," emerged in the 1950s. One of its early appear-
ances—as if a replay of Duchamp's mustache on the *Mona Lisa*—was the
day in 1953 when Robert Rauschenberg, age twenty-eight, erased a draw-
ing done by the Abstract Expressionist painter Willem de Kooning, titling
the blank image, *Erased de Kooning Drawing*.

Neo-Dada, with its American roots, arose as a second wing of the
avant-garde. With no money to go on, it was a lesser twin to the avant-
garde establishment, which was based in the museums and galleries of
upper Manhattan. Duchamp had become a part of this uptown establish-
ment, as had the Abstract Expressionists, the Surrealists, and a circle of
curators, critics, and dealers who still looked to Europe. It was only a mat-
ter of time before some wag spoke of "black-tie Dada," a world of tuxedos
and evening dress, art galas and gallery receptions.

As the poorer cousin, the avant-garde world of neo-Dada had differ-
ent roots, percolating out of lower Manhattan, San Francisco, and Los
Angeles.[2] It also bubbled up from an obscure North Carolina venue, the
experimental art school Black Mountain College, which would exert a
significant influence on the alternative art scene of 1950s New York City.

Black Mountain College was founded in 1933 upon John Dewey's learn-
ing theory (basically, the idea of learning by making things, and by stu-
dents critiquing and managing their own curricula). The school met in a
YMCA lodge in the Blue Ridge Mountains, later moving across the valley
to its own facility by a wooded lake. From the start, its painting program

was led by Josef Albers, former head of the Bauhaus school in Germany, after Albers had migrated to the United States. When Albers left, tapped by Yale University, Black Mountain College drifted in a more radical, anti-aesthetic direction. That final push was helped along by two important figures, the musician John Cage and the visual artist Robert Rauschenberg.

As the older of the two, Cage had already begun to create an anti-aesthetic in music. In 1938 he invented the "prepared piano," an instrument with objects stuck between its strings to create non-conventional sounds. A former student of the German atonal composer Arnold Schoenberg, Cage wanted to go further, much as Jarry had said, to "demolish even the ruins." Like the anti-aesthetic in Dada art, or the Theater of the Absurd, Cage wanted to make anti-music, which was based on chance sounds.

Beginning in 1948, Cage taught at Black Mountain College, where he met Rauschenberg who, before the school closed in 1957, had risen to be its chief artist in residence. Rauschenberg became Cage's art advisor. When they both moved to New York City, it was Cage who became a professor — thus making him the most important influence on the arts. He became an impresario for the young artists. He taught at the New School for Social Research in Manhattan, where a new generation of visual artists gathered around him.[3] Cage argued that true "art" was based on anarchic processes, yet he did not seem to harbor the Parisian cynicism of a Jarry or Duchamp. Cage based his artistic nihilism on the I Ching and Zen Buddhism, both of which pictured the cosmos in a state of chance events and flux. Rauschenberg, in contrast, was a bit more like Jarry. It was to describe Rauschenberg and his rather seedy art — his "combines" of street detritus — that *Artnews* invented the term "neo-Dada" in 1958.

When Duchamp arrived in New York in 1942, Cage was already moving in Manhattan's avant-garde circles. He met Duchamp at Guggenheim's social events in 1942. Privately, Cage admired Duchamp from a distance, but remarkably, he and Duchamp would not have a serious discussion for another twenty years (and that was about chess, not art). Professor Cage's influence on New York's neo-Dada and later Pop art would be far greater than Duchamp's. During the 1950s, Duchamp had other more personal concerns. He was putting order into his own life, his end game as it were.

Duchamp's chief patrons — Dreier and the Arensbergs — had passed away. His ties to Mary Reynolds (who died in 1951), and to Maria Martins,

who left Duchamp to go back to her husband and family, had also dissolved. His major artworks had found a permanent home in Philadelphia. In 1952, *Life* magazine had crowned him as "Dada's Daddy," and his main activity seemed to be as a consultant for uptown galleries, or as a media personality.[4] "The American press, intimidated by Duchamp's authority, adopted Dada like a naughty but beloved child," said Richard Huelsenbeck, one of the founders of Zurich Dada.[5] Duchamp was a gray eminence who had been an eyewitness to modern art.

Of the Abstract Expressionist painters in New York, only Robert Motherwell took Duchamp seriously, primarily as a repository of history. He turned to Duchamp as a major advisor when he compiled, in 1951, his anthology on Dada, *The Dada Painters and Poets*.[6] Meeting Duchamp after Mary's death, her brother Frank Hubachek, a trustee of the Chicago Art Institute, drew an impression not uncommon to others. Duchamp "will be known as a greater philosopher than an artist" is the way Hubachek put it.[7] Duchamp never read formal philosophy, though he once identified with the ancient Greek skeptic Pyrrho of Elis. As a young man, he had been enticed by science, but became persuaded that it was full of difficult methods and, in the end, mere tautologies.

So it was French avant-garde literature that would guide Duchamp as a philosopher. He liked many of the poets, including Jarry and his fantastic verbiage. Most of all, he favored the two French writers Jean-Pierre Brisset and Raymond Roussel. Both of them used wordplay and puns. Each was a fantasist as well. Brisset wrote on the relationship between French and "frog language." He pulled off a great Paris hoax, being elected "Prince of Thinkers" and feted widely until the press unearthed the farce. "This is the direction in which art should turn: to an intellectual expression, rather than to an animal expression," Duchamp said of the two writers. This kind of playfulness with words could make art "literary," he said, and put painting in the service of the mind. "I am sick of the expression '*bête comme un peintre*'—stupid as a painter."[8] Only ideas and words could make art intelligent.

Duchamp was not talking about normal words or logic, however. As with his "playful physics," his linguistic philosophy was playful (since, after all, he concluded that words, too, were useless).[9] At midcentury, Duchamp had good reason to be befuddled by words, and even lose faith in their accuracy. From the 1950s onward, academic university philosophy

began to take what would be called a "linguistic turn." No longer did philosophy ask about "reality." Instead it focused on the shifting relationships of words: reality was produced by a semblance of words alone.

This linguistic debate had an Anglo-American version and, naturally, a rival French version. The first had begun with logical positivism: it tried to make every word describe a thing exactly. Duchamp read a little about this positivism but admitted, "I couldn't understand a word."[10] Eventually the logical positivists had to admit that their quest was impossible, and it was their very own enfant terrible, Ludwig Wittgenstein, a leader in English philosophy, who declared that language was simply in flux. Language was a "game," Wittgenstein said. Each family of languages — cultural or professional — had its own rules to play by.

French philosophy was undergoing its own linguistic revolution. The French-speaking linguists and anthropologists had also looked for order in language, but their claim to have found a universal "structure" was soon challenged, and the challenge came from the Surrealist tradition in French letters.[11] The second generation of quasi-Surrealists, which followed in the footsteps of Breton, included such writers as Jacques Derrida, who said language was relative, its words used like weapons by interest groups. Once the academic world had accepted the relativity of language, as proposed by both Wittgenstein and Derrida, it was only a matter of time before the visual artists would do the same.

The idea that visual art was like a language or text erupted, as an early case, at London's Institute of Contemporary Arts, basically on the heels of Wittgenstein. By the late 1960s, some of these British artists launched a journal, *Art & Language*. Because art is like language, it argued, then art is essentially about "ideas." It was only a short step further to say art is essentially only "ideas." Art no longer required objects if it had ideas or words. Like Duchamp, this group of theoretical artists wanted to put art in service of the mind. Thus was born Conceptual art.

Conceptual art was "art after philosophy," as one American artist, Joseph Kosuth, explained in a benchmark essay in 1969. For Conceptual artists to make their case as visual artists, they needed footing in European art history, since neither Wittgenstein nor Derrida were painters. Kosuth did quote logical positivists and Wittgenstein. However, to argue that the essence of visual arts was "art as idea," disembodied from artworks, he turned to Duchamp:

The event that made conceivable the realization that it was possible to "speak another language" and still make sense in art was Marcel Duchamp's first unassisted *Readymade*. With the unassisted *Readymade*, art changed its focus from the form of the language to what was being said. Which means that it changed the nature of art from a question of morphology to a question of function. This change—one from "appearance" to "conception"—was the beginning of "modern" art and the beginning of "conceptual" art. All art (after Duchamp) is conceptual (in nature) because art only exists conceptually.[12]

Kosuth had made his assertion in the rarified world of "art theory." For a new generation of college-educated artists, theory had become essential reading. With its intellectual approach, theory turned the anti-art of Alfred Jarry's "demolish even the ruins" or Tristan Tzara's "great negative work of destruction" into a more positive outlook. With theory, the traditional art object may be demolished, but the "idea" was preserved.

Duchamp's philosophical grappling was a bit more personal. As the arch-bohemian, a man who united art and life, he floated along, adhering to his "indifference" toward things, having no more ambition, he claimed, than to be a "breather."[13] Indeed, he urged young artists to go "underground" in order to escape both society and the art market.[14] To a person who adopts indifference to life, Duchamp counseled, life offers no philosophical problems, so there are no "solutions" to be looked for. In order to live such a life, he went on, all the bourgeois encumbrances—career, property, art dealing, and family—had to be let go. Marriage, for example, "forces you to abandon your real ideas, to swap them for things it believes in, society and all that paraphernalia!"[15]

But Duchamp was growing old, and as he admitted, he liked to contradict himself. Before the 1950s were over, he was married again. It brought him very much aboveground and offered many bourgeois benefits. These events began one day in 1951. The painter Max Ernst and his fourth wife, the painter Dorothea Tanning, had invited Duchamp for a day trip. They went to a fifty-five-acre farm estate in Oldwick, New Jersey, near the Pennsylvania border. It was the home of Alexina "Teeny" Sattler. As Duchamp concealed his heartaches over Maria, Alexina also had her emotional wounds: she was mending from a bitter divorce from her former husband, the famous New York dealer Pierre Matisse, son of the great painter.

For a few years already, Duchamp and Alexina had circulated in some of the same social events in the New York art world. Her memories went back much further. She recalled Duchamp from Paris in the 1920s. The daughter of a prominent Cincinnati family, Alexina had been a young art and language student in Paris. The suave Duchamp was popular at the local parties, where there was a "sudden rise in the level of excitement" when he arrived.[16] In 1929 she had married Pierre Matisse, whose father had sent him to New York in 1924 to sell his paintings. In New York and Paris, Alexina helped her husband manage a major art dealing operation. She also raised three daughters.

When she and Duchamp met on the day trip to Oldwick, he was a sixty-three-year-old bachelor with no job income, pension, or social security. She was a forty-five-year-old mother, economically independent, having supported her family on the earnings of art sales from a large stock she gained in the divorce. From that point forward Duchamp and Alexina began to see each other, and soon after, Duchamp probably moved into her well-appointed residence in Manhattan. They might have continued on like that: two cohabiting elder bohemians, since Duchamp, in principle, opposed marriage. But he gave in. He said it was for the sake of his wife's children. The marriage also gained him US citizenship, for which he had been applying for several years. In his final letter to Walter Arensberg, he put it this way: "In growing old, the hermit turns devil."[17] So on January 16, 1954, he married Alexina Sattler.

Alexina, who spoke French, was quite at home with the avant-garde and with the world of wealthy collectors. When Duchamp told her about his diorama project, she helped him complete it, but certainly not at a breathtaking pace.

Based on the cast of Maria Martins's body, Duchamp was trying to create a shell-like mannequin that looked like real flesh. He was working with vellum (calfskin). As Alexina would learn, Duchamp had had the basic plan for his diorama since 1948, when he determined the gesture of a reclining female figure. Some of it was cast from Maria's body; some of it he formed in clay. Eventually, Alexina let Duchamp cast her arm to complete the work.

Otherwise, the details began to change or were still to be invented. At first, Duchamp had wanted to put a mirror in the reclining female's hand. This would suggest to visitors that they were "voyeurs" who saw

themselves as they stole a glance at a naked woman through peepholes. (Later, he changed his mind; in her hand, he put a gas lamp reminiscent of his youth, or of popular French posters from the gas lamp companies.) Duchamp had first considered a dark wig to emulate Maria's hair. Now he changed it to blond for Alexina's. Once Alexina joined him, other details fell into place. Together they collected twigs and dried leaves as elements in the diorama setting, upon which the mannequin would be situated.

It was a harmonious marriage with a joint project at its center, and Duchamp kept up his justifying humor. He said he "married a woman who, because of her age, couldn't have children. I personally never wanted to have any . . . simply to keep expenses down." He called his three stepdaughters his "ready-made family." Indeed, Alexina expanded the family, if only momentarily, when she urged her elderly husband to track down in France, and meet, the newborn daughter Duchamp had abandoned in Paris in 1911. (Her name was Yvonne, and having grown up with a good stepfather, she had become an artist.)[18]

Almost immediately, Duchamp and Alexina became a new power couple in the New York art world. His path to US citizenship was not as easy as he and Alexina had expected, however. As a controversial artist, his application hit a few snags. These were the years of the McCarthy era, when suspicion was cast on European artists, many of whom, like Picasso, pledged loyalty to the Communist Party. Senator Joseph McCarthy could not have understood the entirely non-political, even nihilistic, core of artists such as Duchamp. The State Department did understand that some artists, such as Max Ernst, married an American citizen (namely, Peggy Guggenheim) to gain passage to the United States. In any case, Alfred Barr intervened, calling on MOMA president Nelson Rockefeller to push through the Duchamp citizenship approval.

Duchamp finally was standing on solid financial ground. If Duchamp had had only the Fourteenth Street studio flat to call a permanent home for a decade, now he became party to Alexina's household. Before the wedding, they moved into a fashionable part of uptown, taking over the apartment at 327 East Fifty-eighth Street, near Beekman Place, that Max Ernst and his wife had once occupied. They also sold Alexina's land holdings, fifty-five acres with a grand old house and barns. As with Maria, he gave Alexina some small works of art he made, joking that one was a wedding ring.[19]

As to his larger art project, the diorama, he "would work for fifteen or twenty minutes and then he'd smoke a cigar or study chess problems or do something else," Alexina recalled.[20] He taught her to play chess. Every Wednesday evening they repaired to the uptown London Terrace Chess Club. "Chess was such a part of our lives," she said. "Instead of going to a movie or restaurant, we would go to the chess club."[21]

EVENTUALLY SOME OF the young artists of the 1950s began to send letters of inquiry to Duchamp, an elder statesman of Dada. From the European continent, he was contacted by the Swedish artist Pontus Hultén and the Swiss artist Jean Tinguely.[22] They were interested in Duchamp's machine aesthetics, especially the moving spiral devices. The new gallery category of "kinetic art" was taking off. Hultén had tried (unsuccessfully) to have a Duchamp piece included in a 1955 Paris exhibition on kinetics, but Hultén and his friends remained undaunted. They unearthed a copy of Man Ray's film *Anemic Cinema*, with its optical spirals and sex puns. They also found a set of Duchamp's rotorelief cardboard plates and looked at some of his comments about the role of "chance" in art. Before long, these young continental artists argued that Duchamp was a leading founder of not only kinetic art but also "multiple editions" art and "chance" art.

In France, meanwhile, the graduate student Michel Sanouillet was completing the first doctoral dissertation on Dada (and on Picabia), coming a bit after Motherwell's anthology, *The Dada Painters and Poets* of 1951. Still, Sanouillet realized that of the visual artists of that period, Duchamp was probably the most quotable. Duchamp's *Box of 1914* and *Green Box* of 1934 were on the market, and some of his letters to collectors were now in open archives. In the United States, Duchamp had given extensive interviews and a few short public talks. He had also written entries for a Société Anonyme art collection. So in 1958, Sanouillet published in French, *The Salt Seller: The Writings of Marcel Duchamp*. In the opening essay, he praised Duchamp in ways that exceeded even Breton's calling *The Large Glass* a "lighthouse" for civilization. Duchamp "has known how to undermine the very foundations of our art, literature, and dogmas so that even our daily existence shows the effects of his secret assaults," Sanouillet said. (He had also sent Duchamp the essay for pre-publication approval.)[23]

The French-language barrier continued to keep such developments in Europe from arriving in the United States, with some exceptions.[24] That is why an English-language project, headed by the British Pop artist Richard Hamilton, was necessary to grab the attention of young artists in New York. This took a while, propelled ahead when Hamilton finally wrote a letter to Duchamp. Even though Duchamp took a year to reply, the contact galvanized the first project to bring Duchamp and his *Large Glass* to a wider English-speaking public.

In England, Hamilton had been more than a little interested in finding out what secrets *The Large Glass* held. He first saw its image at London's Tate Gallery in 1952, when it was part of traveling exhibit, "20th-Century Masterpieces," organized by the director of the Guggenheim Museum, James Sweeney (an avid Duchamp interviewer). *The Large Glass* beguiled Hamilton. He was soon excited to hear that one of his art teachers, Roland Penrose, owned a *Green Box*. Trained in graphic arts, Hamilton was taken by the strange facsimiles of the notes that Duchamp had made at a printer's shop. The words were in French, but Duchamp's sketchy diagrams came through.

Hamilton was also interested in sex and machinery. In this same period, he was among the young artists who met at the Institute of Contemporary Arts in London, a cauldron of discussion from which the term "Pop art," from "popular consumer art," first emerged in 1954. Two years later, at the British exhibition "This is Tomorrow," Hamilton produced what is now called the first work of Pop art. It was a collage that joked about 1950s consumerism. Titled *Just What Is It That Makes Today's Homes So Different, So Appealing?*, it showed a modern home interior with sexy naked wife, appliances, and a bikini-clad muscle-bound husband. As was obvious, Hamilton was intrigued by how sex and machines worked in advertising. Maybe *The Large Glass*, he thought, offered a clue. As with Michel Sanouillet in France, Hamilton was in search of an academic specialty. The Duchamp topic was ripe but unharvested.

So Hamilton asked a friend who spoke French to translate *The Green Box*. Hamilton also traced out the exact outlines of the entities on *The Large Glass*, hoping to distinguish each, as if dissecting a Rube Goldberg machine. When he gave a lecture on *The Large Glass* at the Institute of Contemporary Arts, however, some in the audience replied that he'd been taken in by Duchamp's French blague. Hamilton was a bit unnerved. He

decided to send his translation to Duchamp, along with a diagram, to make sure he did not misunderstand its profound contents.

A year later, Duchamp wrote back. He liked Hamilton's seat-of-the-pants rendition. Going further, he then suggested that Hamilton (in England) contact George Heard Hamilton (at Yale University) to collaborate on an official translation and diagram of *The Large Glass*. Over the next three years, the British Hamilton would produce the graphics for the book, showing exactly what the notes and *The Large Glass* looked like; Yale's Hamilton would put the notes in perfect English (proofed by Duchamp), laid out in the same fragmented lines that Duchamp used in his handwritten notes. For the English-speaking world, their book — the first of its kind when it came out in 1960 — was like a monograph on a new discovery of an Egyptian tomb, the hieroglyphics shown in images and text. When Duchamp and Alexina saw the final product, he wrote to Hamilton in London. "We are crazy about the book," he said.[25]

Such projects take money, and fortunately both Duchamp and Hamilton (in England) had come into the company of a new millionaire patron, someone to stand in the shoes of Arensberg and Dreier. He was the young William Copley, and he was definitely of a new generation. Having attempted opening an art gallery in Beverly Hills for six months in 1948, Copley decided to become a painter himself, but also a collector and patron of the avant-garde. He was soon introduced to Duchamp, who was happy to meet the young patron, whom he advised on art purchases. As heir to the Copley newspaper fortune, "Bill" Copley was welcomed by the various art circles. When he left to live in Paris in 1951, Duchamp saw him off on a ship voyage that included Man Ray as a traveling companion (Copley owned works by both Ray and Duchamp in his growing collection, around which he formed, in 1954, his Copley Foundation, based in Chicago).

Through introductions by Ray and Duchamp, Copley met Europe's artists as well. He eventually crossed paths with the young Richard Hamilton, titular leader of Pop art in England. When the Duchamp *Large Glass* book project with Yale's Hamilton came up, Copley was happy to foot the bill. (He also hired Richard Hamilton to edit a series of books on contemporary art.) Then when Copley returned to New York in 1963, he pushed his foundation to the center of the wild 1960s art scene. He put Duchamp on his foundation board and turned to him for advice on which artists to fund (which included, incidentally, Richard Hamilton and a later Du-

champ acolyte, Joseph Kosuth). "Wild Bill" Copley and Duchamp found common ground in erotic art. Humorous sexual paintings, done in Pop art and cartoon style, were a specialty of Copley (who dedicated one exhibit to Hugh Hefner, founder of *Playboy*).

When Bill Copley and his wife Noma returned from Paris, they joined Manhattan's social life, of which Duchamp and Alexina were already close observers. The 1950s were well over by now, and in the Manhattan galleries and museums, the neo-Dada artists and the Pop artists were beginning to make their mark. As this took place, Duchamp and Alexina were drawn into the vortex as well. The first instance came in 1960 when the American Federation of Arts, founded in 1909 to promote art exhibits around the country, held a big one in New York, "Art and the Found Object." The exhibit included not only the object-fabricated works of Rauschenberg and his friend (and lover) Jasper Johns, but many others, including some pieces by Duchamp, to give the show historical perspective.

The next year, with the full resources of the Museum of Modern Art behind it, a successor show was held. The title was "The Art of Assemblage," a new term for the types of collage art and sculpture that had been around for a while. Assemblage, too, had a long legacy. The MOMA exhibit began its historic survey with Picasso's 1912 *Still Life with Chair Caning*, on which he had pasted a printed oil cloth. The exhibit had thirteen objects by Duchamp. They were almost unnoticeable amid so many other strange and elaborate works assembled from every kind of sundry object, from appliances to street detritus.

It was finally time for Duchamp to meet some of these new artists. One day in 1960, the Greek-born, Paris-initiated poet Nicholas Calas took Duchamp and Alexina to the Front Street studios of Johns and Rauschenberg. Johns seemed the most interested in Duchamp's ideas. He had bought a *Green Box* and asked Duchamp to sign it. Rauschenberg was more into the Dada aspect. So he went out and bought a bottle rack and asked Duchamp to sign that as a readymade. It was natural for the two young artists to pay their respects to the person whom *Life* magazine had declared "Dada's Daddy." Rauschenberg and Johns went to see the Duchamp exhibit in Philadelphia. They would have a Christmas dinner with the Duchamps at a Manhattan restaurant, and in time made works in homage to them. For this, Rauschenberg—who called his assemblages "combines"—made one titled *Trophy II*, dedicating it to Duchamp and Alexina.

It was Johns who tried to explore Duchamp's ideas. He hinted at Duchamp in some of his new paintings (Johns did iconic images of flags and maps, which put his work under the rubric of Pop art, where artists like Andy Warhol made green Coke bottles images and Roy Lichtenstein did large comic strips). Johns was the only artist to take Duchamp's "theory" seriously enough to try to read *The Green Box*, and indeed, he was the only working artist to write a review of the Hamilton-Hamilton book, *The Bride Stripped Bare by Her Bachelors, Even, Typographic Version*. Johns commented on *The Large Glass's* "erotic machinery" and "the extraordinary quality of Duchamp's thinking" in the notes. He especially noted the precision of Duchamp's craftsmanship and the materials, but again, returned to Duchamp's "brilliantly inventive questioning of visual, mental, and verbal focus and order."[26]

Years later, asked how Duchamp influenced him, Johns said, "It's hard for me to know whether I have ever understood Marcel's ideas, but certainly contacting his work boosted my confidence in my own. I think he showed that an artist could have ideas other than the ones usually being discussed. He was complicated. And when you say 'anti-art' . . ." At this point, Johns recounted how Duchamp actually liked beautiful French paintings by the extremely retinal Monet, as did Johns, who as a Pop artist was a retinal artist through and through.[27]

Of course Duchamp was complicated. When asked about the Pop artists, he liked them as young newcomers. He also had bitter comments. He said they had taken the "easy way out" compared to the supposedly hard times he underwent during his Dada days. True, he said, Pop artists used everyday objects. This was just like his urinal and his shovel. However, they viewed them as beautiful: they added taste and aesthetics, whereas Duchamp opposed both of those attributes:

> When I discovered the ready-mades I thought to discourage aesthetics. In Neo-Dada they have taken my ready-mades and found aesthetic beauty in them. I threw the bottle-rack and the urinal into their faces as a challenge and now they admire them for their aesthetic beauty.[28]

Ever since Duchamp picked up the shovel and urinal, his friends had joked at how beautiful they were. Blague or not, some of these comments were serious: the urinal had its own retinal beauty as a work of shiny masonry. When the Pop art trend began to dominate the American art scene,

Duchamp finally went along. He did so with his own clever caveats. There was some redeeming value in Pop art, he said, despite its retinal prettiness and its money-making ability. To explain the success of Andy Warhol's paintings of multiple Campbell's soup cans, which had recently shot Warhol to fame, Duchamp said: "If you take a Campbell soup can and repeated it fifty times . . . you are not interested in the retinal image. What interests you is the concept that wants to put fifty Campbell soup cans on a canvas."[29]

What bothered him most was the money. Pop art was making piles of money. Indeed, more rapidly than at any other time in modern art history, the Pop artists were making an extremely good living. The Pop artists had begun to mass-produce their images to meet gallery sales. As Duchamp noted, the difference with him was "that I never had to sell my work, so I never repeated myself." Pop artists repeated themselves, "poor dears, because they have to make a living out of it." He wouldn't let that topic alone, saying elsewhere: "I'll tell you the difference between Dada and Pop: Dada never made a penny in its day." Nonetheless, the Pop art boom actually bode well for the career of Duchamp, who was now being called the "Grandpa of Pop."[30]

The Pop artists had become part of a new gallery system and art market. It was led by such figures as art dealer Leo Castelli. Having left the uptown gallery scene, Castelli moved downtown, below Greenwich Village. He knew that in order to sell lower Manhattan's Pop art, or assemblage art, or the new Conceptual art at high prices to collectors, he needed to put the works in a historical timeline. As even Picasso said, "We cast round for justification; we look for ancestors to give us standing."[31] In search of an ancestor to justify neo-Dada and Pop, Castelli found Duchamp: Dada's Daddy and the Grandpa of Pop. He was already a fixture in art museums. When Castelli was asked what criteria he used to select saleable artists for his gallery, he answered: "Marcel Duchamp."[32] And as Pop art and Conceptual art began selling, Duchamp's fortunes as a historic figure — a kind of Rembrandt for his neo-Dada times — rose as well.

These forces first came to a head in 1963. On the West Coast, a group of young art curators, coming out of the California "beat" and "funk" scene and now keen on Conceptual art and Pop art, decided to hold Duchamp's first retrospective. As a result, Duchamp's introduction to the more frothy world of contemporary art did not take place in New York, but in Los An-

geles, where the vibes of Hollywood stardom and Pop art were making waves. The events in Los Angeles were not exactly a coincidence. Arensberg had lived in Hollywood for more than thirty years. During that time he had allowed the public to visit his collection; those visitors had seen Duchamp amid his collections of European paintings and pre-Columbian pottery.

One of those visitors was the high school student Walter Hopps, who in time would open the way for a Pop art commercial boom in Southern California. The son of a doctor, Hopps had studied science at Stanford (where he left after getting in trouble over randy art) and then went to the University of California, Los Angeles, where he met his future wife, soon to have her doctoral degree in art history. Hopps, however, dropped out of school to found a 1950s gallery, which featured the newest art. This was the Ferus Gallery. It was famously shut down once by the Los Angeles vice squad for explicit art. During those early days, Hopps won renown for his outlandish feats. Once he drove a trailer load of paintings down from San Francisco and displayed them on a rotating merry-go-round at the Santa Monica pier.

Despite Hopps's enthusiastic supervision, the Ferus could not make money. So Hopps took a job in 1961 as assistant director of the Pasadena Art Museum. The museum, a former mansion in a pagoda design, was between two exhibits that would gain it some long-needed attention: a retrospective of Kurt Schwitters (the Dada predecessor of much that Rauschenberg was doing), and in fall 1962 "New Painting of Common Objects," considered the first show entirely composed of Pop art. In between, in early 1962, the museum director asked Hopps to put on a Marcel Duchamp retrospective.

This was not an easy proposition. Duchamp's works were bound up with the Philadelphia Museum. Also, such an exhibition would be expensive. So Hopps contacted Bill Copley in New York, both to fund the project and to act as intermediary with Duchamp. This was a dream come true for Hopps (who was director of the museum the next year). Having a taste for California's new beat and funk art, Hopps believed that Matisse and Picasso were passé. From the immediate past, Duchamp and Mondrian were his giants. During a meeting at Copley's New York apartment, Duchamp and Hopps came to an agreement. The relevant art from Philadelphia and elsewhere was shipped to Pasadena, and Hopps, who was an

excellent designer of exhibits, arrayed it by chronology and themes across several rooms.

Andy Warhol's breakthrough show of Campbell's soup cans had taken place at the Ferus Gallery after Hopps had left, but now, in 1963, Warhol was back at the Ferus. His second show's opening overlapped the start of the Duchamp's retrospective, making the Los Angeles art scene a festive art party that orbited around the two of them. A lot could happen in a single year in the 1960s, it was said. After the Duchamp-Warhol alignment, LA seemed to rise from the ashes as a center of contemporary art, fueled by Hollywood money and publicized by the new California-based art journal *Artforum*, among others.

The Duchamp retrospective opened on October 7, 1963, with a black-tie affair at the Pasadena Museum. A few days earlier, Duchamp, Alexina, Copley, and Richard Hamilton (from England) had taken the same flight from New York to Los Angeles. The early arrival allowed for a few photographs of Duchamp amid the Pasadena Museum exhibit. The most famous of these, pulled off unofficially, was a picture of Duchamp playing chess with a naked nineteen-year-old Eve Babitz, the voluptuous girl-friend-on-the-side of the otherwise married Hopps.[33]

The exhibition featured 114 works by Duchamp, with the first room showing his early paintings. The third room, wood-paneled with leaded glass windows, displayed Duchamp's chess paraphernalia. Next came the heart of the exhibit: a room devoted to *The Bride* painting and *The Large Glass* (an approved replica that had been made in Stockholm in 1961 for such uses, since the fragile original could not leave Philadelphia). The two final rooms were dedicated to Duchamp's "optical works," and then his *Box-in-a-Valise* and various ephemera he had jotted down or signed over the years. As part of the staging, Duchamp sat and played chess at times. Visitors walked by in hushed reverence. By the time they reached the ephemera room, one visitor offered the comment that "everything he touched became important . . . famous."[34]

After the evening event at the Pasadena Gallery, everyone repaired to the Green Hotel ballrooms for drinks and a banquet. The city's art collectors were there and even a few minor movie stars. As the elder statesman of art, Duchamp sat at his banquet table, Alexina at his side. Andy Warhol and his friends, like "giddy kids jumping up and down around Marcel Duchamp," asked for autographs on the table cloth.[35] After that, Copley took

the Duchamps, Hopps, Hamilton, and a few others to Las Vegas for a further celebration of the retrospective success.

At the Pasadena Museum for the duration of the show, there actually was not much to "see" for an art exhibit. The displays mainly offered visitors a chance to read about Duchamp, or consider what he was thinking in producing his various objects. Becoming acquainted with Duchamp "is a matter as much of reading as of looking," according to one future Duchamp expert.[36] Whether looking or reading, the young artists in Los Angeles had a kind of revelation. "The L.A. artists, who were outsiders, saw the success of Duchamp, who was an outsider, and thought, 'Hey, if this guy can do it, so can we,'" one Duchamp scholar said later. In reality, Duchamp was currently a New York insider, but the subtle distinction was not important in 1963. As many young artists would recall, Duchamp gave them permission—they often said "moral support"—to do rebellious, off-the-wall things in art.[37]

In short, it was Los Angeles, and not New York or Philadelphia, that catapulted Duchamp into the effervescent limelight of contemporary art, in effect separating him from "modern art," which was ending in the 1960s, and giving him a new life. The early twentieth-century notion that "significant form" was the essence of art was fast eroding, eclipsed by the assertion that Conceptual pieces and ordinary objects—like Duchamp's readymades or Warhol's soup cans—were the new concern of the visual arts. Either way, 1963 marked Duchamp's final apotheosis to art fame.

The Warhol-Duchamp buzz went beyond Los Angeles. After Los Angeles 1963, said a Duchamp biographer, "the international art market could be heard clanking into action."[38] It also helped that 1963 was the fiftieth anniversary of the 1913 Armory Show, when Duchamp's *Nude Descending a Staircase* had made its mark in America. For the fiftieth anniversary, Duchamp attended an official re-enactment event in Utica, New York. He also played chess before news cameras, gave interviews widely, and appeared on television.

In the fast-moving situation, the art critics were looking for connections and anchors. They found them by blurring together Warhol and Duchamp, soup cans with readymades. "Everything owes its tribute to Duchamp and his first bicycle wheel," the magazine *Artforum* said. "The now-popular Campbell's Soup cans come straight out his 'Apollinaire

Enameled' [readymade], an advertising picture for a commercial enamel paint to which Duchamp only added his inscription."[39]

Not everyone in the avant-garde gave such credit to Duchamp, of course. The New York art critic Arthur Danto viewed Duchamp as a mere polemicist against art, his readymades bearing a negative taint. In contrast, Danto said Warhol was the real savior of the new anti-aesthetic, since Warhol gave ordinary objects a positive spin. With his next project, the Brillo boxes, Warhol had become "the nearest thing to a philosophical genius the history of art has produced," Danto declared. "He brought the history [of art] to an end by demonstrating that no visual criterion could serve the purpose of defining art."[40] Warhol biographers (now shifting to Picasso) agreed: "Warhol ignited a revolution as forceful as any since that touched off by Picasso's *Les Demoiselles d'Avignon*."[41]

The pithiest summary of what these artists — Cage, Johns, Rauschenberg, and Warhol — were all saying came from the head of modern art at the very traditional Metropolitan Museum of Art, Henry Geldzahler (who, as a friend of Warhol, gave the artist many of his ideas). Geldzahler said that Duchamp was "not a direct influence" on Warhol, but rather a background for the new contemporary attitude, which was simply: "Whatever we chose to regard as art is art."[42]

Duchamp also stated the case in the simplest possible terms. In 1966 a journalist at his London retrospective show asked, "Art can be anything?"

"Yes, anything," Duchamp said.[43]

Although Duchamp's readymades might have been in the lead, the idea that art could be anything was a cumulative gathering of rebellions. The idea that anything can be art was not exactly new.[44] However, in the 1960s, the idea dovetailed handily with other social revolutions. The sixties marked a general revolt against any kind of older aesthetics, such as the modern art conviction about "significant form," or anyone who still spoke of the refined sensibility of the art connoisseur, or the skill of the painter and sculptor. All of that was now out the window, and as suited the mood of the 1960s, this was the crux of the battle for the soul of modern art. In reality, the battle ended in an armistice. Roughly speaking, the terms of the treaty say that modern art was about "significant form" (up to about 1970), while postmodern art (after the 1970s) is about "art is anything."

Duchamp went with the flow. His friends and allies had once called him the most famous "anti-artist," but in the end, he seemed to prefer a

less negative cast. As one of his closest students, Richard Hamilton, argued in the end, Duchamp was really just like most artists. He made visually interesting things. "Anti-Artist my fanny," is how Hamilton put the case.[45] Similarly, the New York Times art critic John Canaday was bemused at how every new art trend was rushing to link itself with Duchamp, even though Duchamp had become famous by trying to destroy art. "There is hardly an experimental art movement of recent years that cannot trace down through the branches of its family tree to find Marcel Duchamp as its generative patriarch," Canaday wrote.[46]

Whatever ironies or profound misunderstandings were involved, in the 1960s Duchamp was happy to accept his new status as the great precursor. "I suppose each generation needs a prototype," he said. "I certainly play the role. I'm enchanted by it."[47] He had spent a lifetime trying to undermine the self-regarding artist in society. But in the end, he had to admit that he was one himself. "I'm nothing else but an artist, I'm sure," he said in a filmed interview for the BBC in 1963, "and delighted to be . . . the years change your attitude, and I couldn't be very iconoclastic anymore."[48] As for art in society, what could be more important, he finally averred. "Art is the only form of activity in which man, as man, shows himself to be a true individual who is capable of going beyond the animal state," he would say.[49]

ALL OF THIS might have been said by Picasso, who never had doubts about art. Through the 1950s, however, nobody was exactly saying that Picasso was a philosopher. The communist bloc celebrated him as their "Comrade of genius," and on a few occasions he was a photogenic personage at Soviet bloc "peace" conferences, the last being in the early 1950s in Sheffield, England, and in Rome. During the Cold War, such British figures as head of the Royal Academy in London, and Winston Churchill by implication, criticized Picasso's kind of modern art as aiding the Stalinists (as, indeed, Breton had been saying when he angrily split with the pro-Soviet poets).

Nevertheless, Stalin would soon die and, as the Soviets began to send troops into Eastern European countries to suppress freedom movements, it was Picasso's choice to hold his tongue (once, though, he signed a protest about Hungary). "He is not interested in politics," said Roland Penrose, Picasso's devoted chronicler, "regarding them as a crafty game

outside his sphere."[50] His other biographer, Pierre Daix, explained that Picasso had never been interested in Marxism: "Joining the party for Picasso was a way of joining the citizenry, joining society."[51]

As if in a separate world from Europe's Cold War politics, Picasso had also become part of a French celebrity culture, one that mixed art, film, fashion, and gossip. Alfred Barr of MOMA caught that reality when he noted that Picasso was becoming "the most photographed of the living artists."[52] Many of the photographs were generated by his birthday celebrations. Three of them received global attention: his seventy-fifth (1957), eightieth (1961), and eighty-fifth (1966). For his eightieth, Picasso appeared on the cover of *Life* magazine.

By his fame, Picasso was at risk of looking passé. He was becoming a topic for gossip columnists, who placed him at black-tie events at Cannes film festivals, or described him as driving a white Cadillac to bull fights. They no longer portrayed him as a revolutionary in art. For years already, Picasso had ignored (with the exception of Matisse) the other trend-setting artists of his generation: Kandinsky, Mondrian, Malevich, or Marcel Duchamp. Even after the Second World War, Picasso did not see in Abstract Expressionism, neo-Dada, or nascent Pop art anything like a new force in the art world, and thus he did not see anything to go into combat with.

What he felt, actually, was the dying away of his past. He was painting at a furious rate, but it was a race against death, or so it seemed. As others died, Picasso realized, he was somehow still living, smoking his cigarettes as avidly as before. In 1954, Henri Matisse died. The next year his former wife, Olga, passed away; his sister Lola died a few years later (1958). Then, in 1963, Braque and Cocteau were gone.

During these years, Picasso still had a studio in Paris, but he was spending most of his time in the south of France. His first mainstay there was an estate called La Californie, which he bought in 1955. It stood near Cannes and outside the town of Vallauris, where he was still an honorary citizen. Like all of his homes, La Californie had large rooms that were well lighted. It was near to the pottery festivals and (French) bullfights, which Picasso usually attended as guest of honor. In the world of the pottery kilns, Picasso would meet the last women in his life, Jacqueline Rocque.

He met Jacqueline in 1954, the same year that Duchamp married Alexina. A young French divorcee with a daughter, Jacqueline had been an

assistant at the famous Ramié potteries and kiln in the hills around Vallauris. After Jacqueline let Picasso paint her the first time, she moved to Paris with him, where they lived in the Grands-Augustins studio. As she became his new model, Picasso's painting and drawing added to history the recognizable image of Jacqueline's classical profile, dark hair, and large, restful eyes. They finally married, in March 1961, at a quiet ceremony at the Vallauris town hall.

From his perch at La Californie, Picasso painted portraits of Jacqueline and also scenes such as *The Bay of Cannes*. For better or worse, he also took on a major project, which left him exposed to a great deal of scrutiny: was Picasso losing his powers? This was the commission he received from the United Nations cultural agency, UNESCO. It wanted a Picasso mural to decorate its headquarters' walls in Paris. He finished the multi-panel work (30 x 38 feet) at La Californie, and it was exhibited at a Vallauris schoolyard; it was installed at UNESCO in 1958. As critics frowned at the result, the group that would begin to circle around Picasso, his most faithful allies, began to appear and speak regularly in his defense. In general, they were his last *bande de Picasso*: disciples, chroniclers, and art dealers.

The same year that the UNESCO images were installed, friends told Picasso of an old estate for sale near the mountain — Mont Sainte-Victoire — that Cézanne had painted so often. It was the Château Vauvenargues, and the fourteenth-century structure was too impressive not to buy. It had two round towers, a fortress wall, and it stood on a rock knoll with cypress, pine, and oak trees. The view fell over a somewhat stark landscape, reminding Picasso of the Pyrenees. On visiting, Picasso excitedly saw himself as lord of this villa. The purchase was quick and soon enough he and Jacqueline were moving in, transferring much of his artwork out of La Californie. Jacqueline loathed the isolated villa. For Picasso it was a lark, a new adventure.

For a few years, Picasso moved back and forth between La Californie and Vauvenargues, living and working, until both locations began to lose their appeal. Back at La Californie, the close-by city of Cannes was growing apace with the postwar boom. The cement high-rises and human traffic were encroaching on La Californie. So in early 1961, Picasso looked for another place to live and work, a place farther from the modern din.

Before the First World War, he had gotten to know the town of Mougins, a few miles north of Cannes. It was also connected to Vallauris

by winding back roads. In Mougins he found a hilltop country estate called Notre-Dame-de-Vie. He did not sell La Californie or Vauvenargues; they continued to help with storage and as stopovers during travel, such as excursions to bullfights.

By the middle of June 1961, Picasso and Jacqueline had moved about everything into the new villa at Mougins. At the top of a winding road, and through a gate, the villa was surrounded by tall cypress trees, a good deal of land, and it looked over the tiled roofs of the town and beyond to the Bay of Cannes. At this villa, "Our Lady of Life," Picasso set up his household like any sovereign, equipped with studios and now modern accoutrements, the nuisance of a telephone and the enjoyment of a television. It became his new warehouse as well, a jungle of canvasses, statues, and keepsakes piled up in room after room. For a time, he also brought in big yellow construction cranes to add another studio to the villa.

Mougins would be Picasso's final home. Wherever he lived in the south, it was his loyal secretary, Sabartés, who took care of the endless logistics up in Paris. Picasso's paintings and other works were on a constant path of circulation to exhibits around the world, a pattern that expanded geographically as he aged, allowing the myth of Picasso to grow larger than ever. The Paris press began to call him the "hermit of Mougins." His rivals in the art world viewed Notre-Dame-de-Vie as the place from which Picasso thought he reigned over modern art.

However, he had his faithful band around him, and they would become especially important in 1964. In that year, Françoise Gilot, now deeply estranged from Picasso, published her memoir of their years together. It was published first in English, co-written with the American art critic Carlton Lake, and it was soon to be translated into French for publication the next year. Immediately, Picasso called his lawyers into action. He failed to stop publication; the many uncomplimentary revelations offered by Françoise—in a book also rife with interesting anecdotes and quotations—became a resource for countless Picasso biographies ever after.

The book also gave the robust, sun-tanned Picasso, a chain smoker his whole life, his first serious illness as an old man—a significant case of ulcers. To treat the ulcers, Picasso was rushed to an American hospital in Paris's wealthy Neuilly suburb (where Duchamp had painted his *Nude Descending* and launched his *Large Glass* project so many years before). This was Picasso's last trip to Paris. The tell-all book episode also set the course

for a widening gap between Picasso and his children by Françoise, Claude and Paloma, beginning with his and Jacqueline's refusal to let them visit him at the Mougins villa.

Despite all the moving between his villas, and then the uproar over the Gilot memoir, Picasso retained his focus on painting. Those periods of isolation allowed him to work at rates that exceeded all other periods in his life. He turned out paintings, drawings, pottery, murals, etchings, engravings, and lithographs. Many of the projects illustrated books or collections of poetry he was recruited to decorate. In producing so much, the quality was uneven. It ranged from virtuosity to what seemed simply to be self-indulgent scribbles. "While young artists were turning away from picture painting, Don Pablo continued the somewhat empty comedy of using brush and colors on canvas or paper to present musketeers, clowns, maternities, or erotic scenes," said the Picasso biographer Pierre Cabanne.[53]

There was nevertheless a logic to Picasso's final period of paintings. He may have latched onto it in the later 1940s when, on a tour of the Louvre, the curator let him suggest where, among the great Renaissance, classical, and romantic painters, Picasso might want to have his own works hung one day.[54] Therefore, Picasso's final rivalry was not with Pop art, but with the old masters. As biographer Daix says, at a time "when breaking with the art of the past was emphasized everywhere as desirable and even essential, Picasso's attitude was most unusual."[55] Picasso was unusual, in other words, by returning to the old paintings as a new resource.

Picasso had begun this engagement with the old masters in Paris. Working at Grands-Augustins studio, he did fifteen paintings and two lithographs based on Eugène Delacroix's work *Women of Algiers* (1834). A few years later, after he was established at La Californie, he took up an old master from Spain, Diego Velásquez. He spent months doing variations on his great painting *The Maids of Honor* (1656). Picasso moved next to Gustave Courbet's gigantic autobiographical painting, *The Artist's Studio* (1854–55). Picasso fit these projects in amid his moves between the different houses in the south of France. When he left La Californie and Vauvenargues for Mougins in June 1961, for example, he was working on a series of variations on Manet's picnic scene of a landscape and figures, *Luncheon on the Grass* (1862–63). Settled at Mougins, he turned to the French academician Jacques-Louis David's *Rape of the Sabine Women* (1799), redoing it in woodcuts using linoleum blocks (linocuts).

The other prominent theme during his encore years as an aging painter was the "artist and his model." For this, Picasso may well have drawn upon Courbet's *Artist's Studio*, or he could have been thinking about Matisse's work—or he may have simply picked the well-known theme out of the air. In the artist-and-his-model works, Picasso showed off his continued virtuosity with line drawing—continuous line, without lifting the instrument. He also made a considerable number of risqué jokes on the eroticism of painters and their models, and of "dirty old men" painters (such as Matisse, Degas, and now Picasso) with their nubile subjects.

As the world of museums and galleries held an increasing number of Picasso exhibits, his new production had one particular outlet in Paris. This was the Galerie Louise Leiris, founded and operated by the young woman who ran the Kahnweiler gallery during the war, when Kahnweiler had to flee occupied areas. Louise had married the Surrealist and communist poet Michel Leiris. In the early 1950s she opened her own gallery, which exclusively showed Picasso's newest works, season by season, year by year. At times, the newest Picasso show was a revelation. Just as often, his "latest works" show was taken by the art critics as a dull ritual. Either way, the cumulative works shown at Leiris gallery solidified the reputation of the postwar Picasso.

His place in art history was also being solidified with inexorable care by Christian Zervos and his wife Yvonne. Since the early 1930s, they had been producing the authorized volumes of Picasso's lifetime work. By the 1960s, they were into the mid-twenties of the editions (to be thirty-one total). Given Picasso's productivity through the 1960s, their photographic and cataloging work increased exponentially.

———

AS THE REVOLT in modern art got its stride in the 1960s, opening the way for "contemporary art," or "postmodern art," Picasso was mostly ahead of Duchamp in having his life put on the record. He could not control all of it, of course. His friends Sabartés, Daix, and Penrose wrote admiring biographies of him. As a counterpoint, the memoirs by Fernande Olivier (1933) and Françoise Gilot (1964) offered scandalous alternatives. For his part, Picasso gave only four interviews in his life that amounted to any substance, either on his theory of art or his own interior life.[56] He mostly gave people pithy aphorisms, which worked well enough. The Zervos catalog of his works continued apace, and as to the production

of Picasso catalogs in general, there would be no end. For American consumption, Alfred Barr's 1946 book *Picasso: Fifty Years of His Art* had been an important introduction to a wider reading public.

By comparison, it took a much longer while for Duchamp's life to be put on the record. Quite in contrast to Picasso, most of the narrative about him and his work came through the countless interviews he had with the news media, beginning in 1915 in New York, and continuing up to his death. He released his cryptic "notes" on *The Large Glass* gradually, but the notes were taken as works of art, not autobiography. As with Picasso, Duchamp also could not completely control what others would write about him based on intimate knowledge. Some of the women in his life — Gertrude Stein, Gabrielle Buffet-Picabia, Beatrice Wood, Louise Norton, Ettie Stettheimer, and Lydie Sarrazin-Levassor — wrote about Duchamp in factual memoirs and in revealing fiction. His good friend, Henri-Pierre Roché, wrote both ways: factual accounts and fiction.

Not until 1959, however, did something like a full overview of Duchamp's life and his works appear. This was a volume titled simply *Marcel Duchamp*, worked on for several years by Robert Lebel, a da Vinci and Surrealism scholar in Canada. It was published simultaneously in French and English. In addition to giving the first biographical overview of Duchamp, the volume listed 208 items, presumably everything Duchamp had produced as "artwork" up to 1960. (In 1957, Duchamp himself said he'd only done roughly thirty-nine to fifty such works, but in the hands of his biographers and collectors, that number would start ballooning overnight.)[57] As the gallery visitor had said, "Everything he touched became important . . . famous."

The Lebel book also summarized the main themes that scholars would thereafter take away from Duchamp's works, writings, and interviews. Many of these themes were presented as virtual discoveries that Duchamp had made and introduced to modern art: the idea of chance in art, emphasizing "ideas" in art, recognizing the viewer's role in interpreting art, his work with "optics" and machines, his cross-dressing as Rrose Sélavy, his bohemian "indifference" to life, his rejection of museums and, last but not least, his interest in erotic subject matter and sex jokes.

While Lebel was tempted to credit Duchamp with having invented many of these ideas, or to have been first to apply them to art, virtually all of them had been said before in one version or another. Viewer interaction

was an old idea. It was spoken of in 1884 when the Society of Independent Artists created the Salon des Indépendants for artists to "present their works freely to the judgment of the public." The 1912 book *On Cubism* mentioned spectator influence. On the same topic, Picasso once said, "People see in painting things you didn't put in," and in the case of *Guernica* he offered this: "The public who look at the picture must see in the horse and the bull symbols which they interpret as they understand."[58] Duchamp was not the only coy critic of museums, for Picasso said the same thing—"Museums are just a lot of lies"—and at times even Picasso said that "ideas" mattered most in art.[59]

In reality, the only truly original idea offered by Duchamp—his only unique intellectual contribution—was the readymade. And that was quite enough; it would become the most troublesome and expansive concept in modern art.

14 the readymade

The debate on Duchamp's originality in modern art began to surface in New York City in 1965. The occasion was a Manhattan gallery exhibition, titled "Not Seen and/or Less Seen," a congeries of ninety Duchamp items collected by Mary Sisler, a buyer of early Duchamp drawings and paintings (from Henri-Pierre Roché), and a collector of readymade replicas and Duchamp ephemera.

"Much of it hasn't really been seen here before," Duchamp, age seventy-seven, said at the opening. "There's a lot of early work brought over from Paris."[1]

After the Pasadena event, this was Duchamp's second great retrospective in America. Held at the Cordier & Ekstrom Gallery, it opened with a black-tie gala, drawing art celebrities from Andy Warhol, the prince of Pop, to Salvador Dalí, the icon of Surrealism. Now that a Duchamp retrospective had landed in New York City with such fanfare, it was the opportunity for New York's modern art establishment — representing the line of painters and sculptors from Cubism to Abstract Expressionism — to weigh in on Duchamp's growing influence among younger artists.

The representative voice for the modern art establishment was that of Thomas Hess, editor of the venerable *Art News*, whose article "J'Accuse Marcel Duchamp" was prompted by the Cordier & Ekstrom exhibit, which was soon going to spread the Duchamp gospel around the country on a national tour.

Hess opened his article with, "Marcel Duchamp over the years brilliantly has consolidated a position that is practically invulnerable to serious criticism." Hess wanted to explain the difficulty of making valid criticism stick to the Teflon-coated Frenchman. If Duchamp was taken as making jokes, to attack him would be to appear "stuffy." (Elsewhere, Duchamp would say that his critics had "insufficient levity.") On the other hand, Hess said, if a critic attacked Duchamp as a being a professional artist who lacked talent, then the critic would look like a "know-nothing,"

just like the Philistines who attacked Cubism as the product of substandard artists.[2]

What Hess did not dare touch, however, was Duchamp's concept of the readymade, as if realizing that this was more quicksand than any self-respecting art critic cared to wander into. The readymade, after all, was arguably Duchamp's only truly original contribution to modern art. The Surrealist filmmaker and writer Hans Richter described the readymade as Duchamp's "intellectual tour de force."[3] It was also so chameleon-like that anything could be a readymade. In Duchamp's case, that explained why the number of his lifetime "works" seemed to multiply out of nowhere, from fifty at one point to 663.[4] In the case of the art market after Duchamp, almost any object could be sold as art, and his young heirs caught on to this modus operandi fairly quickly.

From 1913 onward, the readymade developed a storied history, Duchamp giving it various permutations along the way. By the 1950s, Duchamp had added a variety of variations to the idea of an object that is simply "chosen": these included the "reciprocal readymade," the "rectified readymade," a "remote" readymade, an "unhappy readymade," and finally a "'ready-made' intention," which came about when an artwork is accidentally broken. "And I respect that," Duchamp said of an artwork's apparent "intent" to break itself under one circumstance or another.[5]

Duchamp was no fool, of course. By the 1960s, he realized how problematic a readymade definition had become, at least for any logical discussion. "The curious thing about the Ready-Made is that I've never been able to arrive at a definition or explanation that fully satisfies me," Duchamp told the curator Katherine Kuh in March 1961.[6] Nevertheless, the readymade genie was out of the bottle, and Duchamp himself recognized it as a personal accomplishment. As he told Kuh:

There's still magic in the [readymade] idea, so I'd rather keep it that way than try to be esoteric about it. But there are small explanations and even certain general traits we can discuss. Let's say you use a tube of paint; you didn't make it. You bought it and used it as a ready-made. Even if you mix two vermilions together, it's still a mixing of two readymades. So man can never expect to start from scratch; he must start from ready-made things like even his own mother and father. . . . I'm

not at all sure that the concept of the Ready-Made isn't the most important single idea to come out of my work.

In fact, the New York art world was paying attention to this singular idea. Seven months after the Kuh interview, the Museum of Modern Art held its "Art of Assemblage" exhibition. There were several speakers at its forum, including Duchamp. Here he gave his most formal — and ever-so-brief — statement on the readymade. After mentioning his early objects, he said that his:

> choice of these "readymades" was never dictated by esthetic delectation. This choice was based on a reaction of visual indifference with at the same time a total absence of good or bad taste . . . In fact a complete anesthesia. One important characteristic was the short sentence which I occasionally inscribed on the "readymade." That sentence instead of describing the object like a title was meant to carry the mind of the spectator towards other regions more verbal. . . .
>
> I realized very soon the danger of repeating indiscriminately this form of expression and decided to limit the production of "readymades" to a small number yearly. I was aware at that time, that for the spectator even more than for the artist, art is a habit forming drug and I wanted to protect my "readymades" against such contamination.
>
> Another aspect of the "readymade" is its lack of uniqueness . . . The replica of a "readymade" delivering the same message; in fact nearly every one of the "readymades" existing today is not an original in the conventional sense.[7]

Given that tubes of paint are manufactured, he concluded, all paintings are thus "readymades aided" or "works of assemblage." To some listeners, Duchamp was blaguing the art world, but on his Olympian perch, he had to be dealt with. One approach was to follow Duchamp's logic of what seemed like infinite regress, going back further and further to determine when something was "manufactured" (though nobody went quite all the way back to the Big Bang, which had not yet been confirmed by scientists).

Duchamp had gotten the ball rolling. He had once jotted down, "find inscription for Woolworth Buldg. as readymade."[8] Others after Duchamp expanded the sizes of readymades. "If a snow shovel becomes a work of

art by simply calling it that, so is all of New York City," said the artist Alan Kaprow, a student of John Cage and pioneer of American "happenings" (of which Duchamp approved of as a kind of "boring" readymade art).[9] Not to be outdone, Italian artist Piero Manzoni put an upside-down pedestal on the ground, signed the floor, and said the Earth was his readymade. The Surrealist painter Salvador Dalí, sardonic as ever, explained where this was leading. "One day, when all objects that exist are considered readymades, there will be no readymades at all," he said. "Then Originality will become the artist's Work, produced by the artist by hand."[10]

In much of his life, Duchamp preferred precision and clarity. This applied to counting his money, catching the train or steamship, playing a chess tournament, or applying lead wire to *The Large Glass*, which he did in precise angles and lines. He was also precise in his paperwork, for, as a notary's son, he would often help acquaintances organize publications or settle estates. But when it came to elaborating on the readymade, he had to default to "magical" connotations, even obfuscation, instead of precise thinking.

The readymade emerged from Duchamp's more nebulous side. He also revealed this side in his preference for ambiguity in language and philosophy. Poetry and rhyming puns spoke to him more deeply than prose or verse, and humor more than logic. "It's always the idea of 'amusement' which causes me to do things," he said.[11] He located his intellectual backdrop in many places, from the ancient Greek skeptics to the fantastical literature of Alfred Jarry and Raymond Roussel. Given such sources, Duchamp's critics realized there was no use picking a logical fight with him. Simply put, said one friendly observer, he had "spent a lifetime constructing traps for the rational mind."[12]

The realms of Duchamp's intellect were further revealed in 1967 when the New York artist Cleve Gray translated Duchamp's last batch of pre-*Large Glass* "notes" for publication. The notes had been jotted down between 1913 and 1916, and, as a set, they were titled *À l'Infinitif* (for the grammatical term) and replicated and boxed for sale to collectors, becoming known as *The White Box* of 1967.

The White Box contained the notes, separated from the others, on which Duchamp mused over the mathematical possibilities of a fourth dimension. They suggest that at one point Duchamp had approached, with serious intent, the new geometry and science of his era, but only for a

moment. He looked at the popular books and magazines on these topics, and he jotted things down. But math and science proved too hard to master. As a result, the science-like notes in *The White Box* (1967) are no more comprehensible than his notes in the *Box of 1914* and *The Green Box* (1934). More than those two, however, Duchamp was reluctant to release the 1967 materials. As he said to Gray during the translation process:

> I mean, does it make sense? You know I don't want to appear foolish.
> . . . this was written long ago, and mathematics today has become such
> a special and complicated field, perhaps I ought not to get involved
> now.[13]

Nevertheless, the publication of *À l'Infinitif* was considered an art world event. In his latter days, Duchamp had dismissed science and mathematics anyway, preferring a kind of nihilism. "I just don't see why we should have such reverence for science, and so I had to give another sort of pseudo explanation," he said of his mature approach. "I am a pseudo all in all, that's my characteristic. I never could stand the seriousness of life, but when the serious is tainted with humor, it makes a nicer color."[14]

The attempt to be a true nihilist, however, has always proved elusive (short of suicide). The alternative was to live in contradiction, as Duchamp often did by dismissing "taste" and "repetition" in art, but then showing his own tastes and repeating himself often. "Nobody's perfect," he would say.[15] There were other humorous analogies for a person like Duchamp. "Duchamp is more like quicksand than a springboard," Richard Hamilton once said.[16] Still, young artists waded in, making a diligent effort to read and understand what Duchamp was saying. Alas, the rational quest was futile, and one can almost hear Duchamp's cosmic chuckle across the ages of art history, saying, as he once did, "You can make people swallow anything."[17]

Even if the readymade was a joke, the philosophical dilemma it proposed would not disappear easily. Eventually, the art world provided forums in which Duchamp's readymade ideas could be looked at more closely. First off, there were the arguments that the readymade was a good thing. It was a harbinger of "idea art," for example. It also freed artists from their egos and ambitions. As a banal, worthless object, moreover, a readymade could not be hijacked by the capitalist art market, or at least that was the idea.

Here was a seemingly profound breakthrough—the readymade defied "commodification." As modern versions of Marxism proposed, since commodities were a central evil of capitalism, an artwork could easily become what Karl Marx had condemned as a "commodity fetish" in the marketplace.[18] The old-time Marxist may have been baffled at how a readymade fought capitalism. But some on the New Left grew fond of the idea, which took a few mental gymnastics to comprehend. To wit: if a readymade was mere detritus, of virtually no conceivable value to anybody, then it could escape being a commodity fetish (that is, an object of irrational devotion). Still, there was a catch. What if somebody saw a useless readymade as "beautiful"—like a porcelain urinal? Then it would quickly become a commodity. Indeed, Pop art was exactly this. It turned banal objects into commodities bought and sold by collectors. Pop art became a pure fetish commodity, and prices rose accordingly.

There was one final escape, however, and that was to take the right point of view in regard to readymades, banal objects, and Pop art. This was the "ironic" point of view. Taken ironically, the sale of a readymade could be seen as an actual criticism of capitalism. If seen in this light, even Pop art dispelled what Marxism called the "false consciousness" of the marketplace, and by doing this, Pop art undermined capitalism.

This was a lot to swallow, of course, as Pop artists, gallerists, and collectors pocketed the money from readymade sales. And so naturally, a more critical approach to the readymade arose at art forums. One solution was to accept that the readymade is simply an absurdity, and to the right person, an absurdity could be both fun and enchanting. Most art historians, though, wanted to approach the readymade as a face-value object, just like any other work of art that is approached for analysis.

This was not going to be easy, as illustrated by attempts to classify the works of Duchamp himself, for example. Of the list of Duchamp "artworks," his readymades defied all the normal generalizations, according to the Duchamp scholar Anne d'Harnoncourt, who had mastered Duchamp's life's works (which include sketches, paintings, verbal jokes, and devices as well as readymades). "Of all Duchamp's creations, the Readymades most resist classification and incorporation into any thematic whole," she said.[19]

That resistance notwithstanding, two other scholars of the art world have tried to take a thematic approach to defining the readymade, focus-

ing mostly on the effect that such an object, as an art object, has on people's minds. At the same "Art of Assemblage" exhibit where Duchamp gave his classic definition of the readymade, the literary historian Roger Shattuck, an expert on the Paris avant-garde, offered one of the most succinct explanations of the readymade, comparing it with the same object that Duchamp had cited — the painting.

Shattuck argued that with a painting by Cézanne or a Picasso, the viewer can look at it repeatedly, every time finding a new sensation, emotion, or thought. Readymades don't work that way. Rather than "stimulate meditation or artistic emotion," the readymade aims for a one-time shock, a kind of anti-art jolt. "Such a shock is not repeatable," Shattuck said. After the first shock, readymades lose their power. "They no longer have any anti-art function, only a practical function — install the urinal and put it to use."[20]

Years later, in 2006, Duchamp's *Fountain* would generate headlines that confirmed the ability of the urinal to evoke both shock and banality. As the *Associated Press* reported from the prestigious Pompidou Center.

> PARIS — A 76-year-old performance artist was arrested after attacking Marcel Duchamp's "Fountain" — a porcelain urinal — with a hammer . . . The suspect, a Provence resident whose identity was not released, already vandalized the work in 1993 — urinating into the piece when it was on display in Nimes, in southern France . . . During questioning, the man claimed his hammer attack on Wednesday was a work of performance art that might have pleased Dada artists. . . . "Fountain" is estimated at $3.6 million.[21]

Other cases of abuse, or mistaken identity, accompanied the rise of the readymade in art history. During the first traveling exhibit of Duchamp's *Snow Shovel*, the janitor at a Minneapolis museum commandeered it from the exhibit hall, ready to deal with the snow storm outside.[22] The same has happened with readymade entrepreneurs in Duchamp's footsteps. When the hard-partying British artist Damien Hirst's set up the *Party Time* artwork at London's Eyestorm Gallery (an exhibit of cigarette butts and empty beer bottles valued at "six figures"), the night janitor accidentally threw it out. "There was so much mess," the janitor said. "So I cleared it all in bin bags, and I dumped it."[23]

Like Shattuck, the art critic Donald Kuspit also tried to classify why

the readymade is so impossible for even janitorial common sense. Kuspit framed the readymade as Duchamp's condescending, and thus negative, joke on ordinary people. "The readymade has no fixed identity," Kuspit said. "Regarded as art, it spontaneously reverts to non-art. It collapses into banality the moment the spectator takes it seriously as art, and becomes serious the moment the spectator dismisses it as a banal object."

This "absurd and tasteless" object has only one goal, Kuspit concluded: "In short, Duchamp's readymades exist to mock and defeat the spectator."[24]

If Kuspit is correct, then Duchamp's belief in spectator interaction with an art work is not possible: the readymade imposes its domineering confusion on the public, and thus violates Duchamp's principle of viewer interaction. The violations continue, for often the readymade is taken as pretty (retinal), intentional, saleable, and even a reflection of the artist's ego—all contrary to Duchamp's original claims. The protean readymade, very much like Dr. Frankenstein's monster, easily turned on Duchamp, contradicting every principle he had enunciated as a critic of painting, artists, and the visual arts. But as Duchamp said, with a smile, "Nobody is perfect."

As the readymade baffled America, it was Richard Hamilton who finally brought the Duchamp juggernaut to England. He also brought Maria Martins back into the picture, which apparently offended Duchamp. For the summer 1966 Duchamp retrospective at the Tate Gallery, "The Almost Complete Works of Marcel Duchamp," Hamilton had not only built a replica of The Large Glass (only the second authorized by Duchamp), but he had written to Maria in Brazil to ask her to provide a tiny model (a kind of plaster sketch) of the naked mannequin, with leg lifted, that Duchamp had made of her. She agreed. Duchamp was caught by surprise. When Duchamp saw it being put up at Tate, it was the only time Hamilton ever saw him angry.

In the catalog for the show, which featured 242 items, Hamilton wrote, "No living artist commands a higher regard among the younger generation than Marcel Duchamp."[25] In New York, the established critics of modern art, from Hess to the New York Times art critic John Canaday, had to agree, and unhappily so.

As Hess had said, young artists had been deceived that they could do what Duchamp had done, which was to create his own lifestyle and biog-

raphy—his celebrity: Duchamp was a persona who grew out of unique periods in bohemian Paris and the wartime art subcultures of the twentieth century. That could not be readily replicated, as many young artists—producing readymades of all sorts—were trying to do in the hothouse of the Pop art market and during the rise of contemporary art. "Duchamp is not responsible for the errors of his followers because they should have known that only Duchamp can be his own work of art," Hess concluded. "When Duchamp did it first, he did it last."[26]

ON HIS RETURN to New York from the Tate Gallery show in London, Duchamp had Maria Martins on his mind for one other reason. His diorama with the naked Maria mannequin was coming to completion. He also found out that by the end of the year he had to vacate his Fourteenth Street flat. So he quickly found another spare studio—at 80 East Eleventh Street—and after transporting the entire diorama to the new location, he spent the first two months of 1966 reassembling it based on snapshots, diagrams, and notes he had prepared.

The new studio was not far from his home. Up to this point, he and Alexina had been living in Greenwich Village for seven years. They had a cozy apartment on the first floor of 28 West Tenth Street. In the last decade of the diorama project, Alexina had been helping in its desultory completion.

Meanwhile, chess had also become a shared part of their lives. Duchamp and Alexina were playing chess as much as they could at the Marshall Chess Club. In 1959, he became director of the American Chess Foundation for a time. He served as a chaperon for young American chess players when they showed up near his vacation spots, such as Monte Carlo. He also helped raised money for the American Chess Foundation. This project was called the "Marcel Duchamp Fund," and after Duchamp's artist friends contributed works, they would be sold at places such as the Cordier & Ekstrom Gallery.

For a few years already, Duchamp and Alexina's life had been a mixture of chess duties, exhibit events, leisure, celebrity, and travel. Duchamp would have two prostate operations, but carried on (Alexina never told him the doctors had found cancer). Since 1959, they had traveled to Europe every spring or summer. After Duchamp's sister, Suzanne, died in 1963, they lived in her Neuilly home during stays in Paris.

On each trip, the ultimate destination was the artists' colony of Cadaqués, Spain. There, Duchamp would meet up with old friends such as Salvador Dalí or Man Ray, who had moved back to Paris (where he would die in 1975). Dalí had long ago been expelled from the Surrealist movement, but Duchamp, like Picasso, always placed friendships and connections over the political disagreements that divided members of his artistic generation. During the visits to Spain and France, Duchamp took photographs of forest scenery. He and Dalí took these to a photo shop and had copies made. Later, Duchamp would cut out pieces of these forest scenes and glue them together as a collage; it would be the scenery backdrop for his diorama with naked Maria.

In Spain also, he and Alexina picked out other parts of the final artwork. They found an old Spanish barn door and, elsewhere, an archway of old Spanish bricks with which to construct what amounted to the "entrance" of the diorama: it would be a large antique door, framed by ornate brick, with two peepholes in the wood to look through. At this time in his life, money was no problem for Duchamp. He had the bricks and heavy wood shipped to New York, where workers prepared them and carried them to Duchamp's studio, and then rebuilt the door and brick frame according to his instructions.

With Alexina by his side all along the way, the completion of the diorama was still rooted in the past, a story of his travails with Maria Martins. As early as 1948, Duchamp had established the naked mannequin as the basic framework of the diorama. He had also worked out the fundamental materials problem of creating a lifelike mannequin with vellum (and, indeed, coating it with pink paint inside to glow through the calf skin). When Maria had left the picture, however, Duchamp had lost a good deal of motivation—the diorama sat moribund. Then he met Alexina, and as part of their marriage, it became her project as well. With a revived sense of purpose, Duchamp began to think about the final touches and accoutrements in the environment—and he began to infuse it with a new storyline, absent Maria.

Whatever oblique "story" the diorama was trying to tell, it included two repetitive elements from Duchamp's past. The first was the waterfall he put in the background scenery, simulated with collage photos and flickering electric light. It was based on the waterfall he first saw in Switzerland with Mary Reynolds. The other touch was the old-fashioned gas

light Duchamp put in the mannequin's raised hand. Apparently, these two elements stood for "waterfall" and "illuminating gas," two words that he jotted down at the very start of his career, and that he used as the opening words for *The Green Box* notes. Now, Duchamp also made those words the essence of the diorama title, written on the mannequin's right shoulder: *Étant donnés: 1o la chute d'eau, 2o le gas d'éclairage . . . (Given: 1st the waterfall, 2nd the illuminating gas).*

When it was done, the diorama had its permanent look, and it would later be described in a museum catalog entry as:

> a realistically constructed simulacrum of a life-sized nude woman lying spread-eagle on a bed of dead twigs and fallen leaves. In her left hand, the mannequin holds aloft an old-fashioned illuminating gas lamp, while behind her, in the far distance, a lush wooded landscape rises toward the horizon. This brilliantly illuminated backdrop consists of a retouched collotype collage of a hilly landscape with a dense cluster of trees outlined against a hazy turquoise sky, complete with fluffy cotton clouds. The only movement in the otherwise eerily still grotto is a sparkling waterfall (powered by an unseen motor), which pours into a mist-covered lake.[27]

At its completion, the diorama still was known to only a few people. That gate widened in spring of 1966 when Duchamp finally gave Bill Copley a phone call. For more than a decade, Duchamp had been designing the diorama to fit the small room next to his *Large Glass* exhibit, the small room occupied by the works of Kandinsky, the oil painter. Now Duchamp wanted Copley's assistance in having the diorama, or what he told Copley was a "big sculpture-construction," installed in the Philadelphia Museum of Art. There was no guarantee. Even Alexina believed it was too sexually explicit to pass muster. When Copley got the phone call, he dashed over to Duchamp's Tenth Street flat, saw it, and was "speechless," as he recalled.

Duchamp and Copley gleefully struck a deal. Copley arranged for his family foundation to purchase the diorama for $60,000 (to be paid in installments), a figure that included calculations for the cost of moving it to Philadelphia, and even of renovating museum space. Then Copley would offer it as a gift to the museum: the offer by a charitable group was much more apropos than having Duchamp, using his inside track and Arensberg

advantage, foisting it on the venerable Philadelphia institution. To pull this off, in fact, Copley changed the name of his art philanthropy, from the Copley Foundation to the Cassandra Foundation, so the diorama gift did not look like his own personal agenda. It was indeed both Copley and Duchamp's agenda, but either way, they could not imagine that the museum would turn it down. After they hatched their plan in March 1966, the Cassandra Foundation made its offer, and for the next two years the two friends carried out a small campaign of persuasion.

It finally would require showing the goods. There were no photographs, and for lack of a handy *bon mot*, Copley had awkwardly described the diorama as a "Rube Goldberg copulating machine."[28] The most important visitors would be a small party led by Evan H. Turner, director of the Philadelphia museum, who brought some of his staff and a trustee. More informally, some of Duchamp's friends also had been allowed to wander into the fourth-floor sanctum for a glimpse: musician John Cage, Duchamp art dealer Arne Ekstrom, artist Cleve Gray, photographer Denise Browne Hare (whom Marcel and Alexina had invited to photo-document their life), and curator Walter Hopps. Maria Martins also saw it in its completed state at Tenth Street. The process of disclosure was delicate. Duchamp had asked his biographer Lebel to keep the project secret. Meanwhile Duchamp never told his other significant biographer, the Milan-based Arturo Schwarz, of its existence.

As Copley and Duchamp reached out to the museum, Duchamp's celebrity around New York continued to ascend on the rising tide of Pop art, which was now being tied almost directly to Dada. When Andy Warhol invited Duchamp to his studio, The Factory, how could Duchamp say no? Warhol then made a twenty-minute film of Duchamp smoking a cigar. Titled *Screen Test: Marcel Duchamp*, it was one of Warhol's early excruciatingly monotonous film shorts. The film was far more Dada than were Warhol's bright, colorful, and extremely retinal Pop art paintings and silkscreens. In any case, such antics as the film further cemented the impression that Warhol was Duchamp's progeny. As one argument went, "It may be that Warhol was Duchamp's truest heir"—pushing Duchampian ideas to their fullest economic implications.[29] Warhol took the anti-marketable readymade and flipped it over. He turned readymades into mass-produced saleable art objects, enjoyed for their visual effects, which Warhol called "beautiful."

At the time, Warhol was unknown in Europe. Surprisingly, the same could be said about Duchamp, even in France. What was known was "the Duchamp family," and in that case his older brother completely outshone what Marcel may have done. Although Marcel outlived all of his siblings, it was thanks to his two brothers—Raymond and Jacques—that the Duchamp family was noticed as part of France's artistic legacy. Their paintings and sculptures were now in assorted museums and collections, and Raymond and Jacques's Puteaux studio was given landmark status for a while before it had to give way to developers. In Marcel's lifetime, the only work of his that was significantly recognized, having been acquired by France's National Museum of Modern Art, was the 1911 oil sketch he did for *The Chess Players*.

When the city of Rouen's Beaux-Arts Museum decided to honor the Duchamp clan in spring of 1967, Duchamp was invited to participate in the April 15 opening. "The Duchamps" exhibit showed eighty-two works by the three brothers and their sister, Suzanne. In addition, the city put up a bronze plaque on the brick house where Marcel's parents had lived. At a ceremony, Duchamp pulled back a little curtain to reveal the plaque. During an interview, he gave a journalist a series of witty, outrageous comments, of which he said later, "What does it matter? It's what he wanted me to say."[30]

The rapidly aging Duchamp was much happier about the latter-day recognition he was receiving in America. It came from several quarters, but especially among those, like John Cage and Jasper Johns, who felt they were his Dada heirs. In addition, Duchamp had broken a number of social conventions regarding sex, including his own androgynous alter-ego, the character Rrose Sélavy. This had been welcomed by homosexual artists, such as Warhol, Rauschenberg, Cage, Johns, and others, and by some feminists as well.

In Toronto, Cage held the first homage event to Duchamp. It was a kind of "happening," an electrically wired chess game that made sounds with each move. Given the name *Reunion*, the event began at eight thirty on a frosty February evening inside the Ryerson Polytechnic high school auditorium. A full house had come to see Cage, now famous for his non-music concerts. This event was different: it aimed to share the experience of chess moves, known only by random sounds, with much silence in between. The auditorium was dark except for a spotlight on Cage and

Duchamp, sitting at a chess table on stage. When the event concluded at midnight, the entire audience, curious at first, had already left, bored to tears by the proceedings. A month later, Cage's lover, the dance choreographer Merce Cunningham, held another homage to Duchamp in Buffalo. It was a ballet titled *Walk Around Time*. For the stage set, Jasper Johns had created seven large, clear cubes on which he put images from *The Large Glass*.

These two events, now in the annals of 1960s "happenings," were probably overshadowed by Duchamp's last great exhibit in his own lifetime. At the Museum of Modern Art, citadel to Picasso, the Picasso expert and curator of modern art William Rubin organized "Dada, Surrealism, and Their Heritage," which opened in late March 1968. It included thirteen works by Duchamp (since, fortunately for MOMA, it owned a few of them already). For one of the few times in his life, Duchamp attended the opening—it was black-tie and in his honor—though he declined to make remarks. As an art historian, Rubin traced Duchamp's "progression from 'anti-artist' to 'engineer,'" after which Duchamp provided an "intellectually oriented nihilism toward art," to which, ironically, some Surrealists and neo-Dadaists "responded with a sensuous affirmation of painting."[31]

For a brief moment in the spring of 1968, Duchamp was doing what Picasso was doing: reinterpreting the old masters. He did a set of nine erotic drawings, "The Lovers," based on classical French artists such as Ingres and Courbet. These were etched and printed by a professional engraver, ready to go on the art market for sale to collectors.

Then Duchamp and Alexina were off to Paris for their annual summer trip. This trip would be eventful indeed. Once settled in Neuilly, the city exploded in the May 1968 student riots, followed by nationwide worker strikes. On May 23, as the strikes spread, Duchamp and Alexina got in a Volkswagen, navigated the Paris traffic and barriers, and headed for Switzerland. At the time, opposition leaders were declaring that "there is no more state," and within a week de Gaulle called an election, the virtual end of his regime. The students, often led by poets, anarchists, and witty sloganeers, also wanted sexual liberation, a page torn from Duchamp's artistic doctrine of nihilism and "eroticism." As he said the year before, "I believe in eroticism a lot, because it's truly a rather widespread thing throughout the world, a thing that everyone understands. . . . a

way to bring out in the daylight things that are constantly hidden . . . because of social rules. it's the basis of everything, and no one talks about it."[32]

For now, the nuisance of traffic and social breakdown in Paris did not hurt a splendid vacation. Their first stop was Lucerne, where they stayed two weeks. Then they drove to Lake Geneva, where Duchamp again enjoyed seeing the Forestay waterfall. If Picasso seemed to stare down death by painting, Duchamp seemed to do it by traveling. He would turn eighty-one that year, and he was keeping up a remarkable pace (not least, with two prostate operations behind him). So on June 5 in Zurich, he and Alexina boarded an airplane for London. They attended the Institute of Contemporary Arts lecture by Arturo Schwarz, a kind of pre-publication party for his massive *Complete Works of Marcel Duchamp*. The lecture restated Schwarz's off-color Freudian theory that Duchamp's early artworks reveal an incestuous desire for his sister, Suzanne. Duchamp, nonplussed, left the lecture calling it "rubbish." He tried to remain indifferent.[33]

Having been in London for three days, he and Alexina could not wait to head for Spain, their next stop. They flew to Zurich, got in their Volkswagen, and drove to Genoa, where they caught a boat to Barcelona, and then traveled to the seaside village of Cadaqués. This would be their eleventh summer there, and they were soon visited by Man Ray and his wife. It was July 28, so they celebrated Duchamp's eighty-first birthday. Try as he might, Duchamp the anti-artist could not stop: he was making small art items for Schwarz's French "deluxe" edition of *Complete Works*, for which he was eager to chalk up good sales. When Schwarz's first edition of *Complete Works* came out, it listed 421 items of note (for art history and collectors) related to Duchamp. By the third edition in 1997, he listed 663 items.

The Duchamps had planned to return to their house in Neuilly in early September, but Duchamp fell ill for ten days. They waited until he was strong enough to travel, and were soon back in their quiet Paris home. The city's May 1968 revolution, which had calmed down four months earlier, was now only a memory. The uprising was something the early Dadaists and Surrealists might have enjoyed, and indeed, many of the young Parisian literary and Marxist figures in the demonstrations put themselves in the stream of Surrealism. This was not Duchamp's style. He wanted nothing to do with political protest or the politics of societies and nations.

At home in Neuilly, Duchamp made plans to fly to Chicago for the October 17 opening of "Dada, Surrealism, and Their Heritage," which had traveled there after the MOMA exhibition. On September 22 he wrote to Mary Reynolds's brother, Frank Hubachek, whose trust continued to support him. The letter spoke warmly of Duchamp looking forward to a quiet return to the Windy City, a place that had always treated him well.

One Tuesday night, when Man Ray and his wife, and Robert Lebel, were in town, the Duchamps invited them over for dinner. Duchamp was pale and quiet. After they left, Duchamp went to another room, where he opened a book of puns and began to read. One of the puns was particularly funny, he told Alexina. They stayed up until about one, when Duchamp went to the bathroom to prepare for bed. When he did not emerge, Alexina went inside. Her husband lay crumpled on the floor, dead at eighty-one.

The Duchamp family had a cemetery plot near their hometown, under a pine tree overlooking the Seine River. Duchamp requested that no funeral be held. His ashes soon joined the remains of his grandfather, the engraver, his father, mother, two brothers, and sister Suzanne, all marked by three simple stones, cracking and mossy. Duchamp specified the epitaph on his grave, a fragment attributed to the sixteenth-century French essayist Michel de Montaigne: "Besides, it is always other people who died."[34] The phrase was odd, so it required approval by city officials.

The obituaries revealed Duchamp's degree of stature in different parts of the world. In Europe, the newspapers and magazine acted as if they hardly knew of him. In France, *Le Figaro* put his obituary in the chess section of the newspaper. The Italian press did not mention the idea of the readymade.[35] Man Ray, who typed out a quick homage to his friend, said for the record: "He laughed . . . Ah yes it is tragic as an endgame in chess."

On his death, it was clear that Duchamp had friends in America, especially in Chicago, where he was remembered fondly by the lovers of modern art. Unlike lesser artists, Duchamp had rejected "everything that shackled art to the visually factual but the spiritually empty," the *Chicago Daily News* editorialized. Thus, to one American newspaper's editorial board, Duchamp had become a "spiritual" leader. *Life* magazine, which always liked to announce new trends, identified Duchamp as "one of the century's most influential artists." The *New York Times* had two obituaries, one on the front page and one inside, where art critic John Canaday

lamented that, given Duchamp's art-world authority, he was possibly "the most destructive artist in history."[36]

Eventually the news of Duchamp death's reached Picasso. Picasso reportedly offered the epitaph, "*Il avait tort*," a succinct statement about Duchamp's views on art as anti-art: "He was wrong."[37]

15 picasso's last stand

During the 1960s, Picasso was both celebrated and pushed to the sidelines. The established art museums of the world, and in France in particular, would build upon his legacy. At the same time, a restless younger generation of artists viewed the old Spaniard as the dead hand of the past. Picasso continued to have a hold over the very idea of "modern art," but even that was getting slippery, for a new attitude toward art was developing. It would be called "contemporary art," and, in many cases, its acolytes would be less the followers of Picasso and painting than of Duchamp and the notion of "idea art."

For celebrations of Picasso, however, the sixties was still a very robust decade. In 1966, the whole world seemed to stop and recognize his eighty-fifth birthday. France would do this in grand style, but of all the nations, it also had the most complicated relationship to its adopted Spanish son. In postwar France, Picasso's generation of artists and poets, by virtue of being in the French Resistance, now governed the nation. They were trying to sort out his role in France's cultural legacy, which was not easy in a nationalist era. For the French tabloids and celebrity columns, Picasso was the object of a different kind of fascination. They were especially mindful that he was an aging luminary. When he died, his massive estate was up for grabs. France was also getting flak from Spain, where proud voices declared that Picasso's homeland should host his birthday party. Through all of this complexity, Paris nevertheless seized the day — and planned the mother of all Picasso retrospectives.

Such fêting of Picasso was fairly routine by now. Large retrospectives had been held at New York's Museum of Modern Art in 1957 and 1960, and one was organized in London by Roland Penrose. However, the friends of Picasso in France wanted Paris to hold the biggest ever. It would aim to regather his art from around the world. They began to put pressure on the new Minister of Cultural Affairs, André Malraux, a former member of the French avant-garde but now loyal to the nationalism of Charles de Gaulle. Malraux did not take kindly to Picasso's communist celebrity

or his lordly status, ensconced in a medieval villa in Mougins. At first try, Malraux refused to support a massive Paris event. Even Picasso, having been approached in Mougins, rejected the idea.

Then Picasso's old friend from the 1940s, the journalist, curator, and professor Jean Leymarie, was brought in. He was asked to resolve a stalemate that, with growing publicity, made the government appear as if it was rejecting its own modern art heritage. Finally, the venture was distanced from government sponsorship, and in January 1966, Leymarie was asked to lead the enterprise. He traveled to Mougins to persuade Picasso. That done, he was on the road to New York, the USSR, London, and elsewhere to fill out an ideal list of Picasso's greatest works, mostly paintings.

The Paris furor would take Picasso down memory lane, as best his memory served him. In 1900, he had arrived in Paris as a nineteen-year-old. To his young eyes the city looked monumental, especially with its two newest buildings, erected for Paris's Universal Exposition. They were the Grand Palais and the Petit Palais. Now Leymarie secured them both (in addition to the Bibliothèque Nationale) as the gallery space for the "Homage to Picasso," which would open on November 19 (a few weeks after Picasso's October 25 birthday). All went well, so naturally, Malraux emerged to ceremonially inaugurate the exhibition.

The Grand Palais was filled with Picasso paintings, 284 in all, and the Bibliothèque with 171 of his graphic works: illustrations, etchings, engravings, and lithographs. It was the Petit Palais—which displayed 205 drawings—that revealed a relatively unknown Picasso: the sculptor and ceramicist. Most of these three-dimensional experiments had been put in his studio storage, but their myriad variety had now been gathered in one place (508 ceramics and 392 sculptures).

For some art critics and devotees, the "Homage" was a celebration of Picasso's scope; for others, his Cubist- and Surrealist-leaning sculptures were more offensive than the paintings. Either way, the nearly three-month exhibition made its mark. Estimates of public attendance ranged from 850,000 to 1.5 million, young and old, with the French Communist Party busing in workers as well. It was the largest art show in European history. It was also a mob scene, a storming of the Bastille, said one American critic, and for anyone trying to look at a painting, it was more crowded and rude than a New York subway.[1] As a mass event, the public was happy enough to ponder Picasso the man, a living myth. Kahnweiler

had represented him at the ceremonies, but Picasso himself was a mysteriously absent persona (as he usually was at such exhibits).

Down in Mougins, Picasso was angry at the French government. As all this celebration transpired, the ministry of housing had reclaimed his residence at rue Grands-Augustins. France faced a housing shortage, and Picasso had not lived at the address since 1955. Friends in government tried to intervene, but even Malraux, Picasso was told, could not dissuade the authorities. With the loss of Grands-Augustins, the studio of *Guernica*, Picasso lost another piece of his past. In the 1960s, other old friends died — Georges Braque (1963), Jean Cocteau (1963), André Breton (1966), his secretary Jaime Sabartés (1968) and even his first love, Fernande Olivier (1966), whose funeral was attended only by Alice Derain, another member of the old Montmartre band.

The isolation at Mougins was allowing Picasso to be more productive than at most other periods of his life. He was surrounded by his "court," whose chamberlain was his wife, Jacqueline. His connection to the outside world came mostly via the new black-and-white television. When Picasso saw Braque's official state funeral outside the Louvre, with all its pomp, he was disgusted, believing his old friend would have objected. Braque had been inducted into the French Legion of Honor as a "commander." In turn, Malraux wanted to install Picasso at an even higher rank, that of "grand officer." The presidential approval (necessary for a foreigner) was given in 1967, but when Malraux contacted Picasso, he declined. He said he was touched, but that "my business is painting."[2] Malraux's feeling was actually mutual. He did not see Picasso as part of France's new future.

Ensconced at Mougins, with television and the newspapers, Picasso did not hear or see, apparently, what the young artists were saying as the 1966 Picasso retrospective, like a giant monolith, cast its shadow over the Paris art world. They were saying Picasso was passé. At the same moment, across the English Channel, Duchamp's retrospective at the Tate Gallery, "The Almost Complete Works of Marcel Duchamp," was vying for attention, especially among a young Anglo-American audience. The glittery quality of Pop art was just taking off, and young artists grew out their hair, wore bell-bottoms, and painted bright optical pictures. On both sides of the Atlantic, the fine arts were rapidly mixing with mass advertising. When *Life* magazine covered the "summer of love" in 1967, it featured psychedelic poster art as the new visual taste of youth.

Through these psychedelic-colored glasses, Picasso, who once seemed the great iconoclast, now looked traditional. He was a keystone of the decrepit art establishment, and indeed lived in a stone castle. According to the French tradition, now exported everywhere, the avant-garde by definition must attack its predecessors as regressive. Picasso had done the same. Now it was the new generation's turn. Even the Abstract Expressionists in New York, only a decade or two behind Picasso, sought to oust his long-term status. To keep Abstract painting in the vanguard, the influential art critic Clement Greenberg made sure that he occasionally put Picasso in his place. In the year of the Paris retrospective, for example, he said that after *Guernica*, Picasso "ceased being indispensable." His work "no longer contributed to the ongoing evolution of major art; however much it might intrigue pictorial sensibility, it no longer challenged and expanded it."[3]

Nevertheless, for those who looked closely at Picasso, many of the newest trends were old trends to him. Arguably, the new trends of "arte povera" (poor art) in Italy or the "art brut" (raw art) of France's Jean Dubuffet were tributaries off Picasso's own use of detritus, gobby paint, or childlike imagery in collages and sculptures. Practitioners of "nouveaux réalisme" (new realism), which was Europe's version of Pop art, used ordinary commercial objects, as did Picasso on a few occasions, with his spoons on an absinthe glass as a case in point. There was also a postwar return to "figurative" drawing and painting, especially in expressionist graffiti or comic-strip mode. Picasso, with his satirical comic strips of Franco (and other series) could be placed at the fountainhead.

In short, Picasso had done so much art that few of the new trends had escaped being foreshadowed in one of his earlier experiments. Some Picasso scholars, partisans to be sure, believed that the Spaniard had prophesied virtually everything that happened in art before and after the explosive 1960s: constructivism, minimalism, assemblage, Surrealism, Dada, and Pop art. "No question about it, Cubism engendered every major modernist movement," said biographer John Richardson.[4] Another Picasso biographer, Pierre Cabanne, said: "Besides, was not Cubism the first of the conceptual arts?"[5]

Nevertheless, in the mid-1960s, these delicate interpretations of "priority" and "provenance"—who did something first and what is authentically original—were swept aside. At face value, Picasso had lost his

revolutionary mantel. If anything, he was an obstacle to the next wave of artists seeking their day in the sun. He was a multi-millionaire and, oddly enough, a symbol of the Old Left. Neo-Marxist art historians such as England's John Berger (in his 1965 *The Success and Failure of Picasso*) began to criticize the old-line party's agitprop praise of Picasso, a Soviet ploy that used the "Comrade of genius" mainly for publicity. The New Left chafed at this conformity, as would be evident during the May 1968 uprising in Paris, during which the student and worker unrest was opposed by the French Communist Party.

WITH THE ARRIVAL of the 1960s, the works by Picasso, regularly shown at the Leiris Gallery, were hardly grabbing headlines or attracting the interest of young painters in France or elsewhere. Nevertheless, on his own last artistic journey—a kind of discussion with old masters and nostalgic themes—Picasso continued with the productivity of a young man in a hurry. A sampling between 1960 and 1970 illustrates his final tempo and themes. Picasso's friends called his last period a remarkable celebration of his powers. His critics were less demure; they saw a flurry of self-indulgence, quantity but not quality.

The decade began with Picasso playing off of Manet's *Luncheon on the Grass*, which pictured two men and two women on a picnic in the forest. In early summer of 1960, Picasso took the first of many stabs at this composition, putting his paint down with a kind of messy, cartoon effect, and then in 1962 he turned to doing iterations of David's *Rape of the Sabine Women*. By the end of 1964, he had also produced a series of etchings—and about one hundred paintings—on the topic of the artist-and-model, exploiting it in a variety of crude, hilarious, and erotic scenes. He continued this through the next year (doing thirty such paintings in a single month, March 1965).

Picasso's locomotion was stopped only by his ulcer operation. A period of fallow and convalescence followed, but then in spring 1968, as Paris flared into riots, Picasso realized he'd beaten the illness, and perhaps even death. He sprang back with a comical cheerfulness: he took up the topic of musketeers, replete with their pointed beards, curled mustaches, plumed hats, ruffles, doublets, and swords.

While Picasso had once dipped into Shakespearean topics to illustrate a book, that was not the most direct source of his musketeer period. For

this, he had turned to Rembrandt. He fixed his attention on Rembrandt's fabulously dressed guardsmen of the seventeenth century. Rembrandt, the other great master of etching, was the figure who haunted Picasso's last days, a ghost who talked about the perfect line on an etching plate.

Whether in his paintings or etchings, Picasso continued in a vein diametrically opposite to an artist such as Marcel Duchamp — Picasso gave his works the simplest, mundane titles. Over his last two decades of painting, very few titles really stand out. Exceptions to rule might include *The Bay of Cannes*, *Cat and Lobster*, *Cavalier with a Pipe*, and *The Kiss*. But most titles were so generic that they could almost be interchanged. For his takeoffs on the old masters, he simply repeated their title (*Women of Algiers, after Delacroix*, 1955, for example). In the rest of his works there were countless named familiarities: studios, sitting women, heads with hats, nudes, armchairs, artists-with-model, musketeers, landscapes, and portraits of Jacqueline.

For many of these painted topics, Picasso also did high-quality engravings. They showed again the virtuosity of his line drawing. Eventually, with comic intent, he was introducing the musketeer into the artist's studio, where the bedazzled soldier sat in full regalia at the easel gazing at the naked model. In terms of eroticism, Picasso could only push further. He evoked the kind of seedy bordello scenes he'd sketched early in his life. To go this direction, he played off yet another old master, Ingres. He again picked up on imitating his *Turkish Bath*, which had been a prod in Picasso's design of *Les Demoiselles d'Avignon* in 1907. Again, all of these works were given similar, generic titles, challenging even Picasso connoisseurs of the future to keep track of them all, usually by numbers and dates.

Between March and October of 1968, Picasso produced what would become one of his most famous "suites," or set of works: 347 etchings of various sizes and techniques that mostly portrayed the erotic debaucheries of the baths and the studio. The suite also included nostalgic scenes of the circus, bullfights, and comic theater (which Picasso could see on television); they naturally included Harlequin and Pierrot. The sequences of drawings seemed to follow a plot, as if installments in a comic strip. Then, suddenly, the stories spiraled in every kind of direction. New characters arrived and left.

The *Suite 347* was shown at the Louise Leiris gallery. So impressive were the fine-line renderings that in 1969 *Suite 347* went on tour to Zurich,

Hamburg, Cologne, Stockholm, Nagoya (Japan), and Toronto. In the end, the virtuosity of Picasso's drawings would overshadow the apparent deterioration in his paintings, or that was one consensus. This contrast prompted the British collector Douglas Cooper, one of Picasso's greatest supporters, to say that Picasso's work had ended ten years before his death, with the burst of drawings and graphics as an exception.[6]

IF THE LIVING PICASSO was a complex quantity in France's fast-changing cultural and political landscape, he was no less so in Spain, a country he had last visited in 1933. In his last fifteen years of life, having moved to the south of France, where both the climate and some culture — such as bullfights — evoked his years in his homeland, Picasso's aging mind returned to Spain. For a long period in his studio, Picasso reinterpreted Velásquez, a figure from the golden age of Spanish painting, subjecting his famous *The Maids of Honor* (1656) to all manner of synthetic Cubist rearrangements. Picasso's Spanish character endured in other ways, from his mischievous machismo in his erotic etchings to his aversion to every kind of legal document. As he said of the day when his heirs would sort out his property, "It will be worse than anyone imagines."[7]

Picasso still remembered his triumphal road trip to Barcelona in 1933. The Republican government had just won the national election. Under threat from Franco's generals, the Republicans had declared Picasso to be honorary director of the Prado, one of the world's great museums. That was the last trip to Spain of his life. In 1960 his modern-art supporters in Spain began to reach out. It began when Picasso urged Sabartés, his long-time friend and secretary, to ask the City Council of Barcelona to open an official "Picasso museum." Already, Sabartés had donated his private collection to the city in 1953. To send more art to Barcelona, and to commission a formal museum, required delicate maneuvering, since Picasso was still persona non grata in Franco's Spain. In Madrid, Picasso was viewed as a communist and advocate of Catalonian succession. So everything about the museum initiative was done in the name of Sabartés, a native son of Barcelona.

Who could resist a major Picasso museum? The city council agreed on July 1960. The city had its choice of ancient mansions, and Picasso surreptitiously requested one from the gothic fifteenth century, the Aguilar Palace in Calle Montcada. In handling his art contracts over a lifetime,

Picasso had done some paperwork, but the amount of paper — records, legal documents, signed bequests — was about to snowball out of all proportion to one artist. This began modestly with the Barcelona donation by Sabartés, and would pick up momentum: after all, either Picasso or his heirs would have to sort out the four to five thousand paintings stacked in his studios around France (and thousands more drawings and sculptures). The Sabartés donation was modest enough: 574 works. The museum opened in 1963 under the name "The Sabartés Collection." To avoid provoking Franco's government, it opened with little fanfare.

Sabartés had suffered a stroke in these years, but he was holding on, a kind of measure for Picasso himself: both of them had been born in 1881. Then Sabartés succumbed. On his death in 1968, Picasso made a further donation. In homage to his old friend, he gave the Barcelona collection his Blue period portrait of Sabartés in the cafe (which Sabartés said launched the Blue period), and the most Spanish-related of his recent paintings, fifty-eight variations on Velásquez's *The Maids of Honor*.

It was dawning on Picasso how much there was to give away. So the next year, he had a lawyer write something like a will, which did not speak of his death, but rather spoke of a time after his "disappearance." The will was more a testament than a clear list of properties, but at least Picasso went that far: the Spanish tradition was to have no will at all. That was a recipe for chaos for a man with vast property holdings and so many relations, from nieces to children born out of wedlock. Picasso remained fairly vague. He also acted without consulting them, though Jacqueline was a final influence.

Amid this complex family genealogy, Picasso began to show his hand, and the first move shocked his relatives in Spain. At the start of 1970, he donated all of his works in storage at his family's Barcelona home, once overseen by his mother and sister Lola, to the Sabartés Collection. This was a mass of work, some nine hundred items. It was mostly from his early years in Spain (but now worth a great deal) and from his Diaghilev theatrical period. The curator traveled to Mougins to flip through photos of the material with Picasso, requiring his signature for each of them. The cash value of the cache had slipped through the hands of his Spanish heirs.

The itemizing of this bequest from his mother's home was a good indication of what was considered an "artwork" by the great artist. Most

obviously, there were eighty-two oils on canvas and twenty-one on other supports. There also were 691 drawings, pastels, or watercolors on paper. The number increased even more when each page of some seventeen notebooks and sketchpads was counted; the same was true with books in which Picasso had merely scribbled in the margin. There were also lots of keepsake objects that he made or altered. Following this first infusion, the amount of additional material donated to the Barcelona museum would swell. In time the housing for the collection expanded to two additional ancient mansions. Picasso was invited to Barcelona, but deferred, joking that he'd have to wear a wig-and-beard disguise.

Picasso also asked that, with the December 18, 1970, unveiling in Barcelona, that the museum not hold a great ceremony. He was tiring of too much pomp; or he was being politically delicate. At the heart of these transactions—and at the heart of his 1969 "will"—stood the fate of *Guernica*, which hung in the Museum of Modern Art in New York. Picasso stated that *Guernica* must end up in Spain when democracy returned, which only suggested that this would come with the departure of Franco (who did, indeed, die in 1975). By 1970, Spain was changing, even if Franco remained in office. The same year of Picasso's family bequest to Barcelona, the nation opened its Museum of Modern Art in Madrid, not far from the Prado. For those who discussed the arrival of *Guernica* in Spain, the new museum and the Prado were the two obvious destinations. For now, Picasso mocked the Prado when anyone said that all his paintings should be there.

PERHAPS TO ITS SURPRISE, in 1971 the world had to deal with Picasso's ninetieth birthday. The previous big event was so elaborate that, this time around, something smaller but elegant was called for. That was the approach taken in France, where a new culture minister in the government of French President M. Georges Pompidou did not want to rock the boat.

Again, Jean Leymarie was called in, and another superlative was achieved. At the Louvre, the Grand Gallery was cleared of several eighteenth-century French works to make space, for ten days, for eight of Picasso's most famous—and least offensive—paintings. It was the first time that a living artist had been hung in the Grand Gallery. At the ceremony, Pompidou said that Picasso was a "volcano," even if the eight works

did not come from his most volcanic episodes. "Whether he is painting a woman's face or Harlequin, there is always the same explosion of youthfulness," President Pompidou said, playing to a generational theme that was becoming important in French politics.[8]

On the same date as the Louvre unveiling, October 25, letters and telegrams arrived at Mougins, and the Communist Party held celebrations for their "Comrade of genius" in Paris and in the town of Vallauris (where they had expected Picasso's arrival, but to no avail). Various delegates arrived at his home with congratulations, but they were all turned away with the usual "Monsieur is not here."

The story was different in Spain, where patience with Franco had once again grown thin. In Barcelona, police broke up anti-government "tribute to Picasso" demonstrations. The extreme supporters of the Franco regime also went into action. Some of them invaded a Madrid gallery. They smashed twenty-four pictures in a display of the "Vollard Suite," a series of one hundred etchings (the Minotaur and artists-with-model, mostly) Picasso had done for art dealer Ambroise Vollard in the 1930s. A gang of anti-Marxists trashed a small exhibit hall called the Picasso Studio. It was still risky, even for a publisher, to flaunt anything that glorified Picasso. Elsewhere, Picasso's honors were celebrated in peace. The town of his birth, Málaga, unveiled a statue, and in La Coruña, where he attended his first art school, the celebrants held a literary event.

Even the modest Louvre event in 1971 could not avoid the clamoring of Picasso partisans: the city needed a big, official, world-class Picasso Museum, they said. Paris had made Picasso an "honorary citizen," but it balked on doing more: it decided not to erect a statue or monument. Ever since the idea of a Picasso museum had been floated, both the national and city government said it was under consideration. With the topic of Picasso, however, government officials always had to make political calculations, testing public opinion and partisan sentiment. A few practical issues remained as well. On leaving the Louvre event, the press caught up with President Pompidou to grill him on a Picasso museum for Paris. He said, "I would be happy to see such a museum," adding, "but what would we fill it with?"[9]

By this date, the great convulsion of the May 1968 demonstration of students and union workers in Paris had come and gone, galvanizing a generation of younger, more radical artists in the process. For them, in

1971, having such an iconoclast as Picasso featured in the Louvre was historically worthy of note. However, it was also just so much celebration of the dead past. By 1970, when Marcel Duchamp had been dead for two years, many of the young artists of Paris were beginning to marshal his name. For them, Duchamp became a rallying cry to define the new iconoclasm: the art of the future would be "idea" art, anti-aesthetic art, even a new Dada spirit.

For this group, Picasso stood in the way. At worst, the Louvre exhibit had simply reinforced "one of the myths useful to the dominant ideology," one young artist said. Others interpreted it as a closing of the past, a closure that had to take place to move forward. "The Greek inheritance ended with Picasso, who tops off the massacre," the Paris-based Surrealist and Pop artist Hervé Télémaque said. "Duchamp is much more relevant at the moment." This was being echoed quite a bit at the time. "Picasso confused creation with the pleasure of painting," said the nouveaux réalisme leader Martial Raysse, as if reciting from a Marcel Duchamp script. "Duchamp and Mondrian were the ones who persevered on the path of invention."[10]

IN MAY OF 1970, as Picasso's old studio on Montmartre, the Bateau-Lavoir, burned to the ground, the final phase of his living public exhibitions began in Avignon at the now-secularized Palace of the Popes. With 167 paintings and 45 drawings on display, this Picasso exhibit was organized by Yvonne Zervos, who had died a few months before it opened. The public came in great numbers, enjoying the visual mood of so many large, bright, and raw oil canvases hung on ancient stone walls in high-ceilinged sanctums, rooms such as the Great Chapel of Clement VI and the Hall of Notaries. The works, done by Picasso from 1969 to 1970, represented one of his most productive stretches. The public, and the press, could not help but be impressed at Picasso's endurance at age eighty-eight. The living myth continued to fascinate. Even so, to many, the Avignon exhibition also revealed his final decline. In many paintings, they saw a "nightmarish quality" and the start of Picasso's descent into "incoherent scribbling."[11]

More than just the scribbling problem, Picasso had gotten a bit too pornographic: some of his recent etchings could not be displayed in public. Clearly, Picasso was leaving the world with a burst of erotic musing. It

began relatively mildly, with the theme of the naughty Mediterranean bacchanal. Eventually his detailed renderings of the animal sexuality of brothels left little to the imagination, and chroniclers of Picasso have had to deal with this final infatuation. Some said that, in old age, the pornographic excitement that Apollinaire, spiritual disciple of the Marquis de Sade, had introduced to Picasso was coming back. Picasso was trying to be avant-garde, and this is what his brain cells supplied. After all, even the great Baudelaire said the "painter of modern life" painted brothels (or carriage rides). Less forgiving, some critics simply styled Picasso as a "dirty old man." This was how Picasso himself seemed to portray artists, from a grizzled Degas to a debauched Matisse, in his cartoonish "artist and his model" drawings.

Others said that Picasso was responding to the 1960s: sexual liberation was in the news. He saw it on television. The old Spaniard did not want to miss the wave. As always, his advocate Pierre Daix, the French Communist Party journalist, found only strength in Picasso's choices. Ever the Frenchman, Daix dismissed Anglo-Saxon prudery, with its "Victorian horror of sexuality in old age," as what pained the critics of Picasso's wild and anatomically specific brothel scenes.[12] Even Picasso's friends reeled back a bit. Their hero, it seemed, was not immune to a descent into good old-fashioned debauchery. The admiring biographer Patrick O'Brian left the Avignon exhibits "disturbed and sad." He lamented that Picasso had, in the end, become isolated as a rich, proud man. Unhappy with what he had become, Picasso had nevertheless believed "that his briefest jotting down of a passing thought, in his private shorthand, was a valid communication of real importance."[13]

The Picasso shows did not stop, regardless. At the start of 1973 another display of his latest work was put up at the Palace of Popes. This included about two hundred paintings he had done in the past eighteen months. In this case, Picasso broke his pattern of staying aloof. He and Jacqueline made a secret visit to see the display in the auspicious ancient buildings, and then rushed back to Mougins. Who was the Picasso of these latter-day paintings, or even of the often dark and cruel paintings of other periods? His friends struggled to present just the right image.

In the 1960s, the first great British retrospective of Picasso, sponsored by the British Arts Council at the Tate Gallery, tried to answer that question. The exhibit was organized by Roland Penrose. Using 270 works (one hundred of them chosen by Picasso from his private collection), Penrose

portrayed Picasso as a great humanist, not a narcissist. At the Tate, in pictures and words, Picasso was presented as a painter for the people with enduring values for society. As a youth, Picasso had sowed his share of wild oats, but in the end, at the Tate Gallery presentation, Picasso was a lovable old master. In contrast, the Avignon productions detoured from that image. The Avignon works, uncensored, showed a Picasso who still sowed wild oats: he sowed paintings with debauched sex and messy, drippy paint, leaving viewers to wonder at what value this had for society. As even Picasso said, "One has to dare to be vulgar."[14]

Early that winter of 1972 to 1973, Picasso caught the flu. Bedridden and weak, he fought against it by continuing to paint and draw as much as he could. In the early spring of 1973, according to visitors such as Daix, he was working on self-portraits, actually death masks. One — his last — became famous for its chilling and raw visage. Unperturbed, Picasso said to Daix rather matter-of-factly, "You see, I really did catch something with this one."[15]

As manager of the Picasso household, Jacqueline's job was far more difficult than her husband's struggle to keep up his painting. Overseeing a small staff, she did the only thing she knew how to: she isolated Picasso and protected him from every possible human harasser or parasite. Their number had grown in Picasso's final years. Mougins had become a place of locked gates, guard dogs, and occasional police protection. As she told a visitor, "I'm entirely in the service of my master."[16] Her husband was stubborn, proud, and determined to keep producing, even as he lost his hearing and his once stout form began to shrink.

Meanwhile, the rumors and media speculation about the "hermit of Mougins" were unforgiving. One said that, inside the secret confines of Mougins, Picasso's circle was pushing him to produce as much art as possible before he died — since its value would skyrocket. Even those who admired him, after seeing his erotic drawings and final paintings, worried that the "rot of self-indulgence" finally had caved in on Picasso, who had descended into his own private world.[17]

One spring day in 1973, Picasso took a phone call from Daix, a welcomed voice of support. It "wasn't going very well," Picasso said, putting off their appointment to meet. "All this is difficult for me."[18] On April 7 he had a few friends over for dinner. Then he became breathless at his bedtime. The local doctor, alarmed by the obvious lung infection and heart

problems, summoned a cardiologist on the morning airplane from Paris. In his bed, Picasso showed the cardiologist some recent works. He passed in and out of alertness, taking interest in all the medical contraptions that were showing, in the end, that he had little time left. As he passed into painless delirium, Picasso mentioned Apollinaire. He told the doctor, a French bachelor, "You are wrong to not marry. It's useful."[19]

Picasso's heart failed a little before noon on Sunday April 8, 1973. The relatives were first to be notified. The local barber came to give Picasso his last trim and Jacqueline covered him with a black cape. By three o'clock, television broadcasts in France and elsewhere had the news: Picasso is dead at ninety-one.

THE AGE OF THE paparazzi had arrived. As journalists and film crews headed for Mougins, so did police with barricades. In the drizzle of the spring day, the flags at Vallauris fell to half-mast. Well-wishers began to put bouquets of flowers along the hillside fence. Even Picasso's family did not get in. The relatives in Spain were informed not to come, and only Paulo, the first child, arrived to play an officiating role. "We're surrounded," he said in a phone call.[20]

Before then, the death had been registered at the City Hall. After some deliberation, the burial was scheduled for two days later, April 10, at Vauvenargues, the ancient villa that had depressed Jacqueline, and that stood in the shadow of Cezanne's mountain. Law forbade a burial in the precincts of the Mougins estate. Also, a public cemetery was out of the question for so famous a figure. The Vauvenargues estate was the best option. Once again, to the chagrin of Spaniards, the French had claimed Picasso. The Minister of Cultural Affairs said, "France became the frame in which his aspirations flowered, no doubt because it was where the air of freedom could be breathed."[21]

A powdery snow fell on the day of the burial. Both a priest and an official of the Communist Party attended the small, private funeral, but it was the words of the church that presided over the events. Picasso was lowered into a grave dug on a garden terrace at the bottom of the steps to the entrance of the villa. His bronze bust, *Woman with a Vase*—shown at the 1937 World's Fair—marked the spot. On the day of the funeral, other family arrived at the Vauvenargues estate: his mistress Marie-Thérèse, and his children, Maya, Claude, and Paloma. They were turned away at that prop-

erty gates, as were many other curiosity seekers. So they placed flowers in the local cemetery instead.

Picasso was gone, but the exhibitions continued. A memorial exhibit came weeks later, again at the Palace of Popes in Avignon. The mood was different, since only Picasso's ghost, not his living myth, seemed to hang in the air. The exhibit featured 201 paintings done from 1970 to 1972. They had been chosen by Picasso before he died. Around the world, museums and collectors also brought out their Picassos for various memorial showings. It was always apropos to speak well of the dead, but not for too long; as time passed and Picasso became history, it was fair game to criticize his final works. The critics spoke ill of his Avignon memorial exhibit. It was a rather desperate show, in the end, and Picasso's death seemed to give permission to drop all the sycophantic praise. Even Picasso's acolytes were strangely silent. No crowds came. But the public was forgiving. If Picasso's last art was not great, the public seemed to say, what can you expect of a man who reached ninety-one and refused to retire?

The death of a famous artist, nevertheless, creates new life elsewhere, and that is the life of the art market. Overnight, the value of Picasso works began to skyrocket. Picasso's death also spread a pall on those closest to him. He had died peacefully, by all accounts, so it was hardly a tragic end. In that aftermath, though, his family was not so fortunate. The question of money and the inheritance soon became a kind of curse that descended on those he left behind.[22]

The amount of money at stake soon became astounding. One of his 1910 paintings, it was told, sold for one million dollars to the Mellon Foundation to be installed in the National Gallery of Art in Washington DC. The Picasso estate soon would be estimated to be worth $240 million, and while his family relations did not know the exact figures, they all knew that much was at stake. Two days after the burial, the family of Paulo engaged in a bitter argument, so bitter that on April 12, Picasso's grandson, Pablito, attempted suicide by drinking bleach. After three months in the hospital he could not be saved. Marie-Thérèse, sixty-three at Picasso's death, had been abandoned by him for three decades. She waited four more years and then, in 1977, took her own life at Cap d'Antibes. As Picasso's wife, Jacqueline endured the difficult aftermath for twelve more years, feeling more and more drained and empty after Picasso's departure. She committed suicide in 1985.

While Picasso's two companions would suffer this fate, it was his children — acutely attuned to the real world, and to their futures — who immediately banded together to make a claim. As biographer O'Brian said, an "unbelievably squalid battle for the inheritance broke out," and it would last for four years.[23] The first steps had already been taken, when the French state ruled that Maya, Claude, and Paloma had the legal right to the surname Ruiz Picasso, and in 1974 further ruled that they were Picasso's "natural children." This entitled them to the inheritance along with the first son, Paulo, and Jacqueline. On this authority, the children filed a legal petition for agents of the court to take an inventory of the entire Picasso estate.

By July 1974, lawyers from all sides were rummaging through the estate to itemize its many elements. Whatever that amounted to, the French state would claim 20 percent as a death tax (which Jacqueline made good on by paying it in artworks, works that eventually filled such state institutions as the future national Picasso Museum, opened in Paris in 1985). From the start, though, Jacqueline stood on the other side from the children. She did not take their claims passively. With her own lawyers, she disputed their share of the estate. When the head of the French Ministry of the Arts, and the city of Paris, finally decided to open a Picasso museum, she agreed to that. However, the children objected, saying the inventory was not yet complete.

By 1977 the French courts had sorted out the inheritance. The first son, Paulo, had died two years earlier, so he did not see that day. That left six equal heirs to the estate: Picasso's three natural children (Maya, Claude, and Paloma), his two grandchildren from Paulo's two marriages, and Jacqueline. She protested the ruling, but it held fast. Everyone signed the ruling in September 1977.

Despite her thoroughly unhappy experience in the inheritance dispute, Jacqueline (and Paulo) did carry out one of Picasso's directives with exactitude. He had donated his private collection of thirty-seven modern painters — including Le Nain, Charron, Corot, Courbet, Degas, Cézanne, Renoir, Rousseau, Matisse, Derain, Braque, Gris, and Miró — to the French state for its museums. The stipulation was that the collection must stay together. In the view of some connoisseurs, while the collection was unique (and sentimental to Picasso), it did not represent the best works of these artists; the authenticity of some of the works also was contested. Nevertheless, it was accepted.

The same year that the family battle over Picasso's estate commenced, the government of Spain also appointed a group of lawyers to analyze what it would take to bring *Guernica* to Spain, as Picasso had vaguely put in print. On the American side, curators such as William Rubin, the Picasso expert at the Museum of Modern Art, did not deny that this was what Picasso wanted. "Picasso made crystal-clear on a number of occasions through the years, indeed confirmed to me in person not long before his death, that 'Guernica' should be sent to Spain only when a genuine Spanish republic has been restored," Rubin wrote in the *New York Times* in 1975.[24]

As the fate of one of Picasso's greatest works remained in flux (resolved only in 1981 with *Guernica's* return to Spain), a decision about Marcel Duchamp's last work had already been made, back in Philadelphia.

16

the duchampians

On January 15, 1969, not long after the first snows fell on Marcel Duchamp's grave, the Philadelphia Museum of Art's top committee gathered. Duchamp had left the museum one more decision to make. By way of William Copley's Cassandra Foundation, Duchamp had offered the museum his diorama, officially titled *Étant donnés* (or "Given" in English, after the usage in mathematical propositions). The museum's executive committee, summoned by the director, Evan H. Turner, had to decide: Would it recommend that the trustees accept Duchamp's "gift," which meant installing *Étant donnés* in the museum?

By the end of the day, the committee voted in the affirmative, reminded by Turner that once the museum accepted the sexually explicit work, it must "stand firmly behind the decision and exhibit it openly."[1] At the same time, the official decision would have no press release, and the diorama would be unveiled with a minimum of publicity. Fortunately, Alexina Duchamp and Copley had provided a fig leaf to justify the low-key approach. They "did not wish any fanfare upon its first being shown," Turner explained. This was in keeping with "the quietness with which the artist created the work."[2] Also, Duchamp had insisted that no one ever photograph the work. For the time being, the museum put a fifteen-year ban on photos.

Everyone seemed to agree that Duchamp's diorama was, as Turner said, "the climax of thoughts he had explored in the *Large Glass*."[3] Otherwise, Duchamp left no explanation.[4] Back in the 1940s, he may have viewed it as something between he and Maria Martins, only secondarily an offshoot of *The Large Glass*. Although Copley said in print that it was clearly a theoretical extension of *The Large Glass*, he also said privately that it was probably just one more of Duchamp's Rube Goldberg-style blagues on sexual mechanics.

With words alone, it was going to be a challenge to explain *Étant donnés* to the public, and in fact, at this juncture, the museum and Alexina strongly believed that mere "words" could dangerously misrepresent the

object. People had to "see" it. Yet the effort to control the verbal news was doomed to fail. Well before the unveiling date of July 7, 1969, the story of *Étant donnés* leaked. The press-savvy Richard Hamilton in England had told what little he knew about it to John Russell, art critic at the *London Sunday Times*. Russell's May 11, 1969, article mangled the description of the mannequin (a "love goddess"). But a new Duchamp mythology came through: he had been "toiling away in total secrecy for all of 20 years." Most presciently, Russell noted that the diorama, which was a very retinal artwork, contradicted Duchamp's entire career as anti-artist. "One of the key facts about modern art blew up in our faces last week," Russell said. "The legend of the great artist who disdained to make art is gone forever."[5]

The floodgates of publicity did not really open for several more weeks. On June 23, *Art in America* magazine released a special issue on Duchamp, boosted by a press release that proclaimed, "Newly Revealed Final Masterpiece by Marcel Duchamp Publicized for First Time by *Art in America*."[6] The magazine's main article, "The Great Spectator," was written by Cleve Gray, the artist who had translated Duchamp's last box of notes (*À l'Infinitif*). To the museum's chagrin, Gray spoke with candor. He coined the phrase "erotic crèche" and stated plainly that it was "as explicitly sexual as any work ever made."[7] He also hinted that the museum, which was supposed to be a bastion of free speech, would make it an adults-only exhibit—which the museum vehemently denied. In fact, it didn't have to set restrictions. The peepholes drilled into the old Spanish door were too high even for old ladies to see, providing what Turner called "the greatest asset in dealing with children."[8]

The *Art in America* article flipped the wider media switch, and the popular press began to arrive at the Philadelphia Museum of Art's door. Unhappy with most of the boisterous coverage, the museum's last line of defense was a scholarly article, published in its *Bulletin*, which put the diorama in a wider, sophisticated art context. On accepting the work, the trustees had been told by one of the museum's art historians that Duchamp had links to Pop art, so a room dedicated to *Étant donnés* would bring that contemporary ethos to Philadelphia. By 1969, Pop art was taking off like nothing else the art world had ever seen, and the nation's art museums were trying to keep up, including in the City of Brotherly Love.

The popular print media's treatment of *Étant donnés*, being both reverent and scandalous, was to be expected. The *New York Times* said that

Duchamp, for all his claims of being a subverter of art, had ended up looking "a bit *retardataire*" (the opposite of avant-garde) by applying old-fashioned diorama craft to a slick and sexually suggestive museum piece. In contrast, *Time* viewed the work as the "triumphant denouement" to Duchamp's artistic career; the work was an "immensely charming paradox." The *Time* story was so worshipful that Turner blushed at its "unbelievably saccharine overtones."[9] In due course, the *Village Voice* invoked the kind of nebulous awe that suited its counter-cultural inflection. The diorama was:

> one part allegory, one part mythology, one part pornography, one part metaphysical geometry, one part hymn, and one part slap in the face — a criticism of all other art, art history, and even of the viewer who may be foolish enough to allow himself to be seduced into its labyrinth of multiple meanings.[10]

Whereas *Time* spoke of a denouement, Americans beyond Manhattan, or even Greenwich Village, did not actually know about Duchamp, let alone his end-of-a-career "triumph." The "Duchamp" headlines were a media controversy alone. It was hauntingly like the 1913 Armory Show, when Duchamp's *Nude Descending a Staircase* had lit a match under the cold, slow start-up of the February 1913 exhibition. Fifty-six years later, the Duchamp legend was resurrected by the mass media, and this time, often enough, with his name in the headline. The hometown paper, the *Philadelphia Inquirer*, summed up the tenor of the opening day with "Last Duchamp Work is a Real Peep Show."[11] Elsewhere, many more headlines had featured his name:

Duchamp Masterpiece Found: Museum Gets Secret Work
"Secret" Work by Duchamp Acquired Here
Duchamp — Artist, also Comedian
The New Art is Nothing New to Duchamp
Phila. Peep Show Unwraps Duchamp Nude, Feet First
Philadelphia Museum Shows Final Duchamp Work
Duchamp "Underground" Sculpture Exhibited by Art Museum Here

What the museum most wanted to hear, of course, came some time later: "Duchamp Nude Triples Art Museum Attendance." Fairly happy with the final outcome, Turner would sigh in relief. Inside the museum,

he joked that probably the biggest problem they had was that old ladies, complaining at the height of the peepholes, had pilfered museum phone books (or moved chairs) to stand on so they could see what Duchamp called his "woman with open pussy."[12]

BESIDES RUINED phone books, the real crisis over Duchamp's final work was internal to the art world. Everyone in the art world had a stake in what Duchamp had left behind, a surprise that was quite out of anybody's control.

For those who liked the way Duchamp had subverted retinal art, *Étant donnés* was a disappointment. The writer John Russell had touched on why: the legend of Duchamp had blown up in the face of Conceptual art. Even John Cage said that his old friend had sold out. If Duchamp had lived, he certainly could have talked his way out of this dilemma, which is why he may have kept it "secret." What was the woman doing? Why had he ended his career making a theatrical tableau with a pretty landscape and traditional materials? As the Philadelphia curator who shepherded through the logistics, Anne d'Harnoncourt, graciously said, the recently deceased Duchamp "is now mercifully spared of all our questions."[13]

Duchamp's two biographers, who were crucial to his fame, felt excluded, one of them entirely. Robert Lebel had faithfully kept the secret, but his request to see the work early on was denied. "It seems to me," he wrote earlier, "that Marcel's close friend should have been warned and given a chance to see the work before the door was sealed." After seeing it, by one account, Lebel was disgusted by Duchamp's final act, and in later days, the former editor of the pro-Duchampian *Artforum* could offer nothing better than a reference to Duchamp's senility, and personal psychological hobby, in making the "strangely gross and amateurish" diorama.[14]

When Duchamp's second biographer, Arturo Schwarz, learned of *Étant donnés*, he was shell-shocked: his massive *Complete Works of Marcel Duchamp* was already at the printer. Alexina suggested he add an errata sheet. She also asked that he "write as little as possible . . . as things get so easily misrepresented by word of mouth."[15] Schwarz nevertheless rushed to Philadelphia, looked through the peepholes, and sent his publisher an additional few pages of text.[16]

As journalist John Russell had first hinted, Duchamp had exploded his own legend. That legend included a solid list of principles that he had ad-

vocated. They ranged from being anti-retinal and not being repetitive, to arguing against selling art and arguing for the power of viewers to decide the nature of an artwork, which meant that the artist's intention did not matter. He also said chance should control the art process; let the chips fall where they may.

All of these principles seemed to be reversed in the case of *Étant donnés*, his final work. This is what Cleve Gray emphasized in *Art in America*. "From pure, intellectual abstraction in an esoteric medium, Duchamp had made a complete reversal into theatrical realism," Gray wrote.[17] While Duchamp experts looked for a complex lineage behind his ideas for *Étant donnés*, it also seemed that Duchamp had simply repeated himself (what curators instead called a "cross-reference" and "super imposition" of the same elements).[18] Duchamp also sold the work for sixty thousand dollars with a very specific plan on its fate. Once the diorama was installed, as one curator said, it "controls the action of the viewer most strictly."[19] This seemed opposite to his belief in viewer control over works of art. Also contrary to his creed, he dictated that the work not be replicated by photographs.

Finally, Duchamp, who often had reviled museums as cemeteries (much as Picasso had done), had spent the last three decades of his life angling to incarnate and canonize himself in a museum. This was not the life of the wandering Greek philosopher, a bohemian wise man offering aphorisms about freedom and indifference: this was a chess player. Duchamp had checkmated the art museum system in America (and, as if in another chess game, would checkmate art academia as well). "There is a great correlation between chess and art," Duchamp had said six years earlier. "They say chess is a science, but it is played man against man, and that is where art comes in. Check."[20]

Almost immediately, the revelation of the diorama spurred curators and critics on a mission to find the "influences" under which Duchamp operated. This was the 1960s, however, when art history was undergoing a revolution. A new question arose: Should such a revolutionary figure as Duchamp be interpreted through the lens of the old model of art history, a model that tended to look for a "genius" (or author) who influenced successors? Years later, during an academic forum on the "The Duchamp Effect," one noted art theorist explained that now (circa 1994), when trying to write art history, the actual artist-author was less important than the

social forces around him, thus making "all attempts at writing history as a history of authors . . . appear utterly futile and methodologically unacceptable."[21] There would always be some, nevertheless, who would view a Picasso or a Duchamp as a singular genius, free of social conditioning or "social construction," and the author of something new.

Accordingly, with due caution, at the 1969 unveiling of *Étant donnés*, the veteran Duchamp curator Walter Hopps tried to find a careful middle path in his article on Duchamp's originality versus his art world context. Writing in the museum's *Bulletin*, he discussed *Étant donnés* in equivocal terms only, even as he pointed out similar kinds of works done in neo-Dada and Pop art, both of which had developed stage-set types of artworks. Otherwise, Hopps did not suggest that Duchamp had a direct impact on the rise of American art in the 1950s and 1960s. Nor, by the same token, had Duchamp himself been an imitator of 1960s American art. Duchamp had a different function, Hopps said. That was "to function as a kind of moral support, a benevolent though not uncritical license for the artist to go ahead and do exactly what he wants."[22] He was the permissive godfather of contemporary art. And as Hopps had prophesied, in the next few decades, a legion of contemporary artists would say that Duchamp had indeed given them a "license" to do just about anything.

If Hopps had arrived at the careful conclusion that Duchamp was more a symbol and celebrity than direct, hands-on teacher, the popular press did not quibble on such matters. It wanted to find dramatic connections, especially those that gave American 1960s artists a leg up. Some popular writers said Duchamp had copied the 1960s artists who were making the newest thing—shocking stage-set art. The most prominent examples of the stage-set style were Edward Kienholz's tableaus (such as the horrific scene of a mental hospital cell) and George Segal's white plaster-cast humans, which in his tableaus sat at restaurant counters or on park benches.

Duchamp had seen the Kienholz and Segal works three or four years before he completed his *Étant donnés*; the public had seen them, too— Kienholz was lighting up pages in *Life*, *Time*, and *Newsweek*. Duchamp felt kinship with the young American eruptions. "Marvelously vulgar artist," he said of Kienholz. "I like that work."[23] However, Duchamp clearly had his own ideas many years earlier. Those earlier influences from Europe were emphasized by coverage of *Étant donnés* in the European art press. Rightly so, the European critics linked *Étant donnés* to Surreal-

ism's work with naked dolls and mannequins, typically violated, during its Depression-era sensationalism. These ranged from the Hans Bellmer's photos of dismembered dolls (1935–38) and Max Ernst's anatomical collages, to Salvador Dalí's *Rainy Taxi* tableau (1938) and the zombie nudes painted by Paul Delvaux (1937).

Either way, Duchamp himself had now become history. With that sainted status, he began to take on a new life among up-and-coming art critics and art history graduate students. Over the next few decades, more than a few Conceptual artists would revive Duchamp and his readymades as a source of new artworks, or plays on art history. In homage to Duchamp, Conceptual artist Bruce Nauman took a photo of himself spraying water from his mouth, titling it *Self Portrait as a Fountain* (1967) and placing himself firmly in the genetic line of Duchampian contemporary art. With the rise of "appropriation" art, practitioner Sherrie Levine did likewise: she produced a golden-bronze urinal, *Fountain/After Marcel Duchamp* (1991). Already by 1989, there had been enough imitators of Duchamp's *Fountain* that the prestigious Menil Collection Museum in Houston (where, incidentally, Walter Hopps was in charge) could stock an entire exhibition on the fountain/urinal theme alone.[24]

For centuries, the idea of artists copying, or riffing off, previously famous artists was fair game, especially if it was done skillfully or cleverly. Imitating works done by Duchamp followed suit. Meanwhile, the question of "influence" continued to rankle art experts. To identify influence was, by turns, to also declare who was the first, and thus who was the greatest. Had Duchamp really invented just about everything in contemporary art—readymades, Pop art, Conceptual art, Installation art, process art, art as irony, ideas, pranks, and on and on, ad infinitum?

Within the professional art world, this delicate matter was called the "game of influence baiting," in the words of one critic.[25] In influence baiting, it was entirely possible for a clever art historian to discover influences that really did not exist. In the marketplace, too, art dealers loved to have their artists known as influencers (not the influenced), since that drove art sales. As was often to be seen in modern and contemporary art, a single article by a noted art critic or art historian that declared a direct "influence" could help make or break a living or dead artist in the marketplace.

Soon after Duchamp's death, followed by his rapid resurrection, the art historian Lucy Lippard argued for restraint. She said that most of

contemporary art in America had its own roots, quite apart from Duchamp or European Dada. This tracing of influence was "a sore point," she argued. "Marcel Duchamp was the obvious art historical source, but most of the artists did not find his work all that interesting," she said, consigning Duchamp to the more ethereal realm of "historical source." She suggested, however, that art historians of the moment were under pressure to acknowledge Duchamp as the founding father: "As responsible critics we had to mention Duchamp as a precedent."[26]

Outside academia, it was not only the popular media that wanted to find a genius with a good story. Many young artists were also looking for an artist-as-hero, an example of avant-garde success. In 1952, *Life* magazine had declared Duchamp to be "Dada's Daddy," and still decades later the multi-faceted "Duchamp Effect" was being testified to by young artists, who offered their oral histories of how Duchamp had influenced them and the next wave of movers and shakers.[27]

The Duchamp effect would also be called the "dematerialization" of art, an "ultra-conceptual art" in which artists pursued ideas or actions, but not artworks.[28] The Conceptual artist Alan Kaprow, a student of Cage's, once despaired that Duchamp's lifelong behavior had stolen every contemporary artist's thunder: after Duchamp it was impossible to do anything "new." Others looked for Duchamp's blind spots. "Marcel Duchamp has already done everything there is to do—except video," said the South Korean Conceptual artist Nam June Paik. So *voilà*! Video art.[29]

———

FOR ALL THE SPECULATION by his followers and detractors after Duchamp's death, he had only left one seemingly clear directive as his last will and testament: he did not want anyone to photograph the diorama. He told this to Copley. Hence, the first crisis over the *Étant donnés* diorama was not bad publicity, but the requests to photograph Duchamp's last great work. It began with the insistent Schwarz, and with media outlets. They all wanted at least *some* picture, even of the Spanish door. The museum did that favor for Schwarz at least. A black-and-white of the Spanish door appeared in his first edition of *Complete Works*, published at the end of 1969. For the second edition, Schwarz was more persistent than ever for another case of stop-the-presses deadlines for his second edition: "*Please, please, please* send me the photo."[30]

Just about this time, a small publication in Chicago was poised to break

the dam of the photo moratorium. For a photograph display in the magazine *Art Gallery*, the Canadian artist Les Levine had obtained bootlegged images of the diorama. He was about to use them to make a collage that "recontextualized" Duchamp's *Étant donnés*.[31] Alexina was outraged by Levine's trespass, her feelings still aligned with Turner's earlier statement that "any reproduction tends to create a travesty of the artist's intent."[32] However, this was a hard argument to make when Duchamp dismissed the idea of artist intent completely. As a Duchampian himself, Levine argued that recontextualization was no worse than putting a mustache on the *Mona Lisa*.

Alexina couldn't argue with that, and she changed her mind. Her husband "hated prohibitions of any sort," she conceded.[33] Once Levine's piece came out in early 1970, the dilemma for the original intention of *Étant donnés* was becoming clear: public photos undermined the shock effect Duchamp wanted to achieve. He wanted people to look through the peepholes, see a splayed naked woman, and feel like a Peeping Tom. He wanted them to feel the surprise, embarrassment, and the mixed feelings of an innocent bystander being turned into a sneaky voyeur.[34]

The photography issue reared its ugly head again in 1977. The year before, internationally known curator Pontus Hultén had asked for complete images of *Étant donnés* to show at the largest-ever Duchamp retrospective in Europe, to be held at the contemporary art museum he directed, the Pompidou Center. Hultén insisted on having large color photos of the *Étant donnés* interior, done stereoscopically to conserve the effect of two eye holes. To avoid forcing Hultén to obtain bootlegged, low-quality photos, the Philadelphia Museum offered a concession. It allowed a professional photographer to take the shots. When Copley heard, he felt betrayed, since Duchamp had "let me know he didn't really want a reproduction."[35] Copley promptly severed his ties with the Philadelphia museum. The fifteen-year rule had ended in tatters, but was quietly reinstated later.

The photos of *Étant donnés* were not the only center of controversy over replication of original and authentic artworks in the 1960s and 1970s. This was the era of "appropriation" art, a euphemism for the unauthorized use of other people's work. In the literary, scholarly, and publishing world it can be called plagiarism, copyright infringement, or piracy. In the visual arts, however, the rush for replication was everywhere, especially in Pop

art and Conceptual art (of which "appropriation art" was a branch). The new technology made replication easy, as Andy Warhol demonstrated in his mass production of images, which he "borrowed" from others, and then multiplied by photographic stencils and silkscreen printing.

In his own day, Duchamp could proceed without any of these plagiarism worries. He never gave credit to any of the manufacturers of his readymade objects, for example. After Warhol, readymades were being mass produced. New photo and print technologies were making it easier and easier. Replicas flooded the market. In the case of Warhol and a few others, these items began to rise exponentially in value, likes stocks and bonds. The day finally came when the "authenticity" and "replication" of a Warhol work became a major issue.

For Duchamp, his bottle racks and shovels were all replicas, deemed "authentic" by his verbal approval or his signature put on various objects. For example, in a rare move, he made a business agreement with Schwarz's Milan art gallery to make replicas of thirteen famous readymade objects, eight of each (totaling 104; a set of thirteen went for twenty-five thousand dollars). As Schwarz watched, the market price of these rose. As a business arrangement, Duchamp naturally received a share.[36] Indeed, Schwarz's Milan operation became the fountainhead for the latter-day Duchamp art market. It was Schwarz who boosted the Duchamp resume from under two hundred items to more than 660.

Over time, the replication mode got out of hand. While the commercial Duchampians escaped legal scandal—though some of their antics were breathtaking—the Warhol market was not so lucky.[37] Eventually lawyers and forensic experts had to rule on "authentic" Warhols, which could fetch millions. Not a few fake Warhols were exchanging hands, apparently.

Even Hultén, Duchamp's great advocate, got caught in the Warhol replica maelstrom. After finishing his tenure as head of France's prestigious Pompidou Center, he went into the gallery business. In 1990, he produced 105 fake Warhol Brillo boxes and passed them off as 1968 "originals." The fraud was found out. By then, Hultén had died (2006), leaving behind a bitter debate over money and fraud in contemporary art, a sad legacy that extended through Duchamp, Warhol, and finally Hultén, an advocate for them both.[38]

The world of appropriation art began to meet a similar fate. Artists

began to sue other artists for stealing their work and ideas. The American federal courts would almost universally rule in favor of the "original" artist, drawing the distinction between wholesale copying for commercial gain, and merely referencing known artwork as a matter of commentary and free speech.[39] Under US federal law, other people's work could be referred to as a matter of "fair use," a kind of free speech in the public domain that was not designed to earn money.

When making money was at stake, however, these fine distinctions, well intentioned by the law, quickly become highly technical, problematic, and contested by appropriation artists (or Internet providers who wanted to give away various art forms). When Duchamp, in a moment of personal humor, proposed the idea of readymade art, he could not have imagined that it would eventually be put before judges and juries. As the idea of the readymade spread, it wreaked unparalleled havoc on the art-world marketplace. The time would come when original artists had to be careful. Even the "Duchamp estate" would put strict copyright controls on anything related to Duchamp's life and works.[40]

AFTER DUCHAMP had done his part, some Duchampian artists believed that he had not gone far enough. In Europe, in the wake of the May 1968 protests, one group declared that Duchamp had stopped short. He had failed to take the readymade revolution beyond the four walls of the traditional museum. For the final Duchampian revolution to take place, the galleries and museums themselves had to be obliterated, a kind of "demolish the ruins" that would have impressed even Alfred Jarry. This meant taking "idea" art into the street. As an alternative, it also meant pouring the street into the gallery (which, in one case, meant filling it eyeball-high with street trash).[41]

In this activity, pioneered mostly in Europe (but also incarnated as "happenings" or "fluxus" events in America), social activism and street protest offered a new definition of art.[42] The line between art and life was becoming harder to see. The new breed of artists went into the street with "art ideas" in their heads, thus making their actions "artistic," at least philosophically. However, most of society already was out in the street, where plenty of ideas were motivating all kinds of social life. Ordinary people had lots of names for their own idea-driven social activity, such things as political canvassing, festivals, adolescent hooliganism, or even religious

proselytizing. They called it life, not art. The post-Duchampians, making a finer point, argued that art-ideas added something ineffably higher to this street life, and thus something more. This was the final stage of the Duchampian revolution. The Duchamp shovel had come down off the gallery wall and returned to the streets.

As all of this was happening, the readymade also stirred competition between Conceptual artists. Like everyone else, artists, too, argued over pet ideas and who among them had the best theory on the block. A few of them came to conceptual blows, as seen in the case of two rising stars of the 1980s, Jeff Koons and Cindy Sherman. In 1980, Koons created a readymade. It was two off-the-shelf vacuum cleaners in a Plexiglas case titled *New Hoover, Deluxe Shampoo Polishers*. He found a contemporary art gallery that would feature it (and years later, it sold at Sotheby's for $2.16 million). As Koons gained recognition, he cited Duchamp as his precedent.[43] He also took Duchamp seriously about needing to "shock" the public. "In this century, there was Picasso and Duchamp," Koons said in 1990. "Now I'm taking us out of the twentieth century." So Koons produced full-scale explicit sex art with his then-wife, an Italian porn star.[44]

Koons's xxx art, which gained him considerable publicity as it rolled out from 1989 to 1991, was too much for Sherman, also at the peak of her fame. She was known for replicating scenes from old movies in self-taken photographs of herself in costumes. To battle Koons, though, Sherman broke from her normal repertoire of self-portrait photographs to launch, in 1992, her "Sex Pictures" series, color photos of decapitated and sexually suggestive plastic body parts (medical school anatomical prosthetics), much on the model of Hans Bellmer's 1930s Surrealist dolls. The "Sex Pictures" were widely seen as Sherman's market challenge to Koons.[45] Who could leave the century of Picasso and Duchamp most triumphantly, and who could shock the most?

Sherman has said she is not a feminist. Generally, though, the new generation of feminist artists admired Duchamp. This was partly due to his androgyny as Rrose Sélavy. For these feminists, moreover, Duchamp's obsession with naked women was not problematic when seen in the correct light, which was the "ironic" light. They believed that Duchamp's artistic sex objects made a progressive commentary on "voyeurism." In other words, his vulgar art confronted society with how it gazed at women. For

feminists of a Marxist leaning, moreover, Duchamp's readymades provided a criticism of capitalism, since they presumably could not turn into the evil art objects that Marx had called "fetish" commodities.

The feminist affection toward Duchamp was by no means universal. When it came to the *Étant donnés* diorama, Duchamp could also be seen as just another male exploiting a naked woman for gain. The feminist artist Hannah Wilke — indeed, the short-lived mistress of the married Richard Hamilton — posed her own voluptuous naked body by *The Large Glass* (with museum permission), and then posed likewise on the beaches of Cadaqués (Duchamp's and Hamilton's summer retreat) to produce photographic art in response to Duchamp. In the words that the *Village Voice* once used for Duchamp's diorama, Wilke's erotic photos were a "slap in the face" to men who made naked-woman dioramas. Wilke's photo art was a feminist statement, or perhaps merely the age-old taunt of the femme fatale, something like what Maria Martins had said in her poem: "I want to torture you. / I want the thought of me / to coil around your body like a serpent of fire without burning you."[46]

FORTUNATELY, A CADRE of sincere and careful Duchamp scholars set out to calm the waters and dispel the serpents of fire. Biographers such as Lebel and Schwarz had done the bulk of the work, as had André Breton in his essays and Yale's George Heard Hamilton in his English translations. For the 1963 retrospective in Pasadena, it was Walter Hopps and Richard Hamilton (of England) who stood in the gap. Hopps organized the catalog and Hamilton gave the related lectures. At the time, Hopps listed only six "major authorities" on Duchamp he could rely upon.

The number would expand, and that era can be traced in more respects than one to a young woman just starting out in her art museum career. She was Anne d'Harnoncourt, a curatorial assistant at the Philadelphia Museum the day that the *Étant donnés* gift came through. Anne was the only child of the Austrian-born Count René d'Harnoncourt, who for nearly twenty years had been the director of the Museum of Modern Art. He was a leader in the arts, and it rubbed off on Anne. He had begun as an expert in antiques and Mexican art, then became a public educator, hosting the radio program "Art in America" and advising art patron Nelson Rockefeller. Sadly, a year after Anne had earned her graduate degree at the prestigious Courtauld Institute of Art in London and returned to

America to begin her career, her father was killed by a drunk driver. That was 1968, the year she began to focus on Marcel Duchamp.

When Evan Turner first went to Duchamp's threadbare Manhattan studio to see *Étant donnés*, he took Anne d'Harnoncourt along. She was up to speed, therefore, when Turner handed her the logistical task of transferring and installing the Duchamp diorama. Although d'Harnoncourt became known for her wide knowledge of art, and especially modern art, she would soon be saying that she was a proud "Duchampian," a term of which she heartily approved. She had even met the great man. Before he died, and before the gift, she had interviewed him in New York about the provenance of the Arensberg Collection, and then touched on his own work. In her early twenties, d'Harnoncourt was persuaded by the eighty-year-old gray eminence that his readymade idea was brilliant, what she called "his infinitely stimulating conviction that art can be made out of anything."[47]

In her first essay on Duchamp she cited the "Duchamp myth." Four years later, in another essay, she said he "died a modern legend."[48] Soon after the 1969 opening season of Duchamp's last work had passed, the hardworking d'Harnoncourt was on her way up. She was hired by the Chicago Art Institute as a curator of twentieth-century art. Back in Philadelphia, meanwhile, the museum was evaluating its next step. It owned virtually all of the major Duchamp assets, and it wanted to gain a boost from that art-world monopoly. So it turned its eyes in the direction of Chicago, where D'Harnoncourt had recently married. Easily enough Philadelphia persuaded her to return as the museum's head of twentieth-century art. Her first mission was to put on a Duchamp retrospective, the largest ever. It would open in September 1973. The exhibit ran for nearly five months, which included travel to New York and Chicago.

In the process, d'Harnoncourt built the Duchamp collection and archive. At the time of the 1973 retrospective, the circle of Duchampians had modestly expanded. The exhibition listed sixty-one private and institutional loaners of objects, in addition to the Philadelphia Museum's Duchamp holdings. All together this produced an exhibition of 292 items plus an additional eighteen portraits of Duchamp. Fifty-one of the items, moreover, were actually books, catalogs, periodicals, or posters related to Duchamp.

A great American stamp of approval was put on Duchamp, furthermore, when the exhibit was partly funded by American taxpayers through

the National Endowment for the Arts. (Before his death, in 1960, Duchamp had gained other American honors, having been elected into the National Institute of Arts and Letters, something out of the question for a bullfight-loving character like Pablo Picasso.) In America, Duchamp became a teacher of the youth. The directors of the Philadelphia Museum and the Museum of Modern Art (a co-sponsor) said the 1973 Duchamp retrospective was an important moment of taking stock, given "the impact of Duchamp on the younger generation of artists."[49]

As the chief curator of the Duchamp retrospective, it was d'Harnoncourt's task to secure his place in art history. She preserved him as a human being. As if a topic more for biography than for art, she said that "we are tempted to see the life [of Duchamp] itself as the artist's invention." To be sure, Duchamp did a few major paintings, she said. However, he "was not a painter but a jack-of-all-trades, and perhaps a poet as well." There was no way to avoid this either: he had a "fundamental preoccupation with eroticism," she wrote in the 1973 retrospective catalog. The Duchamp collection was now enclosed in the four walls of a museum. Nevertheless, she said that Duchamp had tried to stay outside such walls with his mystifying puns and his ambiguity, his "open-endedness." His objects, installations, and publications were hard to fit under normal definitions of art, but after all, "he sought to eliminate the demand for a definition of art."[50]

Tall and elegant, a veritable child of the modern art world in New York City, Anne d'Harnoncourt was good at what she did. By 1982 she was director of the entire Philadelphia Museum (and later CEO). Her purview was wide. But she also spoke of how the Duchamp rooms made Philadelphia a "pilgrimage site."[51] Although many of the big museums in New York and Washington DC, tried to hire her away from Philadelphia, she had sunk her roots. For a start, her fundraising skills proved astounding. At times, she even felt that she outdid herself. The 1996 Cézanne retrospective she organized drew eight hundred thousand visitors. These were busy years for a museum executive, but from time to time, d'Harnoncourt reflected on the bronze Amazonian goddess statue by Maria Martins that stood, for a time, on the East Terrace of the great Greek-temple museum grounds.

The story of Duchamp and Maria, who had died in 1973, had still not been told in its entirety. The key was a set of thirty-five letters that

Duchamp had written Maria from the middle to the end of their transient affair. For years, the museum and the Duchamp estate had appealed to Maria's daughter to give them the letters. Finally, in 2006, the Martins' estate put the letters up for auction, and the Duchamp estate was the highest bidder. The Duchamp family next allowed the Philadelphia Museum to publish and archive the letters. In other words, the *Étant donnés* diorama, sitting by for forty years, had a new story to tell. Its fortieth anniversary was approaching in 2009, so the museum decided to once again unveil *Étant donnés* to the general public, but now as a massive retrospective, presenting every imaginable detail about the work.

The 2009 *Étant donnés* retrospective was a major project for the museum curators, especially considering that d'Harnoncourt herself was in the midst of a five-hundred-million-dollar capital campaign for the museum, seeking to fund a vision of grandeur that would include expansion of the building, new acquisitions, more staff, and a future of ever-greater art exhibits. Then tragedy struck. On Sunday evening, June 1, 2008, d'Harnoncourt died of heart failure at her home. When the *Étant donnés* anniversary went forward the next year, it was presented as a memorial to sixty-four-year-old d'Harnoncourt, one of Duchamp's greatest advocates.

What had first inspired the young d'Harnoncourt — Duchamp's "infinitely stimulating conviction that art can be made out of anything" — had now spread. It had moved laterally through the world of practicing artists and vertically into art academia. Duchamp's last work, *Étant donnés*, seemed to have broken every rule that he had enunciated. After undermining five hundred years of traditional art, he seemed to be saying, "I was only kidding." Not a few contemporary art scholars, such as Robert Storr, head of the Yale School of Art, have pointed out that, despite his rhetoric, Duchamp was a consummate craftsman, using a wide array of materials, doing precision work, and often relying on the visual (that is, the retinal) effect to present his work.

Nevertheless, said Storr, it has been Duchamp's theories that seem to have won the day: "It was Duchamp's condemnation of 'retinal' art (i.e., painting) and of perceptual art in general, coupled with the elevation of ideas to the status of primary medium, that set the conceptual dematerialization of art in motion," Storr said in 2009."[52] As Duchamp's condemnation of retinal things moved up into art academia, moreover, it no longer

retained the radical feel that it once had. "His example spread," Storr said, but added quickly, "it became academic."[53]

Thanks to the Duchampians, the notary's son would be successfully installed in the pantheon of art history. In 2004, for example, a survey conducted by the sponsors of the Turner Prize for younger artists in England found that the art object most cited by art leaders—mostly on the contemporary art wing—as the "most influential" in the twentieth century was made by Duchamp. They did not choose his best Cubist oil painting, his experiment with "chance" and strings, or his optical device with an electric motor. They chose Duchamp's *Fountain*, his urinal, an object born of both hoax and daring. Picasso's *Les Demoiselles d'Avignon* came in second, followed by Warhol's triptych photo-silkscreen of Marilyn Monroe.[54]

For now at least, the artistic match of the century was still between Duchamp and Picasso, or Picasso and Duchamp, depending on who you asked—even in the twenty-first century.

17
year of picasso, age of duchamp

In 2010 a gigantic banner hung at the front of the Greek-temple facade of the Philadelphia Museum of Art, the museum that houses the works of Marcel Duchamp. The banner read: PICASSO. Inside the museum, the "Picasso and the Avant-Garde in Paris" exhibition surveyed the time of ferment from which Picasso and Duchamp had emerged. Across the ten gallery rooms, Picasso appeared often, whereas Duchamp took a central place at just one site, a scene that replicated the 1912 Section d'Or exhibit, where his *Nude Descending a Staircase* hung.

Nearly a century after the 1912 Section d'Or, and the Armory Show of 1913, Picasso and Duchamp were even further apart in the rooms they occupied in art history. Between the halcyon Paris salon days and the First World War, Picasso and Duchamp, each in his own way, set modern art on its fateful trajectory. They have been called the most influential artists of the twentieth century, with the typical argument being that Picasso had dominated the first half, and Duchamp the years after the 1960s.

For both Picasso and Duchamp, this has been the story of how artists become monuments and myths. The process began almost immediately after their deaths. With promptness, their inheritors consolidated and interpreted the Picasso and Duchamp legacies, especially in the museum systems. Their personalities had something to do with the consolidation as well. Picasso loathed paperwork. He simply lunged ahead, like a Spanish bull. "In the end, everything depends on one's self, on a fire in the belly with a thousand rays. Nothing else counts," he once said.[1]

In the end, with his belly on fire, Picasso was not necessarily a philosopher, but a skilled producer, someone who used visual art to rearrange reality. He left behind a mountain of artworks — and a daunting challenge to artists, especially painters, who came after him, both to match his skill and to somehow exceed his imagination, as suited to new times, new

places, and new audiences in human history. Without a doubt, Picasso became a kind of Hollywood celebrity. But above and beyond that, it was his signature art that cast his influence on the world.

Whereas Picasso has impressed the world visually, Duchamp has, in ways, set a higher bar for himself: he has tried to impress the world intellectually. With his readymade, invented as "a form of denying the possibility of defining art," Duchamp gave a new generation of artists an intellectual justification for rejecting all art of the past.[2] Duchamp said art should have a higher goal than mere visual satisfaction. Art should be in the "service of the mind." To achieve this revolution in art, Duchamp had to persuade the world that all of reality is a *readymade*—that is, that virtually anything can be art. "If ever there were a watershed . . . between the artistic past and whatever the present is turning out to be, it was Duchamp's snow shovel," the Yale art curator George Heard Hamilton, a friend of Duchamp's, said in 1966.[3] With this watershed, art as it was traditionally understood could no longer exist—that is, art as an object subject to aesthetic appraisal, or, as *Webster's* says, the "making or doing of things that display form, beauty, and unusual perception."

As a personality, Duchamp was equipped to pursue his agenda patiently. Whereas Picasso focused on creating mystery when he was alive, Duchamp seems almost to have conspired to leave a mystery behind after his death. Not only was he a methodical notary's son (and aspiring librarian); he had also moved ahead in his life like the chess player, eyes always on the end game. He learned how art history worked, and he was able to maneuver and cajole himself to the very center of the art establishment. "Marcel must have known that the game would be played out," said William Copley, Duchamp's last patron. "He knew more about [art] history than any of us."[4] Pierre de Massot, an early Dadaist, said that Duchamp had "been preparing his pedestal" since the 1920s. "He always knew exactly what he was doing."[5]

Nobody forgot that Duchamp was a chess player, either, although it was a persona evaluated in different degrees of importance. Even the greatest chess master cannot predict the outcome of a game, but every chess master goes into a game with a plan on how to win. Duchamp did not know the details of his end game, but he probably knew he could win. He knew the art world like a chessboard. As Walter Hopps had said, Duchamp was a master at feigning indifference. At the same time, an "exquisite sense of

timing seems to have informed his whole career, despite his occasional protest that 'nothing was intentional.'"[6]

Part of what Duchamp was doing was persuading other artists that they should be "idea men" more than traditional craftsmen (and certainly not painters). As Duchamp himself realized, however, this radical detour in art history was a hard notion to foist on the world, for even he could not live up to pure "idea art," leaving behind a wide sample of things that would fit *Webster's* traditional definition. Despite all these obstacles, with Duchamp's permission, part of the art world has nevertheless accepted his argument. Thus was born the movement called Conceptual art. As Yale School of Art's senior critic Steven Henry Madoff has said:

> After Duchamp, the concept is more important than the medium through which it's brought to visibility, and so a conceptually based practice, which is the air that artists breathe today, is given to a disciplinary ecumenicism, a penchant for the nomadic to traverse disciplines and media freely in the expression of an idea.[7]

Worldwide, in the past few decades, there have probably been more Conceptual art "pieces" made than any other kind of work of art.[8] Despite this dizzying number, though, such pieces of art are so ephemeral and temporary that virtually none of them last in memory or have an enduring impact on art history, except perhaps the very first Conceptual art projects that are now in textbooks — with Duchamp's urinal, *Fountain*, as the superlative example, leading the pack.

The readymade was not the end of Duchamp's intellectual proposals, most of which have proved just as nebulous, or contradictory, as the readymade itself. In his fondest memories of his younger days in the art world, Duchamp spoke of the art scene that he and his friends navigated as "laboratory work." About the same time, Picasso had dismissed such laboratory "research" in art, saying instead, "My object[ive] is to show what I have found and not what I am looking for."[9] Even today, these two attitudes toward art endure. The Duchampians now call it "process art," which focuses on the ambulatory process of creative thinking (with no particular end in mind); the Picasso outlook still stands for the traditional goal of making a complete and "resolved" work of art.

In yet another one of his theoretical postulates, Duchamp spoke of "pictorial nominalism," seeming to suggest that art should move toward

some purist state of simplicity, perhaps with pure "idea art" as the purest attainment of all. As a European, trained in its lycées, he had studied nominalism, the idea that reality should be explained with the simplest reasons possible, minus all metaphysical speculations. However, Conceptual art theory has now become so complex and esoteric that, quite to the contrary, a simple Picasso painting has become far simpler than Conceptual art. A painting that speaks for itself is a nominalist achievement. Conceptual art has become the new metaphysics, just as many of Duchamp's ideas have the feel of a medieval scholasticism taking hold of the mind.

Much of Duchamp's presentation of intellectual proposals was based on humor, or what he called his goal of being "pseudo," not quite authentic or serious. In a strange twist of art history, what Duchamp called humor has now been taken seriously, as if the National Academy of Sciences had decided to adopt a research program based on Alfred Jarry's 'pataphysics. It has been as if Duchamp launched a great flotilla bearing a cargo of jest, humor, sarcasm, obfuscation, and off-color puns, and it came back after the 1960s as a fleet of serious philosophical propositions about art, the artist, and aesthetics. Nonetheless, if Western culture has always had its ribald side, its love of jest and absurdity, Duchamp has probably helped root that in modern art as much as anybody. In 2011 the publication *Artnews* asked:

> Why has the past century in particular been rich in jokes, hoaxes, forged identities, subversive graffiti, and mass and solo performances with an aim to shock or annoy, as well as shenanigans that some would be loath to qualify as art?[10]

Duchamp is not the entire answer to the question, but even *Artnews* could do no better than to evoke his name as a kind of explanation.

Humor and pranks aside, the Duchampian claim to have cleared the way for the use of ideas in art, freeing the gray matter of artists from the slavery of paint, breaking forever the "enslaving chains of Naturalism," is as much rhetorical panache as it is factual. It really depends on how the nature and role of "ideas" in art is defined, and that is not an easy definition. Picasso scholars, for example, have long spoken of his ideas, and though often contradictory, Picasso, too, has said, "Painting is a thing of intelligence."[11] As the Picasso scholar Carsten-Peter Warncke offers:

In a real sense, Picasso transferred idea into art, and created unified harmonies of idea and artwork, form and content, which are fundamentally traditional in nature and highlight his classical character. In this respect he was essentially different from modern concept art and the father of the movement, Marcel Duchamp. In concept art, the concept precedes and accomplishes the work, which in turn refers to the concept. A verbal key or explanation is required if the whole is to be grasped. Picasso's work, by contrast, shows. The statement is made visible. His work is inherently comprehensible. There is no gap between abstract content and concrete form.[12]

Still, when it came to influencing the intellectualization of art, Duchamp's legacy has been able to outmaneuver Picasso. Like an aircraft carrier, the legacy of Picasso turns slowly. It is a product of the Old World, weighted down by bequests and state records, divided between five official museums from France to Spain and the United States. In a material sense, the number of works by Picasso is overwhelming. Not until the 1980 retrospective on Picasso at the Museum of Modern Art, for example, had enough of his works been unearthed to summarize the many artistic tributaries that fed into the torrential river named Picasso.

By contrast, Duchamp is like a speedboat, compact and easy to maneuver; he designed it this way. As one Duchampian aptly described his material legacy, it is "a small but highly concentrated body of work." To approach Duchamp's work "is a matter as much of reading as of looking."[13] With the future in mind, Duchamp had consolidated his works several times, with his *Box-in-a-Valise* being emblematic (since the small container held nearly everything he ever did). Later, Duchamp dictated how his works were installed in a museum, where they were guaranteed scholarly attention. As he once said, it will take time for an artist to be included "in the primers of Art History," and that is usually when the artist is gone.[14]

It would take the great shift of the 1960s, however, to produce the changes that eventually put Duchamp on par with Picasso when it came to defining modern art, or declaring its end, and moving on to postmodern art. The shift was almost seismic, as were the sixties. For example, after Walter Arensberg and Duchamp piloted (in 1950) the Duchamp-centric Arensberg Collection into the Philadelphia Museum of Art, one of

the largest in the United States, the museum showed a "wholesale neglect of the artist" for nearly the next twenty years.[15] It was as if Duchamp's work had been forced on the museum, a proverbial white elephant. During the 1960s, then, Duchamp was rediscovered. It was a decade of celebrity-making, and the cult of celebrity would be a chief element of Duchamp's influence, carrying him to yet-unseen heights, right along with Andy Warhol and Marilyn Monroe. Quite unexpectedly, "he became one of the great personalities of our times," a prominent Dada artist said.[16] He was lofted on the crest of the Pop art wave, and a new generation of writers and artists looked to him in hopes of finding art that was both "intellectual" and hip, or, as they said then, "Groovy, man!"

For that new generation, his European-style bohemian life seemed to have achieved the goal first set out in the early 1800s, the age of romanticism, which was to live life as if it was art, the "blurring of art and life," as the happenings artist Alan Kaprow said. One way or another, "after Duchamp, it is no longer possible to be an artist the way it was before," said the literary historian Roger Shattuck. "Because of his style and his cool, Duchamp has grown into a widely admired shadow-hero of the century. He is very hard to put down, or put aside."[17]

Many decades earlier, with the rise of Dada and Surrealism, an art provocateur such as Tristan Tzara would make the bold claim that "one could be a poet without ever having written a single poem."[18] By extension, in the era after Duchamp, one could apparently also be an artist without ever making art. It was Duchamp's fate, as the so-called anti-artist, to become the persona who exemplified this type of person, and while he definitely made things, there were followers who wore the proud badge of artist without doing much in the way of artistic production.

Duchamp was more than a bohemian patron saint, however. Even though his "influence" has been more symbolic than empirical—since he never founded an organization, for example—he has shaped art institutions. By putting Conceptual art in the avant-garde—the "avant-garde" being a well-known marketing practice since the modern art revolution in Paris—he gave it financial wings.[19] In practical terms, the lives of both Picasso and Duchamp have conspired to radically change the modern and contemporary art market, now a world driven by auctions and a place where a readymade can sell for millions, right alongside a painting by Picasso, or by Rembrandt, for that matter. After Duchamp, in tandem with

Pop art, of course, a whole new "art world" has risen on the face of the earth, an entirely new complex of institutions, scholars, galleries, and museums.

BACK IN THE HEYDAY of Cubism, a writer such as Gertrude Stein could amuse herself about the jockeying of "Picassoites and Matisseites," young painters at the salons who followed the style of either Picasso or Matisse. Today it would be impossible to speak of card-carrying "Picassoites" and "Duchampians." That is because the world of art theory and art practice has become so pluralistic that no movement, or great artist, could possibly dominate a significant group.

Nevertheless, if a painter wants to consider his or her role in contemporary art, it is nearly impossible to ignore what Picasso had accomplished with the basic materials of the painter: the drawing stick, the canvas, and the paint. The institutional legacy of Picasso — museums, books, exhibits — has been significant, as many artists have testified. "When he died it was like the death of a much-respected but extremely domineering father — you were sad but also a little relieved," the artist Chuck Close said in 1980.[20] Yet after that brief sigh of relief, by the sheer weight of his legacy, Picasso's influence has not yet been exhausted. The domineering father is still being called back from the grave for close study and emulation, a "revisiting and recasting [of] the master's work," as some artists state the case.[21] By a rough approximation, artists who take that calling seriously may not be Picassoites, but they surely fall under the shadow of Picasso, a larger-than-life artist of the twentieth century.

By the same token, if there are true Duchampian thinkers and artists today, they are not any easier to pigeonhole. During the official opening of the 1973 Duchamp retrospective, struck by the "reverence that attends a religious spectacle," one critic surmised that "the cult of Duchamp will always be a cult of true and ardent believers," but clearly, that is not the only way to describe a diverse group that looks to him as a founder of something new in art.[22] Without doubt, there is a small world of Duchamp specialists. They are a dedicated group of scholars and theorists who, having done academic dissertations on aspects of Duchamp's life, are his most dedicated acolytes, those who keep up with such online Duchamp-studies journals as *tout fait*, which is French for readymade. Duchamp's specific ideas continue to be topics for specialized confer-

ences, or for sessions at the annual convention of the College Art Association in the United States. One recent CAA convention panel explored this set of topics, presented under "titles" that Duchamp would have liked for their off-the-wall quality:[23]

- Restaging the Readymade
- alwaysalreadymade
- Readymade Biomatter: Art and Synthetic Biology
- *Tout fait*: Bergson, Time, and Choreographic Being-Made
- Rendezvous at the Unreadymade

Specialized art conferences notwithstanding, through the general effects of art world academia, every college-educated artist after the 1970s has been introduced to Conceptual art, often justified by Duchamp's life and works. In many cases art students have been told that "after Duchamp" painting is dead, making idea-art the only real option. As an institutional effect, the very few "hard" Duchampians in higher education have produced a myriad of "soft" Duchampians. The ideas and attitudes of Duchamp, dead since 1968, nevertheless continue to be "the air that artists breathe today," especially in college and university art education.

This atmosphere is also breathed heavily in the contemporary world of art festivals, such as the historic Venice Biennale, and in art markets, art museums, and even political activities. The United States, for example, has participated in the Venice Biennale since 1930. As befits the influence of traditional and modern art before 1978, all of the artists selected as American representatives in the American Pavilion up to that year were traditional or modernist painters, with minor exceptions (such as minimalist Donald Judd or Pop artist Andy Warhol). Then after 1980, more than sixty percent of the solo or group artists representing the United States were practitioners of Conceptual art.

These Conceptual and performance artists made their names well before the Biennale selection, and they did so by taking Duchamp seriously: Bruce Nauman did his own *Fountain* and also made simple words in neon; Laurie Anderson played neo-Dada music, Bill Viola produced experimental optical videos; Vito Acconci exposed himself in public based on his concept of spreading his own "seed"; and Robert Gober made high-quality replicas, like readymades, of porcelain sinks and other everyday objects.

Today the "Armory Show" still exists, and it, too, reflects the art world

after Duchamp. Now held annually on the chic warehouse docks of Manhattan's Hudson River, the Armory Show (Inc.) has been revived in recent decades as a purely business proposition, one of many art fairs now dotting the world, drawing jet-setting collectors and a large sampling of the cosmopolitan public. Revealingly, the new Armory Show is bifurcated. It features one massive building for modern art before 1970, and another massive venue for contemporary art, much of which has the flavor of the Duchampian legacy of pranks, oddities, and whiz-bang devices, some with deeply cultivated "ideas," but many just glamorously humorous or absurd.

Beyond America, where Duchamp had staked his major claim, neo-Dada and Conceptual art have deployed themselves as social and psychological weaponry. In postwar Germany, for instance, a good many artists seized on Dada's nihilism to protest, or exorcise, the Nazi past. They found Conceptual art to be a social catharsis, much as Zurich Dadaists turned to Dada absurdity to cope with, and protest, the First World War. They tapped the anarchic spirit of Alfred Jarry.

In the Iron Curtain countries, whereas jazz music had once been a form of underground resistance to the afterglow of Stalinism, Conceptual art and performance art became the new thorns in the side of communist strictures. A new generation of Eastern European artists, many of them children of communist privilege, turned to Conceptual art in all its exhibitionism and anarchy to state a form of protest (and also, in many cases, to find an outlet for their precocious artistic personalities). Most recently, the traditionally trained mainland Chinese artist Ai Weiwei has become one of the world's most famous political dissidents — once arrested by the Party regime — by adopting the Dada "performance" spirit of protest. He also produces readymade-type objects, such as millions of clay sunflower seeds; as art, this work bore his "signature," but each seed was made and hand painted by hundreds of Weiwei's studio workers, a very Duchampian, outsourcing kind of approach.

Only since the 1970s, furthermore, have major cities of the Western countries begun to feature "contemporary art" museums. These museums exclude traditional art (1500-1900), of course. But they also typically banish modern art (1900–70). The contemporary art museum, dedicated to "idea" art, is as tangible a legacy of Duchamp's influence as the average citizen is likely to experience, short of going to the library and reading academic books on Duchamp, the pages of which can stretch to eye-glazing

length, covering his every action, word, and byproduct — from his paintings to his thirty-second sketches and his leftover cigar ashes.

Across the art-world landscape, the institutional influences of Picasso and Duchamp, by turns, can be itemized, from country to country, museum by museum. Above all of this, however, floats their influence on modern attitudes in the visual arts. This involves the attitudes of artists, but also very much the way public attitudes are shaped and perpetuated. All of this might be summarized under the dual heading of the role of democracy, and the role of elitism, in visual arts. After Picasso and Duchamp, in our democratic age, the simplest restatement of this question would be: Who has truly democratized art, Picasso or Duchamp? The Duchampians and the Picassoites must answer this differently.

Duchamp said that virtually anything can be art, and therefore anyone can be an artist. This is pure democracy in art "making," and indeed may be so absurdly broad that it actually eliminates "art" as a specific kind of human endeavor. In his final days, Duchamp would indeed say, in his iconic blague, that to breathe was enough to be an artist.

On the other hand, Duchamp has also made art an extremely elite pursuit, though his supporters deny this ("Duchamp eludes the charge of esoterism or elitism," said one curator).[24] To be sure, Duchamp, in his own way was a kind of ordinary guy, and for public consumption he would offer *bon mots* about art that anybody could understand, such as his statement that "unless a picture shocks, it is nothing."[25] Even so, Duchamp's candor also revealed his elitism. "When painting becomes so low that laymen talk about it, it doesn't interest me," he once said. Duchamp's own practice was elite. He produced "deluxe" editions and said that only a few people had the gift of the "esthetic echo," a kind of ability to truly understand art. In public talks, he often rebuffed the "general public" for its mediocre tastes and commercialism, and spoke of the elite "underground" role of the more enlightened artist.

When it comes to knowledge about art — a knowledge called art *appreciation* — the Duchamp outlook is unabashedly elite. His academic followers, by the sheer density of Duchamp's abstruse intellectual exploits, had no choice but to become elite, entering a realm barred to ordinary people. As one critic said, "More than most modern masters Duchamp remains hostage to the exegetes," his scriptural interpreters.[26] The Duchamp approach in art is naturally elite (as is the study of string theory in physics,

for instance). Among the public, a Duchampian kind of art can only speak to a certain slice of the population: the people who are brainy, the lovers of the ironic and abstruse, indeed, the joy of the blague. "Any dope can marvel at a Rembrandt, but only an elite few can make sense of a work such as Sherrie Levine's *Fountain/After Marcel Duchamp*, and so only an elite few are going to enjoy it," said the Yale psychologist Paul Bloom.[27]

At worst, Duchamp's combination of "anything goes" in art, added to his espousal of an intellectual art elite, has produced an artistic culture that downplays skill, discipline, and tradition in favor of clever ideas, shocking exhibitionism, and pseudo-intellectualization. Overall, the public is not interested in Duchampian elitism, and as contemporary art comes under the microscope, everyone from the sociologist to the evolutionary biologists is trying to explain why. The case has been made, for example, that human appreciation of artworks that show skill and beauty is hardwired into the human brain, since such visual skill has always been a sign of "fitness" for biological life, as the evolutionists say, or helpful toward a community in inspiring cultural solidarity, as the anthropologists will offer.[28]

Those who follow in Picasso's footsteps have a different answer from the Duchampians in regard to democracy and elitism in the visual arts. When it comes to the art-maker—the actual artist—the Picasso approach is quite elite, to be sure. Artists must master skill and craft, pay their dues over years of practice, and put their ideas and forms together, creating something visually "new" and moving. Not everyone can be an artist, therefore. For all this elitism, however, Picasso democratized art in the realms of public art appreciation. Indeed, any dope *can* marvel at a Picasso. Picasso's role in making art appreciation democratic was on full display as the first decade of the twenty-first century came to an end.

Around the time of the Philadelphia Museum of Art's 2010 exhibition, with its twinning of Picasso and Duchamp, the art of Picasso was storming public attention all across the United States. Museums know that a Picasso exhibit will always draw the masses. Between February 2010 and June 2011, for example, six major Picasso exhibitions erupted in the United States, perhaps drawing as many as 1.5 million visitors, and probably more.

Both the Philadelphia Museum of Art (as already mentioned) and the Metropolitan Museum of Art pulled out the stops in early 2010, putting their entire collections of Picasso on display in banner exhibitions,

premeditated crowd-pleasers.[29] On the heels of that, a world tour of key works by Picasso from the Musée National Picasso arrived in the United State for a total of twelve months, with stops in Seattle, Richmond (Virginia), and San Francisco, drawing nearly a million viewers and, in the case of Seattle and Richmond, adding a needed financial boost to the contemporary art scene.[30]

This suggests that when it comes to the democracy of art appreciation, there always seems to be a "year of Picasso" in terms of mass turnout to see works of art. At the same time, in the more elite world of art academia, it has become an "age of Duchamp." In what has been called the era of "postmodern" art, Duchamp has set the intellectual horizon for the latest generation of curators, artists, and art critics. As Picasso remains important to a wider public — simply as a matter of looking at art — Duchamp has become important to the cerebral subculture of contemporary art itself.

Shorn of their personal foibles and failings, Picasso stands for honing skills and making art, whereas Duchamp stands for relying on ideas to justify calling something art. This has been the battle for the soul of modern art. That battle has been played out, but its aftermath is still defining the world of the visual arts today.

"One hundred years of the retinal approach is enough," Duchamp had said in 1961, and he may have won that game, in particular among academics, and within the esoteric world of Conceptual art practices.[31] But retinal art endures in a very big way, and in that sense, Picasso has won in another game, with stakes that are equally high. Duchamp's game was for the elites, and by understanding his story, the masses may be able to comprehend why contemporary art museums are what they are today. Picasso wins with the masses. This is the world not of the chessboard, but of public opinion, or, as the Society of Independent Artists said in 1884, the realm in which artists must "present their works freely to the judgment of the public."

author's note

Any biography about an artist must balance the life and the works, and that has been the challenge in this brief treatment of Picasso and Duchamp. By mingling their lives, I have left significant gaps in both. But by drawing selective contrasts, I have also tried to offer a new way of looking at each character. At face value, both were talented, mischievous, and ambitious men, and both tried to make a mark on the world of art. Otherwise, if I have engaged in any typecasting to shape this narrative, I have emphasized Picasso's productivity as a painter and Duchamp's cunning as an idea man and a chess player.

The net effect has probably been more narrative about Duchamp than Picasso. Much of Picasso's life can be told by his art, but in a book such as this, the cost of reproducing copyrighted works has been prohibitive. Meanwhile, Duchamp has said far more on the record than Picasso. Duchamp also traveled through some of the most interesting art scenes from Paris to New York, a kind of subplot in this book. As a consolation to the visual paucity of Picasso's art (and the same for Duchamp) everything cited and more can be found in full color on the Internet.

In writing this book, I have been mindful of the warnings that Picasso and Duchamp have given to would-be biographers. Picasso said, "You must not always believe what I say." Duchamp offered: "I have forced myself to contradict myself in order to avoid conforming to my own tastes." Much of what the two artists have said came late in life, when they were reconstructing their own life stories, and they do indeed contradict themselves often. Therefore, I am indebted to the many Picasso and Duchamp biographers and analysts (amply cited in the notes) who have organized the documents needed to establish the facts and compare their statements, and who have offered plausible interpretations of both artists' thoughts and actions.

To get a sense of current attitudes toward Picasso and Duchamp, I also conducted a few interviews. I received generous e-mail replies from Jerrold Seigel, Linda Dalrymple Henderson, and Francis Naumann that helped me narrow down the issue of how Picasso and Duchamp first met (we still know almost nothing). Interviews were also consented to by author and painter Brian Curtis; two scholars of Cubism and modern art, John Cottington and Michael Taylor (also a Duchamp expert); art world chronicler Irving Sandler; and professor emeritus of art history and theory at MIT Wayne Andersen. I have not quoted from these interviews, but have taken various pointers from all of them related to themes in this book, for which I am solely responsible.

The main theme of this book is a simple plot: As Picasso became modern art's

reigning symbol, Duchamp decided to rebut Picasso's approach to art (though not Picasso personally). The fame that Duchamp generated at the 1913 Armory Show in New York gave him the prominence necessary to rival Picasso's influence. With the strategic thinking of a chess player, Duchamp worked his way up in the art establishment, finally installing his so-called "anti-art" ideas in the Western canon. Today, the debate continues on who was most influential in modern art, Picasso or Duchamp, and what consequences their lives have had for the "soul of modern art." Meanwhile, the question of artistic "influence" has become controversial in art history writing, and accordingly, I have tried to stay carefully skeptical about stating how influence among artists works. Still, in the end, I have argued that both Pablo Picasso and Marcel Duchamp have obviously influenced two major viewpoints about art today.

I would like to thank the institutions that offered me the chance to see an extensive array of works by Picasso and Duchamp: the National Gallery of Art, the Philadelphia Museum of Art, the Barnes Collection, the Museum of Modern Art, the Metropolitan Museum of Art, the Baltimore Museum of Art, and the Virginia Museum of Fine Art. My appreciation is also due to the staff at the Art Library at the University of Maryland, College Park, and the Library of Congress. Thanks also to Lindsey Alexander for the superb editing, to my agent Laurie Abkemeier, and to my editor at University Press of New England, Stephen P. Hull.

illustration credits

The following sources made images available for this book: Yale University Art Gallery, Bridgeman Art Library, the Smithsonian Institution's Archive of American Art, the Library of Congress, and the Artists Rights Society (ARS). All images of artworks by Pablo Picasso and Marcel Duchamp are copyrighted by ARS. All other images are used by permission or are in the public domain.

Figure 1 Marcel Duchamp, Jacques Villon, Raymond Duchamp-Villon, and Villon's dog Pipe in the garden of Villon's studio, Puteaux, France, c. 1913. Unidentified photographer. Walt Kuhn, Kuhn family papers and Armory Show records. Archives of American Art, Smithsonian Institution.

Figure 2 Pablo Picasso in his studio, rue Schoelcher, 1914. B/w photo by French photographer. Private collection/Archives Charmet/The Bridgeman Art Library.

Figure 3 Poster for International Exhibition of Modern Art, 69th Infantry Regiment Armory, 1913. Yale University Art Gallery. Gift of George Hopper Fitch, B. A. 1932.

Figure 4 Armory Show, 1913. Interior view. Unidentified photographer. Walt Kuhn, Kuhn family papers and Armory Show records, Archives of American Art, Smithsonian Institution.

Figure 5 International Exhibition of Modern Art postcard, 1913. [Marcel Duchamp's *Nude Descending a Staircase*, 1912]. Walt Kuhn, Kuhn family papers and Armory Show records, Archives of American Art, Smithsonian Institution.

Figure 6 *Life*, 1903 (oil on canvas) by Pablo Picasso. Cleveland Museum of Art, OH. USA/Giraudon/The Bridgeman Art Library.

Figure 7 *Les Demoiselles d'Avignon*, 1907 (oil on canvas) by Pablo Picasso. Museum of Modern Art, New York. USA/Giraudon/The Bridgeman Art Library.

Figure 8 *Mother and Child*, c. 1922 (pen and ink) by Pablo Picasso. Haags Gemeentemuseum, The Hague, Netherlands/The Bridgeman Art Library.

Figure 9 *The Crucifixion*, 1930 (oil on panel) by Pablo Picasso. Musee Picasso, Paris, France/Giraudon/The Bridgeman Art Library.

Figure 10 *The Minotaur* [or *Minotaurmachy*], 1935 (etching) by Pablo Picasso. Museo Picasso, Barcelona, Spain/Index/The Bridgeman Art Library.

Figure 11 Gertrude Stein sitting on a sofa in her Paris studio, with a portrait of her by Pablo Picasso and other modern art paintings hanging on the wall behind her. Wide World Photos, Inc., May 1930. Library of Congress, Prints & Photographs Division.

Figure 12 Guillaume Apollinaire (1880–1918) in Picasso's studio at the Bateau-Lavoir, early twentieth century. B/w photo by French photographer. Private Collection/Archives Charmet/The Bridgeman Art Library.

Figure 13 Olga Khokhlova and Serge Diaghilev. Monte Carlo, 1928. Photo by Serge Grigoriev (1883–1968). Serge Grigoriev/Ballets Russes Archive, Music Division, Library of Congress.

Figure 14 André Breton, Paul Eluard, Benjamin Peret, and Tristan Tzara, 1932. B/w photo by French photographer. Bibliotheque Litteraire Jacques Doucet, Paris, France/Archives Charmet/The Bridgeman Art Library. Detail shown.

Figure 15 Portrait of Man Ray and Salvador Dalí, Paris. Photo by Carl Van Vechten (1880–1964), June 16, 1934. Gelatin silver print. Library of Congress, Prints & Photographs Division, Carl Van Vechten Collection.

Figure 16 *Little Large Glass: The Bride Stripped Bare by Her Bachelors, Even* (1935–41) by Marcel Duchamp. Yale University Art Gallery. Gift of the Estate of Katherine S. Dreier.

Figure 17 Marcel Duchamp and Katherine Dreier in Katherine Dreier's Living Room. Photo by Leslie E. Bowman. Yale University Art Gallery. Bequest of Katherine S. Dreier.

Figure 18 Marcel Duchamp and the *Revolving Glass* [or *Rotary Glass Plates*]. Unknown photographer. Yale University Art Gallery. Gift of the Estate of Katherine S. Dreier

Figure 19 Marcel Duchamp. *Boîte-en-valise (Box in a Valise)*. Yale University Art Gallery. Gift of Katherine S. Dreier to the Collection Société Anonyme.

Figure 20 View of the painting *Guernica* by Pablo Picasso in his studio, rue des Grands-Augustins, Paris. Illustration from *Verve*, December 1937. B/w photo by Dora Maar (1907–97). Private Collection/Archives Charmet/The Bridgeman Art Library.

Figure 21 Pablo Picasso in Paris, c. 1928. B/w photo. Private Collection/Roger-Viollet, Paris/The Bridgeman Art Library.

abbreviations used in notes

AMSC Francis M. Naumann and Hector Obalk, eds., Jill Taylor, trans., *Affect/Marcel: The Selected Correspondence of Marcel Duchamp* (London: Thames and Hudson, 2000).

CWMD Arturo Schwarz, *The Complete Works of Marcel Duchamp* (New York: Harry N. Abrams, 1969).

DB Calvin Tomkins, *Duchamp: A Biography* (New York: Henry Holt, 1996).

DMD Pierre Cabanne, *Dialogues with Marcel Duchamp* (New York: Da Capo Press, 1979).

DPP Robert Motherwell, ed., *The Dada Painters and Poets: An Anthology*, 2nd ed. (Cambridge, MA: Harvard University Press, 1981 [1951]).

LP1 John Richardson, *A Life of Picasso, Vol. 1, 1881–1906* (New York: Random House, 1991).

LP2 John Richardson, *A Life of Picasso, Vol. 2, 1907–1916* (New York: Random House, 1996).

MD Robert Lebel, *Marcel Duchamp*, trans. George Heard Hamilton (New York: Grove Press, 1959).

MD73 Anne d'Harnoncourt and Kynaston McShine, eds., *Marcel Duchamp* (New York: Museum of Modern Art; Philadelphia: Philadelphia Museum of Art, 1973). Volume for the 1973 retrospective on Marcel Duchamp.

MDBSB Alice Goldfarb Marquis, *Marcel Duchamp: The Bachelor Stripped Bare, a Biography* (Boston: MFA Publications, 2002).

MDED Michael Taylor, *Marcel Duchamp: Étant donnés* (Philadelphia: Philadelphia Museum of Art, 2009).

MDP Joseph Masheck, ed. *Marcel Duchamp in Perspective* (Englewood Cliffs, NJ: Prentice-Hall, 1975).

PLA Pierre Daix, *Picasso: Life and Art*, trans. Olivia Emmet (New York: HarperCollins, 1993).

POA Dore Ashton, ed., *Picasso on Art: A Selection of Views* (New York: Viking Penguin, 1972).

SAS Milton W. Brown, *The Story of the Armory Show* (New York: Abbeville Press, 1988).

SS Michel Sanouillet and Elmer Peterson, eds., *Salt Seller: The Writings of Marcel Duchamp (Marchand du Sel)* (New York: Oxford University Press, 1973).

notes

1. "sensation of sensations"

1. Gelett Burgess, "The Wild Men of Paris," *Architectural Record* 27 (May 1910): 400–14.

2. See Brown, *SAS*. See also *Catalogue of International Exhibition of Modern Art, at the Armory of the Sixty-Ninth Infantry, February 15 to March 15, 1913* (New York: Association of American Painters and Sculptors, 1913).

3. Frank Anderson Trapp, "The Armory Show: A Review," *Art Journal* 23 (Autumn 1963): 2–9.

4. H. P. Roché, "Souvenirs of Marcel Duchamp," in Lebel, *MD*, 79.

5. Duchamp quoted in Cabanne, *DMD*, 23.

6. When I queried Duchamp experts, the names Guillaume Apollinaire, a writer, and Jean Metzinger, a painter, were suggested as likely people to have introduced Picasso and Duchamp. Meanwhile, Picasso expert John Golding has stated: "Duchamp was in fact introduced to Picasso . . . by his friend Maurice Princet," an amateur mathematician. See John Golding, *Cubism: A History and an Analysis, 1907–1944* (London: Faber and Faber, 1959), 164. No biographies of Picasso or Duchamp address the topic. Pierre Cabanne says, "No one ever knew what [Picasso] thought" of other prominent artists, including Duchamp. See Cabanne, *Pablo Picasso: His Life and Times* (New York: Morrow, 1977), 10. The Picasso-Duchamp encounter, or whether there were others, remains a relative mystery.

7. Duchamp quoted in Cabanne, *DMD*, 66.

8. Guillaume Apollinaire comment on Duchamp in *Theories of Modern Art*, ed. Herschel B. Chipp (Berkeley: University of California Press, 1996), 245. The comment comes from a 1912 review, later published in Apollinaire's book *The Cubist Painters* (1913).

9. Cabanne, *DMD*, 25. The two rival branches of Parisian Cubism have also been called "salon Cubism" (Duchamp et al.) and "gallery Cubism" (Picasso). See David Cottington, *Cubism and Its Histories* (Manchester, UK: Manchester University Press, 2004), 141, 146.

10. Richardson, *LP1*, 160.

11. Duchamp quoted in Cabanne, *DMD*, 25.

12. For the debate on defining art in the twentieth century, see Gordon Graham, *Philosophy of the Arts: An Introduction to Aesthetics* (London: Routledge, 2000). Graham argues that the better approach is to ask "what is the value of art," since art itself may be impossible to define to everyone's satisfaction.

13. Don Thompson, *The $12 Million Stuffed Shark: The Curious Economics of Contemporary Art* (New York: Palgrave/Macmillan, 2008).

14. Charles Baudelaire, *The Painter of Modern Life and Other Essays*, second ed. (London: Phaidon Press, 1995), 7.

15. Duchamp quoted in Katherine Dreier, "Marcel Duchamp," *Collection of the Société Anonyme: Museum of Modern Art 1920* (New Haven, CT: Yale University Art Gallery, 1950), 148.

2. the spanish gaze

1. See Antonina Vallentin, *Picasso* (Garden City, NY: Doubleday, 1963), 45.

2. Richardson said Picasso had "done well at school." See Richardson, *LP1*, 42. Huffington says Picasso may have had dyslexia, and that his father pulled strings for him to get around normal entrance exams. See Arianna Stassinopoulos Huffington, *Picasso: Creator and Destroyer* (New York: Simon and Schuster, 1988), 23, 25.

3. Quoted in Daix, *PLA*, 5.

4. Picasso quoted in Vallentin, *Picasso*, 5. Richardson said, "Picasso may have despised academicism; he did not despise academic teaching." See Richardson, *LP1*, 64.

5. Daix, *PLA*, xi.

6. Picasso's father quoted in Anthony Blunt and Phoebe Pool, *Picasso: The Formative Years* (London: Studio Books, 1962), 6. Picasso's early traditional paintings, encouraged by his father, were *First Communion* (1896), *Christ Appearing to Blessed Marguerite* (1896), *Annunciation* (1896), *Science and Charity* (1897), and *Last Moments* (1900).

7. On the northern influence, see Blunt and Pool, *Picasso*, 7–21.

8. Mallarmé letter to Henri Cazalis (c. 1864), in Rosemary Lloyd, ed., *Selected Letters of Stéphane Mallarmé* (Chicago: University of Chicago Press, 1988), 39.

9. Rusiñol quoted in Blunt and Pool, *Picasso*, 10.

10. Picasso quoted from an 1897 letter in Blunt and Pool, *Picasso*, 5.

11. Picasso letter quoted in Ashton, *POA*, 104.

12. Since his student days Picasso had sided with anarchism. See Patricia Dee Leighten, *Re-Ordering the Universe: Picasso and Anarchism, 1897–1914* (Princeton: Princeton University Press, 1989). In general, Picasso biographers say he was a nonpolitical moral anarchist. He became a politicized Republican during the Spanish Civil War, and stayed mum during the Nazi occupation of Paris. When he joined the French Communist Party in 1945, his fame mainly helped as propaganda.

13. Rusiñol quoted in Blunt and Pool, *Picasso*, 7.

14. Barcelona artist Miquel Utrillo quoted in Richardson, *LP1*, 145.

15. Sabartés quoted in Daix, *PLA*, 16.

16. Richardson, *LP1*, 160.

17. Charles Baudelaire, *The Painter of Modern Life and Other Essays*, second ed. (London: Phaidon Press, 1995), 34.

18. *Revue Blanche* and *Le Journal* quoted in Richardson, *LP1*, 198.

19. Picasso quoted in Daix, *PLA*, 27. Picasso did three paintings of Casagemas after his death, the second and third in blue. The second was a satirical apotheosis of Casagemas (done after Velásquez, and featuring prostitutes, not saints), while the third turned out to be Picasso's first masterpiece, *La Vie*. On the use of blue in art see Blunt and Pool, *Picasso*, 19–20. Blue was widely recognized as the color of melancholy. Art nouveau had used peacock blue, or ice blue. Toulouse-Lautrec used a gloomy blue, and

photographic proof sheets came in blue. El Greco, then being celebrated anew, had used blues with elongated figures. Picasso may have used blue because it was easier to work with and cheaper.

20. Daix, *PLA*, 30. See also Richardson, *LP1*, 218.

21. *La Revue Blanche*, September 1902. Quoted in Richardson, *LP1*, 248.

22. *Mercure de France*, December 1902. Quoted in Daix and Georges Boudaille, *Picasso: The Blue and Rose Periods*, trans. Phoebe Pool (Greenwich, CT: New York Graphic Society, 1967), 334. See also Richardson, *LP1*, 263.

23. On *maudits* poets and artists, see Jerrold Seigel, *Bohemian Paris: Culture, Politics, and the Boundaries of Bourgeois Life, 1830–1930* (Baltimore: Johns Hopkins University Press, 1999), 256. See a discussion of François Villon, the origin of the *poète maudit*, and "artistic license" in Wayne Andersen, *Marcel Duchamp: The Failed Messiah*, 2nd printing (Geneva: Éditions Fabriart, 2001), 5–6; 176–79.

24. Picasso quoted in Vallentin, *Picasso*, 46.

25. *El Liberal*, June 4, 1903. Quoted in Daix, *PLA*, 35.

3. the notary's son

1. See the headline, Benjamin Genocchio, "Fin-de-siècle Admen," *New York Times*, January 14, 2007, L10.

2. Marcel Duchamp, "Emile Nicolle 1830–1894," *SS*, 156. Nicolle was Duchamp's maternal grandfather.

3. Robert Lebel interviewed Duchamp about his parents and summarized this in Lebel, *MD*, 2.

4. Tomkins, *DB*, 41, 439–41; Marquis, *MDBSB*, 58–59; 279–80.

5. Cabanne, *DMD*, 25. See also 15: "I've never worked for a living. I consider working for a living imbecilic from an economic point of view."

6. See "Albert Londe (1858–1917)," in *Who's Who of Victorian Cinema: A Worldwide Survey*, ed. Stephen Herbert and Luke McKernan (London: British Film Institute, 1996), 84; and Margit Rowell, "Kupka, Duchamp, and Marey," *Studio International* 189 (January/February 1975): 49.

7. This description was conveyed by Olga Popovich, a friend of Jacques Villon and director of the Rouen Fine Arts Museum, to the author Alice Goldfarb Marquis in a September 22, 1977, interview. See Marquis, *MDBSB*, 30.

8. Duchamp quoted in *SS*, 166. He frequently used the term "amuse" to explain his motivations. See Cabanne, *DMD*, 36, 41.

9. Duchamp describes himself as a Cartesian in Dore Ashton, "An Interview with Marcel Duchamp," *Studio International* (June 1966): 144–45. He described Cartesian as "an acceptance of all doubts . . . an opposition to unclear thinking." See also Linda Dalrymple Henderson, *Duchamp in Context: Science and Technology in the Large Glass and Related Works* (Princeton: Princeton University Press, 1998), 77, 269 n. 59. Henderson describes Duchamp as anti-Bergsonian and as a self-described Cartesian.

10. Marcel Duchamp, "Notes for a Lecture, 1964." Unpublished typescript. Cited in Tomkins, *DB*, 30.

11. Duchamp quoted in Arturo Schwarz, *The Complete Works of Marcel Duchamp* (New York: Abrams, 1969), 381.

12. David Cottington, *Cubism and Its Histories* (Manchester, UK: Manchester University Press, 2004), 13.

13. Historian David Cottington emphasizes the commercial competition in this period, while historian Jeffrey Weiss shows how it could disillusion an artist such as Marcel Duchamp. Cottington reports that between 1900 and 1914, 185 *petites revues* (small review sheets or publications) appeared in Paris, mostly around 1910. Most of them also advocated an artistic "ism" to stand out in the crowd. The isms in pamphlets, said Albert Gleizes at the time, "multiply according to the will of the artists seeking more attention to themselves than to realise serious works." Cottington also notes that there were two "promotional strategies," one being organizing group salons, the other being the issuance of small reviews (often associated with a gallery). See Cottington, *Cubism and Its Histories*, 13–14. Weiss says, "The sensory overload of schools and scandals presented him [Duchamp] with a sarcastic yet logical option of disowning his brushes and tubes." Jeffrey Weiss, *The Popular Culture of Modern Art: Picasso, Duchamp, and Avant-Gardism* (New Haven, CT: Yale University Press, 1994), 116. See also Robert Jensen, "The Avant-Garde and the Trade in Art," *Art Journal* (Winter 1998): 360–67.

14. As an art dealer in New York City beginning in 1931, Pierre Matisse's first marriage was to Alexina Sattler, whom he divorced in 1949 to marry twenty-five-year-old Patricia Echaurren, former wife of Chilean surrealist painter Roberto Matta (a close friend of Duchamp); Matta had in turn abandoned Patricia for an affair with artist Arshile Gorky's wife (causing Matta's expulsion from the Surrealist movement). Then in 1951 Duchamp and Alexina began seeing each other and married in 1954; Pierre Matisse's three daughters became Duchamp's stepdaughters.

15. Duchamp quoted in "Duchamp 50 Years Later," *Show*, February 1963, 28–29. Cited in Marquis, *MDBSB*, 41.

16. Art historian Wayne Andersen has pointed this out, and noted its likely influence on Duchamp's future work on *The Large Glass*.

17. Michel Sanouillet, "Marcel Duchamp and the French Intellectual Tradition," in d'Harnoncourt, *MD73*, 48–54.

18. See Tomkins, *DB*, 36.

19. Duchamp quoted in Cabanne, *DMD*, 58.

20. Quoted in Jerrold Seigel, *Bohemian Paris: Culture, Politics, and the Boundaries of Bourgeois Life, 1830–1930* (Baltimore: Johns Hopkins University Press, 1999), 253, 242.

21. France had its supreme example of the bohemian dandy in the poet Charles Baudelaire, who died in 1867. He hated the dirt of the street, but loved the opulent extremes of drugs, drink, horror literature, and sex. He appreciated how beauty can be extracted from evil (in his case, by "beautiful" verse depicting depravity). This kind of bohemian was often a flâneur as well, an unemployed, detached observer of the transience of urban life. The male flâneur wanders about, watching, not judging, but enjoying. He was the classic "voyeur" of women, a theme that spoke to young Duchamp.

22. Besides Montmartre, the other main entertainment district in Paris was in the south, near the Left Bank, called Montparnasse. On the history and story of Mont-

martre and Montparnasse as centers of bohemia and art, see Seigel, *Bohemian Paris*; and Daniel Franck, *Bohemian Paris: Picasso, Modigliani, Matisse, and the Birth of Modern Art* (New York: Grove Press, 2001).

23. On blague, fumiste, and mystification see Weiss, *The Popular Culture of Modern Art*, 111, 119–123, 142; and Seigel, *Bohemian Paris*, 121–22, 137.

24. As a struggling writer living in Paris's Left Bank in the 1840s, Henry Murger wrote a series of vignette stories about bohemians for a literary magazine. He was approached in 1849 by a playwright, and they collaborated on turning the stories into the plot for a play, *La Vie de la bohème*. The play popularized Murger's work, so in 1851 he knitted his stories together as a novel, *Scenes of the Bohemian Life*. The novel was the basis for the Italian opera derivation, *La Bohème*, developed by Giacomo Puccini and first performed in 1896. Since then, the opera has become the most famous expression of Murger's otherwise little-known work. In his 1851 novel, he offered a preface that first defined the modern "bohemian."

25. Tomkins, *DB*, 35.

4. bohemian paris

1. Duchamp quoted in Pierre Cabanne, *The Brothers Duchamp* (Boston: New York Graphic Society, 1977), 23–24. Duchamp biographer Alice Goldfarb Marquis doubts that Duchamp attended since he had military duty. She argues that Duchamp's memory is "frequently unreliable" in his many latter-day interviews about his life. See Marquis, *MDBSB*, 327, n. 2. Duchamp concedes that often his "memory is unfaithful," as quoted in Calvin Tomkins, *The Bride and the Bachelors: Five Masters of the Avant-Garde* (New York: Viking, 1965), 1.

2. See Jack Flam, *Matisse and Picasso: The Story of Their Rivalry and Friendship* (Cambridge, MA: Westview Press, 2003). As to Matisse's Fauvism stirring controversy and gaining Paris market share, Cottington says Matisse successfully evoked "a gratifyingly loud critical response." See David Cottington, *Cubism and Its Histories* (Manchester, UK: Manchester University Press, 2004), 13.

3. Gertrude Stein, *Picasso* (New York: Dover Publications, 1984), 49.

4. See Carlton Lake, *Henri-Pierre Roché: An Introduction* (Austin, TX: Harry Ransom Humanities Research Center, University of Texas, 1991).

5. Picasso's early struggling dealers included Berthe Weill (a bespectacled Jewish matron who helped many artists get started); Clovis Sagot, who had a good eye for the avant-garde; a Eugène Soulié; and later the German businessman Wilhelm Uhde. After April 1906, Picasso sold mostly to Ambroise Vollard. In late 1907, Uhde urged Daniel-Henry Kahnweiler to go see Picasso; hence, they soon began an exclusive contractual relationship. For the early dealers see Richardson, *LP1*, 351–57.

6. Duchamp quoted in Cabanne, *DMD*, 24.

7. Braque quoted in Dora Vallier, "Braque: La peinture et nous," *Cahiers d'Art*, October 1954, 18. Cited in Richardson, *LP2*, 102.

8. Apollinaire quoted in Anthony Blunt and Phoebe Pool, *Picasso: The Formative Years* (London: Studio Books, 1962), 25.

9. Francis Carco, *The Last Bohemian* (New York: Henry Holt, 1928), 110.

10. See Jerrold Seigel, "Publicity and Fantasy: The World of the Cabarets" (chapter 8) in Jerrold Seigel, *Bohemian Paris: Culture, Politics, and the Boundaries of Bourgeois Life, 1830–1930* (Baltimore: Johns Hopkins University Press, 1999), 215–41.

11. The cafe owner who invented the cabaret was Émile Goudeau, and he told his story in a memoir, *Ten Years of Bohemia*. His bohemian fantasyland, Hydropathes, soon failed, but it was followed in Montmartre in 1881 by the Chat Noire (Black Cat) and later the Moulin Rouge, both now famous in the history of art and artists. Picasso's first "French" painting (in 1900) was of the Moulin Rouge, and the place must have also thrilled seventeen-year-old Marcel Duchamp when he arrived in Paris.

12. On Alfred Jarry, see Roger Shattuck, *The Banquet Years*, rev. ed. (New York: Vintage Books, 1968), 187–251; Seigel, *Bohemian Paris*, 310–22. On Jarry and science, see Linda Dalrymple Henderson, *Duchamp in Context: Science and Technology in the Large Glass and Related Works* (Princeton: Princeton University Press, 1998), 47–51. See also Alastair Brotchie, *Alfred Jarry: A Pataphysical Life* (Cambridge, MA: MIT Press, 2011).

13. Quoting the Parisian writer Madame Rachilde, a close friend of Jarry, cited by Seigel, *Bohemian Paris*, 318; Shattuck, *The Banquet Years*, 188.

14. Jarry quoted in Richardson, *LP1*, 474.

15. Quoted in Fernande Olivier, *Picasso and His Friends* (New York: Appleton-Century, 1965 [1933]), 36. See also Daix, *PLA*, 14. Daix notes that a standard greeting was "à bas Laforgue! Vive Rimbaud!" and that Sabartés said Picasso liked Rimbaud most.

16. A gifted writer herself, Fernande was probably helped in composing her memoir by Max Jacob, himself a wordsmith and eyewitness to the early days with Picasso. The memoir forever linked Picasso to Montmartre, and by that means, Picasso's fame made the otherwise obscure hilltop world famous.

17. Olivier, *Picasso and His Friends*, 50.

18. Gertrude Stein, *The Autobiography of Alice B. Toklas* (New York: Vintage Books, 1961 [1933]), 24.

19. On Princet, see Linda Dalrymple Henderson, *The Fourth Dimension and Non-Euclidean Geometry in Modern Art* (Princeton: Princeton University Press, 1983), 64–72. See also, in French, Marc Décimo, *Maurice Princet, Le Mathématicien du Cubisme* (Paris: Éditions L'Echoppe, 2007).

20. Poincaré quoted in Linda Dalrymple Henderson, "X Rays and the Quest for Invisible Reality in the Art of Kupka, Duchamp, and the Cubists," *Art Journal* (Winter 1998): 326.

21. Quoted in Henderson, *The Fourth Dimension*, 70.

22. Duchamp used the word "shit" (*merde*) in his brief "notes" for the *Large Glass* project, collected in his *Box of 1914*. See Marcel Duchamp, "The 1914 Box," *SS*, 24. Duchamp writes: "arrhe is to art as shitte is to shit."

23. In his report for *L'Intransigeant*, March 20, 1910, Apollinaire described two of Duchamp's Fauvist-like nudes at the 1910 Salon des Indépendants as "very ugly." See Tomkins, *DB*, 40. Later he wrote: "Duchamp is the only painter of the modern school who today [Autumn 1912] concerns himself with the nude." See Guillaume

Apollinaire in *Theories of Modern Art*, ed. Herschel B. Chipp (Berkeley: University of California Press, 1996), 245.

24. Of the Duchamp biographers, Calvin Tomkins, in *DB*, most thoroughly reports on Duchamp's many sexual affairs. Tomkins seems to have had no alternative: Some of Duchamp's closest friends — Henri-Pierre Roché, Man Ray, Beatrice Wood, Gabrielle-Buffet Picabia, and Mary Reynolds, et al. — wrote or spoke about his promiscuity.

25. Duchamp quoted in C. Baekeland and Geoffrey T. Hellman, "Talk of the Town: Marcel Duchamp," *New Yorker*, April 6, 1957, 26.

26. Duchamp quoted in Cabanne, *DMD*, 15.

27. American symbolist poet Stuart Merrill (d. 1915), quoted in Anthony Blunt and Phoebe Pool, *Picasso: The Formative Years* (London: Studio Books, 1962), 26.

28. Stein's claim that she sat eighty times is problematic: How could Picasso be so slow? If true, it has been suggested that she and Picasso mostly talked. Marianne Tauber has proposed that Stein showed Picasso the two-volume *Principles of Psychology* (1890), written by her former Harvard professor, William James. The chapter on Space Perception has diagrams similar to what Picasso eventually did in Cubism. See Robert M. Crunden, *American Salons: Encounters With European Modernism 1885–1917* (New York: Oxford University Press, 1993), 302; 475 n. 34. He quotes Tauber: "Even James's terminology comes through in the few interviews with Picasso that we have."

29. See Picasso's explanation of the name "Avignon" in Ashton, *POA*, 153–54. He said it was associated to the French city and to a street in Barcelona. Leading scholars of *Les Demoiselles d'Avignon* have heatedly debated Picasso's motives and influence, and whether he felt the painting was finished or unfinished — all of which is beyond the scope of this book.

30. Cézanne's "Letters to Emile Bernard" were published in *Mercure de France* on October 1 and 15, 1907, at the same time as his Salon d'Automne retrospective.

31. Picasso quoted in Richardson, *LP1*, 469.

32. Stein, *The Autobiography of Alice B. Toklas*, 64.

5. little cubes

1. See a simple account of the naming of "cubism" in John Golding, *Cubism: A History and an Analysis 1907–1914* (London: Faber and Faber, 1959), 20–21.

2. On salon and gallery Cubism see David Cottington, *Cubism and Its Histories* (Manchester, UK: Manchester University Press, 2004), 141, 146. The two approaches had philosophical differences, but were also two different marketing strategies. See Robert Jensen, "The Avant-Garde and the Trade in Art," *Art Journal* (Winter 1998): 360–67.

3. Picasso quoted in Daix, *PLA*, 94. Daniel-Henry Kahnweiler, *The Rise of Cubism* (New York: Wittenborn, Shultz, 1949 [1920]), 10.

4. Picasso's inroads into America began early but slowly. The first advocates of Picasso in America were Max Weber and Marius de Zayas, two young artists visiting Paris, who returned to New York with news of his work. Weber returned in 1909 and his enthusiasm converted Alfred Stieglitz (who ran *Camera Works* magazine and 291

Gallery) to modern art. Then in May 1910 *Architectural Record* ran the article "The Wild Men of Paris," which featured Picasso and showed the first photograph anywhere of *The Brothel of Avignon*. After Stieglitz visited Paris, in 1911 he held the first US exhibit of Picasso (at 291 Gallery), with de Zayas, who had interviewed Picasso in Spanish, writing the catalog. The show was of drawings and a small sculpture, easy to ship from Paris. De Zayas was first to try commercial gallery sales of Picasso.

The other early Picasso connection was an aborted project (1911) in which Picasso began to paint Cubist murals (on canvas) for the library of Brooklyn's Hamilton Easter Field, a wealthy Quaker businessman. Picasso's detailed "analytic" Cubism was not suited for large canvases, and anyway, Field quickly lost interest. See Doreen Bolger, "Hamilton Easter Field and His Contribution to American Modernism," *American Art Journal* 20 (1988): 78–107. In attempting the mural project, Picasso was trying to match Matisse, who at this time did canvas murals for the Russian Prince Sergei Shchukin's home in Moscow.

5. Fernande Olivier, *Picasso and His Friends* (New York: Appleton-Century, 1965 [1933]), 135.

6. Gertrude Stein, *The Autobiography of Alice B. Toklas* (New York: Vintage Books, 1961), 91.

7. Stein, *The Autobiography of Alice B. Toklas*, 91.

8. Olivier, *Picasso and His Friends*, 139.

9. Braque quoted in Richardson, *LP2*, 105.

10. Picasso quoted in Richardson, *LP2*, 175.

11. Ibid., 175.

12. Ibid., 105.

13. Ibid., 429. Picasso is generally seen as being anti-theory in art, especially based on his first published interview in English, "Picasso Speaks," *The Arts*, May 1923, 315–26. Picasso suggested that Cubism can't be intellectualized; nor is it "research." See the interview in Ashton, *POA*, 3–6.

14. It has been noted, for example, that the geometric shapes in Picasso's *Portrait of Vollard* (1910) are similar to a diagram in Jouffret's *Elementary Treatise on Four-Dimensional Geometry*. See Linda Dalrymple Henderson, *The Fourth Dimension and Non-Euclidean Geometry in Modern Art* (Princeton: Princeton University Press, 1983), 58.

15. Olivier, *Picasso*, 139.

16. Braque quoted in Richardson, *LP2*, 105.

17. Braque quoted in Daix, *PLA*, 100.

18. Duchamp said he was not influenced by the Italian Futurists' use of parallel lines to paint motion. The Futurists arrived in Paris saying a speeding automobile was more beautiful than a Greek statue. They published a manifesto on the front page of *Le Figaro* in 1909 and held their first Paris exhibit in early 1912 at the prestigious Galerie Bernheim-Jeune.

19. Linda Dalrymple Henderson, "X Rays and the Quest for Invisible Reality in the Art of Kupka, Duchamp, and the Cubists," *Art Journal* (Winter 1998): 323–40.

20. Linda Dalrymple Henderson, *Duchamp in Context: Science and Technology in*

the Large Glass and Related Works (Princeton: Princeton University Press, 1998), 103; and plate 164.

21. On Londe, see Henderson, "X Rays and the Quest for Invisible Reality," 326; 331–32. For the Etienne-Jules Marey image (1883), see Henderson, *Duchamp in Context*, plate 7.

22. Duchamp was the sad young man, as suggested by the way he phrased the title. Perhaps his prospects were not good that year; perhaps he was lonely, or perhaps he did not like the man, a pharmacist, his sister Suzanne was about to marry.

23. Duchamp quoted in Tomkins, *DB*, 80.

24. Duchamp quoted in "A l'Infinitif," *SS*, 92. Before using the term elementary parallelism, Duchamp coined the term "demultiplied body," in Duchamp, "The Green Box," *SS*, 35. Duchamp quoted in Katherine Dreier, "Marcel Duchamp," *Collection of the Société Anonyme: Museum of Modern Art 1920* (New Haven, CT: Yale University Art Gallery, 1950), 148.

25. Duchamp quoted in Tomkins, *DB*, 84.

26. Picasso quoted in Daix, *PLA*, 116.

27. See Roland Penrose, *Picasso: His Life and Work* third ed. (Berkeley: University of California Press, 1981[1958]), 192.

28. Clive Bell, *Art* (London: Chatto and Windus, 1914). The idea of an intuitive "significant form" had originally been suggest by the Prussian philosopher Immanuel Kant, and was later written upon in the 1890s by French artists who defined "art" as colors, lines, and shapes composed on a flat surface — the basic definition of "formalism" as a way to interpret art.

29. Neither Picasso nor Duchamp commented on art theory until they were interviewed. Picasso was interviewed in 1911 and 1923; Duchamp was first interviewed after his arrival in New York in 1915. They both waited until later in life (again, in interviews) to respond to questions about "theory" in art. Neither, however, presented a formal case. The exception would be Duchamp's comments on creativity ("The Creative Act," 1957) and his brief words on the readymade (1961).

30. Whereas historian Jeffrey Weiss sees the commercial images as simply environmental influences on the two artists, scholars who use linguistic theory to analyze Cubism see Picasso and Braque making statements (even unconsciously) about politics and reality. For the range of this debate (historical versus theoretical) see the special issue on Cubism in *Art Journal* (Winter 1998).

31. These kinds of theoretical readings use linguistic analysis or Marxist and Freudian theory, all of which rivals the earlier "formalist" readings, which looked solely at visual effects. See Rosalind E. Krauss, *The Picasso Papers* (New York: Farrar, Straus and Giroux, 2000); and Lisa Florman, "The Flattening of 'Collage,'" *October Magazine* 102 (Fall 2002): 59–86.

6. modernist tide

1. Apollinaire also had a temporary, but painful, falling out with Picasso over their embroilment in the late 1911 theft of the *Mona Lisa* from the Louvre by a crook who

had befriended Apollinaire. At the police station, Picasso, frightened that he would be deported, denied that he knew Apollinaire. Though Apollinaire was innocent in the Louvre incident (at least), it was his greatest public humiliation and an emotional break with Picasso. Apollinaire was also now receiving financial support from a salon Cubist, so he began touting them in his writings. For the complex Louvre story, see R. A. Scotti, *Vanished Smile: The Mysterious Theft of Mona Lisa* (New York: Knopf, 2009).

2. Albert Gleizes and Jean Metzinger, *On Cubism*, first English trans. (London: T. Fisher Unwin, 1913), 14, 13. It could be argued that this little book gave Duchamp four ideas he claimed as his own: the importance of the brain over the retina; rejection of Courbet and the Impressionists; spectator response; and chance associations in artistic effects. For example, in *On Cubism*, Gleizes and Metzinger said that Courbet "accepted without the slightest intellectual control, all that his retina presented him" (11) and that in Impressionism, "even more than in Courbet, the retina predominates over the brain" (14).

3. Quoted in Jeffrey Weiss, *The Popular Culture of Modern Art: Picasso, Duchamp and Avant-Gardism* (New Haven, CT: Yale University Press, 1994), 117.

4. Between 1881 and 1889, four volumes of Da Vinci's notes were translated into French (and into English) for the first time.

5. Apollinaire quoted in Linda Dalrymple Henderson, *The Fourth Dimension and Non-Euclidean Geometry in Modern Art* (Princeton, NJ: Princeton University Press, 1983), 62. Max Weber, the young American painter in Paris, heard the fourth dimension discussions and, on return to New York in 1909, wrote an article, "The Fourth Dimension from a Plastic [painting] Point of View," for Stieglitz's magazine, *Camera Work*. Back in Paris later, Apollinaire used Weber's article for his own writings. See William Bohn, "In Pursuit of the Fourth Dimension: Guillaume Apollinaire and Max Weber," *Arts Magazine* 54 (June 1980): 166–69.

6. Gleizes quoted in Henderson, *The Fourth Dimension*, 61.

7. Stein letter to Mabel Dodge, undated. Quoted in Robert M. Crunden, *American Salons: Encounters With European Modernism 1885–1917* (New York: Oxford University Press, 1993), 392.

8. Quoted in Weiss, *The Popular Culture of Modern Art*, 91.

9. The words of Jacques and Raymond (Duchamp) are recalled by Marcel. This, and Marcel's comments, are quoted in William Seitz, "What's Happened to Art? An Interview with Marcel Duchamp," *Vogue*, February 15, 1963, 112.

10. The golden ratio was an ancient mathematical discovery, cited by Plato and Euclid and continually updated. The ratio is produced by dividing a line (or rectangle) such that the smaller segment has the same proportion to the larger segment that the larger segment has to the entire line. As an algebraic division, the value of the ratio is 1.61803 . . . as a proportion it is roughly 1 to 6.

11. Raynal quoted Daix, *PLA*, 125.

12. Apollinaire also put a portrait photo of Duchamp in his book. Thus Duchamp had the self-affirming experience of being visually represented as part of the Cubist intelligentsia.

13. Lampué quoted in Daix, *PLA*, 124. See an account also in David Cottington, *Cubism and Its Histories* (Manchester, UK: Manchester University Press, 2004), 3–4.

14. Jules-Louis Breton quoted in Daix, *PLA*, 124.

15. Gleizes and Metzinger, *On Cubism*, 57–59.

16. Duchamp quoted in Tomkins, *DB*, 83.

17. Linda Dalrymple Henderson, *Duchamp in Context: Science and Technology in the Large Glass and Related Works* (Princeton: Princeton University Press, 1998), xxii, 176.

18. Duchamp said he admired Roussel's "delirium of imagination"; Roussel was his "great enthusiasm" as a young artist. See Marcel Duchamp, "The Great Trouble with Art in this Country," *SS*, 126.

19. Herbert Molderings, "Relativism and a Historical Sense: Duchamp in Munich (and Basel . . .)," in *Marcel Duchamp*, ed. Museum Jean Tinguely Basel (Berlin: Hatje Cantz, 2002), 16.

20. Marcel Duchamp, "The Great Trouble with Art in this Country," *SS*, 125.

21. Molderings, "Relativism and a Historical Sense," 16; 21 n13.

22. Vassily Kandinsky, *Concerning the Spiritual in Art*, rev. ed. (New York: Dover Publication, 1977 [1912]), 18–19.

23. Duchamp quoted in d'Harnoncourt, *MD73*, 263. This is from a Duchamp lecture, "Apropos of Myself," given at the City Art Museum of St. Louis, November 24, 1964.

24. John Golding, *Cubism: A History and an Analysis, 1907–1944* (London: Faber and Faber, 1959), 31.

25. Weiss, *The Popular Culture of Modern Art*, 136–38.

7. the armory show

1. For the story of Walter Pach and the Armory Show, see Brown, *SAS*; and Laurette E. McCarthy, *Walter Pach (1883–1958): The Armory Show and the Untold Story of Modern Art in America* (University Park, PA: Pennsylvania State University Press, 2011). Pach chronicles his own adventures related to Picasso, the Duchamps, and modern art in Walter Pach, *Queer Thing, Painting: Forty Years in the World of Art* (New York: Harper and Brothers, 1938).

2. Davies quoted in Brown, *SAS*, 70. Duchamp's four paintings at the Armory were all in his biomorphic, linear style: *Nude Descending a Staircase*; *Sad Young Man on a Train*; *Portrait of Chess Players*; and *King and Queen Surrounded by Swift Nudes*.

3. See Walter Pach, *A Sculptor's Architecture* (New York: Association of American Painters and Sculptors, 1913). This is one of a few publications officially handed out at the Armory Show.

4. Kahnweiler was probably short of available paintings. Some were being returned from the current Sonderbund exhibit, others he saved for his wealthiest patrons, and the best were also saved for Picasso's retrospective coming to Munich in early 1913.

5. Brown, *SAS*, 60.

6. Ibid., 86.

7. The Sonderbund, officially called the International Art Exhibition of the Federation of West German Art Lovers and Artists, was held in Cologne, the center of a

massive modern art market opening up in Germany's Rhineland (to the west), ending on September 30, 1912. It was the largest gathering of the newest modern art anywhere in Europe so far: 125 Van Goghs, 26 Cézannes, 25 Gauguins, 15 pointillist paintings, 18 by Paul Signac, 32 by Edvard Munch, and 16 by Picasso.

The rivalry between Picasso and the salon Cubists extended through various German exhibitions of 1913. Before Picasso's February 1913 Munich retrospective, Berlin's Sturm Gallery featured salon Cubist leader Robert Delaunay, rival to Picasso. See Richardson, *LP2*, 216. Picasso had his second largest show to date in Berlin in December 1913, titled "Picasso and Tribal Culture."

8. Davies quoted in Brown, *SAS*, 65.

9. Kuhn quoted in Brown, *SAS*, 65.

10. Duchamp quoted in Cabanne, *DMD*, 32.

11. Gabrielle Buffet-Picabia, "Some Memories of Pre-Dada: Picabia and Duchamp," in *DPP*, 257.

12. Kuhn quoted in Brown, *SAS*, 78.

13. Brown, *SAS*, 92.

14. Mabel Dodge, "Speculations, or Post-Impressionism in Prose," *Arts and Decoration* 3 (March 1913): 172, 174.

15. The *New York Times* ran the free-standing photo in late March 1913, shortly after the Armory Show finished in Manhattan, under the headline: "Brothers Who Paint Those Queer Cubist Pictures." Reproduced in William C. Agee, ed. *Raymond Duchamp-Villon, 1876-1918* (New York: Walker and Company, 1967), 121.

16. *New York Times*, March 1, 1913, 14; *New York Times*, March 16, 1913, SM1.

17. *New York Tribune*, February 17, 1913.

18. Brown, *SAS*, 177, 167, 159, 162.

19. Ibid., 182–83.

20. The only Parisian news coverage of the Armory Show came from a new, feisty art journal, *Montjoie*: "[T]his exhibition is merely a pretext for giving prominent display to the pictures of certain bad American painters. . . . The works of the French artists are scattered and badly hung, serving only as bait for the public. . . . [and since] Picasso's canvases are not grouped together, no idea can be formed of this artist's talent." Neither *Nude* nor Duchamp were mentioned. *Montjoie* also complained at the treatment of salon Cubist Robert Delaunay, who had submitted such a large canvas (the largest in the entire show) that the American committee refused to hang the work, *La Ville de Paris*, which measured 9 x 12 feet. See Brown, *SAS*, 148–49.

21. "Picabia, Art Rebel, Here to Teach New Movement," *New York Times*, February 16, 1913, 49.

22. In New York, there were 87,620 paid admissions to the Armory Show. An enthusiastic Pach claimed a quarter of a million. Admission was free in Chicago, which drew 188,650. Boston had a low admission and small event, drawing 12,676. With newspaper and radio reports, several hundreds of thousands of Americans must have first heard about "Cubism" or "modern art" thanks to the traveling exhibit. See Brown, *SAS*, 118, 203, 217.

23. Picasso letter to Daniel-Henry Kahnweiler, June 12, 1912. Quoted in Judith

Cousins, "Documentary Chronology," in *Picasso and Braque: Pioneering Cubism*, ed. William Rubin (New York: The Museum of Modern Art, 1989), 394–95.

24. Duchamp quoted in Lebel, *MD*, 84. Duchamp also said the library job "was a sort of grip on an intellectual position, against the manual servitude of the artist." See Cabanne, *DMD*, 41.

25. On the "machine aesthetic" see Robert M. Crunden, *American Salons: Encounters With European Modernism 1885–1917* (New York: Oxford University Press, 1993), 379–80. See also William A. Camfield, "The Machinist Style of Francis Picabia," *The Art Bulletin* 48 (September–December 1966): 309–322.

26. For Duchamp's research at the library, see "A l'Infinitif," *SS*, 86; Cabanne, *DMD*, 41.

27. Leonardo da Vinci, *The Notebooks of Leonardo Da Vinci*, vol. 1, ed. Edward Mac-Curdy (New York: Reynal and Hitchcock, 1938), 43.

28. Duchamp said his choice of glass came from seeing how paint looked on glass palettes. See Calvin Tomkins, *The Bride and the Bachelors: Five Masters of the Avant-Garde* (New York: Viking, 1965), 29. There are other probable influences. A fellow painter at Puteaux, Frank Kupka, painted on glass, and Duchamp had also read Da Vinci's text on how an artist can look with one eye through a window glass, and visualize how to draw perspective lines of objects in the distance. When Duchamp visited the National Conservatory of Arts and Industry Museum in Paris, he also walked past rows and rows of large glass cases, each divided by a metal bar at the middle, each filled with curious mechanical devices. See Linda Dalrymple Henderson, *Duchamp in Context: Science and Technology in the Large Glass and Related Works* (Princeton, NJ: Princeton University Press, 1998), 103; and plate 164.

29. For Duchamp's notes on these topics see Marcel Duchamp, *Notes and Projects for the Large Glass*, ed. Arturo Schwarz (New York: Abrams, 1969), 36–42. See also "A l'Infinitif," *SS*, 74–101.

30. Marcel Duchamp, "The Green Box," *SS*, 30.

31. Jeffrey Weiss, *The Popular Culture of Modern Art: Picasso, Duchamp, and Avant-Gardism* (New Haven, CT: Yale University Press, 1994), 133.

32. Marcel Duchamp, "The Green Box," *SS*, 49; Duchamp, "The 1914 Box," *SS*, 22. At the turn of the century, Poincaré was among those talking about "relativity," or how objects must shorten in length near the speed of light, a problem ultimately solved by Einstein's special theory of relativity (1905).

33. For Duchamp on chance see Katharine Kuh, *The Artist's Voice: Talks with Seventeen Modern Artists* (Cambridge, MA: Da Capo Press, 2000 [1962]), 81, 92. The idea of chance is unoriginal in modern art. See Miles Unger, "Finding Art in Random Images Is as Old as Art Itself," *New York Times*, August 22, 2000, AR28. Using chance images in art dates to Pliny the Elder and da Vinci, and Picasso said: "What can become a stimulus for a new work? . . . sometimes a spot in the picture which happens to be there by mistake or by chance." See Antonina Vallentin, *Picasso* (Garden City, NY: Doubleday, 1963), 37.

34. Duchamp quoted in Kuh, *The Artist's Voice*, 81.

35. Marcel Duchamp, "A l'Infinitif," *SS*, 74.

36. The role of Picasso and Duchamp in causing a "shift in the situation of the art object" in the twentieth century—through the auction and the readymade—I borrow from the analysis (here quoted) of Yve-Alain Bois, *Painting as Model* (Cambridge, MA: MIT Press, 1993), 236–37.

37. Duchamp letter to Walter Pach, April 27, 1915, in Naumann, *AMSC*, 37.

38. Éva's letter of June 23, 1914, quoted in Daix, *PLA*, 138.

39. Guillaume Apollinaire, *Calligrammes: Poems of Peace and War (1913–1916)* (Berkeley: University of California Press, 2004), 111.

40. Duchamp letter to Walter Pach, April 27, 1915, in Naumann, *AMSC*, 36–37.

41. Pach letter to John Quinn, April 15, 1915. Quoted in Marquis, *MDBSB*, 108.

42. Pach letter to John Quinn, October 10, 1915. Quoted in d'Harnoncourt, *MD73*, 43. This letter is often cited to prove that Duchamp was anti-commercial: "He has always made his living at other employment and while neither he or I have any idea that he would grow commercial if he were to rely on his art for a livelihood he would not have the sense of independence he has had thus far,—and it has been of great importance to him."

8. the return to order

1. Picasso letter to Gertrude Stein, December 9, 1915. Quoted in Richardson, *LP2*, 375.

2. After the war was over, the confiscated Picasso paintings were auctioned off by the French government, putting the works in the hands of new dealers (and even back into Kahnweiler's hands), and from there they entered the art market once again.

3. The three women Picasso pursued were Gabrielle "Gaby" Depeyre, a twenty-seven-year-old cabaret singer and dancer; the Paris fashion model Emilienne Pâquerette; and the Montparnasse model Irene Lagut.

4. Picasso probably had a tryst with Helen Férat, in addition to his rendezvous with Serge's mistress, Irene (who refused Picasso's marriage intentions along with Gaby; see n. 3 above).

5. Cocteau quoted in Richardson, *LP2*, 380.

6. Gertrude Stein, *The Autobiography of Alice B. Toklas* (New York: Vintage Books, 1961 [1933]), 172; Satie letter to Valentine Gross, February 15, 1917. Quoted in Richardson, *LP2*, 431.

7. French wartime views of Cubism swung from the sublime to the absurd. The German maker of bullion cubes had posted billboards with the trademark "KUB" around France before the war, and some French saw them as German propaganda or code. (Years earlier, Picasso and Braque had put "KUB" in some of their paintings as an element of humor.) On the other hand, not a few of the Cubist painters were recruited by the French army to design camouflage, a new innovation in warfare. Of the camouflage-painted armaments, Picasso said, "We're the ones who did that." Quoted in Stein, *The Autobiography of Alice B. Toklas*, 23.

8. Daix, *PLA*, 170.

9. Picasso did some comical drawings of Apollinaire as a soldier, and during his *papier collé* period included several newspaper headlines about the Balkan conflict. He once did a pipe-smoking soldier, but painted over it in 1915. See Richardson, *LP2*, 405.

10. Cocteau quoted in Richardson, *LP2*, 389.

11. See Richardson, *LP2*, 388–90, 420–21.

12. Picasso quoted in Richard Buckle, *Diaghilev* (London: Hamish Hamilton, 1979), 321.

13. Cocteau letter to Valentine Gross, September 4, 1916. Quoted in Richardson, *LP2*, 419.

14. Satie letter to Valentine Gross, September 14, 1916. Quoted in Richardson, *LP2*, 419.

15. Leonide Massine, *My Life in Ballet* (London: Macmillan, 1968), 108.

16. Picasso quoted in Daix, *PLA*, 155.

17. Quoted in Daix, *PLA*, 156.

18. Mark Polizzotti, *Revolution of the Mind: The Life of André Breton*, rev. and updated (Boston: Black Widow Press, 2009 [2005]), 53–54.

19. See Jerrold Seigel, *Bohemian Paris: Culture, Politics, and the Boundaries of Bourgeois Life, 1830–1930* (Baltimore: Johns Hopkins University Press, 1999), 359–65.

20. Picasso worked with Diaghilev on four other productions: *Le Tricorne* (June 1919, London), *Pulcinella* (May 1920, Paris), *Cuadro Flamenco* (May 1921, Paris), and *Le Train Bleu* (June 1924, Paris). He also did scenery, costumes, or curtains for three more by other producers in Paris (*Antigone*, 1922; *Mercure*, 1924; and *Le Rendez-Vous*, 1945). See "Theater Productions in which Picasso has collaborated," in Alfred H. Barr, Jr., *Picasso: Fifty Years of his Art* (New York: Museum of Modern Art, 1946), 275.

21. See Mark Antliff and Patricia Leighten, *Cubism and Culture* (New York: Thames and Hudson, 2001), 111–18.

22. Reviewer quoted in Daix, *PLA*, 170.

23. Derain quoted in Daix, *PLA*, 170.

24. Poet and critic Blaise Cedrars quoted in Daix, *PLA*, 170.

25. Guillaume Apollinaire, *Calligrammes: Poems of Peace and War (1913–1916)* (Berkeley: University of California Press, 2004), 345.

26. Apollinaire quoted in Daix, *PLA*, 161–62. The letter is dated August 22, 1918.

27. Daniel-Henry Kahnweiler, *The Rise of Cubism* (New York: Wittenborn, Schultz, 1949 [1920]). Kahnweiler borrowed these terms (analytic and synthetic) from the philosophy of Emanuel Kant. For a history of theoretical interpretation of Cubism, see David Cottington, *Cubism and Its Histories* (Manchester, UK: Manchester University Press, 2004), 165–240.

28. Quoted in Jack Flam, *Matisse and Picasso: The Story of Their Rivalry and Friendship* (Cambridge, MA: Westview Press, 2003), 114.

29. Picasso quoted in Daix, *PLA*, 174.

30. Flam, *Matisse and Picasso*, 125.

9. a parisian in america

1. "The Nude-Descending-a-Staircase Man Surveys Us," *New York Tribune*, September 12, 1915.

2. Mabel Dodge Luhan, *Intimate Memories: The Autobiography of Mabel Dodge*, abridged (Santa Fe, NM: Sunstone Press, 2008 [1999]), 124.

3. For the story of the three salons—Stieglitz, Dodge, and Arensberg—see Robert M. Crunden, *American Salons: Encounters With European Modernism 1885–1917* (New York: Oxford University Press, 1993).

4. Gabrielle Buffet-Picabia, "Some Memories of Pre-Dada: Picabia and Duchamp," in *DPP*, 260.

5. Buffet-Picabia, "Some Memories," in *DPP*, 259.

6. Arensberg believed that great works of literature were coded with secret messages. He wrote and self-published two books on the secret codes that Dante and "Shakespeare" left behind in their greatest works: *The Cryptography of Dante* (1921) and *The Cryptography of Shakespeare* (1922). At his death, Arensberg left behind a research foundation dedicated to showing that "Shakespeare" was actually the pen name of the English polymath and statesman Francis Bacon.

7. Crunden, *American Salons*, 418–23. See also Man Ray, *Self-Portrait* (Boston: Atlantic-Little, Brown, 1963).

8. Duchamp letters to John Quinn, November 5 and 12, 1915. Quoted in Marquis, *MDBSB*, 116.

9. Ray, *Self-Portrait*, 82.

10. Duchamp quoted in Frederick Macmonnies, "French Artists Spur on an American Art," *New York Tribune*, October 24, 1915; 203.

11. Undated letter from Duchamp to John Quinn, received January 27, 1916. Quoted in Marquis, *MDBSB*, 120.

12. Duchamp quoted in Cabanne, *DMD*, 61.

13. Susan Grace Galassi, "Crusader for Modernism," *Art News*, September 1984, 93. As a flip side to Dreier's idealism, her Theosophy and belief in art collectives and the spirituality of Russian abstraction (and her own German heritage) made her naive about Stalinism in Russia and Nazism in Germany. See "Introduction," *The Société Anonyme and the Dreier Bequest at Yale University* (New Haven, CT: Yale University Art Gallery, 1984), 17, 19–20.

14. Picabia quoted in Macmonnies, "French Artists Spur on an American Art," 203.

15. For the emphasis on word-objects in poetry see the treatment of Pound, Stein, and Williams in Crunden, *American Salons*. For poetry as "free verse" and "imagist" (which is how Duchamp defined Arensberg's object-oriented poetry), and "little magazines," see Steven Watson, *Strange Bedfellows: The First American Avant-Garde* (New York: Abbeville Press, 1991), 188–204, 282–311. Pound quoted in Watson, 194.

16. "A Complete Reversal of Art Opinion by Marcel Duchamp, Iconoclast," *Arts and Decoration*, September 1915, 12.

17. Buffet-Picabia, "Some Memories," in *DPP*, 258, 257.

18. Beatrice Wood, *I Shock Myself* (San Francisco, Chronicle Books, 1988 [1985]).

19. Duchamp letter to Suzanne, January 15, 1916, in Naumann, *AMSC*, 44.

20. Unpublished Duchamp interview with George and Richard Hamilton for BBC series, "Art, Anti-Art," November 1959. Quoted in Tomkins, *DB*, 405.

21. On the Montross and Bourgeois mystery, see Thierry de Duve, *Kant After Duchamp* (Cambridge, MA: MIT Press, 1996), 102 n. 22.

22. *Evening World*, April 4, 1916. The complete "Big, Shiny Shovel" article is quoted in Rudolf E. Kuenzli, ed., *New York Dada* (New York: Willis Locker & Owens, 1986), 135–37. Duchamp and Crotti mainly bragged about amorous Paris.

23. See William A. Camfield, *Marcel Duchamp/Fountain* (Houston, TX: Menil Collection, Houston Fine Arts Press, 1989); William A. Camfield, "Marcel Duchamp's *Fountain*: Its History and Aesthetics in the Context of 1917," *Dada/Surrealism* 16 (1987): 65–94; Francis M. Naumann, "The Big Show: The First Exhibition of the Society of Independent Artists," I and II, two articles in *Artforum*, February 6 and April 8, 1979.

24. Quoted in de Duve, *Kant After Duchamp*, 128.

25. Cézanne quoted in Wayne Andersen, *Marcel Duchamp: The Failed Messiah*, 2nd printing (Geneva, Éditions Fabriart, 2001), 97.

26. Ira Glackens, *William Glackens and the Ashcan Group* (New York: Grosset and Dunlap, 1957), 187–89.

27. Quoted in Francis Naumann, ed., "I Shock Myself: Excerpts from the Autobiography of Beatrice Wood," *Arts Magazine* 51 (May 1977): 135–36. I have truncated this text a bit. Wood gives a slightly different version in Beatrice Wood, "Marcel," in *Marcel Duchamp: Artist of the Century*, ed. Rudolf E. Kuenzli and Francis M. Naumann (Cambridge, MA: MIT Press, 1990), 14. There is a third slightly different version in her biography, Beatrice Wood, *I Shock Myself* (San Francisco, Chronicle Books, 1988 [1985]), 29–30.

28. Duchamp letter to Suzanne Duchamp April 11, 1917, in Naumann, *AMSC*, 47.

29. Louise Norton, "Buddha of the Bathroom," in Masheck, *MDP*, 71. From *The Blind Man*, May 1917.

30. Dreier letter quoted in William A. Camfield, "Marcel Duchamp's *Fountain*," 73.

31. Quoted in Marquis, *MDBSB*, 135.

32. "The Richard Mutt Case," *The Blind Man*, May 1917, in *Art in Theory 1900–2000: An Anthology of Changing Ideas* new ed., ed. Charles Harrison and Paul J. Wood (Malden, MA: Wiley-Blackwell, 2003), 252. Unsigned text written by Duchamp.

33. Marcel Duchamp, "The Green Box," *SS*, 39.

34. Duchamp quoted in Cabanne, *DMD*, 38.

35. Duchamp, "The Green Box," *SS*, 42.

36. Ibid., 39.

37. Scholars have said Duchamp used "allegory" in *The Large Glass*, a term Duchamp also used in his notes. One obvious allegorical source for his "apotheosis of virginity" was the "adoration of the Virgin Mary" in European painting. He may have seen Cézanne's parody of the adoration, *The Eternal Feminine* (1876–78), which showed men gazing at a voluptuous female. See Wayne Andersen, *Cézanne and the Eternal Feminine* (Cambridge, UK: Cambridge University Press, 2004). Duchamp said he got the bride-and-bachelors idea from a game booth at the Neuilly Fair: fairgoers threw

wooden balls to try to knock down dolls; a central bride doll surrounded by bachelor dolls, all in work uniforms. When it came to an allegory for the bachelors, France at this time had Europe's lowest birthrate. The number of single males skyrocketed, so promiscuous (and adulterous) bachelors were the butt of cabaret jokes. See Jeffrey Weiss, *The Popular Culture of Modern Art: Picasso, Duchamp, and Avant-Gardism* (New Haven, CT: Yale University Press, 1994), 141.

38. Duchamp, "The Green Box," *SS*, 56, 68.

39. Ibid., 78.

40. Ibid., 30.

41. Ray, *Self-Portrait*, 82.

42. Duchamp quoted in Calvin Tomkins, *The Bride and the Bachelors: Five Masters of the Avant-Garde* (New York: Viking, 1965), 38. For a chronology of Duchamp's work on *The Large Glass*, see Schwarz, *CWMD*, 144–46.

43. Duchamp quoted in Hans Richter, *Dada: Art and Anti-Art* (New York: McGraw-Hill, 1977), 208.

44. Duchamp quoted in Cabanne, *DMD*, 59.

45. Dreier letter quoted in Camfield, "Marcel Duchamp's *Fountain*," 74.

46. Duchamp letter to the Stettheimer sisters, August 24, 1919. Quoted in Tomkins, *DB*, 207; Duchamp letter to Walter Arensberg, August 26, 1918, in Naumann, *AMSC*, 62.

47. Duchamp letter to Walter Arensberg, November 8, 1918, in Naumann, *AMSC*, 65.

48. Duchamp letter to Ettie Stettheimer, November 12, 1918, in Naumann, *AMSC*, 68.

49. Duchamp letter to the Stettheimer sisters, May 3, 1919, in Naumann, *AMSC*, 82. See also Arturo Schwarz, "Precision Play—An Aspect of the Beauty of Precision," in Schwarz, *CWMD*, 58.

50. Duchamp letter to Walter Arensberg, June 15, 1919. Quoted in "Marcel Duchamp's Letters to Walter and Louise Arensberg, 1917–1921," trans. Francis M. Naumann, in Kuenzli and Naumann, *Marcel Duchamp: Artist of the Century*, 218–19.

51. Dreier had arrived to visit relatives in Germany. She also wanted to start buying lots of art. Duchamp met her at Rotterdam, and he and Henri-Pierre Roché showed her around the galleries of Paris. As the "introducer," Roché even took the heavyset Dreier to meet the famous, and equally heavyset, Gertrude Stein. Roché called the encounter a "shock of two heavy masses," with Stein dominating. Duchamp also took Dreier to Rouen to meet his parents, and then too Puteaux. In the many Parisian settings, Roché noted, Dreier kept taking Duchamp's arm, and he awkwardly disengaged. See *Journals of Henri-Pierre Roché*, November 28, 1919, quoted in Tomkins, *DB*, 219.

52. During the war, Braque, Léger, Derain, Metzinger, Apollinaire, and the older Duchamp brothers had served. Picasso, Gleizes, Delaunay, Picabia, and Duchamp found safe havens.

53. Tristan Tzara, "Dada Manifesto 1918," in *DPP*, 78, 81.

54. Quoted in Mark Polizzotti, *Revolution of the Mind: The Life of André Breton*, rev. and updated (Boston: Black Widow Press, 2009 [2005]), 102.

10. surrealist bridges

1. Quoted in Jack Flam, *Matisse and Picasso: The Story of Their Rivalry and Friendship* (Cambridge, MA: Westview Press, 2003), 114, 118.

2. Tzara quoted in Tomkins, *DB*, 216. From *Dada3*, 1918, the third issue of Tzara's publication.

3. Breton quoted in Mark Polizzotti, *Revolution of the Mind: The Life of André Breton*, rev. and updated (Boston: Black Widow Press, 2009 [2005]), 35.

4. Breton quoted in Motherwell, *DPP*, xxxiii.

5. Polizzotti, *Revolution of the Mind*, 86.

6. At this 1920 exhibition, the salon Cubists included Braque, Léger, Gris, Gleizes, Metzinger, Villon, Marcoussis, Lhote, Herbin, and Férat. Léger's highly Cubist-mechanistic *The City*, a very large canvas, was hailed as proof of a Cubist rejuvenation.

7. Gide quoted in Wayne Andrews, *The Surrealist Parade* (New York: New Directions, 1990), 40.

8. Recital quoted in Georges Ribemont-Dessaignes, "History of Dada (1931)," in *DPP*, 109.

9. See "Introduction," *The Société Anonyme and the Dreier Bequest at Yale University* (New Haven, CT: Yale University Art Gallery, 1984).

10. Full article quoted in Rudolf E. Kuenzli, ed. *New York Dada* (New York: Willis Locker and Owens, 1986), 139.

11. Quoted in Kuenzli, *New York Dada*, 140.

12. All quotes from Kuenzli, *New York Dada*, 141, 140.

13. Ray quoted in Neil Baldwin, *Man Ray: American Artist* second ed. (New York: Da Capo, 2000), 73–74. On the life of Greenwich Village before "New York Dada," see Steven Watson, *Strange Bedfellows: The First American Avant-Garde* (New York: Abbeville Press, 1991). In Kuenzli, *New York Dada*, the editors note: "The problem of defining New York Dada is a serious one" (164).

14. See Anthony Blunt and Phoebe Pool, *Picasso: The Formative Years* (London: Studio Books, 1962), 14.

15. Duchamp letter to Florine Stettheimer, September 1, 1921, in Naumann, *AMSC*, 101.

16. Duchamp letter to Ettie Stettheimer, July 6, 1921, in Naumann, *AMSC*, 99–100.

17. Man Ray, *Self-Portrait* (Boston: Atlantic-Little, Brown, 1963), 108.

18. See Herbert R. Lottman, *Man Ray's Montparnasse* (New York: Abrams, 2001).

19. André Breton, "Marcel Duchamp," in *DPP*, 209, 210.

20. André Breton, "Marcel Duchamp," in *DPP*, 211; Breton quoted from *Littérature*, October and December 1922, in Jennifer Gough-Cooper and Jacques Caumont. "Ephemerides on and about Marcel Duchamp and Rrose Sélavy," in *Marcel Duchamp*, ed. Pontus Hultén (Cambridge, MA: MIT Press, 1993). See "October 1, 1922" and "December 1, 1922."

21. Duchamp quoted in Tomkins, *DB*, 250.

22. Duchamp letter to Jean Crotti, July 8, 1918, in Naumann, *AMSC*, 56.

23. Duchamp letter to Francis Picabia, November 1922, in Michel Sanouillet, *Dada in Paris* rev. ed. (Cambridge, MA: MIT Press, 2009), 482.

24. Duchamp letter to Jacques Doucet quoted in Arturo Schwarz, "Precision Play —An Aspect of the Beauty of Precision," in Schwarz, *CWMD*, 59. *Les Femmes savantes* (*The Learned Ladies*) is a comic play by Molière; it hinged on the story of three "learned" ladies who overly admired a so-called scholar as the celebrity of their salon.

25. Breton quoted in Polizzotti, *Revolution of the Mind*, 368.

26. Freud quoted in Polizzotti, *Revolution of the Mind*, 420. Freud also wrote to Breton, saying, "I am not able to clarify for myself what Surrealism is and what it wants. Perhaps I am not destined to understand it, I who am so distant from art" (348).

27. Breton quoted in Daix, *PLA*, 179.

28. John Richardson, *A Life of Picasso: The Triumphant Years, 1917–32*, vol. 3 (New York: Knopf, 2008), 231.

29. Ray quoted in Arturo Schwarz, *New York Dada: Duchamp, Man Ray, Picabia* (Munich and New York: Prestel-Verlag, 1974), 97.

30. Duchamp letter to Jacques Doucet, September 22, 1924, in Naumann, *AMSC*, 146.

31. Duchamp letter to Jacques Doucet, October 19, 1925, in Naumann, *AMSC*, 152.

32. Duchamp letter to Jacques Doucet, January 16, 1925, in Naumann, *AMSC*, 149.

33. Anaïs Nin, *The Diary of Anaïs Nin* (New York: Swallow Press, 1969), 356. See Reynolds's entire story in Susan Glover Godlewski, "Warm Ashes: The Life and Career of Mary Reynolds," *Museum Studies* 22 (1996), 103ff.

34. Dreier letters to Marcel Duchamp quoted in Ruth Louise Bohan, "The Société Anonyme's Brooklyn Exhibition, 1926–1927: Katherine Sophie Dreier and the Promotion of Modern Art in America" (doctoral dissertation, University of Maryland, 1980), 104, 103.

35. Duchamp letter to Katherine Dreier, July 3, 1926. Quoted in Bohan, "The Société Anonyme's Brooklyn Exhibition," 117.

36. Dreier quoted in Bohan, "The Société Anonyme's Brooklyn Exhibition," 117.

37. Bohan, "The Société Anonyme's Brooklyn Exhibition," 127.

38. After his death in 1924, John Quinn's collection of more than 2,500 paintings, drawings, prints, and sculptures was dispersed by private sales and auctions. It was the most significant US collection of modern art before 1930. Walter Pach and Henri-Pierre Roché were his key advisors. He decided to sell it piecemeal for his family's benefit, and did not think American institutions would appreciate it as a bequest. See Judith Zilcher, "The Dispersal of the John Quinn Collection," *Archives of American Art Journal* 39 (1990): 35–40.

39. Julien Levy, *Memoir of An Art Gallery* (New York: G. P. Putnam's Sons, 1977), 20.

40. Duchamp letter to Katherine Dreier, June 27, 1927. Quoted in Marquis, *MDBSB*, 201.

41. Man Ray, *Self-Portrait* (Boston: Atlantic-Little, Brown, 1963), 237.

42. Reynolds quoted in Godlewski, "Warm Ashes." 103–04; and commenting to Roché, in Tomkins, *DB*, 258.

43. H. P. Roché, "Souvenirs of Marcel Duchamp," in Lebel, *MD*, 79.

11. europe's chessboards

1. Duchamp letter to Francis Picabia, February 8, 1921, in Michel Sanouillet, *Dada in Paris* rev. ed. (Cambridge, MA: MIT Press, 2009), 204.

2. André Breton, "Marcel Duchamp," in *DPP*, 210–11; *Little Review* quoted in Marquis, *MDBSB*, 203. Actually, despite such reports, Duchamp never gave up making things, and later in life he often protested the statement that he had "given up" art for chess.

3. Chess player François Le Lionnais (who knew the Dada founders) quoted in Ralph Rumney, "Marcel Duchamp as a Chess Player and One or Two Related Items," *Studio International* (January/February 1975): 24. Alternatively, Raymond Keene argues that Duchamp followed the non-conformist grandmaster Aron Nimzowitsch, and that Duchamp did indeed see chess as a "gray matter" battle, not a visual aesthetic. See Raymond Keene, "Marcel Duchamp: The Chess Mind," in *Duchamp: passim*, ed. Anthony Hill (Langhorne, PA: Gordon and Breach Arts International, 1994), 122–23.

4. Arturo Schwarz, "Precision Play — An Aspect of the Beauty of Precision," in *CWMD*, 58.

5. Lasker quoted in Calvin Tomkins, *The Bride and the Bachelors: Five Masters of the Avant-Garde* (New York: Viking, 1965), 51.

6. Duchamp quoted in Tomkins, *DB*, 289. Duchamp said he eventually concluded that his chess ambition was "hopeless, that there was no use in trying," as quoted in Schwarz, "Precision Play," in *CWMD*, 59. Duchamp was a strong player, said Edward Lasker, but probably no match for world chess: "He would always take risks in order to play a beautiful game, rather than be cautious and brutal to win." Lasker quoted in d'Harnoncourt, *MD73*, 131. Duchamp did become the undefeated "champion" of the four-year International Correspondence Chess Federation tournament he managed beginning in 1935.

7. Quoted in Schwarz, "Precision Play," in *CWMD*, 70. Cleve Gray recalls Duchamp saying to him, "When you play a game of chess it is as if you were sketching something, or as if you were constructing the mechanism by which you would win or lose. The competition part of the business has no importance . . . ," but alternatively Duchamp saying this to Hans Richter, "Hans, You will never be a good player because you are not competitive enough. You have to want to crush your opponent, to *kill* him!" See Cleve Gray, "Marcel Duchamp: 1887–1968," *Art in America*, July 1969, 21–22.

8. Quoted in Schwarz, "Precision Play," in *CWMD*, 69. Linking chess to art, Duchamp said chess moves are like "a pen-and-ink drawing," or that chess moves "express their beauty *abstractly*, like a poem." Quoted in Schwarz, "Precision Play," in *CWMD*, 68. Neither idea, however, was particularly profound in terms of chess, art, poetry, or aesthetics. Duchamp wrote the 1932 chess book, *Opposition and Sister Squares are Reconciled*, with French-Russian player Vitaly Halberstadt to analyze a rare end game when only two kings remain.

9. In general Duchamp's "strengths" in character have been summarized as the ability to escape conflicts, to say "yes" to what people requested, his slowness to anger

(if ever), his emotional indifference to women, his patience and acclimation to solitude, and his clerical skills. He made no serious enemies.

10. Duchamp quoted in the *New York Tribune*, September 12, 1915, cited in Tomkins, *DB*, 151; Duchamp's 1952 speech to the chess association in Schwarz, "Precision Play," in *CWMD*, 67.

11. Duchamp quoted in Marquis, *MDBSB*, 188, 189.

12. Man Ray, "Bilingual Biography," *View*, March 1945. This is a series of brief recollections by Ray about Duchamp.

13. Duchamp letter to Katherine Dreier, January 1, 1936. Quoted in Marquis, *MDBSB*, 226.

14. Duchamp letter to Katherine Dreier, September 6, 1935. Quoted in Marquis, *MDBSB*, 226.

15. Duchamp letter to Katherine Dreier, December 7, 1935. Quoted in Marquis, *MDBSB*, 226.

16. Kahnweiler quoted in Daix, *PLA*, 211.

17. For Jung's essay see Patrick O'Brian, *Pablo Ruiz Picasso: A Biography* (New York: W.W. Norton, 1994 [1976]), 488–92.

18. Blanche quoted in Daix, *PLA*, 223.

19. Picasso quoted in Daix, *PLA*, 227.

20. Duchamp letter to Katherine Dreier, July 3, 1926. Quoted in Ruth Louise Bohan, "The Société Anonyme's Brooklyn Exhibition, 1926–1927: Katherine Sophie Dreier and the Promotion of Modern Art in America" (doctoral dissertation, University of Maryland, 1980), 117.

21. Duchamp quoted in *SS*, 127; and Cabanne, *DMD*, 75.

22. Duchamp quoted in Katherine Kuh, *The Artist's Voice: Talks with Seventeen Modern Artists* (Cambridge, MA: Da Capo Press, 2000 [1962]), 83.

23. Duchamp was uncertain about his exact note selection: before he picked the ninety-four he wrote to Arensberg (February 20, 1934) about looking over "approximately 135 notes and a dozen photographs." See Linda Dalrymple Henderson, *Duchamp in Context: Science and Technology in the Large Glass and Related Works* (Princeton: Princeton University Press, 1998), 267n31.

24. "Lo, Marcel Duchamp Himself Descends the Stair," *New York Times*, June 30, 1935, X6.

25. Duchamp letter to Katherine Dreier, March 5, 1934. Quoted in Marquis, *MDBSB*, 220. Twenty boxes would be "deluxe editions" (these would have a bonus item and be shipped in the actual "valise," or small suitcase, which did not come with the standard versions).

26. Most of the replication of items in *The Green Box* involved easy photographing or color printing, although Duchamp had to hire masons, sewers, and woodworkers to make the tiny urinals, typewriter covers, *Three Standard Stoppages*, and glass vials.

27. Albert Gleizes, "The Dada Case (1920)," in *DPP*, 301.

28. André Breton, "Lighthouse of the Bride," in Lebel, *MD*, 89, 94.

29. On Duchamp's motive for repairing *The Large Glass*, see "Introduction," *The Société Anonyme and the Dreier Bequest at Yale University* (New Haven, CT: Yale Uni-

versity Art Gallery, 1984), 18. The head of the Chicago Art Club was Alice Roullier, half French by birth, who in the 1920s had met Duchamp on her annual trips to Paris. When she put on the Brancusi show in 1926, Duchamp had arrived as the curator.

30. C. J. Bulliet, *Chicago Daily News*, February 5, 1937.

31. The episode, and Duchamp's advice, in "Introduction," *The Société Anonyme*, 18.

32. Barr letter to Marcel Duchamp, May 8, 1936. Quoted in Tomkins, *DB*, 309. This appeal was for the December 1936 MOMA exhibit, "Fantastic Art, Dada, Surrealism." Eventually, MOMA obtained eight Duchamp works. Often a single MOMA room is dedicated to their display.

33. Duchamp quoted in "Restoring 1,000 Glass Bits in Parcels; Marcel Duchamp, Altho an Iconoclast, Recreates Work," *Literary Digest*, June 20, 1936, 20.

34. Bataille quoted in Daix, *PLA*, 243.

35. Sabartés quoted in Daix, *PLA*, 238.

36. Penrose quoted in Daix, *PLA*, 247.

37. Picasso quoted in Ashton, POA, 143.

38. Spain's "political Left" quoted in Daix, *PLA*, 251–52.

39. André Breton, "Manifesto of Surrealism (1929)," in André Breton, *Manifestos of Surrealism*, ed. and trans. R. Seaver and H. R. Lande (Ann Arbor: University of Michigan Press, 1969), 14, 18.

40. Headlines quoted in Mark Polizzotti, *Revolution of the Mind: The Life of André Breton*, rev. and updated (Boston: Black Widow Press, 2009 [2005]), 406.

41. Peggy Guggenheim, *Out of This Century: Confessions of an Art Addict* (New York: Macmillan, 1960), 50.

42. Peggy Guggenheim was the daughter of one of the Guggenheim brothers, Benjamin, who died on the Titanic in 1912. She inherited $450,000, not a great fortune, but considerable at the time. Her uncle, Solomon, founded the Museum of Non-Objective Painting in 1939 in New York and later built the Guggenheim Museum, designed by Frank Lloyd Wright and opened in 1959.

43. Guggenheim, *Out of This Century*, 47.

44. Éluard quoted in Daix, *PLA*, 257.

45. Picasso quoted in Daix, *PLA*, 261–62.

46. Matisse letter to his son in September 1940 quoted in Daix, *PLA*, 262.

47. Duchamp letter to Katherine Dreier, September 26, 1939. Quoted in Marquis, *MDBSB*, 233.

48. Arensberg cable to Marcel Duchamp, June 20, 1940. Quoted in Marquis, *MDBSB*, 233.

49. Arensberg letter to Marcel Duchamp, August 22, 1940. Quoted in Marquis, *MDBSB*, 234.

50. Roché quoted in Lebel, *MD*, 84.

51. Duchamp quoted on his trip in "Artist Descending to America," *Time*, September 7, 1942; 100, 102.

12. flight of the avant-garde

1. Picasso quoted in Daix, *PAL*, 267.

2. See Michèle C. Cone, *Artists Under Vichy: A Case of Prejudice and Persecution* (Princeton, NJ: Princeton University Press, 1992); Julian Jackson, *France: The Dark Years, 1940–1944* (Oxford University Press, 2003), the chapter "Intellectuals, Artists, Entertainers," 300–326.

3. Picasso paraphrased in Ashton, *POA*, 148. He also said directly: "A more disciplined art, less unconstrained freedom, in a time like this is the artist's defense and guard."

4. Quoted in Daix, *PLA*, 279.

5. Picasso quoted in Daix, *PLA*, 277. Picasso made his full statement to the American communist magazine, *New Masses*, and this was reprinted in *Humanité*.

6. Peggy Guggenheim's Art of This Century gallery, which opened October 20, 1942, closed in 1947. After that, she moved to a villa in Venice and installed her collection there. The Venice collection was merged with the larger Guggenheim museum system in the 1970s.

7. Frederick J. Kiesler, "Design-Correlation," *Architectural Record*, May 1937, 53–59.

8. Edward Alden Jewell, "Surrealists Open Display Tonight," *New York Times*, October 14, 1942; 26.

9. George Heard Hamilton, "In Advance of Whose Broken Arm?" in *MDP*, 74.

10. Marcel Duchamp, "Pablo Picasso: Painter, Sculptor, Graphic Artist, Writer," *SS*, 157. Duchamp wrote twenty-nine of the 170 entries in the Société catalog, mostly of people he knew in Paris from the Cubist years before WWI. Dreier wrote the lengthy entry on Duchamp himself. See Yale University Art Gallery, *Collection of the Société Anonyme: Museum of Modern Art 1920* (New Haven, CT: Associates in Fine Arts at Yale University, 1950).

11. See Francis M. Naumann, *Marcel Duchamp: The Art of Making Art in the Age of Mechanical Reproduction* (Ghent: Ludion, 1999), 286. Duchamp said in conversation with Jasper Johns: "I like Picasso . . . except when he repeats himself." Also, *Time* magazine summarized in 1949 that Duchamp said Picasso "long ago ran out of ideas." See "Be Shocking," *Time*, October 31, 1949, 42.

12. Hamilton, "In Advance of Whose Broken Arm?" in *MDP*, 74.

13. "Irascible Group of Advanced Artists Led Fight Against Show," *Life*, January 15, 1951; 34.

14. Tomkins, *DB*, 362.

15. "Art Was a Dream," *Newsweek*, November 9, 1959, 118–19; Duchamp letter to Yvonne Lyon, January 8, 1949. Quoted in Tomkins, *DB*, 367.

16. Marcel Duchamp, "The Great Trouble with Art in this Country," *SS*, 123; Duchamp quoted in "Interview by Dorothy Norman," *Art in America*, July 1969, 38.

17. See "Marcel Duchamp," *Wisdom: Conversations with Wise Men of Our Day*, ed. James Nelson (New York: Norton, 1958), 89–99.

18. Sidney Janis quoted in Tomkins, *DB*, 378.

19. Harriet and Sidney Janis, "Introduction, Anti-Artist," *View* 5 (March 1945). Reprinted in Masheck, *MDP*, 27–40.

20. Martins quoted in Taylor, *MDED*, 26.

21. Duchamp quoted in Taylor, *MDED*, 31.

22. For the history and process of Duchamp's diorama project see Michael Taylor, *Marcel Duchamp: Étant donnés* (Philadelphia: Philadelphia Museum of Art, 2009).

23. Duchamp quoted in Taylor, *MDED*, 31.

24. Winthrop Sargeant, "Dada's Daddy," *Life*, April 28, 1952, 108, 111.

25. Duchamp quoted in Alexander Liberman, *The Artist in His Studio* (London: Thames and Hudson, 1969 [1960]), 207.

26. Duchamp quoted in Sargeant, "Dada's Daddy," 108; Duchamp letter to Katherine Dreier, June 16, 1944. Quoted in Marquis, *MDBSB*, 246.

27. Duchamp letter to Katherine Dreier, November 4, 1942. Quoted in Marquis, *MDBSB*, 243.

28. Duchamp quoted in Liberman, *The Artist in His Studio*, 207.

29. Duchamp quoted in Cabanne, *DMD*, 58.

30. Maria did a multi-spiked, dangerous-looking sculpture titled *Impossible*, probably an ode to her relationship with Duchamp. They were very different. See Taylor, *MDED*, 29–30.

31. Duchamp letters to Maria Martins, June 6, 1949; March 19, 1950; October 25, 1951. Quoted in Michael Taylor, *MDED*, 31, 32.

32. As Breton biographer Mark Polizzotti points out, the "accounts vary widely" on the argument at which Breton and Picasso ended their twenty-five-year friendship. I have used what Polizzotti considers the more ideological and colorful account from Françoise Gilot's 1964 memoir, *Life with Picasso*. Polizzotti offers another account in which Breton and Picasso leave on friendlier terms and do not dispute politics. See Mark Polizzotti, *Revolution of the Mind: The Life of André Breton*, rev. and updated (Boston: Black Widow Press, 2009 [2005]), 494.

33. Picasso quoted in Françoise Gilot with Carlton Lake, *Life with Picasso* (New York: McGraw-Hill, 1964), 137–38.

34. Janet Flanner, *Paris Journal 1944–1965* vol. 1 (New York: Atheneum, 1965), 79–80.

35. Gerasimov's statement was made in an August 11, 1947, article in *Pravda*, "The Russian Painters and the School of Paris." Quoted in Daix, *PLA*, 299.

36. The congress quoted in Daix, *PLA*, 283.

37. Garaudy quoted in Daix, *PLA*, 295. For this complex story about European communism, the Cold War, and modern art, see Gertje Utley, *Picasso: the Communist Years* (New Haven, CT: Yale University Press, 2000); David Caute, *The Dancer Defects: The Struggle for Cultural Supremacy During the Cold War* (New York: Oxford University Press, 2005), the chapter "Picasso and Communist Art in France," 568–88; and Serge Guilbaut, *How New York Stole the Idea of Modern Art: Abstract Expressionism, Freedom, and the Cold War* (Chicago: University of Chicago Press, 1983).

38. French Communist Party quoted in Daix, *PLA*, 309.

39. Picasso quoted in Daix, *PLA*, 285.

40. Duchamp quoted in Marquis, *MDBSB*, 259.

41. Duchamp letter to Arensberg, September 7, 1950. Quoted in Tomkins, *DB*, 376.

42. As a trustee of the Chicago Art Institute, Hubachek bequeathed Mary's records and memorabilia about the Paris art world to the institute's Reyerson Library. To provide Duchamp a lifelong stipend, he set up a $250,000 family trust that would, before reverting to Hubachek's two children, generate an annual interest payment of $6,000 to Duchamp, providing "a sort of minimum living for him." Hubachek quoted in Marquis, *MDBSB*, 259. Duchamp said the money would "allow me to live in my free way, although not quite orthodox, yet consistent." Duchamp letter to Hubachek, January 23, 1962. Quoted in Marquis, *MDBSB*, 259.

43. Arensberg quoted in Mary Roberts and George Roberts, *Triumph on Fairmount: Fiske Kimball and the Philadelphia Museum of Art* (New York: Lippincott, 1959), 256.

44. The four-session "Western Round Table on Modern Art," held at the San Francisco Museum of Art (April 8–10, 1949) was perhaps Duchamp's most auspicious academic encounter. During the sessions (one was public) he espoused his theory of the "esthetic echo"—a rare, even elite, ability to understand art held by only a few special people. Other participants were: philosopher George Boas, architect Frank Lloyd Wright, composers Darius Milhaud and Arnold Schoenberg (the latter by statement only), art historians Robert Goldwater and Andrew Richie, artist Mark Tobey, cultural anthropologist Gregory Bateson, literary critic Kenneth Burke, and *San Francisco Chronicle* critic Alfred Frankenstein. See Also Arturo Schwarz, *The Complete Works of Marcel Duchamp* (New York: Abrams, 1969), 504.

45. Duchamp letter to Walter Arensberg, May 8, 1949. Quoted in Marquis, *MDBSB*, 263.

46. Arensberg quoted in Roberts and Roberts, *Triumph on Fairmount*, 274–75.

47. Arensberg letter to Marcel Duchamp, January 11, 1945. Quoted in Tomkins, *DB*, 372.

48. Tomkins, *DB*, 373.

49. Duchamp letter to Walter Arensberg, May 8, 1949. Quoted in Marquis, *MDBSB*, 264.

13. art in revolt

1. Duchamp quoted in "The Great Trouble with Art in this Country," *SS*, 123.

2. The writings of Edgar Allen Poe and Walt Whitman were the most salient examples of the early American "underground," or bohemianism. Such an important founder of Paris modernism as Charles Baudelaire translated Poe and believed that he was the ideal artist. The great countercultural poem of the 1950s "beat" and "funk" artists was Alan Ginsberg's "Howl," an idea that Ginsberg did not derive from Zurich Dadaists (who did, indeed, howl), or Alfred Jarry, but from Whitman's 1855 "barbaric yawp over the roofs of the world" (in Whitman's "Song of Myself" poem). Literary influences from Paris had indeed made their way to America, of course. As early as 1953, the beatniks in San Francisco had opened the "King Ubu Gallery" of art and poetry. In from Paris also came Henry Miller's *The Tropic of Cancer*, a story of 1930s bohemian artist life there, an underground import later to spark a Supreme Court "obscenity" ruling (in 1964 in favor of the book). By then, though, it was Jack Kerouac's 1957

novel *On the Road* that was influencing 1960s artists. For examples of sundry Dada-like movements before the 1950s, see Gina Renee Misiroglu, ed., *American Countercultures: An Encyclopedia of Political, Social, Religious, and Artistic Movements*, 3 vols. (Armonk, NY: Sharpe Reference, 2009).

3. See Irving Sandler, "The Duchamp–Cage Aesthetic," in Irving Sandler, *The New York School: The Painters and Sculptors of the Fifties* (New York: Harper and Row, 1978), 163–73.

4. Winthrop Sargeant, "Dada's Daddy," *Life*, April 28, 1952; 100.

5. Richard Huelsenbeck, *Memoirs of a Dada Drummer* (New York: Viking, 1974), 84. When asked in 1951 about Duchamp's significance, the painter Willem de Kooning described him as "a one-man movement."

6. Robert Motherwell, ed., *The Dada Painters and Poets: An Anthology*, second ed. (Cambridge, MA: Harvard University Press, 1981 [1951]).

7. Hubachek letter to Barbara Burn, a publisher, June 1, 1971. Quoted in Marquis, *MDBSB*, 294.

8. Duchamp quoted in "The Great Trouble with Art in this Country," *SS*, 126.

9. Duchamp, after reading the logical positivists on language, said, "Language is just no damn good." Quoted in Calvin Tomkins, *The Bride and the Bachelors: Five Masters of the Avant-Garde* (New York: Viking, 1965), 31. Also see Duchamp quoted in Tomkins, *DB*, 394: "I do not believe in language."

10. Duchamp was familiar with logical positivism: "Once I became interested in that group of philosophers in England, the ones who argue that all language tends to be tautological and therefore meaningless. I even tried to read that book of theirs on *The Meaning of Meaning*. . . . I agree with their idea that only a sentence . . . has meaning [based] on the fact perceived by the senses." Quoted in Calvin Tomkins, *The Bride and the Bachelors: Five Masters of the Avant-Garde* (New York: Viking, 1965), 31–32.

11. The Swiss linguist Ferdinand de Saussure (1916) presented the case for a common grammatical structure in all language, and the French anthropologist Claude Lévi-Strauss (1958) argued for a common cultural structure. This "structuralism" was challenged by Wittgenstein and by the French "post-structuralists," French writers with Surrealist roots. On the Anglo-American debate on language, see Richard M. Rorty, ed., *The Linguistic Turn: Essays in Philosophical Method* (Chicago: University of Chicago Press, 1992).

12. Kosuth quoted in *Art in Theory 1900–2000: An Anthology of Changing Ideas* new edition., ed. Charles Harrison and Paul J. Wood (Malden, MA: Wiley-Blackwell, 2003), 855–56. Originally published in three parts as Joseph Kosuth, "Art after Philosophy, I," *Studio International* (October to December 1969). See also Michael Archer, *Art Since 1960*, new ed. (New York: Thames and Hudson, 2002), 78–81.

13. Duchamp, "The Green Box, *SS*, 30; Duchamp quoted in Tomkins, *DB*, 15.

14. Marcel Duchamp, "Where Do We Go From Here?" *Studio International* (January/February 1975): 28. A talk given at the Philadelphia Museum College of Art, March 1961.

15. Duchamp quoted in Cabanne, *DMD*, 76.

16. Calvin Tomkins, "Dada and Mama," *New Yorker*, January 15, 1996, 58.

17. Duchamp letter to Walter Arensberg, January 23, 1954. Quoted in Tomkins, *DB*, 389.

18. See Tomkins, *DB*, 439–41.

19. These wedding gifts are a set now called Duchamp's "erotic objects." They are based on plaster and dental wax objects Duchamp fashioned to hold down the wet vellum (as it dried) on his female mannequin, around the crotch. Now considered valuable artworks, the objects are titled: *Wedge of Chastity* (the "wedding ring"); *Female Fig Leaf*; and *Object-Dard*.

20. Alexina Duchamp quoted in Tomkins, *DB*, 400.

21. Ibid.

22. Dieter Daniels, "Marcel Duchamp: The Most Influential Artist of the 20th Century?" in *Marcel Duchamp*, ed. Museum Jean Tinguely Basel (Berlin: Hatje Cantz, 2002), 26.

23. Michel Sanouillet, "Introduction," *SS*, 4.

24. The major exception was Princeton University art history student Lawrence D. Steefel, Jr., probably the first to do a serious analysis of Duchamp's *Passage from the Virgin to the Bride* painting (1912) and *The Large Glass*. He interviewed Duchamp in 1956.

25. Marcel Duchamp letter to Richard Hamilton, November 26, 1960. Quoted in Tomkins, *DB*, 415.

26. Jasper Johns, "The Green Box," Masheck, *MDP*, 110–11.

27. Johns quoted in "From Aunt Gladys to Duchamp," *Artnews*, Summer 2011, 30.

28. Duchamp quoted in Hans Richter, *Dada: Art and Anti-Art* (New York: McGraw-Hill, 1977), 207–8.

29. Duchamp quoted in Rosalind Constable, "New York's Avant-Garde and How It Got There," *Sunday (New York) Herald Tribune Magazine*, May 17, 1964, 10.

30. Duchamp quoted in Dana Adam Schmidt, "London Show Pleases Duchamp and So Do Museum's Patrons," *New York Times*, June 19, 1966, 15; Grace Glueck, "Duchamp Opens Display Today of 'Not Seen and/or Less Seen,'" *New York Times*, January 14, 1965, 45.

31. Picasso quoted in Ashton, *POA*, 154.

32. Castelli quoted in Francis M. Naumann, "Minneapolis: The Legacy of Marcel Duchamp," *Burlington Magazine*, February 1995, 137. Castelli's comment came in a public interview with Robert Rosenblum, New York University School of Continuing Education, Bobst Library, October 19, 1994.

33. Eve Babitz, "I Was a Naked Pawn for Art," *Esquire*, September 1991, 164–66.

34. Exhibit visitor quoted in Rosalind G. Wholden, "Duchamp Retrospective in Pasadena," *Arts*, January 1964, 65.

35. Warhol friend Gerard Malanga quoted in Tony Scherman and David Dalton, *Pop: The Genius of Andy Warhol* (New York: Harper, 2009), 176.

36. Anne d'Harnoncourt, "Introduction," in d'Harnoncourt, *MD73*, 36.

37. Duchamp scholar Dickran Tashjian quoted in Hunter Drohojowska-Philp, *Rebels in Paradise: The Los Angeles Art Scene* (New York: Henry Holt, 2001), 15.

38. Duchamp quoted in Calvin Tomkins, *The Bride and the Bachelors: Five Masters of the Avant-Garde* (New York: Viking, 1965), 10.

39. Paul Wescher, "Marcel Duchamp," *Artforum*, December 1963, 20.

40. Arthur Danto, *Encounters and Reflections: Art in the Present Historical Moment* (New York: Farrar, Straus, Giroux, 1990), 287.

41. Scherman and Dalton, *Pop: The Genius of Andy Warhol*, 438.

42. Geldzahler quoted in Scherman and Dalton, *Pop: The Genius of Andy Warhol*, 40.

43. Duchamp quoted in "London Show Pleases Duchamp," 15.

44. The British philosopher of art Robin G. Collingwood, in *The Principles of Art* (1938), said: "Every utterance and every gesture that each one of us makes is a work of art." However, Collingwood was speaking of self-knowledge and authenticity, not the kind of "indifference" alluded to by Duchamp. Quoted in Gordon Graham, *Philosophy of the Arts: An Introduction to Aesthetics* (London: Routledge, 2000), 34.

45. Richard Hamilton, "Duchamp," *Art International* 7 (December 1963–January 1964), 22. Review of Duchamp retrospective.

46. Pierre Cabanne and Pierre Restany, *L'Avant-garde au XXéme siècle* (Paris: André Balland, 1969), 216. Translated in Marquis, *MDBSB*, 269.

47. John Canaday, "Iconoclast, Innovator, Prophet," *New York Times*, October 3, 1968, 51.

48. Duchamp quoted from a 1963 filmed interview with Richard Hamilton and Katharine Kuh for the BBC. Quoted in Tomkins, *DB*, 416.

49. Duchamp quoted in James Nelson, ed., *Wisdom: Conversations with Wise Men of Our Day* (New York: Norton, 1958), 99. This is the NBC television interview, "A Conversation with Marcel Duchamp," with James Johnson Sweeney, January 1956.

50. Roland Penrose, *Portrait of Picasso* (New York: Museum of Modern Art, 1957), 92.

51. Daix, *PLA*, 375.

52. Alfred Barr, "Preface," in Penrose, *Portrait of Picasso*, 6.

53. Pierre Cabanne, *Pablo Picasso: His Life and Times* (New York: Morrow, 1977), 9.

54. Françoise Gilot with Carlton Lake, *Life with Picasso* (New York: McGraw-Hill, 1964), 202–203.

55. Daix, *PLA*, 336.

56. According to biographer Cabanne, in Picasso's entire life there are only "three or four interviews or statements of his worth taking seriously." See Cabanne, *Pablo Picasso*, 10. For the best collection of Picasso's comments on art, artists, and politics see Ashton, *POA*.

57. See C. Baekeland and Geoffrey T. Hellman, "Talk of the Town: Marcel Duchamp," *New Yorker*, April 6, 1957, 26.

58. In Albert Gleizes and Jean Metzinger, *On Cubism*, first English trans. (London: T. Fisher Unwin, 1913), 42, the authors emphasize the role of the spectator's being "free to establish" unity in Cubist artworks by their own "creative intuition," not by dictate of the artist. For Picasso's quote see Ashton, POA, 138, 15. Picasso said elsewhere: "The paintings, finished or not, are the pages of my journal, . . . and as such they are valid. The future will choose the pages it prefers. It's not up to me to make the choice."

59. Picasso quoted in Ashton, *POA*, 119.

14. the readymade

1. Duchamp quoted in Grace Glueck, "Duchamp Opens Display Today of 'Not Seen and/or Less Seen,'" *New York Times*, January 14, 1965, 45. Richard Hamilton wrote the catalog notes for the month-long exhibit. *Artnews* described it as more than one hundred items: paintings, drawings, notes, original readymades, reproductions in limited editions of readymades, memorabilia, typographies, and photos of all periods in the artist's career. This was also the year the *New Yorker* ran a major profile on Duchamp, and Calvin Tomkins's book (*The Bride and the Bachelors: Five Masters of the Avant-Garde*) elevated Duchamp to "master" status in contemporary art.

2. Thomas Hess, "J'Accuse Marcel Duchamp," in Masheck, *MDP*, 115.

3. Hans Richter, "In Memory of a Friend," *Art in America*, July 1969, 40.

4. In 1957, Duchamp said that thirty-nine items (or perhaps around fifty) was "practically my entire output" of "works." Duchamp quoted in C. Baekeland and Geoffrey T. Hellman, "Talk of the Town: Marcel Duchamp," *New Yorker*, April 6, 1957, 26. Art dealer Arturo Schwarz's 1969 first edition of *The Complete Works of Marcel Duchamp* listed 421 items (of note for art history and collectors) and the third edition (1997) boosted the list to 663 items.

5. Duchamp quoted in "Marcel Duchamp," *Wisdom: Conversations with Wise Men of Our Day*, ed. James Nelson (New York: Norton, 1958), 90.

6. Duchamp quoted in Katherine Kuh, *The Artist's Voice: Talks with Seventeen Modern Artists* (Cambridge, MA: Da Capo Press, 2000 [1962]), 90, 92.

7. Marcel Duchamp, "Apropos of 'Readymades,'" *SS*, 141–42. A talk delivered at the Museum of Modern Art, October 19, 1961.

8. Marcel Duchamp, "A l'Infinitif," *SS*, 75.

9. For Duchamp's significance in "happenings," see Anne d'Harnoncourt, "Introduction," in d'Harnoncourt, *MD73*, 41; "Interview by Colette Roberts," *Art in America*, July 1969, 39.

10. Allan Kaprow, "Doctor MD," in d'Harnoncourt, *MD73*, 204–5. Dalí quoted in Cabanne, *DMD*, 14. Similarly, Max Kozloff said in 1964: "Duchamp merely says that everything in life is a readymade." Quoted in Masheck, *MDP*, 141.

11. Duchamp quoted in Herbert Molderings, *Duchamp and the Aesthetics of Chance* (New York: Columbia University Press, 2010), 2.

12. Lawrence D. Steefel, Jr., *The Position of Duchamp's Glass in the Development of His Art* (New York: Garland, 1977), 5.

13. Duchamp quoted in Cleve Gray, "Marcel Duchamp: 1887–1968," *Art in America*, July 1969, 21.

14. Duchamp quoted in Tomkins, *DB*, 445.

15. Duchamp quoted in Robert Morris, "Three Folds in the Fabric and Four Autobiographical Asides as Allegories (or Interpretations)," *Art in America*, November 1989, 150. Duchamp's classic anti-taste statement has been: "It is a habit. It is a repetition of the same thing long enough to become taste. If you refuse to imitate yourself, I mean after you have done something, then it stays as a thing by itself. But if it is repeated a number of times it becomes a taste, a style, if you want." See Nelson, *Wisdom*, 94.

16. Hamilton letter to Anne d'Harnoncourt and Walter Hopps, July 10, 1969. Quoted in Taylor, *MDED*, 15.

17. Quoted in Marquis, *MDBSB*, 308. Original quote in French in Raymonde Moulin, *Le Marché de la peinture in France* (Paris: Éditions du Minuit, 1967), 471.

18. Karl Marx, *Capital, Volume I: A Critique of Political Economy* (New York: Penguin Classics, 1999), 187.

19. Anne d'Harnoncourt, "Introduction," in d'Harnoncourt, *MD73*, 36.

20. Shattuck's comment is paraphrased by Hans Richter in Hans Richter, *Dada: Art and Anti-Art* (New York: McGraw-Hill, 1977), 208.

21. *The Associated Press*, January 6, 2006.

22. On Minnesota see George Heard Hamilton, "In Advance of Whose Broken Arm," in *MDP*, 74.

23. On Hirst, see Warren Hodge, "Art Imitates Life, Perhaps Too Closely," *New York Times*, October 20, 2001, A13.

24. Donald Kuspit, *The End of Art* (Cambridge, UK: Cambridge University Press, 2004), 23.

25. Richard Hamilton, "Introduction," *The Almost Complete Works of Marcel Duchamp*, exhibition catalog, Tate Gallery, June 18–July 31, 1966 (London: Arts Council of Great Britain, 1966).

26. Thomas Hess, "J'Accuse Marcel Duchamp," in Masheck, *MDP*, 120.

27. Taylor, *MDED*, 23.

28. Copley quoted in Taylor, *MDED*, 130.

29. Calvin Tomkins, *DB*, 460.

30. Duchamp at Rouen events quoted in Marquis, *MDBSB*, 296.

31. William S. Rubin, *Dada, Surrealism, and Their Heritage* (New York: The Museum of Modern Art, 1968), 23, 185.

32. Duchamp quoted in Cabanne, *DMD*, 88.

33. Duchamp quoted in Tomkins, *DB*, 247. Alexina Duchamp had otherwise urged her husband to rebut Schwarz on the incest theory. In another case, Duchamp refused to sign a protest petition (circulated by André Breton) against a group of French painters (anti-Duchampians) who produced a large painting mocking Duchamp's decline and death.

34. Epitaph quoted in Marquis, *MDBSB*, 299.

35. See Marquis, *MDBSB*, 301.

36. John Canaday, "Iconoclast, Innovator, Prophet," *New York Times*, October 3, 1968, 51; "Duchamp and the Rest of Us," *Chicago Daily News*, October 5, 1968. For other obituaries see Marquis, *MDBSB*, 301.

37. Picasso quoted in "Letter From Paris," *New Yorker*, November 2, 1968; 173. The *New Yorker* translates "*Il avait tort*" as, "He was mistaken," but a standard translation would be, "He was wrong."

15. picasso's last stand

1. John Canaday, "Art: Picasso Sets Off a Paris Culture Explosion," *New York Times*, November 21, 1966, 54.

2. Picasso quoted in Pierre Cabanne, *Pablo Picasso: His Life and Times* (New York: Morrow, 1977), 539.

3. Greenberg's comment was reported in France at the time in Georges Courthion, "Picasso," *Gazette des Beaux Arts* (1967): 261.

4. Richardson, *LP2*, 106.

5. Cabanne, *Pablo Picasso*, 530.

6. Douglas Cooper cited in Cabanne, *Pablo Picasso*, 569. Cooper averred "that Picasso's work had ended ten years earlier, except for the graphics."

7. Picasso quoted in Cabanne, *Pablo Picasso*, 567.

8. Pompidou quoted in Cabanne, *Pablo Picasso*, 559.

9. Ibid., 560.

10. Télémaque and Raysse quoted in Cabanne, *Pablo Picasso*, 559.

11. Patrick O'Brian, *Pablo Ruiz Picasso: A Biography* (New York: W.W. Norton, 1994 [1976]), 474.

12. Daix, *PLA*, 360. On the 1960s, see Carsten-Peter Warncke and Ingo F. Walther, ed. *Picasso* (Cologne, Germany: Taschen, 2002), 650: "Picasso's explicit pictures were part of the Sixties revolution."

13. O'Brian, *Pablo Ruiz Picasso*, 477.

14. Picasso quoted in Cabanne, *Pablo Picasso*, 513.

15. Picasso quoted in Daix, *PLA*, 369.

16. Jacqueline quoted in Cabanne, *Pablo Picasso*, 544.

17. O'Brian, *Pablo Ruiz Picasso*, 477. Duchamp received a similar criticism of his final work, *Étant donnés*, as old-age self-indulgence. Former *Artforum* editor Joseph Masheck said in 1975: "This one seems startlingly gross and amateurish. It dissolves into a senile hobby, altogether private in its psychological function, out of place and embarrassingly unengaging when shown even to friends." Masheck, *MDP*, 23.

18. Picasso quoted in Daix, *PLA*, 370.

19. Picasso quoted in O'Brian, *Pablo Ruiz Picasso*, 479.

20. Paulo Picasso quoted in *Daix*, PLA, 370.

21. Minister for Cultural Affairs quoted in Cabanne, *Pablo Picasso*, 565.

22. For an account of the fallout of Picasso's death on his family, see Deborah Trustman, "Ordeal of Picasso's Heirs," *New York Times (Sunday Magazine)*, April 20, 1980, 11.

23. O'Brian, *Pablo Ruiz Picasso*, 464.

24. William Rubin, "On Returning Picasso's 'Guernica,'" *New York Times*, letters, December 1, 1975, 30.

16. the duchampians

1. Turner quoted in Taylor, *MDED*, 149.

2. Ibid.

3. Ibid.

4. By way of explanation, Duchamp left behind only a three-ring binder of instructions to assemble the diorama's parts: stationary, moving, and electrical.

5. John Russell, "Riches in a Little Room," *London Sunday Times*, May 11, 1969, 54. Quoted in Taylor, *MDED*, 169. Later, Duchamp's allies would put a friendly full-court press on Russell, who came to Philadelphia and in October wrote a review that likened Duchamp to Titian, Rubens, and Courbet. See Taylor, *MDED*, 176–77.

6. Press release quoted in Taylor, *MDED*, 170.

7. Cleve Gray, "Marcel Duchamp: 1887–1968," *Art in America*, July 1969, 20.

8. Turner quoted in Taylor, *MDED*, 173.

9. John Canaday, "Philadelphia Museum Shows Final Duchamp Work," *New York Times*, July 7, 1969, 30; "Peep Show," *Time*, July 11, 1969, 58. Reports quoted in Taylor, *MDED*, 174; *Time* quoted, 175. Turner quoted in Taylor, *MDED*, 175.

10. John Perreault, "The Bride Needs New Clothes," *Village Voice*, September 11, 1969, 16.

11. Quoted in Taylor, *MDED*, 177. Other "Duchamp" headlines at page 188, notes 243, 244, 241, 247, 248, 262, 265.

12. Quoted in Taylor, *MDED*, 188n258; 188n173; 31.

13. Anne d'Harnoncourt and Walter Hopps, *Étant donnés: 1o la chute d'eau, 2o le gas d'éclairage: Reflections on a New Work by Marcel Duchamp* (Philadelphia: Philadelphia Museum of Art, 1987), 7. This is the second reprint of the museum's *Art Bulletin* (April–September 1969).

14. Lebel quoted in Taylor, *MDED*, 131. See Tomkins, *DB*, 455, for Lebel finding it repellant and Cage seeing it as a reversal of Duchamp's principles. Joseph Masheck, "Introduction," in Masheck, *MDP*, 23: "It is not a masterwork of any kind."

15. Alexina letter to Arturo Schwarz quoted in Taylor, *MDED*, 155.

16. Alexina quoted in Taylor, *MDED*, 156. Schwarz was embarrassed to have been excluded from the secret, but as a Freudian, mystic, and Surrealist, he covered himself by saying he had, nevertheless, seen the work in a dream.

17. Cleve Gray, "Marcel Duchamp: 1887–1968," *Art in America*, July 1969, 20.

18. D'Harnoncourt and Hopps, *Étant donnés*, 27.

19. Ibid., 23.

20. Duchamp quoted in Harold C. Schonberg, "Creator of 'Nude Descending' Reflects After Half a Century," *New York Times*, April 12, 1963, 20.

21. Benjamin H. D. Buchloh, "Introduction," *The Duchamp Effect*, ed. Martha Buskirk and Mignon Nixon (Cambridge, MA: The MIT Press, 1996), 3.

22. Walter Hopps, "Postscript," in d'Harnoncourt and Hopps, *Étant donnés*, 46. Hopps's phrasing showed a mastery of subtlety in making connections: "Duchamp has emerged as a major historical source of unity behind the apparent heterogeneity of these [1960s] movements." Other artists had "introduce[d] Duchampian issues in their work," but in doing so, it was more like a "distant ancestor" and "more independent than derivative." Metaphorically speaking, the 1960s artists were "currents in the Duchampian stream."

23. Duchamp quoted in Walter Hopps, *Kienholz: A Retrospective* (New York: Whitney Museum of American Art, 1996), 3.

24. See the scholarly catalog, William A. Camfield, *Marcel Duchamp/Fountain* (Houston, TX: Menil Collection, Houston Fine Arts Press, 1989).

25. Art critic Max Kozloff quoted in Masheck, *MDP*, 144.

26. Lucy Lippard, ed. *Six Years; The Dematerialization of the Art Object from 1966 to 1972* (New York: Praeger, 1973), ix.

27. Martha Buskirk and Mignon Nixon, eds. *The Duchamp Effect* (Cambridge, MA: The MIT Press, 1996). This book of conference papers includes a section of interviews with artists influenced by Duchamp.

28. Art historians Lucy Lippard and John Chandler introduced the idea of "dematerialization" in 1967, published as Lucy Lippard and John Chandler, "The Dematerialization of Art," *Art International*, February 1968. They noted that "ultra-conceptual art" had branched in two directions, ideas and actions.

29. Kaprow paraphrased in Dieter Daniels, "Marcel Duchamp: The Most Influential Artist of the 20th Century?" in *Marcel Duchamp*, ed. Museum Jean Tinguely Basel (Berlin: Hatje Cantz, 2002), 27. Paik quoted in Irmeline Lebeer, *Chroniques de l'art vivant* 55 (February 1975): 35. See Daniels, *Marcel Duchamp*, 27.

30. Schwarz letter to Evan Turner quoted in Taylor, *MDED*, 159.

31. Taylor, *MDED*, 157–58, 200–201.

32. Turner quoted in Taylor, *MDED*, 155.

33. Alexina quoted in Taylor, *MDED*, 158.

34. See voyeurism and *Étant donnés* in Taylor, *MDED*, 24, 51, 100, 157.

35. Copley quoted in Taylor, *MDED*, 160.

36. On the Duchamp-Schwarz business dealings, see Tomkins, *DB*, 425–28.

37. The now-defunct Andy Warhol Art Authentication Board, Inc., was formed around 1995 as a private corporation that certifies the authenticity of works by Warhol. It was funded by the Andy Warhol Foundation for the Visual Arts. The board, based in New York City, had six members who met three times a year to examine works and authenticate them as genuine (but did not appraise their value). The foundation announced in late 2011 that the authentication board would be dissolved. The board had a history of conflicted judgments on "real" and "fake" Warhol works amid the financial acrimony of dealers, collectors, museums, and galleries. The Foundation said it prefers to focus its endowment on promoting art (not on solving art-market claims, lawsuits, and problems created in the age of readymade and appropriation art). See also Eileen Kinsella, "Warhol Inc." *Artnews*, November 2009, 86–93.

38. Eileen Kinsella, "The Brillo-Box Scandal," *Artnews*, November 2009, 94–99.

39. Duchamp was never sued by the Louvre for using the *Mona Lisa* to commercial benefit, but Warhol was sued by the designer of the original Brillo box and by the photographer of a hibiscus flower photo from *Modern Photography* magazine that Warhol used directly for his 1964 mass-produced "Flowers" silkscreen series (all of which generated commercial profits at the Castelli Gallery). Appropriation artists Jeff Koons and Sherrie Levine have been sued for plagiarizing original photographs in their own works, which became commercial ventures that profited from sales. In three separate cases in 2011, the courts found that appropriation artists Shepard Fairey and Richard Prince and filmmaker Thierry Guetta had violated the copyrights of other artists

(i.e., plagiarized) for commercial benefit. The court followed the "fair use" doctrine, which says artists can use other art for parody or commentary, but not to plagiarize it in works done primarily for profitable sales. The Andy Warhol Foundation has joined galleries and other groups in asking an appeals court to overturn the Prince ruling, arguing that the "fair use" law allows "appropriation" art as a matter of free speech (even if money is made).

40. The Marcel Duchamp Estate is located in Paris and is represented in North America by the Artists' Rights Society in New York City, which controls use and charges fees for reproduction of images of Duchamp-related art.

41. The evolution of art into the street as action and "declaration" has been called the "fourth stage," with the readymade in the gallery being the third. See Daniels, "Marcel Duchamp," 30–31.

42. See Michael Archer, *Art Since 1960*, new ed. (New York: Thames and Hudson, 2002), 69–72; 100–108.

43. See Calvin Tomkins, *Lives of the Artists* (New York: Henry Holt, 2008), 191. Tomkins says "the readymade is the Rosetta stone of Koons's art." See also David Sylvester, *Interviews with American Artists* (New Haven, CT: Yale University Press, 2001), 353, 356.

44. Koons quoted in Tomkins, *Lives of the Artists*, 189. On "Made in Heaven," see Tomkins, *Lives of the Artists*, 193–97.

45. Tomkins, *Lives of the Artists*, 40.

46. Michael R. Taylor details the story of feminist artist Hannah Wilke in "A-Trophy in a Museum Case," in Taylor, *MDED*, 202–205.

47. Anne d'Harnoncourt, "Introduction," in d'Harnoncourt, *MD73*, 37.

48. D'Harnoncourt and Hopps, *Étant donnés*, 6; Anne d'Harnoncourt, "Introduction," in d'Harnoncourt, *MD73*, 34.

49. "Foreword," in d'Harnoncourt, *MD73*.

50. D'Harnoncourt, "Introduction," in d'Harnoncourt, *MD73*, 34, 35, 36, 38.

51. D'Harnoncourt quoted in Taylor, *MDED*, 17.

52. Robert Storr, "Dear Colleague," in *Art School: Propositions for the 21st Century*, ed. Steven Henry Madoff (Cambridge, MA: MIT Press, 2009), 60.

53. Storr, "Dear Colleague," 61.

54. "Duchamp's Urinal Tops Art Survey," *BBC News*, December 1, 2004.

17. year of picasso, age of duchamp

1. Picasso quoted in Ashton, *POA*, 45.

2. Duchamp quoted in an unpublished interview with George and Richard Hamilton for BBC series, "Art, Anti-Art," November 1959. Quoted in Tomkins, *DB*, 405.

3. George Heard Hamilton, "In Advance of Whose Broken Arm," in *MDP*, 73.

4. Copley quoted in Taylor, *MDED*, 160.

5. Massot quoted in Calvin Tomkins, *The Bride and the Bachelors: Five Masters of the Avant-Garde* (New York: Viking, 1965), 64.

6. Walter Hopps, "Postscript," in d'Harnoncourt and Hopps, *Étant donnés*, 43.

7. Steven Henry Madoff, "States of Exception," in *Art School: Propositions for the 21st Century*, ed. Steven Henry Madoff (Cambridge, MA: MIT Press, 2009), 279.

8. Roberta Smith, "Conceptual Art," in *Concepts of Modern Art* third ed., ed. Nikos Stango (New York: Thames and Hudson, 1994), 256–70. Smith traces Conceptual art to Duchamp.

9. Marcel Duchamp, "The Great Trouble with Art in this Country," *SS*, 123; Picasso quoted in Ashton, *POA*, 4.

10. Ann Landi, "The Joke's on Us," *Artnews*, December 2011, 93.

11. Picasso quoted in Ashton, *POA*, 16.

12. Carsten-Peter Warncke and Ingo F. Walther, ed. *Picasso* (Cologne, Germany: Taschen, 2002), 680.

13. Anne d'Harnoncourt and Walter Hopps, *Étant donnés: 1o la chute d'eau, 2o le gas d'éclairage: Reflections on a New Work by Marcel Duchamp* (Philadelphia: Philadelphia Museum of Art, 1987), 6, 25. This is the second reprint of the museum's *Art Bulletin* (April-September 1969); Anne d'Harnoncourt, "Introduction," d'Harnoncourt, *MD73*, 36.

14. Marcel Duchamp, "The Creative Act," *SS*, 138.

15. Taylor, *MDED*, 14.

16. Richard Huelsenbeck quoted in Tomkins, *The Bride and the Bachelors*, 64.

17. Roger Shattuck, "The Dada-Surrealist Expedition: Part II," *New York Review of Books*, June 1, 1972, part. vi.

18. Tzara quoted in Mark Polizzotti, *Revolution of the Mind: The Life of André Breton*, rev. and updated (Boston: Black Widow Press, 2009 [2005]), 87.

19. On the avant-garde as a marketing strategy, see Robert Jensen, "The Avant-Garde and the Trade in Art," *Art Journal* (Winter 1998): 360–67.

20. Close quoted in Grace Glueck, "How Picasso's Vision Affects American Artists," *New York Times*, June 22, 1980, D7.

21. "'Dear Picasso': How Today's Artists are Rediscovering the Master," *Artnews*, May 2011.

22. James R. Mellow, "Retrospective Honors Marcel Duchamp," *New York Times*, September 22, 1973, 27.

23. "Restaging the Readymade," panel session, College Art Association (CAA), Los Angeles Convention Center, February 23, 2012. Panel organizers said it was held to clarify that art academia should not confuse "found objects" with readymades. The CAA slated a 2013 panel on, "Cultural Negotiations of the 'Readymade.'"

24. D'Harnoncourt, "Introduction," in d'Harnoncourt, *MD73*, 39.

25. Duchamp quoted in "The Great Armory Show of 1913," *Life*, January 2, 1950, 60.

26. Mellow, "Retrospective Honors Marcel Duchamp," 27.

27. Paul Bloom, *How Pleasure Works* (New York: W. W. Norton, 2010), 146. For Duchamp's elite comments, see C. Baekeland and Geoffrey T. Hellman, "Talk of the Town: Marcel Duchamp," *New Yorker*, April 6, 1957, 27; Tomkins, *DB*, 368–69, 397; Marcel Duchamp, "Where Do We Go From Here?" *Studio International* (January/February 1975): 28. Evolutionary psychologists argue that, given human nature itself, modern

people naturally enjoy more traditional artwork because it is readily understandable, shows clear skills and knowledge, and helps makes sense of the human tradition of the arts. Conceptual art, or ironic art, usually lacks these qualities, although human beings also respond to wry humor when it is at least comprehensible (perhaps like a mustache on the *Mona Lisa*).

28. See Denis Dutton, *The Art Instinct: Beauty, Pleasure, and Human Evolution* (New York: Bloomsbury, 2008); and Ellen Dissanayake, *Homo Aestheticus: Where Art Comes From and Why* (New York: Free Press, 1992).

29. The Picasso tour, "Picasso: Masterpieces from the Musée National Picasso, Paris," traveled from Seattle (October 8, 2010–January 17, 2011) to Richmond, Virginia (February 19–May 15, 2011) to San Francisco (June 11, 2011–October 10, 2011). The exhibition "Picasso and the Avant-Garde in Paris" was held February 24, 2010 through May 2, 2010, at the Philadelphia Museum of Art; "Picasso in The Metropolitan Museum of Art" was held at the Met April 27–August 15, 2010; and "Picasso: Guitars 1912–1914" was held February 13–June 6, 2011, at the Museum of Modern Art.

30. "Economic Impact of Picasso Show Estimated at $66 Million," *The Seattle Times*, April 29, 2011. John Reid Blackwell, "Picasso Exhibit had a Nearly $29 Million Impact in Virginia," *Richmond Times-Dispatch*, July 7, 2011. The Seattle reports suggested that the exhibition revived the future—indeed "saved"—the Seattle Museum of Art, which was sinking financially.

31. Duchamp quoted in Katharine Kuh, *The Artist's Voice: Talks with Seventeen Modern Artists* (Cambridge, MA: Da Capo Press, 2000 [1962]), 89.

index

Abstract Expressionism, 195, 205, 212, 214, 230, 237, 257
Académie Julian, 23, 29–30, 32, 82
African art, 53, 55, 60, 65, 106
American Committee for Aid to Intellectuals, 190
American Federation of Arts, 222; "Art and the Found Object," 222
Andalusian, 9–10, 45, 57
anthropologists on art, 298
anti-Semitism, 76
Apollinaire, Guillaume, 108–9, 135–36, 174, 265, 267; as Cubist leader, 67, 71–72, 74–75; *Cubist Painters, The*, 4, 75; and Duchamp, 40, 48, 75, 83, 90; and *Mona Lisa* theft, 315n1; and Picasso, 40–41, 44–46, 49–50, 107, 149; and *Soirées de Paris*, 66, 100; on Surrealism, 108, 111
appropriation art, 277, 279–81; and lawsuits, 340n39
Aragon, Louis, 136, 147, 163, 171,174–75, 180, 189, 203–5
Architectural Record, 191, 313n4
Arensberg, Walter, 89, 190, 197, 225; art collection of, 145, 169, 180, 207–11, 284, 292; artists' salon of, 113–19; cryptology of, 138, 322n6; and Duchamp, 112, 131–33, 139, 165–66, 170, 183–84, 217; Francis Bacon Foundation of, 184; and Philadelphia Museum of Art, 207–11, 247, 292; and urinal (*Fountain*) hoax, 121–26
Armory Show, 1–4, 80–99, 156, 227, 273, 288, 295–96; attendance at, 88, 318n22; news coverage of, 86–88, 318n20. See also *Nude Descending a Staircase*
Art & Language, 215
art brut, 257

Art in America, 272, 275, 283
Art Club of Chicago, 169
art dealers: Level, André, 163; Mañach, Pere, 17; of Picasso, 311n5; Rosenberg, Léonce, 102; Rosenberg, Paul, 108; Sagot, Clovis, 39; Uhde, Wilhelm, 163; Weill, Berthe, 19. *See also* Kahnweiler, Daniel-Henry; Janis, Sydney; Levy, Julien; Schwarz, Arturo; Vollard, Ambroise
Art Institute of Chicago, 207–8, 214, 284
art market, 96, 163, 216, 227, 268, 280, 293; auctions, 94–95, 152, 156, 286, 293; and Pop art, 224, 242, 245; and readymades, 238, 241
arte povera, 257
Arte Joven (Young Art), 16, 143
Artforum, 226–27, 274
artiste maudit, 19, 34
Artnews, 213, 291
Arts and Decoration, 86, 118
Ashcan School, 84–85, 122
assemblage art, 64, 222, 224, 239, 243, 257
Association of American Painters and Sculptors, 81, 88

Babitz, Eve, 226
Ballets Russes, 104, 107
Barcelona, 11–13, 16–21, 51, 74, 107, 119, 147: Picasso museums in, 173, 260–62; politics of, 10, 18, 260; School of Fine Arts, 10
Barr, Alfred, 169–70, 176, 184, 195, 218, 230, 235; *Picasso: Fifty Years of His Art*, 235
Bataille, Georges, 164, 171–72
Bateau-Lavoir, 21, 33, 41, 44–46, 50–51, 56, 264

Baudelaire, Charles, 7, 15, 265; "Painter of the Modern Life, The," 15
Beardsley, Aubrey, 11
beat and funk art, 224
Bell, Clive, 67, 121, 134. *See also* significant form
Bellmer, Hans, 277, 282
Bellows, George, 84–85
Berger, John, 258; *Success and Failure of Picasso, The,* 258
Bergson, Henri, 77, 110, 295; *élan vital,* 77
Berlin, 79, 107
Black Mountain College, 212–13
blague, 35, 42
Blanche, Jacques-Émile, 163
Bloom, Paul, 298
bohemians, 34–35, 332n2; salons of, 39, 50, 57, 113–14
Bordeaux, 98, 181
Boston, 3, 88, 89, 112–13
Boston Museum of Fine Arts, 208
Braque, Georges, 67, 72, 75, 79, 95–96, 109, 230, 256; on Cubism, 58–60; *Emigrant, The* (1911), 64; at Le Havre, 56, 64, 65; at L'Estaque, 53, 55; and Marcelle Lapré (wife), 57; *Viaduct at L'Estaque* (1908), 53
Brassaï (Gyula Halász), 164, 176
Breton, André, 134–39, 141–48, 152, 154, 164, 174, 177–81, 256; in America, 190–91, 193, 195, 197–99; at Café Certa, 136, 143; and Duchamp, 159, 168, 202–3; and Gradiva Gallery, 177; "Lighthouse of the Bride, The," 168; *Littérature,* 135–36, 139, 141, 144, 147, 159; *La Révolution surréaliste,* 151; *Le Surréalisme au Service de la Révolution,* 168; manifestos of, 147, 150, 151, 163, 177; and Picasso, 147–48, 202; and "Surrealism in 1947," 202–3; and Surrealist factions, 141, 171, 174; and Trotsky, 174, 180
Brisset, Jean-Pierre, 214

British Arts Council, 265
Brooklyn Museum of Art. *See* Dreier, Katherine
brothels, 15
Bruant, Aristide, 42
Buffet-Picabia, Gabrielle, 84, 114, 118, 131, 133, 135, 138, 235

Cabanne, Pierre, 233, 257
cabaret, the, 34–35, 42, 312n11
Cage, John, 167, 190, 213, 228, 240, 248–50, 274, 278; *Reunion,* 249
Cage, Xenia, 167
Calas, Nicholas, 222
Canaday, John, 229, 244, 252
cartoons, 31. *See also* Goldberg, Rube
Casagemas, Carlos, 14–18, 20, 188
Castelli, Leo, 224
Catholic, 18, 57, 206
Ce Soir, 175
Cézanne, Paul, 38–39, 52, 82, 85, 111, 123, 285; influence on Cubism, 53, 55, 58, 71; retrospective (1907), 53, 66
Chaplin, Charlie, 132, 137, 140
Chat Noir, 42, 43
Chavannes, Pierre Puvis de, 12, 50
chess: American Chess Foundation, 245; Cubists and, 72; and Edward Lasker, 160; and Frank Marshall, 130, 146, 160; French Chess Federation, 160; French Olympic chess team, 160; International Chess Federation, 160; and José Raúl Casablanca, 132, 146, 159–60; London Terrace Chess Club, 219; Marshall Chess Club, 130, 138, 146, 190, 245; and Walter Arensberg, 112–114. *See also* Duchamp and chess
Chicago Daily News, 169, 252
Chicago, 3, 88, 156, 169, 184, 207, 221, 252
Chirico, Giorgio de, 102–3, 105; metaphysical painting of, 102
Churchill, Winston, 229
classical mythology, 78, 106

classicism, 30, 49, 51, 110–11, 134, 163, 186

Close, Chuck, 294

Cocteau, Jean, 101, 109, 155, 179, 186, 256; *Parade*, 103–5, 107–8; and return to order, 109

Cold War, 205, 229–30

College Art Association, 295

Columbia University, 191

Conceptual art, 67–68, 224, 257, 277–78, 290–91, 295–96; as appropriation art, 280; and Joseph Kosuth, 215–16; as text, 7

contemporary art, 6–8, 226–27, 234, 254, 276–80, 296, 298–99

Coordinating Council of French Relief Societies, 190

Copley, William, 221–22, 225–26, 247–48, 271, 278–79, 289; and Cassandra Foundation, 248, 271; and Copley Foundation, 221, 248

Cordier & Ekstrom Gallery, 237, 245; "Not Seen and/or Less Seen," 237

Courbet, Gustave, 15, 48, 71, 78, 204, 233, 250, 269; *Artist's Studio, The* (1854–55), 233–34

Courrier Français, Le, 24, 33

Cravan, Arthur, 125

Crotti, Jean, 119, 121–22, 131, 141, 143, 145

Crotti, Yvonne, 131–32, 143

Cubism, 4, 55, 57–59, 64–68; analytic, 58, 75, 86, 110, 155; gallery, 55; Orphic, 75; salon, 55, 67, 70–73, 75, 93, 102–3, 137–38; scientific, 75; synthetic, 3, 64, 65, 68, 110, 152, 260

Cubist room, 2, 71, 73, 74, 76, 81, 86

Cunningham, Merce, 250; *Walk Around Time*, 250

Dada, 136–45, 169, 170, 197, 219, 250; and "Dada's Daddy," 214, 224, 278; as neo-Dada, 212–13, 222–24, 230, 250, 276, 295, 296; as New York

Dada, 140–41; in Paris, 134–35, 140; and Picasso, 147–48; in Zurich, 111, 133–35, 140, 214, 296

Daix, Pierre, 230, 233–34, 265–66

Dalí, Salvador, 142, 173, 177–78, 195, 237, 240, 246, 277; *Rainy Taxi* (1937), 178, 277

Danto, Arthur, 228

David, Jacques Louis, 233, 258; *Rape of the Sabine Women* (1799), 233, 258

Davies, Arthur, 81–82, 85

Da Vinci, Leonardo, 31, 131, 235; on golden section, 74; notebooks of, 32, 72, 90, 92, 97, 165

Degas, Edgar, 52, 265

De Gaulle, Charles, 254

Degenerate Art (*Entartete Kunst*), 176

De Kooning, Willem, 212

Delacroix, Eugène, 15, 233, 259; *Women of Algiers* (1834), 233, 259

Delvaux, Paul, 178, 192, 277; *Break of Day, The* (1937), 192

De Massot, Pierre, 289

Demoiselles d'Avignon, Les (1907), 52–53, 57, 142, 148, 151, 169, 228, 259, 287; title of, 53, 102, 313n29

department stores, 42

Derain, Alice, 46, 256

Derain, André, 46, 54, 109, 269

Derrida, Jacques, 215

De Zayas, Marius, 313n4

D'Harnoncourt, Anne, 242, 274, 283–86

D'Harnoncourt, René, 283

Diaghilev, Serge, 104, 106, 108

Dionysian art, 12

Dodge, Mabel, 85–86, 113, 115

Doucet, Jacques, 142–43, 146, 148, 152–54

Dreier, Katherine, 117–18, 125–26, 131–33, 157, 162, 193–94, 210; beliefs of, 117, 132, 322n13; and Brooklyn Museum of Art, 155–56, 191; and *The Large Glass*, 145, 165. *See also* Société Anonyme

Dubuffet, Jean, 205, 257

Duchamp, Alexina "Teeny" Sattler (second wife), 216–19, 222, 226, 245–48, 250–52, 271, 274, 279

Duchamp, Eugène (father), 25–26, 29, 48

Duchamp, Lucie (mother), 24–26, 28, 61

Duchamp, Lydie Sarrazin-Levassor (first wife), 157, 235

Duchamp, Marcel: on allegory, 323n37; on art theory, 315n29; on beauty of precision, 160; at Bibliothèque de Sainte-Geneviève, 89–90; borrows from *On Cubism*, 316n2; as breather, 216; and chance in art, 93–94, 235, 275, 287, 319n33; as commercial, 320n42; early life of, 25–29; as elitist, 297; erotic objects of, 334n19; on esthetic echo, 209, 297; at Forestay Waterfall, 202, 251; on Futurism, 314n18; glass use by, 319n28; at Imprimerie de la Vicomte, 31, 32; on indifference, 129, 144, 160, 216, 235, 239, 289; at Institut Français, 116, 117; last years of, 245–53; at Lycée Corneille, 26–27; making diorama (*Étant donnés*), 199, 201–2, 210, 217–19, 245–48; and military service, 32, 97, 131; and modern philosophy, 10, 11, 215, 333nn9; at Monte Carlo, 153, 184; promiscuity of, 49, 119, 313n24; as a *raté*, 79; retrospectives exhibits, 224–27, 237, 244, 279, 284–85; as Rrose Sélavy, 140, 144–46, 152–53, 161, 178, 235, 249, 282; urinal hoax (*Fountain*) of, 122–26; at Western Roundtable on Modern Art, 209; and Yvonne (daughter), 218

Duchamp, Marcel, and chess: as art, 115, 226, 227, 249–50; as a career, 90, 130, 146–47, 152–57, 245, 252, 275; column in *Ce Soir*, 175; in Duchamp family, 24–25, 28, 32, 48, 70; paintings on, 48, 62, 74, 208, 249; theories about, 60–61, 327nn3, 6, 7, 8

Duchamp, Marcel, artworks: *50 cc of Paris Air* (1919), 133; *À l'Infinitif* (Box of 1967), 240–41, 272; *Anemic Cinema* (1925–26), 161, 219; *Apollinaire Enameled* (1916–17), 227–28; *Bicycle Wheel* (1913), 93–94, 120; *Blind Man, The* (1917), 126; *Bottle Rack* (1914), 93, 120; *Box of 1914* (1914), 97, 166, 219, 241; *Box-in-a-Valise* (1935–41), 167, 169, 177, 183–84, 192, 200, 292; *Bride, The* (1912), 78; *Chess Game* (1910), 48; Christmas menu (1907), 47; *Coffee Grinder* (1911), 63, 68, 75, 90; *Defective Landscape* (c. 1948), 201; Dentist check (1919), 133; *Dulcinea* (1911), 61; *Étant donnés* (1948–1968), 247, 271–76, 278–79, 283–86; "*Femme-Cocher*" (1907), 33; *Fountain* (1917), 7, 124, 126, 243, 277, 287; *Green Box, The* (1934), 166–69, 219–20, 222–23, 241, 247; *In the Manner of Delvaux* (1942), 192; *King and Queen with Swift Nudes* (1912), 74; "*Lovers, The*" series (1968), 250; *Mona Lisa* "*L.H.O.O.Q*" (1919), 7, 133, 141; *Monte Carlo Bond* (1924), 153–54, 169; *Network of Stoppages* (1914), 93; *Passage from Virgin to Bride* (1912), 78; *Pharmacy* (1914), 169; *Please Touch* (1947), 203; *Portrait of Chess Players* (1911), 62; *Rotary Demisphere (Precision Optics)* (1924), 152; *Rotary Glass Plates (Precision Optics)* (1920), 139, 146, 152, 178; *Rotoreliefs* (1935), 162, 168, 219; *Sad Young Man on a Train* (1911), 62; *Snow Shovel (In Advance of the Broken Arm)* (1915), 119–20, 194, 243, 289; *Sonata* (1911), 61, 75; *Three Standard Stoppages* (1913–14), 93–94, 169; *Tu m'* (1918), 117, 131, 194, 210; "Wanted, $2,000 Reward, RROSE SELAVY" (1923), 146. See also

Large Glass, The; *Nude Descending a Staircase*

Duchamp, Marcel, homes and studios: 23 rue Saint-Hippolyte, 89, 92; 28 West Tenth Street, 245; 80 East Eleventh Street, 245; 210 West Fourteenth Street, 190, 194, 198–99, 218, 245; 246 West Seventy-third Street, 138; Blainville-Crevon, 24–25, 27–28; Buenos Aires, 131–32; Cadaqués, 246, 251, 283; Café Manière, 33, 47; Hôtel Istrai, 154; Lincoln Arcade Building, 112, 114, 116, 119, 126, 139; Munich, 3, 77–79; Nice, 110, 153, 157, 188; Neuilly, 47–48, 60–62, 74, 89, 207; Normandy, 24, 25, 27, 48, 148, 151, 187; Puteaux, 47–48, 63, 70, 82, 85, 161; Rouen, 26–27, 31, 32, 61, 90, 160, 249; rue Caulaincourt, 23, 29, 33, 47; Sanary, 183–84; Veules-les-Roses, 48

Duchamp, Suzanne (sister), 25, 120, 131, 141–42, 181, 183, 245

Duchamp-Villon, Raymond (brother), 22, 24, 28, 74, 81–82, 96, 131, 133, 249; and Puteaux Cubism, 32, 41, 48, 70

Dürer, Albrecht, 43

El Liberal, 20–21

Els Quatre Gats, 14, 20, 42

Éluard, Paul, 136, 147, 168, 171–74, 206; in Communist Party, 180, 186, 189, 203–4; *Painting as Defiance*, 163; and Surrealist exhibits, 177, 179

Ernst, Max, 142, 150, 177, 190, 216, 218

Errazuriz, Eugenia, 104, 107, 171

evolutionary psychologists on art, 298

Fauvism, 22, 37, 53, 60, 134

femmes savantes, 146, 326n26

Férat, Serge and Helen, 100, 102

Ferus Gallery, 225–26

fetishism, 242, 283

Field, Hamilton Easter, 314n4

fin-de-siècle, 11, 21, 49

First World War, 36, 38, 76, 113, 181, 231, 288, 296; and Cubism, 320n7

Flanner, Janet, 203

formalism, 67. *See also* significant form

Fougeron, André, 204

Fourier, François, 193

fourth dimension, 43, 46–47, 59, 71–72, 75, 316n5; Duchamp and, 92, 127, 166, 240

Franco, Francisco, 173–75, 180, 257, 260–63

French Chamber of Deputies, 76

French Communist Party, 174–75, 189, 204–5, 255, 258, 265, 267

French Riviera, 65, 111, 148, 150, 176, 180, 202, 205

Freud, Sigmund, 136, 141, 147, 177, 188, 203, 251, 326n26

fumiste, 35, 42, 83

Futurism, 60, 68, 73, 87

Garaudy, Roger, 204

Gauguin, Paul, 15, 21, 51

Geldzahler, Henry, 228

Gerasimov, Alexander, 203

Germany, 95, 173; art of Picasso in, 53, 56, 76, 100, 103; Duchamp in, 78; and modern art, 11, 67, 75, 101, 155, 176, 213, 296; wars with France, 76, 95–97, 118, 181–83, 187

Gide, André, 137

Gilot, Françoise, 187–89, 205–6, 232–34

Glackens, William, 84, 85, 123

Gleizes, Albert, 67, 70–78, 89, 103, 114, 122, 168–69; *On Cubism*, 4, 67, 75, 77, 236

Gober, Robert, 295

Goldberg, Rube, 91–93, 118, 128, 140, 165, 220, 248, 271; "Invention of the Week," 91

golden ratio, 74, 316n10; as golden section, 74–75

Gotham Book Mart, 193
Gouel, Éva, 57–58, 65, 95–96, 100
Goya, Francisco, 2, 14, 85, 86, 175; *Third of May, The* (1814), 175
Gray, Cleve, 240, 248, 272, 275
Greco, El, 10, 11, 13, 19, 51
Greenberg, Clement, 176, 257
Greenwich Village, 84, 113, 140, 143, 154, 224, 245
Gris, Juan, 33, 35, 57, 75, 139, 269
Grünewald, Matthias, 152
Guernica (1937), 175–76, 182, 189, 204, 236, 256–57, 262, 270
Guggenheim, Peggy, 154, 180, 182–83, 185, 196, 198, 213, 218; Art of This Century gallery, 190–91, 195, 330n6; *Out of This Century*, 179
Guggenheim Museum, 179, 196, 220, 329n42

Hamilton, George Heard, 194, 221, 223, 283, 289
Hamilton, Richard, 220–21, 229, 241, 244, 272, 283; book on Duchamp, 223; *Just What Is It That Makes Today's Homes So Different*, 220
happenings, 240, 249–50, 281, 293, 336n9
Hare, Denise Browne, 248
Hegelianism, 170
Henri, Robert, 84–85
Hess, Thomas, 237–38, 244–45
Hirst, Damien, 243
history painting, 84
Hopps, Walter, 225–27, 248, 276–77, 283, 289; on *Etant donnés*, 339n22
Hubachek, Frank, 184, 207, 214, 252
Huelsenbeck, Richard, 214
Hultén, Pontus, 219, 279–80
Humanité, 189, 203, 204

Ingres, Jean-Auguste-Dominique, 15, 37–38, 50–52, 106, 110, 250; *Turkish Bath, The* (1862), 38, 52, 259

Installation art, 277
Institute of Contemporary Arts (London), 215, 220, 251
International Brigade, 173
International Exhibition in Paris (1900), 11, 14, 15
International Exhibition of Modern Art (1913). *See* Armory Show
International Exposition of Modern Industry, 191
Italian Renaissance, 31, 74

Jacob, Max, 19, 44, 102, 107, 149, 164, 186
Janis, Sydney, 180, 190, 196, 197
Jarry, Alfred, 42–44, 91, 128, 213, 296; and Dada, 133, 135, 138, 141; *Exploits and Opinions of Doctor Faustroll, 'Pataphysician*, 43; 'pataphysics, 43, 44, 93, 121, 291; *Ubu Roi*, 43, 44
Jouffret, Pascal, 59, 72, 92, 129; *Elementary Treatise on Four-Dimensional Geometry*, 59, 92
Joyce, James, 129, 196; *Finnegan's Wake*, 129
Judd, Donald, 295
Jung, Carl, 163

Kahnweiler, Daniel-Henry, 39–40, 53, 55, 59–61, 81, 100, 255; on Cubism, 56, 58, 64; *Rise of Cubism, The*, 110, 163
Kandinsky, Vassily, 76, 110, 155, 156, 210, 230, 247; *Concerning the Spiritual in Art*, 78–79
Kaprow, Alan, 240, 278, 293
Kent, Rockwell, 124
Kienholz. Edward, 276
Kiesler, Frederick, 191–92, 194, 199, 202
kinetic art, 219
Klimt, Gustav, 12
Koons, Jeff, 282
Kosuth, Joseph, 215, 216, 222
Kuh, Katherine, 238–39

Kuhn, Walt, 81–83, 85
Kuspit, Donald, 243–44

Lacan, Jacques, 188
Laforgue, Jules, 44, 62, 78, 115
Lake, Carlton, 232
Laport, Geneviève, 188
Large Glass, The (The Bride Stripped Bare
 by the Bachelors, Even) (1915–1923):
 breaking of, 165, 169; content of,
 126–32, 139, 271; exhibits of, 156,
 169, 210, 220–21, 226; notes on by
 Duchamp, 90–92, 166–68, 235, 240;
 origin of, 78, 91–92, 97–98, 116;
 ownership of, 112, 118, 145, 210
Lautréamont, Comte de, 136; Songs of
 Maldoror, 136, 203
Lebel, Robert, 235, 248, 252, 274, 283;
 Marcel Duchamp, 235
Léger, Fernand, 102, 156, 210
Lettres françaises, Les, 205
Levine, Sherrie, 277, 279, 298; Fountain/
 After Marcel Duchamp, 298
Levy, Julien, 156, 180, 190, 192
Leymarie, Jean, 255, 262
Lichtenstein, Roy, 223
Life magazine, 176, 200, 214, 230, 252,
 256, 278; "Irascibles, The" 195
linguistic turn, 215
L'Intransigeant, 71, 164
Lippard, Lucy, 277
Literary Digest, 170
Littérature, 135–36, 139, 141, 144, 147,
 159
Londe, Albert, 28, 61
Los Angeles art scene, 144, 176, 180,
 208, 212, 225–27
Louvre, 15, 170, 207, 233, 256, 262–64

Maar (Markovitch), Dora, 171–72, 174,
 186, 188
machine aesthetic, 90, 102, 118, 219
Madrid, 16, 107, 143, 173; San Fernando
 Academy in, 13, 26

Malevich, Kasimir, 76, 230
Mallarmé, Stéphane, 44
Malraux, Andre, 254–56
Manet, Edouard, 15, 204, 233, 258;
 Luncheon on the Grass (1862–63),
 233, 258
mannequins, 103, 178, 193, 199, 245–47,
 277
Manzoni, Piero, 240
Marey, Etienne-Jules, 61–62
Marquis de Sade, 150, 154, 168, 172, 203,
 265; 120 Days of Sodom, 46
Marseille, 183, 184, 190
Martins, Maria, 197–202, 209, 217–18,
 244–46, 248; Duchamp letters to,
 201, 285–86
Marxism, 168, 193, 230, 242; and
 commodity fetish, 242, 283; and
 false consciousness, 242
Matisse, Henri, 21, 30, 37, 38, 87, 294,
 182 ; Blue Nude (1907), 52, 53; Joy
 of Life, The (1905–6), 51, 52; and
 Picasso, 50–55, 57, 110–11, 134, 188,
 203, 206, 230; Woman with the Hat,
 The (1905), 38
Matisse, Pierre, 30, 190, 216–17, 310n14
Matta, Roberto, 193
May 1968, 250–51, 258, 263, 281
McBride, Henry, 145
McCarthy, Joseph, 218
Medrano Circus, 21
Mercure de France, 19, 76
Métamorphoses (Ovid), 151
Metropolitan Museum of Art, 195, 228,
 298
Metzinger, Jean, 67, 71–78, 89; On Cub-
 ism, 4, 67, 75, 77, 236
Mexico, 174, 180, 182
Miller, Henry, 168, 193; Tropic of Cancer,
 168, 193
Minneapolis museum, 243
Minotaure, 164
modern art, 6–8, 57–58, 66–68,
 94–95, 102, 110, 170, 173, 228, 299;

bifurcation of, 120–21, 134; politics of, 176, 229; in the US, 81, 85–90, 112–13, 117, 156, 190, 237. *See also* art market; Abstract Expressionism; Armory Show; contemporary art; Cubism; Museum of Modern Art; Pop art; postmodernism; significant form; Société Anonyme

modernism, 12, 86, 137

Mona Lisa: mustache on 7, 72, 133, 141, 212, 279; theft of, 315n1

Mondrian, Piet, 75, 110, 156, 176, 196, 225, 264

Monet, Claude, 15, 48, 223

Montmartre, 4, 15, 18–20, 64, 188, 256, 264; as cabaret district, 14, 16, 34, 312n11; Duchamp's life in, 22–23, 29–31, 33, 47; Picasso's life in, 16, 21–23, 39–42, 44–46, 53, 56, 58; Surrealists in, 154. *See also* Bateau-Lavoir

Montparnasse, 4, 14, 58, 65, 104, 150, 199; as Greenwich Village, 143, 154; poetry in, 101, 135

Mont Sainte-Victoire, 231

Motherwell, Robert, 195, 214, 219; *Dada Painters and Poets, The*, 214, 219

Munch, Edvard, 11; *Scream*, (1893), 11

Munich, 3, 76–79, 81, 83, 89, 91, 176

Murger, Henri, 35; *Bohemian Life*, 35

Murphy, Gerald and Sarah, 148

Museum of Modern Art (MOMA), 176, 195, 222, 230, 270, 292; "Art of Assemblage" exhibit, 222, 239, 243; "Cubism and Abstract Art" exhibit, 169; "Dada, Surrealism, and Their Heritage" exhibit, 250, 252; "Fantastic Art, Dada, Surrealism" exhibit, 169–70. *See also* Barr, Alfred; Rubin, William; Sweeney, James

Mutt, R., 124–26, 131

Muybridge, Eadweard J., 61; *Human Figure in Motion, The*, 61

mystification, 35, 42, 83

National Academy of Design, 85

National Endowment for the Arts, 285

National Gallery of Art, 208, 268

National Institute of Arts and Letters, 285

Nauman, Bruce, 277, 295; *Self Portrait as a Fountain*, 277

New Left, 242, 258

New School for Social Research, 213

New York City, 179, 212–13, 237, 285; Duchamp in, 26, 145, 161, 184; galleries, 121, 156, 190–91, 195–96, 198, 224, 237, 245. *See also* Armory Show

New York Dada, 140–41

New York Times, 87–88, 166, 192, 229, 244, 252, 270, 272

Nietzsche, Friedrich, 12

non-Euclidean geometry, 72, 90

Norton, Louise, 113, 121, 123–24, 126, 235

nouveaux réalistes, 257, 264

Nouvelle Revue Française, La, 141

Nude Descending a Staircase (1912), 7, 62–63, 73–74, 77–78, 165, 169, 288; at Armory Show, 1–3, 85–86, 89, 156, 227, 273

Oceanic art, 52, 53, 55, 60

Old Left, 258

Olivier, Fernande, 21, 45, 49–52, 56–59, 89, 186, 256; memoir by, 44, 53, 164, 188, 234

opium, 44–47, 83

Pach, Walter, 81–85, 88–89, 95–98, 112, 115, 156, 208

Paik, Nam June, 278

Pallarès, Manuel, 13

papier collé(s), 65, 68, 79

Paris: annual salons of, 4, 33, 35, 37, 204; Boulevard Clichy in, 56; Boulevard Raspail in, 65, 96; Concours Lépine at, 162; Ecole des Beaux-Arts, 30–31; Eiffel Tower, 41, 93; Ferris Wheel,

41, 93; Grand Palais, 35–37, 41, 70, 71, 76, 137, 189, 255; Left Bank, 34, 38, 58, 65, 96, 100, 172; Moulin de la Galette, 16; Municipal Council of, 76; National Conservatory of Arts and Industry, 60, 319n28; Petit Palais, 255; Priory of Saint-Martin-des-Champs, 60; Right Bank, 35, 108, 155; Saint-Lazare hospital, 18; Trocadéro Palace, 53, 60. *See also* Montmartre; Montparnasse

Paris Commune, 41, 204

Pasadena Art Museum, 225–27

peace movement (Soviet), 205, 229

Penrose, Roland, 166, 171–72, 174, 220, 229, 234, 254, 265

perspective (linear) in art, 58, 59, 72, 91, 92, 97, 102, 127

Philadelphia Inquirer, 273

Philadelphia Museum of Art, 200, 212, 225, 248, 279, 283–86, 288, 298; Arensberg Collection at, 207–11, 247, 292; *Bulletin* of, 272, 276; *Étant donnés* at, 271–75, 286

photography, 28, 47, 60, 84, 129, 166, 171, 279; as chronophotography, 61

Picabia, Francis, 83–84, 113–14, 152, 157, 161; at Armory Show, 88–89; and Dada, 119, 133–36, 138–39, 141–42, 219; and machine aesthetic, 90, 102, 118

Picasso, Claude (second son), 188, 233, 267, 269

Picasso, Jacqueline Roque (second wife), 230–33, 256, 259, 261, 265–69

Picasso López, María (mother), 9, 107, 261

Picasso, Maya (first daughter), 150, 171, 181–82, 186–87, 189, 267, 269

Picasso Museum (Paris), 260, 263, 269

Picasso, Olga Khokhlova (first wife), 106–8, 110–11, 147–52, 164, 171–73, 186, 230

Picasso, Pablito (grandson), 268

Picasso, Pablo: on art theory, 315n29; artist-and-model works of, 234, 258, 259, 263, 265; and *bande de Picasso*, 5, 35, 41–42, 44, 100, 231; Blue period,17, 27, 45, 51, 163, 261, 308n19; and Catalonia, 10, 11, 13, 20, 260; and centaurs, 106; commemorative birthdays of, 230; as "Comrade of genius," 203, 229, 258, 263; early impact in America, 313n4; early life of, 9–22; etchings by, 151, 174, 233, 255, 258–60, 263–64; final years of, 254–270; and Galerie Louise Leiris, 234; use of Harlequin, 21, 45, 50, 101–3, 105, 149, 259, 263; in Italy, 106; and Jouffret's diagrams, 314n14; at Lapin Agile, 42, 64; and ma jolie, 57, 64; and the Minotaur, 106, 164, 175, 263; and *mirada fuerte*, 10; and Peace Temple, 206; politics of, 13, 18, 189, 229–30, 308n12; and pottery, 188, 230, 233; promiscuity of, 10, 100, 172, 187; retrospective exhibits, 163, 167, 176, 189, 254–57, 265, 292; and Ripolin, 65; Rose period, 45, 49, 50, 57, 95, 103, 176; and Stalin/Lenin Peace Prizes, 204; Surrealist art of, 66, 103, 108, 111, 148, 150–52, 163–64; theater projects of, 321n20; and William James, 313n28

Picasso, Pablo, artworks: *Actor, The* (1904–05), 21; *Ascetic, The* (1903), 20; *Bather with a Beach Ball* (1929), 151; *Bathers* (1918), 111; *Bay of Cannes, The* (1958), 231, 259; *Blind Flower Seller, The* (1906), 51–52; *Boy Leading a Horse* (1906), 50; *Bull's Head* (1942), 187; *Cafe at Royan* (1940), 181; *Chair with Gladiolus* (1943), 189; *Charnel House, The* (1945), 204; *Crucifixion, The* (1930), 152, 163; *Death of Harlequin* (1905), 50; *Dream and Lie of Franco, The* (1937), 174; *Figures by the Sea* (1931), 151; *Harlequin* (1915),

102; *Head of a Woman* (1932), 175; *L'Usine* (1909), 56; *La Vie* (1903), 20; *Last Moments* (1900), 11, 14, 20; *Man with a Guitar* (1912), 151; *Man with a Lamb* (1944), 187, 206; *métamorphoses* (1930s), 152, 164; *Minotauromachy* (1935), 175; "Mother and Child" series (1922), 149; *Night Fishing at Antibes* (1939), 180; *Parade* (1917), 105, 108; *Portrait of Daniel-Henry Kahnweiler* (1910), 59; *Reading the Letter* (1921), 149; *Saltimbanques* (1905), 95; *Science and Charity* (1897), 11, 26; *Seated Man, The* (1914), 102; *Seated Bather* (1930), 151; *Self-Portrait with Palette* (1906), 51; *Standing Female Nude* (1910), 86; *Still Life with Fish* (1923), 149; *Still Life with Chair Caning* (1912), 64, 222; *Still Life with Steer's Skull* (1942), 187, 189; *Studio with Plaster Head* (1925), 150; *Suite 347* (1968), 259; *Three Women at the Spring* (1921), 149; *Three Musicians* (1921), 149; *Two Sisters* (1902), 18; *War and Peace* (mural, 1952), 206; *Woman in a Chemise* (1913), 66; *Woman with a Mustard Pot* (1909–10), 86; *Woman with Artichoke* (1941), 189; *Woman with a Vase* (1933), 175, 267; *Woman with Loaves* (1906), 51; *Woman-Flower* (1946), 188; *Women of Algiers, after Delacroix* (1955), 259; *Women Running on the Beach* (1922), 149. See also *Demoiselles d'Avignon, Les*; *Guernica*

Picasso, Pablo, homes and studios: 5 rue Schoelcher, 65, 100, 101, 104; 23 rue la Boétie, 108, 148, 149; Antibes, 148, 180, 260, 268; Avignon, 52, 57, 65, 95–96, 101, 264–66, 268; Biarritz, 107; Boisgeloup, 151, 172; Cannes, 172, 176, 230–32, 259; Cap d'Antibes, 268; Céret, 57, 65; Fontainebleau, 148, 149; Gósol, 51; Grimaldi Palace, 206; Horta, 13, 56–57, 61, 206, 256; Hôtel du Cap, 148; Juan-les-Pins, 150; La Californie, 230–33; La Coruña, 9, 10, 263; Málaga, 9–11, 263; Mougins, 176, 231–33, 255–56, 261, 253, 265–67; Notre-Dame-de-Vie, 232; Royan, 181–82; La Rue-des-Bois, 55; rue des Grands-Augustins, 172, 182, 186, 187, 206, 231, 233, 256; Tremblay-sur-Mauldre, 172; Vallauris, 205, 206, 230–31, 263, 267; Vauvenargues Château, 231–33, 267. *See also* Barcelona; Bateau-Lavoir

Picasso, Paloma (second daughter), 188, 233, 267, 269

Picasso, Paulo (first child), 148–49, 186, 267–69

Pierrot, 21, 149, 259

poète maudit, 34

Poincaré, Henri, 26, 46, 72, 75, 92, 129

Pompidou Center, 243, 279, 280

Pompidou, M. Georges, 262–63

Pop art, 213, 220–25, 242, 245, 256, 257; and Duchamp, 248, 272, 276, 293

positivism, 215

post-Impressionism, 17, 39, 66, 85

postmodernism, 8, 68, 121, 228, 234, 292, 299

Pound, Ezra, 118

Poussin, Nicolas, 109, 110, 111, 149

Prado Museum, 10, 13, 174, 260, 262

Pravda, 203

primitive art, 21, 50, 51, 55, 60–61

Princet, Maurice, 46, 47, 59, 71, 72

process art, 277, 290

Pyrenees, 51, 56, 57, 198, 231

Quinn, John, 88, 98, 112, 115–16, 145, 156, 196; collection, 326n38

radioactivity, 46, 72

Rauschenberg, Robert, 212, 213, 222, 225, 228, 249; combines of, 213, 222; *Erased de Kooning Drawing*, 212; *Trophy II*, 222

Ray, Man, 89, 115–16, 119, 138, 209, 221, 246, 251–52; *Anemic Cinema*, 161, 219; *Gift*, 144; and New York Dada, 140; as photographer, 125, 129, 139, 144, 148, 157

Raynal, Maurice, 75

Read, Herbert, 180

readymade, 95, 216, 227–28, 237–53, 281–84, 289, 294–95; definition of, 94, 238–39; dilemmas of, 240–244; origin of, 119–22, 125–27; variety of, 133, 144, 146, 169, 194, 238

Redon, Odilon, 12

Rembrandt, 259, 298

Renoir, Pierre-Auguste, 15, 16, 269

return to order (*retour à l'ordre*), 100–1, 108–9, 111, 134–36

Revue Blanche, 17, 19

Revue Immoraliste, 40

Reynolds, Mary, 154, 157, 179, 181, 198, 202, 207. See also Hubachek, Frank

Richardson, John, 148, 257, 308nn2, 4

Richter, Hans, 238

Rimbaud, Arthur, 12, 44, 135, 154, 159

Roché, Henri-Pierre, 39–40, 119, 126, 133, 145, 183–84, 237

Rockefeller, Nelson, 197, 218, 283

Rogue, 113

Roussel, Raymond, 77, 78, 91, 93, 128, 214, 240; *Impressions of Africa*, 77, 91

Rubin, William, 250, 270

Ruiz Blasco, José (father), 9–11, 13, 20, 89

Ruiz Picasso, Lola (sister), 230, 261

Rusiñol, Santiago, 12, 14

Russell, John, 272, 274

Sabartés Collection, 261

Sabartés, Jaime, 14, 20, 171–73, 181–82, 232, 256, 260–61; memoirs of Picasso, 206, 234

Salon d'Automne, 30, 47, 48, 50, 79, 83, 133, 189; of 1905, 36, 37–39, 40, 42; and Cubism, 55, 72, 73, 76

Salon de la Section d'Or, 74, 79

Salon des Artistes Humoristes, 33

Salon des Indépendants, 30, 37, 53, 55, 64, 236, 299; Cubists at, 71, 73–74, 137; impact on United States, 82, 122–23; and Matisse, 51, 52

Salon of the Liberation, 189, 203

saltimbanques (acrobats), 95, 108

San Francisco, 119, 176, 208, 209, 212, 225, 299

Sanouillet, Michel, 219–20; *Salt Seller: The Writings of Marcel Duchamp, The*, 219

Satie, Erik, 101, 104–5, 107

Schoenberg, Arnold, 213

Schwarz, Arturo, 251, 248, 274, 278, 280, 283; *Complete Works of Marcel Duchamp, The*, 351, 256, 274

Schwitters, Kurt, 155, 225

Second World War, 181–82, 201, 230. *See also* Degenerate Art; Vichy government

Segal, George, 276

Serre, Jeanne, 49

Shakespeare, 103, 138, 184, 258

Shattuck, Roger, 243, 293

Sheeler, Charles, 84

Sherman, Cindy, 282; "Sex Pictures" by, 282

significant form, 66–68, 121, 134, 227–28; and Immanuel Kant, 315n28, 321n27

Sisler, Mary, 237

socialist realism, 174, 176, 186, 203–4

social realism, 84

Société Anonyme, 138–40, 145, 170, 193–94, 219. *See also* Dreier, Katherine

Society of Independent Artists (France), 73, 236, 299

Society of Independent Artists, Inc. (US), 122, 125

Sonderbund Exhibition, 82, 317n7

Soviet Union, 173–74, 180, 182, 229; and modern art, 176, 203, 205, 258. *See also* socialist realism

Spanish Civil War, 173, 176
Stein, Gertrude, 40, 44–45, 50, 54, 72, 85, 100, 104, 106, 113, 118, 143, 235, 294; at 27 rue de Fleurus, 38–39; *Autobiography of Alice B. Toklas*, 164
Stein, Leo, 38–39, 50, 57
Stettheimer sisters, 117, 235
Stieglitz, Alfred, 118, 125, 126, 166; and 291 Gallery, 84, 113, 119; *Camera Work*, 313n4, 316n5
Storr, Robert, 286–87
Stravinsky, Igor, 104, 106; *Rite of Spring*, 194
Surrealism, 134, 146, 154, 162, 171, 167, 177–79; definition of, 141, 147; "First Papers of Surrealism, The," 190–92; and International Surrealist Exhibition (1937); in literature and poetry, 135–36, 141, 150, 164, 168, 174; manifestos, 147, 151, 163; in painting, 142, 173, 176, 192, 193, 240; as *sur-realism*, 108; and "Surrealism in 1947," 202–3. *See also* Breton, André; Dalí, Salvador; Chirico, Giorgio de; Ernst, Max; Freud, Sigmund; *Littérature*; mannequins; Picasso, Pablo
Sweeney, James, 190, 196, 220; "Eleven Europeans in America," 196; *Wisdom: Conversations with Elder Wisemen of Our Day*, 196
symbolist art, 12–13, 20, 44, 48, 50

Tate Gallery, 220, 244–45, 256, 265–66; "Almost Complete Works of Marcel Duchamp, The," 244, 256
Télémaque, Hervé, 264
Theater of the Absurd, 44, 121, 213
Time, 185, 192, 195, 273, 276
Tinguely, Jean, 219
Tomkins, Calvin, 129, 209, 313n24
Toulouse-Lautrec, Henri de, 15–17, 19, 23, 42, 52
Trotsky, Leon, 174, 176, 180, 203

Turner, Evan H., 248, 271–73, 279, 284, 287
Turner Prize, 287
Tzara, Tristan, 133–38, 140–43, 145, 147–48, 216, 293; *Anthologie Dada*, 135; *Dada Manifesto*, 133, 135

US Congress, 130–31
UNESCO, 231
University of California, 208, 225

Van Gogh, Vincent, 15, 16, 39, 85, 88, 111, 117, 139
Vanity Fair, 148
Varèse, Edgard, 101, 103,
Velásquez, Diego, 10, 13, 233, 250; *Maids of Honor, The* (1656), 261
Venice Biennale, 155, 295
Verlaine, Paul, 34, 44, 115
Verne, Jules, 77
Vichy government, 181–83, 186, 189, 202–3
View, 197
Village Voice, 273, 283
Villon, Jacques (Gaston Duchamp; older brother), 15, 22–24, 29, 81, 96, 114, 133, 249; and Puteaux Cubism, 32, 41, 48, 70, 72–74
Virgin Mary, 127
Vlaminck, Maurice, 186
Vollard, Ambroise, 17–19, 21, 39, 50, 52, 102, 263

Walter, Marie-Thérèse, 150–51, 163, 171–72, 175, 181–82, 186–89, 267–68
Warhol, Andy, 223, 226–28, 237, 249, 280, 287, 293, 295; Campbell soup cans, 224; Foundation and Authentication Board, 340n37; *Screen Test: Marcel Duchamp*, 248
Weber, Max, 313n4, 316n5
Weiwei, Ai, 296
Wilke, Hannah, 283

Wittgenstein, Ludwig, 215
Wood, Beatrice, 119, 123–126, 131, 235
World's Fair (1937), 175–77, 267

X–rays, 26, 46, 59, 61–62, 72, 75; in
 photography, 28, 60

Yale School of Art, 286, 290
Yale University, 194, 213, 221, 283, 289,
 298; art gallery, 117, 210. *See also*
 Hamilton, George Heard

Zervos, Christian, 163, 167, 234, 264